JAM: Tokyo-London
JAM: Tokyo-London
JAM: Tokyo-London
JAM: Tokyo-London
JAM: Tokyo-London
JAM: Tokyo-London
JAM: Tokyo-London
JAM: Tokyo-London
JAM: Tokyo-London
JAM: Tokyo-London
JAM: Tokyo-London
JAM: Tokyo-London

Direction and project co-ordination:
Jane Alison with Mami Kataoka and
Catherine Wood

Ideas and contributions:
Jane Alison, David Elliott, Ekow Eshun,
Liz Farrelly, Toru Hachiga,
Mami Kataoka, Fumiya Sawa, Nobuko Shimuta,
Masa Sugatsuke, Lucy Swift,
Suzannah Tartan, Catherine Wood

Shiseido The Makeup
Shiseido The Makeup
Shiseido The Makeup
Shiseido The Makeup
Shiseido The Makeup
Shiseido The Makeup
Shiseido The Makeup
Shiseido The Makeup
Shiseido The Makeup
Shiseido The Makeup
Shiseido The Makeup
Shiseido The Makeup

Shiseido The Makeup is proud to sponsor
JAM:Tokyo-London at the Barbican.

For more than one hundred years
Shiseido has recognised the natural
affinity between the creative
avant-garde and contemporary beauty.
This exhibition represents an
extension of the close relationship
Shiseido has enjoyed with many of
the Japanese artists showing in JAM.
We are delighted that these artists
can bring their work to the attention
of a wider international audience.

As a company, Shiseido embodies the
spirit of this exhibition and the
symbiotic relationship between Eastern
philosophies and Western artistic
values. The importance of revolutionary
technology and the popularity of
visual culture lie at the very heart
of both this exhibition and Shiseido.
The Makeup is an example of this dynamic
fusion and we invite you to discover
it as part of JAM at the Barbican.

SHISEIDO
The Makeup

JAM:Tokyo-London Foreword
JAM:Tokyo-London Foreword
JAM:Tokyo-London Foreword
JAM:Tokyo-London Foreword
JAM:Tokyo-London Foreword
JAM:Tokyo-London Foreword
JAM:Tokyo-London Foreword
JAM:Tokyo-London Foreword
JAM:Tokyo-London Foreword
JAM:Tokyo-London Foreword
JAM:Tokyo-London Foreword
JAM:Tokyo-London Foreword

 Foreword Jane Alison
 Foreword Jane Alison
 Foreword Jane Alison
 Foreword Jane Alison
 Foreword Jane Alison
 Foreword Jane Alison
 Foreword Jane Alison
 Foreword Jane Alison
 Foreword Jane Alison
 Foreword Jane Alison
 Foreword Jane Alison
Foreword Jane Alison

Jane Alison, Curator, Barbican Art Galleries

JAM is an exhibition and project space; an exploration of inspirational, creative practice
in an urban context. The second in a possible series of exhibitions, JAM is a follow up to
our exhibition of the same title held at the Barbican Gallery in 1996. The previous exhibition
celebrated exciting new work at the interface between different media not normally shown
in a gallery context. Within one space we integrated fashion and fashion photography, music,
graphics and new media installations. The exhibition design, by the acclaimed furniture
designer, Tom Dixon, was forward looking, upbeat and experiential.

The exhibition coincided, and unwittingly gave credibility to the "Cool Britannia" hype that
was around at that time. It was also open-ended and inclusive and as the title suggests,
improvisational. It didn't begin with an institutional thesis and therefore avoided the
possibility of stifling the way we see "art". As well as meshing different kinds of work,
younger emergent artists were shown alongside their mentors and established figures.
It was an attempt to break away from the white cube aesthetic of exhibition curating and be
non-hierarchical in the way that exhibits were displayed and discussed.

This exhibition picks up from where the first left off, yet not surprisingly it offers a
very different experience. This is a reflection that, five years on, the creative community
in London has evolved and mutated. But more significantly, JAM #2 is a celebration of
contemporary practice in two urban centres, East and West, Tokyo and London. As such
it becomes a dialogue, a celebration of difference and commonality. The idea of interaction
between disciplines is coupled to one in which physical distance is bridged and new lines
of communication and connection are formed.

Why Tokyo? The answer is in the idea of London and Tokyo being of parallel standing in the
world, each one commanding an important place on either side of the globe, and each having
vibrant artistic communities and richly expressive subcultures. I also sense an incredible
ground swell of interest here in the contemporary art and music that comes out of Tokyo.
The time seemed absolutely right to profile the leading lights of Tokyo's creative scene.
And like the first JAM, to mix established figures, well known in Tokyo, with a scattering
of younger artists.

Our interest in the East is not a new one, but historically it has been coloured by a tendency
to admire only the exotic. Understandably then, the contributors in Tokyo were determined to
present a vision of their city that would be at variance with any crude ideas we might be
tempted to adopt. Old stereotypes, centred on kimonos and Zen, are replaced by equally skewed
new ones, i.e., Pokemon, Play Station and love hotels. While the worlds of fantasy sex and
cute toys are undoubtedly to the fore in Tokyo culture, JAM's contributors bring more to these
subjects; a sense of humour and intelligent attitudes that sets them apart from everyday,
mainstream usage.

The process of bringing JAM together has involved groups of advisors and friends of the
exhibition discussing new directions across the fields of media, art, music and fashion.
In Tokyo, we acknowledged the overwhelming significance of technology and manga and the
autobiographic emphasis of contemporary photography. We mused on the central place of
consumerism and the disposable culture that follows. My first visit to Tokyo made me realise
the extent to which fine art is a borrowed concept. Barriers and definitions we are
familiar with in the West become pretty meaningless as many of the Tokyo contributors move
effortlessly between different art forms in order to express their vision.

In London, subversion - the opposing of norms and social mores - is something embedded in
our cultural life, and ironical humour too. Whereas technology rules in Tokyo, in London
a return to the hand-made appears to be the order of the day. We found a common denominator
in the strong desire to create moments of calm and beauty in the chaos of urban existence.

I would like to take this opportunity to thank all those people in London and Tokyo who have been committed to achieving the best possible results for this project, especially the advisors and artists who are listed on the title pages. It has been a pleasure to work with Mami Kataoka of the Tokyo Opera City Art Gallery, where this exhibition will travel in early 2002. Her work in support of the exhibition has been invaluable. The Tokyo showing has been made possible by the British Council who have also given significant support to the project in London. We have received further help from the Japan Foundation; their contribution went toward the making of this book and bringing artists and advisors from Tokyo to London.

Shiseido, The Makeup, are sole sponsors of the exhibition and we are indebted to them for that.

It is a keynote of JAM to think of the exhibition and book design as exhibits in their own right. We are delighted to be working with Shin and Tomoko Azumi who, at the time of writing, are coming up with wonderful ideas to transform the gallery space. They have also been extraordinarily sensitive to the rationale of the exhibition and the work of individual designers and artists. This book, designed by Ben Parker and Paul Austin of Made Thought, is yet another splendid contribution to the JAM project. A direct reflection of the exhibition itself, this book will be of ongoing benefit to all those who wish to ponder the state of creative expression in two of the world's most vibrant cities.

Foreword Mami Kataoka
Foreword Mami Kataoka
Foreword Mami Kataoka
Foreword Mami Kataoka
Foreword Mami Kataoka
Foreword Mami Kataoka
Foreword Mami Kataoka
Foreword Mami Kataoka
Foreword Mami Kataoka
Foreword Mami Kataoka
Foreword Mami Kataoka
Foreword Mami Kataoka

Mami Kataoka, Curator, Tokyo Opera City Art Gallery

At the dawn of the new century, a mounting interest in the fusion of diverse artistic genres seems to be a world-wide phenomenon. Genres in various media, that have previously coexisted are naturally overlapping and attempting to expand the margins of their activity. Energies emitted on the fringes have all but overwhelmed the centre.

It may be said that the cultural and artistic phenomena produced in metropolises like Tokyo and London have always relied heavily on energies spawning spontaneously from the street; and no-one can grasp all the visual and aural stimuli or the lively chaos that floods these streets. All of us, depending on our tastes, perform a procedure of selection from the various sensual stimuli. We download and adapt to our own style, but to a great extent, the trends and currents formed from the wealth of information floating about the city are generated by a collective unconscious, and while the individual seeks originality, it is also true that there is satisfaction to be had from a sense of belonging to one of the many urban tribes and groups that exist within the city. This complexity of group psychology, desire for recognition and intense stimuli, create new energies. The energies rising from the streets in Tokyo, especially the unique contemporary "character" culture of manga, animation programmes and video games, has not only exerted influence over the diverse modes of artistic expression, but has, created a significant stronghold within the fashion industry that supports the economics of a nation where long term recession has set in.

It is extremely meaningful and timely that JAM: London-Tokyo is taking place during such a period. In the same way that Tokyo is Tokyo, and not representative of all Japan, London too is at once England and an independent urban space that is not England. While each has their own cultural background, each is receptive to new stimuli regardless of borders. With the unique phenomena of both cities being generated by vital chaos, and brought together in this exhibition, it is with great anticipation that we wait to learn how each shall respond to the other, and merge.

Finally, alongside Jane Alison, I too would like to express my deepest gratitude to the artists and creators who willingly offered their works for this exhibition, to the advisors and the British Council who continue to give their warm and enthusiastic support, and to the other various individuals who contributed their efforts in various ways to the realisation of this exhibition.

Foreword David Elliott
Foreword David Elliott
Foreword David Elliott
Foreword David Elliott
Foreword David Elliott
Foreword David Elliott
Foreword David Elliott
Foreword David Elliott
Foreword David Elliott
Foreword David Elliott
Foreword David Elliott

David Elliott, Assistant Director (Arts), British Council, Japan

JAM: Tokyo-London is a snapshot of two urban cultures on opposite sides of the world. On the one hand it highlights the differences that distance makes inevitable, on the other it celebrates an increasing synergy, and how, as globalisation marches inexorably on, cultures are not so much colliding as overlapping and morphing.

If globalisation is a relatively recent phenomenon, then there are other binding agents at work: our status as island nations adrift from continents with whom we have not always had easy relations: a tendency for reserve on the one hand countered with a penchant for exhibitionism on the other, and a wilful desire to drive on the left. But it is in the cities' youth cultures, its street style, shops and clubs, where the similarities are most apparent. This can be illustrated by two scenarios.

Exit Harajuku Station, with its ubiquitous Punks and Goths posing for photos at the entrance to Yoyogi Park: take a right down Takeshita Dori (Carnaby Street by any other name) past the Mod signs, Beatles' shop and other remnants of Swinging Sixties culture: walk past Pizza Express, HMV, Boots and the Body Shop, before cutting through the back streets to Trico, agents for Michael Marriott and Inflate. Just time to flick through some UK Garage imports at Rough Trade before heading down to Shibuya to meet friends for a Kirin or Boddingtons at Soft (decked out by the Azumis and Jam). Then it's off to Max Brennan and Susumu Yokota's Sublime night in Aoyama Cay.

Conversely, you're one of 600 Japanese students studying at the London Institute. You've had a creative morning at Central Saint Martins but now it's time to head across Leicester Square, where the Beat Takeshi-directed, Jeremy Thomas-produced "Brothers" is showing, for lunch at Kulu Kulu on Brewer Street or just grab a Marks and Spencer take-way sushi: walk up Regent Street past the Pokemon in Hamleys and pick up some stationery at Muji before taking the tube across town: katakana is everywhere, on clothes, Asahi Super Dry ads, even an Everything but the girl sleeve, the music of which is playing on someone's Sony Discman. Check out Tomoko Takahashi's installation at the Saatchi Gallery before rounding off the evening with Ken Ishii and Mixmaster Morris at The Dogstar in Brixton.

Although a bit of a cliché, this is not so far-fetched. Of course, similar cross-pollination is happening in many cities, many countries, but London and Tokyo seem to have a special relationship fuelled by a restless media, hungry for popular culture's latest trend.

As the UK's principal cultural agency overseas, the British Council is a natural conduit for the promotion of post "Cool Britannia" creativity, as well as for encouraging cultural traffic in the opposite direction. Its strong presence in Japan has made it a natural partner for the Barbican Art Gallery and Tokyo Opera City Art Gallery in producing this exhibition, and we have been delighted to play a part in bringing together the two countries in this unique and creative way.

JAM:Tokyo-London E-mail conversations
JAM:Tokyo-London E-mail conversations
JAM:Tokyo-London E-mail conversations
JAM:Tokyo-London E-mail conversations
JAM:Tokyo-London E-mail conversations
JAM:Tokyo-London E-mail conversations
JAM:Tokyo-London E-mail conversations
JAM:Tokyo-London E-mail conversations
JAM:Tokyo-London E-mail conversations
JAM:Tokyo-London E-mail conversations
JAM:Tokyo-London E-mail conversations
JAM:Tokyo-London E-mail conversations

E-mail conversation Tomoko and Shin Azumi
E-mail conversation Tomoko and Shin Azumi
E-mail conversation Tomoko and Shin Azumi
E-mail conversation Tomoko and Shin Azumi
E-mail conversation Tomoko and Shin Azumi
E-mail conversation Tomoko and Shin Azumi
E-mail conversation Tomoko and Shin Azumi
E-mail conversation Tomoko and Shin Azumi
E-mail conversation Tomoko and Shin Azumi
E-mail conversation Tomoko and Shin Azumi
E-mail conversation Tomoko and Shin Azumi
E-mail conversation Tomoko and Shin Azumi

From: Jane Alison
To: Tomoko and Shin Azumi

We loved the idea of involving Japanese artists working in London as part of the London JAM contingent. And at the time of this conversation you are currently finalising the exhibition design for JAM. It's looking fabulous. Can you say how you came to be working in London and what path your career has followed to date?

From: Tomoko and Shin Azumi
To: Jane Alison

We came to London in March 1992, to study design again, after three years work experience in Tokyo. During our time at the Royal College of Art (Shin 1992-1994, Tomoko 1993-1995) we learned how designers run their practices, then started our own from 1995. We created self-production pieces and took part in exhibitions. Since 1996 we have exhibited in "100% Design", which has been a good opportunity for us to meet people in the industry. In the first two years we met retailers, interior designers and architects who would buy our products and also journalists and international press. After three years, in around 1998, we started to talk with manufacturers about how we could work together. In 2000 we took part in the "Tectonic" exhibition at the Crafts Council and made our first spatial installation named "Misty Lounge", using our Wire Frame Furniture and thousands of bungee cords. This "Misty Lounge" created more opportunities for working in spatial design.

From: Jane Alison
To: Tomoko and Shin Azumi

Has JAM been a natural progression for you?

From: Tomoko and Shin Azumi
To: Jane Alison

Yes, we think so. We always wanted to design an exhibition space.

From: Jane Alison
To: Tomoko and Shin Azumi

What keeps you here, and are you known in Japan?

From: Tomoko and Shin Azumi
To: Jane Alison

Because we started our careers here, we now have a network of people who we work with. Also, we like the British people who admire innovative and experimental design. Additionally, London is a good location from which to work with other European companies. Our works are introduced in Japan both as "Japanese" and "London-based".

From: Jane Alison
To: Tomoko and Shin Azumi

To what extent do you feel your work is Japanese?

From: Tomoko and Shin Azumi
To: Jane Alison

In furniture and product design our work often has a "transformable" aspect and that comes from our cultural background. In space design, we like to play with light and shadow and we

think that comes from our memories of Japan, where the contrast of sunshine and shadow is much stronger than here.

From: Jane Alison
To: Tomoko and Shin Azumi

What do you enjoy about the different areas of design you cover?

From: Tomoko and Shin Azumi
To: Jane Alison

In furniture and product design, we look at small details of daily life and try to solve problems. On the other hand, in space design, we wish to create something theatrical, which may be far away from daily life. We enjoy both sides of design and one brings us some hint of the other.

From: Jane Alison
To: Tomoko and Shin Azumi

What issues have you had to think about in designing the exhibition?

From: Tomoko and Shin Azumi
To: Jane Alison

We tried to understand and extract the exhibiting artists' ideas as much as possible, and create the best environment for them within the limited space available. As the works are very lively and they are happening now, we tried to exhibit the works as live phenomena that are breathing the same air as us. As the number of the exhibitors is high compared to the space available, we looked at the site carefully for areas that are not usually used but have great potential to create a big impact.

From: Jane Alison
To: Tomoko and Shin Azumi

What do you want the feel of the exhibition to be?

From: Tomoko and Shin Azumi
To: Jane Alison

To show a kind of optimism for the future; that is what we feel from the works.

From: Jane Alison
To: Tomoko and Shin Azumi

Have you been most conscious of difference or similarities between the London and Tokyo contributions?

From: Tomoko and Shin Azumi
To: Jane Alison

We picked up more similarities at the beginning. Now, we find more differences between the two cultures. At the end we found that the conflict could generate a high creative temperature.

From: Jane Alison
To: Tomoko and Shin Azumi

What next for the Azumis?

From: Tomoko and Shin Azumi
To: Jane Alison

We are hoping to collaborate with people who we admire; show our work to an international audience; have more opportunities to design space.

E-mail conversation Ekow Eshun
E-mail conversation Ekow Eshun
E-mail conversation Ekow Eshun
E-mail conversation Ekow Eshun
E-mail conversation Ekow Eshun

E-mail conversation Ekow Eshun
E-mail conversation Ekow Eshun
E-mail conversation Ekow Eshun
E-mail conversation Ekow Eshun
E-mail conversation Ekow Eshun
E-mail conversation Ekow Eshun
E-mail conversation Ekow Eshun

From: Jane Alison
To: Ekow Eshun

As part of the advisory group on JAM you've been key to shaping the London end of the exhibition. From your personal perspective, can you pinpoint any tendencies that sum up what you feel is happening in London at the moment?

From: Ekow Eshun
To: Jane Alison

That's a more difficult question to answer than it seems, because things that are vital don't happen in isolation. For instance, UK Garage, which I love, isn't just about the music. It's about the appropriation of labels such as Moschino and Versace. It's about the pirate radio stations and the energy and moodiness in the clubs. It's about the "feel" of a bassline. But I'd also say what's key to me is that this is also a playful city where artists and musicians and fashion people tend to have a sense of the absurd. It's not stuck-up like Paris or Milan or money-obsessed like New York. Even though both of those tendencies exist, they don't define London. Just yesterday I went to see artist Michael Landy destroying all his possessions in the former C&A on Oxford Street. I love the dancing on the grave of the banal involved in that, and also the restless urge to erase, destroy, keep moving, which is what London, in its ceaseless search for the new, is captivated by.

From: Jane Alison
To: Ekow Eshun

Yes, we've talked about how things cross-over and how there is such energy in that. And also about the playfulness that often borders on the subversive – something that characterises much of the London work in JAM. There are many points to pick up on here but as you mentioned UK Garage first – what is it that you love about it, when some people are so quick to write it off?

From: Ekow Eshun
To: Jane Alison

I get impatient and annoyed if people slag off UK Garage, although most people I know are very positive about it. It takes a long time for music/club/youth cultures to permeate the collective consciousness. At the beginning they're normally taken as a danger to the moral health of the nation, before they're re-evaluated over time as what the nation is. Certainly that's what happened with Punk and House – both of which are now seen as proud exemplars of British creativity and innovation. Same with UK Garage. Here's a music and club scene that's multi-racial in its origins and constituency, that's evolved unilaterally out of London's inner cities, and is essentially about those young people who live there articulating the world on their own terms, not simply accepting what they've grown up with. I love the scene's impatience to grow, its ambition to be heard, its pace and motion and willingness to rewind, reinvent itself over and over, and keep moving.

From: Jane Alison
To: Ekow Eshun

Do you think of UK Garage as a youth thing? I won't say how old I am, but I certainly feel out of touch with the club scene. I'm interested to know because lots of people thought the first JAM was a youth culture exhibition and I kept trying to say that it was about something else – attitude or mixing it or urban experience, etc. But perhaps the whole thing is just about new ideas and where innovation happens – and quite often that is with the young? I was also interested to read your comment about UK Garage being a multi-racial scene. I wonder if you're optimistic about that crossing over into other areas? Certainly, I wanted to acknowledge in JAM the very significant black contribution to London's creative experience.

From: Ekow Eshun
To: Jane Alison

I wouldn't say JAM, as a whole, is a youth culture exhibition. Far from it. The urban experience I think you're trying to capture in the show is normally a hard won sensibility, in that it takes a realisation of the unloveliness of the city - too many nights spent walking down pavements strewn with the remnants of kebabs, watching fights break out in clubs, wondering whether you should venture down a dimly-lit subway - before you can come to an appreciation of what's beautiful in the city. And fundamentally what's beautiful and what's ugly in the city is the same thing - think about how pollution turns the sky pink or how oil can turn a puddle into a rainbow. One of the things that excites me about living in London is the on-going possibility for change - new things happen all the time, new conflicts, new crossovers, new love affairs. UK Garage starts as a fascination between Rave, Reggae and R&B - and it starts amongst both black people and white people. That's not to say that London is a racially utopian place - it's still the city of Stephen Lawrence and Damilola Taylor - but it's also a place that embraces rather than fears contradiction. And that tendency produces beautiful, surprising hybrids all the time - like UK Garage, Drum 'n' Bass, James Jarvis and his smiling, anxious, existential cartoon characters, Chris Ofili's Hip-Hop-influenced art, Chris Cunningham's dazzlingly cinematic promo video... the list is very long.

From: Jane Alison
To: Ekow Eshun

Thanks for that Ekow. It's good to be reminded of what can be beautiful in the city. The worry is always how to bring some clarity - not too much just a little - to the diversity of what is happening at any given time. Embracing contradiction? Perhaps there is something in JAM of that too. Masa Sugatsuke in Tokyo was saying to me that he thought London was the "healthy bad boy for global culture" and Tokyo is the "unhealthy good guy". Those certainly seem like contradictions. I'd be interested to hear how you respond to that.

From: Ekow Eshun
To: Jane Alison

Clarity is a good word in this context. It puts me in mind of a character in John Dos Pasos' *Manhattan Transfer*, an immigrant fresh off the Ellis Island ferry who searches the city announcing that "I want to get to the centre of things". His search proves fruitless because of course there is no "centre" to a city - they are random, diffuse projects, places of possibility. But searching for clarity is a great thing. I don't think you mean "the centre of things" with that word, but an attempt at scale, perspective, focus, and looking for the human in the midst of the artificial and constructed. Ultimately, cities make fools of us. They turn us into busy worker ants wrapped up in our own importance, heads down, failing to look around us. That's why I like Masa Sugatsuke's notion of London and Tokyo as errant, mischievous children. Sometimes it's easy to forget that London is a playground.

E-mail conversation Liz Farrelly
E-mail conversation Liz Farrelly
E-mail conversation Liz Farrelly
E-mail conversation Liz Farrelly
E-mail conversation Liz Farrelly
E-mail conversation Liz Farrelly
E-mail conversation Liz Farrelly
E-mail conversation Liz Farrelly
E-mail conversation Liz Farrelly
E-mail conversation Liz Farrelly
E-mail conversation Liz Farrelly

From: Jane Alison
To: Liz Farrelly

Liz, you've done lots of travelling lately and now you're back with the not insubstantial task of bringing this book together; and this is no doubt only one of the many things on your busy agenda. Is London still a special place to be for a creative practitioner?

From: Liz Farrelly
To: Jane Alison

London is a magical place. Now I'm also seeing it through the eyes of Gregg, a London-novice, who finds it both overwhelming and highly stimulating. I've grown and changed and my own view is that my life isn't as chaotically mixed up with underground creativity as it was. After all that travelling I also think London isn't the only place on the planet where good stuff gets done, but at one time in my life I think I did - I was fiercely London-centric. On the down

side, it's very expensive for young talent to come and live here and still create without wasting too much energy having to work a Mac-job. Thankfully the dole helps on that level. Then there's the fact that EU de-regulation has allowed for a mass of fun-loving youngsters from all over Europe to add a cosmopolitan flavour to the city. I think London is one of the only world-cities where meritocracy rules over old-money etc. The colleges see to that. So the diversity and youth of entrepreneurs and creatives is unprecedented, and the fact you can wear very silly clothes whenever is also a big plus... the sheer size of the fashion, graphics, photography, publishing and music industries here is, I think, unique in the world.

From: Jane Alison
To: Liz Farrelly

Thanks Liz. It seems that London does have a strong pull and qualities that make it the place to be if you want to be stimulated and challenged (on this side of the globe at least). So the contributors to JAM tell me anyway. You're recently back from Tokyo. What surprises did that have for you?

From: Liz Farrelly
To: Jane Alison

I was surprised by how ordered the chaos was; how difficult it is to find places in the city, but hey it's big, with hardly any street names. The use of space was impressive; every floor of every building seemed to be crammed with stuff to buy, and shopping seemed to be the principle reason for being. That and posing. And was it expensive! And was it mono-cultural! All that sounds negative. It was all those things not in a negative way, but in a very focused and accomplished way. It is everything London isn't in regards efficiency, transportation, being tidy and polite. It's also really beautiful in a timeless and temporary way; the little lanes were so peaceful, but just steps away from some of the most crowded intersections in the world, where pedestrians rule over cars. Thankfully. If everyone in the city had a car, it'd smell worse than London!

From: Jane Alison
To: Liz Farrelly

You were involved in the first JAM with me. I have a sense that the project has matured. This exhibition feels more considered and grounded somehow. Also, adding "fine art" to the equation has shifted everything — so the project seems overall less "street". I wonder how this one seems different to you — and perhaps you could say something about how the design world has changed in your view?

From: Liz Farrelly
To: Jane Alison

Well, the first exhibition had a sort of energy that came out of recession and a joyful realisation that dull, dull old London was the centre of the universe again; the whole Brit-brat-pack thing was going crazy. It was great timing. This exhibition reflects the maturing of possibilities. London is now a place that people come to because of its reputation, not just a place that stallwart Brits who love the life stick to and eek out an existence in, while all the canny designers relocate to Milan, and the photographers/artists go to New York. It has matured into a city more like Tokyo, where there is industry and media to soak up that creativity — well, media at least. I think showing the cross-over between too island-cities is very interesting, it reveals how they feed off each other, in a healthy way — sending ideas, people and cash back and forth. Having visited Japan, I see more similarities in temperament and attitude than I thought was the case, so that collaboration is born out of understanding, perhaps more so between the Japanese and the Brits than say it would be with the Americans or the French.

As far as the design world changing, well, it's no longer the poor relation to advertising, now it's the creative well from which advertising draws its chic, its wit and its nerve. Now many ad-creatives work with designers to realise a brief, whereas in the past they may just have tried to rip-off the style of someone groovy and failed miserably. It's much more honest!

From: Jane Alison
To: Liz Farrelly

As editor, you've been wading through all the interviews with artists — has anything particularly jumped out at you as inspirational? And if you could pick an artist or piece of work from the exhibition to illustrate something hopeful for the future, what would it be?

From: Liz Farrelly
To: Jane Alison

I have to say that the maturity, subtlety and diversity of content and approach is awe-inspiring in itself. It's not about trends, but about people having the courage to be individual and play with their own obsessions. that's very healthy in the creative world. OK, I love the idea of relocation as true integration – so for me Deluxe is a great achievement. Plus they make beer!

E-mail conversation Toru Hachiga
E-mail conversation Toru Hachiga
E-mail conversation Toru Hachiga
E-mail conversation Toru Hachiga
E-mail conversation Toru Hachiga
E-mail conversation Toru Hachiga
E-mail conversation Toru Hachiga
E-mail conversation Toru Hachiga
E-mail conversation Toru Hachiga
E-mail conversation Toru Hachiga
E-mail conversation Toru Hachiga
E-mail conversation Toru Hachiga

From: Mami Kataoka
To: Toru Hachiga

What do you think of the graphic design scene in Tokyo compared with ten years ago?

From: Toru Hachiga
To: Mami Kataoka

I don't think the basics of graphic design have changed at all in the last ten years. However, I do think that the growth of computers and the internet has altered the range and the speed of expression, as well as the definition of what a graphic designer is.

From: Mami Kataoka
To: Toru Hachiga

What do you think is demanded of graphic design today, now that computers and the internet are such an integral part of everyday life?

From: Toru Hachiga
To: Mami Kataoka

Confining my answer to the medium of graphic design, then I think that it can basically be defined as design that adds value to printed material. The concerns, technique, knowledge and sensibility that are unique to the graphic designer are necessary to all printed media. However, with the spread of the internet and the computer, the term graphic designer is being replaced with the broader term, designer. Nowadays, everyone can become involved to some extent in designing printed material, websites, images, packaging, interiors and fashion. And for that very reason, there is definitely an added value that can only be provided by graphic design.

From: Mami Kataoka
To: Toru Hachiga

On an international level, what do you see as the position of graphic art in Tokyo?

From: Toru Hachiga
To: Mami Kataoka

Well, if anything, I don't think national boundaries exist in design. No matter which country or city we visit, we are able to see outstanding examples of graphic design. Similarly, wherever we go, we also encounter uninteresting designs. However, the city of Tokyo happens to be overflowing with examples of graphic design, and we are confronted with these examples on a daily basis, and so this is perfectly natural for those of us who live in Tokyo. I personally feel that this makes for a very interesting situation.

From: Mami Kataoka
To: Toru Hachiga

I'm sure that information related to design in London can be readily accessed in Tokyo. What is your opinion of design in London today?

From: Toru Hachiga
To: Mami Kataoka

From the point of view of someone living in Japan, that is, looking at London from the outside, I think that of all the cities in the world, Tokyo and London are the two cities with the most in common. Apparently design in London is closely related to the music and fashion in London, and as music and fashion are media in which there is a constant search for new forms of expression, I assume that there would be a similar thirst for new and interesting forms of design. And from that aspect, I sense a contemporary energy that reflects fashion and the times.

From: Mami Kataoka
To: Toru Hachiga

A character-based culture, no doubt influenced by manga and computer games, is a feature of the contemporary art scene in Tokyo, but is a similar tendency evident in graphic design? And if so, what do you think is the reason for this?

From: Toru Hachiga
To: Mami Kataoka

I think there is an influence. But that is very natural, in the sense that computer games and manga have greatly influenced the lives of people who happen to be designers. These have become a part of the environment in which we have been raised, and so I think it's only natural that these elements are incorporated into the work of someone who is attempting to create something.

From: Mami Kataoka
To: Toru Hachiga

On the subject of generational differences, do you think there are any differences between the generation of people born in the 1960s and the generation preceding it?

From: Toru Hachiga
To: Mami Kataoka

Well, the people born in 1960 reached age 40 in 2000. Discussing graphic designers specifically, I believe that whether a designer is 40, or born in 1980 and therefore only 20, any graphic designer who regards design seriously is always attempting to create something interesting, to design something outstanding. If there is any generational difference, it would probably lie in the difference in attitude towards computers. People in their 40s have a tendency to regard computers as something special. But to people in their 20s and 30s computers are nothing special, they're nothing more than another convenient tool. The type of computer or the kind of applications used were often subjects of discussion in design magazines in the early 1990s. But no one is concerned with these issues today.

> E-mail conversation Made Thought
> E-mail conversation Made Thought
> E-mail conversation Made Thought
> E-mail conversation Made Thought
> E-mail conversation Made Thought
> E-mail conversation Made Thought
> E-mail conversation Made Thought
> E-mail conversation Made Thought
> E-mail conversation Made Thought
> E-mail conversation Made Thought
> E-mail conversation Made Thought

From: Catherine Wood
To: Made Thought

Can you say something about what is essential to Made Thought's vision? What are the key features or philosophy?

From: Paul Austin
To: Catherine Wood

It's difficult to assimilate one core vision. Our overriding philosophy is always to question and challenge what we've done in the past and where we want projects to go in the future. I think it's important to constantly question in order to understand where you're at, all the time; this enables you to move forward. It's not like we work to a big masterplan, we tend to pursue different goals project by project. It's difficult to talk about graphic design without sounding like an arsehole. Basically we enjoy what we do.

From: Catherine Wood
To: Made Thought

Who would you cite as influences in the design world?

From: Paul Austin
To: Catherine Wood

We both studied at Ravensbourne College of Design and Communication, which taught a strong Swiss modernist approach, so that's probably our main influence. I suppose this disciplined grounding is the backbone to the way we currently look at and think about things. Since graduating in 1996, we both worked at North Design in London, until last year, and being part of such a strong group of designers had a great impact on us. And I suppose, the reason we set up a company together is that we influence each other. If we were to list any external influences, Paris and Tokyo seem to be the places we look to most at the moment.

From: Ben Parker
To: Catherine Wood

I would say that product design and fashion also seem to effect our work more and more. Tactility and the use of materials being the crossover, as we are very conscious of how a piece of graphics should feel, as well as how it looks. We think that the use of materials is a fairly neutral platform for communication. Everyone experiences tactility on a similar level, whereas graphics are often pitched to a particular audience or type of audience, which can be negative. I suppose what goes on in product design, fashion, photography and even architecture we often find more interesting than what goes on in graphics. These subjects seem to have so much to offer and that's why we are always looking at these areas for inspiration. But at the same time graphic design is the broadest discipline.

From: Paul Austin
To: Catherine Wood

On a wider creative level, I suppose we respond to anyone's work that possesses a similar set of values as our own regardless of discipline.

From: Catherine Wood
To: Made Thought

Do you see yourselves as part of a creative community in London?

From: Ben Parker
To: Catherine Wood

Yes and no. Everyone goes on about this creative community but there actually seems little interaction, integration or discussion between groups. There seem to be very few avenues where collaborations can naturally occur, which is a real shame, as the best work comes out of a fusion of different experiences and viewpoints. Everyone seems far too protective about what they are doing.

From: Catherine Wood
To: Made Thought

How do you see creative exchange between Tokyo and London?

From: Paul Austin
To: Catherine Wood

We love what they do. They love what we do.

From: Catherine Wood
To: Made Thought

Can you say anything about Made Thought's ambitions or aspirations for the future?

From: Ben Parker
To: Catherine Wood

I think the problem with what we do is that the job only gets harder. We're reluctant to repeat ourselves and find it unrewarding to revisit the same ground. We're always looking for new ways of doing things differently and I think its possible to find something new in everything. This, I suppose, is the challenge for us and why ultimately we love what we do. That challenge keeps us working, and pursuing, and what will ultimately dictate the kind of work we take on in the future. Due to our background I think we are constantly trying to learn to become less rigid. Our work can suffer from being overly refined at times and I think this is dangerous as it can categorise you into one predictable style of design. This is sometimes the most difficult agenda to keep ahold of.

From: Paul Austin
To: Catherine Wood

We are also keen to involve more screen-based design in our future work. There's so much potential to do interesting things, but it seems that the majority of projects are being approached from technical capabilities rather than from a design perspective.

E-mail conversation Fumiya Sawa
E-mail conversation Fumiya Sawa
E-mail conversation Fumiya Sawa
E-mail conversation Fumiya Sawa
E-mail conversation Fumiya Sawa
E-mail conversation Fumiya Sawa
E-mail conversation Fumiya Sawa
E-mail conversation Fumiya Sawa
E-mail conversation Fumiya Sawa
E-mail conversation Fumiya Sawa
E-mail conversation Fumiya Sawa
E-mail conversation Fumiya Sawa

From: Jane Alison
To: Fumiya Sawa

Thanks for your support of JAM in both London and Tokyo. As a result of promoting art and music and writing and doing all the other things you do, you spend time in both London and Tokyo and know both cities well. I know it is a big question, but can you reflect on the kind of creative energies and directions to be found in London and Tokyo and say something about how you feel they compare and interface with each other.

From: Fumiya Sawa
To: Jane Alison

It is a cliché with "e-acute"; but both the English and Japanese are known for their island mentality, and for being reserved and polite, according to our friends on the huge Eurasian continent. We are also sensitive but sometimes crooked, aren't we? Having said that, those generalisations are getting less relevant because of our global mass culture and the independent network of like-minded people encouraged by advanced communication systems and cheap flight tickets. But it is true that both London and Tokyo have very strong youth cultures with powerful media and music industries attached. English style magazines and TV programmes can be seen anywhere in the world, but it is not the case with the Japanese media. And yet, it is easier to publish books and magazines in Japan. So it is like London has long-range missiles while Tokyo has lots of short-range missiles! Also contemporary art has been less supported by the public and the government in England compared to other European countries. And contemporary art is even less supported in Japan, if at all. Many young people in London and Tokyo seem somehow frustrated as well, which could generate good creative energy. Sometimes the same repressed energy can turn out as violence though. When I say Tokyo, I include also the more anarchic town of Osaka which pours good creative ideas and talents to Tokyo. I also have to add that I do not mean to promote art, music or comedy for anyone. I am just attracted to the energy of musicians, artists and comedians of both towns. I am like a pendulum swinging between the Far East and the Far West. England is the Far West on the world map in our classroom.

From: Jane Alison
To: Fumiya Sawa

You've made some really interesting points of connection and described our geographical
reality very visually. It makes me think again just how exciting this project is: bridging the
space that exists between our two countries and creative communities. I wonder if you have a
sense of whether JAM will be significant at all in mapping out some kind of creative terrain
and what would you like to see it accomplish?

From: Fumiya Sawa
To: Jane Alison

I hope JAM will demonstrate that subcultures at both "ends of the world" have actively been
responding to and inspiring each other; there is a new visual language we communicate with.
We Japanese have never been good speakers of foreign languages including yours, but are quite
good at visual language. The same thing applies to musicians and fashion designers. Also,
we are talking about a network of artists and musicians; it is not a whole nation meeting with
another nation; it is not politics or the Olympic games. It was once only lonely terrorists
who were actively seeking their possible comrades around the world, but now anyone can be
inspired by people in other countries. It is just that the world has become smaller and our
consciousness has expanded. That's all. Or am I too optimistic?

From: Jane Alison
To: Fumiya Sawa

Well I was certainly amazed at how easy it was to get from here to there - with the Barbican
paying that is! And now I realise how many of our JAM contributors on the London side have
exhibited in Tokyo and been so well received already - Paul Davis and James Jarvis spring to
mind, and Elaine Constantine's work for Parco. Recently there were A BATHING APE posters
all over London, and I suddenly find that I've been the last person to discover the joys of
Cornelius. That's not to mention Shin and Tomoko doing our exhibition design and Tomoaki
Suzuki and World Design Laboratory being Japanese artists nominated on the London side.
I was also thinking about how JAM should be a celebration of both commonality and difference,
but in a balanced way. I've certainly been trying to grapple with that one - not wishing to
be trapped by the lure of the "exotic other" (as they say in the text books!). You've said
quite a lot about a shared energy and shared endeavour, but I would appreciate your
insights into the more idiosyncratic aspects of Tokyo output? At the risk of sounding
simplistic, I'm thinking of the whole cute thing and the sex thing too - oh, and then there
is the shopping.

From: Fumiya Sawa
To: Jane Alison

I would be better to leave your question to sociologists to answer properly, but it looks
quite simple to me. Every kid around the world likes cute things. What makes the situation
different in Japan is that Japanese fathers are busy making money and mothers like buying
cute things for their kids. And kids have got money anyway. It is a big market. It is how
capitalist society works. Also in our society, women are encouraged to remain cute even
after their "cute-age" rather than being independent and confident, I think. In other words,
we like cute women. But if you go to Bangkok or Taipei, you see more cute things there.
Talking about sex, it seems like the Japanese have always been very open about it. We are
not Christians anyway. When Japan decided to westernise 130 years ago, we learnt the great
Victorian morals from the developed countries, as well as eating beef. But it had been
repressed too much. Eruption was bound to happen like a volcano. And of course men contribute
a lot to the never ending growth of this particular industry, with their spare money and
limited free time. Many talented film directors have to go to either the sex industry or
advertising industry to shoot films. In fact, the sex industry in Japan is as innovative and
creative as Sony and Sharp. Again, it is another result of a democratic capitalist society
without any good planning or a leader. Desire attracts money. As for shopping, you just feel
very pleasant shopping in Japan: nice wrapping, strange products and over-the-top-service.
Spending money makes us happy. It is simple conditioning. We also like to be brainwashed by
the media to conform in order to feel secure.

From: Jane Alison
To: Fumiya Sawa

Thanks for expanding at length on that question - it helps clarify many things. To round this
up, can you say something about the artists you have suggested for JAM and perhaps tell us
what we should look out for in the work. Plus, two other questions are nagging to be asked.

018
019

I think there is an awareness here of how Japanese people like to simulate things and become obsessed with cult here; i.e., Punk or Rock music or whatever. Suzannah has elaborated on how Tokyo artists bring to these things their very particular "own" quality, but I wonder whether you have any further observations. What would you say is truly a Japanese form of expression? My other question is about "rebellion". You've said there is a frustration among some young people and that makes for a creative energy, but does it amount to a "new anger" as some people have suggested to me? And do you agree that this is something which has previously made London and Tokyo so different?

From: Fumiya Sawa
To: Jane Alison

I realise that the artists I support (or often the other way around) have one common attitude; they are all inspired by their own roots, but at the same time, positively relate to the subculture around them as well. And that, I think, is their strength. For example, Yoshitomo Nara found the drawing style of his childhood most comfortable to work with. So his style did not come from the current manga scene, but he is simply connected to his own roots, which makes his work very powerful. Also Takashi Homma and Masayuki Yoshinaga always remember where they came from and where they are throughout working on their photographs of suburban kids and bikers respectively. Kyoichi Tsuzuki relates to his own town of Tokyo as if he was a stranger, but with a sense of humour and affection. Probably his background as an editor has given him these objective eyes, which makes his work very interesting. Kyupi Kyupi stay away from Tokyo and at the same time stimulate Tokyo with their clever use of media. They are a mixture of everything; sexy, funny and stylish. Kyupi Kyupi is also art, music, fashion, TV and graphics; it is both low culture and high culture and neither.

And what makes London different from Tokyo is its cosmopolitan environment. Many artists I nominated have an international background. Talvin Singh, for example, who I am currently working with here in Mumbai, is in search of his missing roots in India, without neglecting his own native environment where he grew up in London. Musically, he speaks the language of cosmopolitan London.

To answer your question about copying or simulating styles. I think we believe or are made to believe that learning starts with copying good models. To the Japanese, you Europeans may be too obsessed with originality and being unique. Any music or art cannot be that original. If there is a fraction of a very original and interesting idea in a "good copy", I think that is enough. As regards our obsession with cult, we are probably brought up to conform to society without being encouraged to be unique, but we may fancy something very extreme. Talking about "new anger", I didn't know if people are angry again in Tokyo. I think people are just frustrated with the pre-set way of life. They want more excitement, even taking risks, as much as they want security. But I don't think our cultures are that different.

E-mail conversation Nobuko Shimuta
E-mail conversation Nobuko Shimuta
E-mail conversation Nobuko Shimuta
E-mail conversation Nobuko Shimuta
E-mail conversation Nobuko Shimuta
E-mail conversation Nobuko Shimuta
E-mail conversation Nobuko Shimuta
E-mail conversation Nobuko Shimuta
E-mail conversation Nobuko Shimuta
E-mail conversation Nobuko Shimuta
E-mail conversation Nobuko Shimuta
E-mail conversation Nobuko Shimuta

From: Mami Kataoka
To: Nobuko Shimuta

You have experienced the visual arts scene and the graphic design scene in Tokyo. How do you think these have changed compared to ten years ago?

From: Nobuko Shimuta
To: Mami Kataoka

A very strong relationship has been established between the visual arts scene and the graphic design scene. And I think that the reason for this is that animation and technology are common to both disciplines. For example, when Takashi Murakami slices up Japanese art with his "Super Flat" concept, Groovisions then becomes involved in the same concept. Ten years ago, the words used to describe any artist attempting to cross the boundary between visual art and graphic

design were, "blending" or "transcending boundaries". But nowadays, these terms are largely irrelevant. Although the creators themselves recognise the differences in value of the medium of expression, no one is particularly concerned with the differences in the medium itself. I also believe that there are a growing number of creative people working in the so-called "intermediate area". In comparison to art or design, the act of creating something is more straightforward in this intermediate area and there are increasing numbers of creative people working in this area.

From: Mami Kataoka
To: Nobuko Shimuta

As you mentioned, there has been an unconscious transcending of boundaries, and there are certainly increasing numbers of creative people who move quite naturally from one medium to another. This does not only apply to media, but seems to be equally applicable to national identity, in the sense that there seems to be a weakening of a form of expression unique to Japan. What are your thoughts on this?

From: Nobuko Shimuta
To: Mami Kataoka

I feel that a national form of expression does exist. I have the feeling that the very nature of contemporary culture, in which the subculture and the mainstream culture of Japan coexist, and the uniquely Japanese situation of indiscriminate acceptance of the world's cultures is actually resulting in the formation of a new Japanese form of expression.

From: Mami Kataoka
To: Nobuko Shimuta

If one were to examine this intermediate area of expression in terms of the market, what is most demanded of today's graphic designers, who, while promoting artistic value, at the same time can't ignore market values?

From: Nobuko Shimuta
To: Mami Kataoka

Not to be too concerned by the medium. A tendency of graphic designers in the past was their concern with the poster. This might be a particularly Japanese issue, but what is important today is to be able to control every medium related to communication. With the expanding concept of design. I think that graphic design should tie in all visual elements.

From: Mami Kataoka
To: Nobuko Shimuta

One of the features of contemporary art and graphic design is the animation-like, the manga-esque character. Graffiti-like drawings and the "kawaii" (cute) element are not exclusive to Japan, but how do you explain their strong popularity among Japanese youth?

From: Nobuko Shimuta
To: Mami Kataoka

I wonder about that myself! This popular love of characters that resulted in the character boom of recent years is very strange. I don't really understand it as I personally don't particularly like characters. But Hideyuki Tanaka, who uses characters in his work because he likes them, has said that using characters is no different from using other conventional methods as they create an interface with people. And I feel that there is a strong connection between Japan's unique manga culture and the empathy that exists among the Japanese towards these imaginary characters. As manga is something that is experienced by young creative people in particular, it plays a major role as a means of visual communication.

From: Mami Kataoka
To: Nobuko Shimuta

What is it that you like about Tokyo? And what significance does Tokyo have for you as a place to live and work?

From: Nobuko Shimuta
To: Mami Kataoka

From the point of view of a resident of this city, Tokyo is not a terribly attractive place.

First of all, the housing situation is bad. The city is crowded and unplanned. It can be claustrophobic, and I find the childish popular culture tiring. But the reason I'm based in Tokyo is that the Tokyo design scene is going through a massive change. There are many small economies or economic communities in Tokyo, and there are many designers who are active within them. I live here because I'd like to continue to map out this situation. I'd also like to tie this map in with situations overseas.

From: Mami Kataoka
To: Nobuko Shimuta

If you could live in London for a year, what would you like to do?

From: Nobuko Shimuta
To: Mami Kataoka

I'm not sure... actually, I'd rather live in London permanently than just for a year. I'd like to operate a design agency that connects London and Tokyo. And I'd like to spend my time in London writing a book.

E-mail conversation Masa Sugatsuke
E-mail conversation Masa Sugatsuke
E-mail conversation Masa Sugatsuke
E-mail conversation Masa Sugatsuke
E-mail conversation Masa Sugatsuke
E-mail conversation Masa Sugatsuke
E-mail conversation Masa Sugatsuke
E-mail conversation Masa Sugatsuke
E-mail conversation Masa Sugatsuke
E-mail conversation Masa Sugatsuke
E-mail conversation Masa Sugatsuke
E-mail conversation Masa Sugatsuke

From: Jane Alison
To: Masa Sugatsuke

You are an advisor to JAM in Tokyo and the editor of *Composite*, an influential Japanese contemporary culture and style magazine. Can you say what it is that you are trying to do with the magazine and why?

From: Masa Sugatsuke
To: Jane Alison

I'd like to make a 100% culture magazine that has international creative contributors filtered through Tokyo's point of view, which also considers that each megalopolis has a character, for example, Paris is a kind of monograph. But I think that Tokyo is a chaos – the most chaotic megalopolis in the world. I also think that the magazine is an organised chaos. I really feel that Tokyo is like a magazine and Tokyo is a great subject for magazine editors to keep tracking and figuring out what's going on here.

From: Jane Alison
To: Masa Sugatsuke

I'm intrigued by that sense of Tokyo as chaos and the magazine being a kind of reflection of that. It might also apply to this exhibition, which is attempting to grasp something that is in a constant state of change, growth and perhaps crossover. Can you give some kind of graphic example of what that actually means to you – in relation to some of the exhibitors in JAM.

From: Masa Sugatsuke
To: Jane Alison

Regarding your new question, it's not easy to give a graphic example of what I mean. But I can say, I feel such a chaotic sense from Naohiro Ukawa's crazy visions, Enlightenment's super-2-D computer generated paintings, Hiropon Factory's Super Flat art works, Takashi Homma's suburban images, etc. I think modern creativity in Tokyo looks more ill than London. I think, London has always had fever; Tokyo is always ill.

From: Jane Alison
To: Masa Sugatsuke

"More ill" – tell me more!? And don't you get a fever when you're ill?

From: Masa Sugatsuke
To: Jane Alison

London is a healthy bad boy for the global culture scene and Tokyo is an unhealthy good guy.
I think Tokyo is a sort of capital of hyper-consumerism. It consumes to excess. I think it's
really unhealthy. Too much speed and too much eclecticism are considered to be right and they
really work for an ill global capitalism. But since the 1960s London has provided a DIY
attitude to the world. Youthquake lasts in London and it has attitude. London's edgy culture
has a great market named Tokyo because Tokyo is a kind of first, sympathetic audience for it.
For example, PIL was really successful and JAPAN was also successful in Tokyo in the 1980s,
"Trainspotting" became a big smash here, Vivienne Westwood has been really loved by Tokyo and
Tomato is a graphic cult.

Without London, Tokyo's edgy culture can't explore their foreign market, because London is
also the first audience of Tokyo's cutting edge. Talking about pop music, London loved YMO,
Plastics, UFO, Boom Boom Satellites first and Takeshi Kitano was discovered by the global film
market via London. Hysteric Glamour, A BATHING APE and UNDER COVER are the same.

 E-mail conversation Suzannah Tartan
 E-mail conversation Suzannah Tartan
 E-mail conversation Suzannah Tartan
 E-mail conversation Suzannah Tartan
 E-mail conversation Suzannah Tartan
 E-mail conversation Suzannah Tartan
 E-mail conversation Suzannah Tartan
 E-mail conversation Suzannah Tartan
 E-mail conversation Suzannah Tartan
 E-mail conversation Suzannah Tartan
 E-mail conversation Suzannah Tartan
E-mail conversation Suzannah Tartan

From: Jane Alison
To: Suzannah Tartan

You're an American living in Tokyo and an advisor to this exhibition, a music journalist
and all-round cultural commentator as well as being a girl-about-town and mother – how do you
do it?!

From: Suzannah Tartan
To: Jane Alison

Insatiable curiosity, an understanding partner, and lots of chocolate.

From: Jane Alison
To: Suzannah Tartan

What is it specifically about Tokyo that you enjoy and what do you feel sets it apart from
other cities around the world?

From: Suzannah Tartan
To: Jane Alison

Because I've lived in Tokyo for so long, it is difficult to pick out exactly those aspects
that are particularly enjoyable separate from that feeling of being comfortable in one's own
home. Living in Tokyo is often like existing in two synchronous realities. The first is one of
sensory overload and constant flux. Tokyo is a nexus for information more so than any other
place I've ever been. For music especially, the Japanese public seems exquisitely attuned to
what is going on in the rest of the world. In two small areas of Tokyo – the Shibuya and
Shinjuku districts – one can find perhaps more music of every variety than anywhere else in
the world. On any give night one can find live houses (small clubs) hosting 70s-style Punk
bands, to clubs featuring the most forward thinking Dance music. At the same time, there is
comfort in the fact that profound change happens very slowly. The bank machines still don't
work all night. Many, many things are still not computerised. On a quainter note, the fire
patrol still goes around our neighbourhood in the traditional way – clapping sticks together
to signal that all is well.

From: Jane Alison
To: Suzannah Tartan

There is enormous interest here in all things coming out of Tokyo, music included. But given the kind of diversity you speak of, I think it would be really valuable for you to give a brief guide to the types of music that are popular in Tokyo and to say something about the work you have done specifically for JAM.

From: Suzannah Tartan
To: Jane Alison

There is an incredible curiosity about music here, which combined with a collector's mentality, means that just about everything is celebrated in some small circle or another and as an adjunct, commercially available. This is also related to the idea of "lifestyle" design; the sense that one's musical taste is integrated with a whole range of other lifestyle choices from fashion to one's neighbourhood, interior decor, etc. Although this is certainly found in other cities, it has been elevated to an art here I think. DJ Hiroshi Fujiwara is a good example as is Nigo; there is a seamlessness to the way his A BATHING APE brand encompasses everything from shoes to records.

The most common criticism of Japanese music has been that it thrives on copying, that there is nothing indigenous about it. But I would argue that this is also its most interesting and fruitful aspect. Western musical forms – everything from classical music to Jazz to Techno – are all viewed from essentially the same viewpoint. As Cornelius once explained to me, divorced from their historical context, they are basically all forms of information, of raw material to be exploited and processed. Gorgerous is a good example; they are reworking the constructs or as Ujino says, the "kata" (basic forms) of rock into a meditation on gender and sexuality while at the same time being hugely entertaining and funny.

For me, the most interesting music happening in Tokyo comes from precisely those moments when seemingly disparate styles collide – when Cornelius drops a Bach motif into a frenzied pop song that draws as much from a Disneyland children's song as from Punk. Or when improvisational groups explore the ecstatic junction where Grateful Dead-style jams meet Techno and Free Jazz. This ability to rework and recombine musical tropes into something that is at once familiar and new, and is the particular genius of Japanese music.

I hope that the sheer diversity of the art, design, and music presented in JAM will help lay to rest once and for all the one-dimensional, gee aren't the Japanese weird and groovy, hipster Orientalism that still informs so much thinking about Japanese popular culture. Tokyo artists are grappling with the same concerns as artists in post-industrial megalopolises everywhere – the impact of technology, globalism and consumerism. It's just that they have the benefit of a quite different cultural and aesthetic heritage.

JAM:Tokyo-London Artists
JAM:Tokyo-London Artists
JAM:Tokyo-London Artists
JAM:Tokyo-London Artists
JAM:Tokyo-London Artists
JAM:Tokyo-London Artists
JAM:Tokyo-London Artists
JAM:Tokyo-London Artists
JAM:Tokyo-London Artists
JAM:Tokyo-London Artists
JAM:Tokyo-London Artists

Fred Deakin, Nat Hunter and Alex
Maclean, who run Airside, create
innovative and exciting experiences
for contemporaries and clients via
a diverse array of media. Relishing
the democratic opportunity that
digital technology offers they aim to
make interaction with a computer both
accessible and fun; plus, they are
quick to think outside the box for
alternative means of communicating.
Though their website is animated
and patterned with primary colours,
it's not simply eye candy. Coming from
diverse backgrounds (music and clubs,
human-computer psychology and
architecture) the directors fuse their
talents to create a range of truly
interactive projects that charm and
surprise. From the user-friendly
portfolio of artists at the White Cube,
to a dark and sophisticated game for
John Paul Jones that begrudgingly
delivers data in tantalising packets,
Airside's websites are unique.

Airside
JAM:Tokyo-London
Website illustration
2001

Airside
Tokyo pylon
Website illustration
2000
Ellen
Fashion illustration
Nova
2000

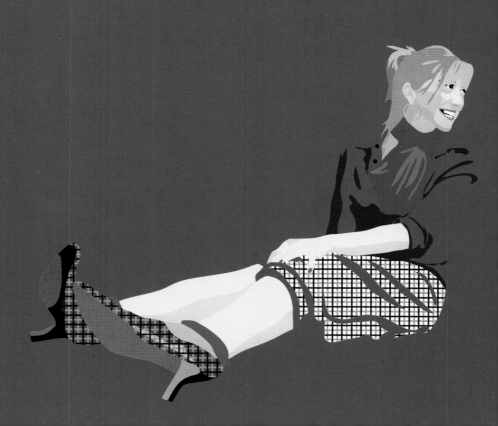

Airside
Lemon Jelly
Album sleeve (detail)
2000

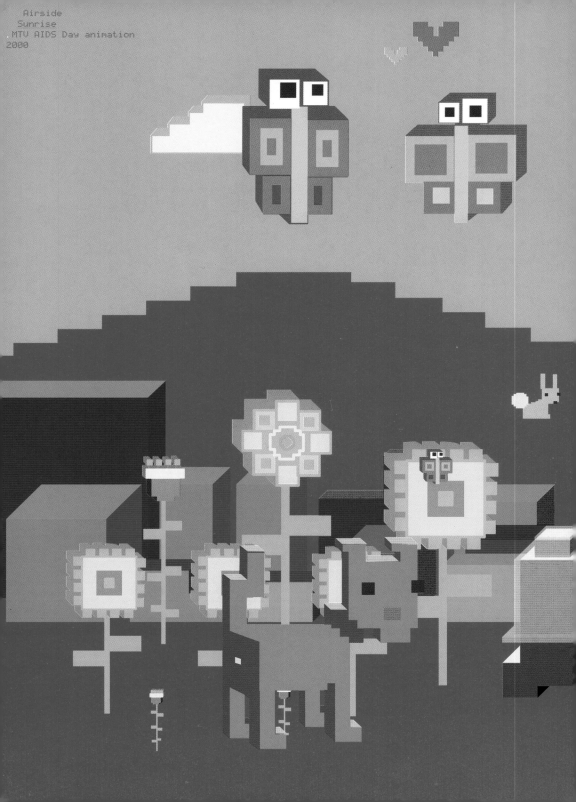

Airside
Sunrise
.MTV AIDS Day animation
2000

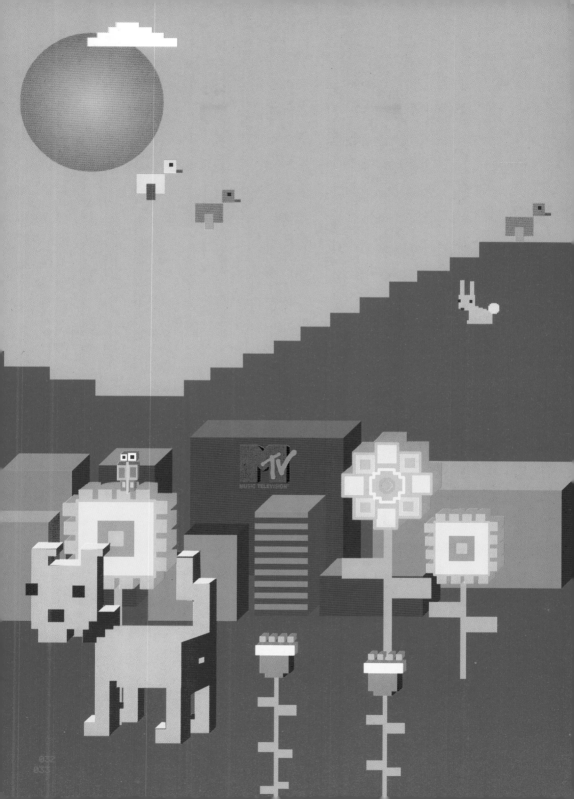

```
"*+JAM:Tokyo-London<=>?@(){}&8%#'[\];London^-'02   Bump
*+JAM:Tokyo-London<=>?@(){}&8%#'[\];London^-'02   Bump
+JAM:Tokyo-London<=>?@(){}&8%#'[\];London^-'02   Bump
JAM:Tokyo-London<=>?@(){}&8%#'[\];London^-'02   Bump
AM:Tokyo-London<=>?@(){}&8%#'[\];London^-'02   Bump
M:Tokyo-London<=>?@(){}&8%#'[\];London^-'02   Bump
:Tokyo-London<=>?@(){}&8%#'[\];London^-'02   Bump
Tokyo-London<=>?@(){}&8%#'[\];London^-'02   Bump
okyo-London<=>?@(){}&8%#'[\];London^-'02   Bump
kyo-London<=>?@(){}&8%#'[\];London^-'02   Bump
yo-London<=>?@(){}&8%#'[\];London^-'02   Bump
on<=>?@(){}&8%#'[\];London^-'02   Bump
n<=>?@(){}&8%#'[\];London^-'02   Bump
<=>?@(){}&8%#'[\];London^-'02   Bump
=>?@(){}&8%#'[\];London^-'02   Bump
>?@(){}&8%#'[\];London^-'02   Bump
?@(){}&8%#'[\];London^-'02   Bump
@(){}&8%#'[\];London^-'02   Bump
(){}&8%#'[\];London^-'02   Bump
){}&8%#'[\];London^-'02   Bump
}&8%#'[\];London^-'02   Bump
8%#'[\];London^-'02   Bump
%#'[\];London^-'02   Bump
#'[\];London^-'02   Bump
'[\];London^-'02   Bump
[\];London^-'02   Bump
\];London^-'02   Bump
];London^-'02   Bump
;London^-'02   Bump
London^-'02   Bump
ondon^-'02   Bump
ndon^-'02   Bump
don^-'02   Bump
on^-'02   Bump
n^-'02   Bump
^-'02   Bump
-'02   Bump
'02   Bump
02   Bump
2   Bump
   Bump
  Bump
Bump
ump
mp
p

   Bump
```

Model citizens
1999

Bump keep saying that they're rubbish,
but we don't agree. A two-man design
team, they've worked together since
1995, and are still "up for anything".
In fact, they run a successful,
two-tiered business; on the one hand,
designing print graphics for corporate
clients, including advertising agencies
M&C Saatchi and Leagas Delaney. In
their other guise, they make artworks
ranging from a "backseat driver"
cassette, for playing when solo
driving, and a useful set of stickers
for people who get annoyed with things
in the city but are too polite to say
anything. There is also a performance
element to their work; dressed in
tweed and flat-caps they set up a
china-smashing stall at the Victoria
and Albert Museum's village fete.
The curator of Chinese antiquities
is reputed to have emptied his wallet
having a go.

**TONIGHT MATTHEW
I WILL BE...**

**ICE AND A
SLICE WITH THAT SIR**

**WE'RE HANGING AT HOME
THIS NEW YEAR'S EVE**

THE SOUND OF LOSERS ON WILLOW

ITS A TOUGH JOB BUT SOMEONE HAS TO DO IT

In Association with
LR
BRAND

BRING A FRIEND

Bump
333 flyers
2000/2001

```
London^-'02  Bump/Shoreditch Twat
ondon^-'02  Bump/Shoreditch Twat
ndon^-'02  Bump/Shoreditch Twat
don^-'02  Bump/Shoreditch Twat
on^-'02  Bump/Shoreditch Twat
n^-'02  Bump/Shoreditch Twat
^-'02  Bump/Shoreditch Twat
-'02  Bump/Shoreditch Twat
'02  Bump/Shoreditch Twat
02  Bump/Shoreditch Twat
2  Bump/Shoreditch Twat
   Bump/Shoreditch Twat
 Bump/Shoreditch Twat
Bump/Shoreditch Twat
ump/Shoreditch Twat
mp/Shoreditch Twat
p/Shoreditch Twat
/Shoreditch Twat
Shoreditch Twat
horeditch Twat
oreditch Twat
reditch Twat
editch Twat
ditch Twat
itch Twat
tch Twat
ch Twat
h Twat
 Twat
Twat
wat
at
t
```

SHOREDITCH TWAT
ISSUE 2
let him have it

SHOREDITCH TWAT
ISSUE 5
standing on the shoulders of midgets

Working with Neil Boorman of the
333 club, Bump design the low-budget
fanzine-style *Shoreditch Twat*,
which takes an irreverent look at the
fast-evolving style trends of Hoxton.
While it annoys the select few, this
irreverent publication makes everyone
else laugh.

Bump/Shoreditch Twat
Issue 2: Let him have it
2000
Issue 5: Standing on the
shoulders of midgets
2000
Issue 8:
The Hoxton creeper returns
2000
Issue 9: Womb with a view
2000

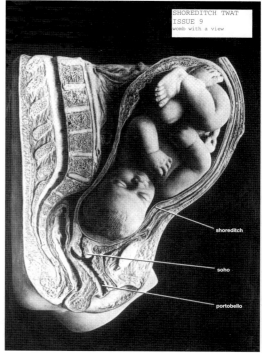

```
2001/2002,"*+JAM:Tokyo-London<=>?@(){}&8%#'[\];London^-'03  Hussein Chalayan
001/2002,"*+JAM:Tokyo-London<=>?@(){}&8%#'[\];London^-'03  Hussein Chalayan
01/2002,"*+JAM:Tokyo-London<=>?@(){}&8%#'[\];London^-'03  Hussein Chalayan
1/2002,"*+JAM:Tokyo-London<=>?@(){}&8%#'[\];London^-'03  Hussein Chalayan
/2002,"*+JAM:Tokyo-London<=>?@(){}&8%#'[\];London^-'03  Hussein Chalayan
2002,"*+JAM:Tokyo-London<=>?@(){}&8%#'[\];London^-'03  Hussein Chalayan
002,"*+JAM:Tokyo-London<=>?@(){}&8%#'[\];London^-'03  Hussein Chalayan
02,"*+JAM:Tokyo-London<=>?@(){}&8%#'[\];London^-'03  Hussein Chalayan
2,"*+JAM:Tokyo-London<=>?@(){}&8%#'[\];London^-'03  Hussein Chalayan
,"*+JAM:Tokyo-London<=>?@(){}&8%#'[\];London^-'03  Hussein Chalayan
"*+JAM:Tokyo-London<=>?@(){}&8%#'[\];London^-'03  Hussein Chalayan
*+JAM:Tokyo-London<=>?@(){}&8%#'[\];London^-'03  Hussein Chalayan
+JAM:Tokyo-London<=>?@(){}&8%#'[\];London^-'03  Hussein Chalayan
JAM:Tokyo-London<=>?@(){}&8%#'[\];London^-'03  Hussein Chalayan
AM:Tokyo-London<=>?@(){}&8%#'[\];London^-'03  Hussein Chalayan
M:Tokyo-London<=>?@(){}&8%#'[\];London^-'03  Hussein Chalayan
:Tokyo-London<=>?@(){}&8%#'[\];London^-'03  Hussein Chalayan
Tokyo-London<=>?@(){}&8%#'[\];London^-'03  Hussein Chalayan
okyo-London<=>?@(){}&8%#'[\];London^-'03  Hussein Chalayan
kyo-London<=>?@(){}&8%#'[\];London^-'03  Hussein Chalayan
yo-London<=>?@(){}&8%#'[\];London^-'03  Hussein Chalayan
o-London<=>?@(){}&8%#'[\];London^-'03  Hussein Chalayan
-London<=>?@(){}&8%#'[\];London^-'03  Hussein Chalayan
London<=>?@(){}&8%#'[\];London^-'03  Hussein Chalayan
ondon<=>?@(){}&8%#'[\];London^-'03  Hussein Chalayan
ndon<=>?@(){}&8%#'[\];London^-'03  Hussein Chalayan
don<=>?@(){}&8%#'[\];London^-'03  Hussein Chalayan
on<=>?@(){}&8%#'[\];London^-'03  Hussein Chalayan
n<=>?@(){}&8%#'[\];London^-'03  Hussein Chalayan
<=>?@(){}&8%#'[\];London^-'03  Hussein Chalayan
=>?@(){}&8%#'[\];London^-'03  Hussein Chalayan
>?@(){}&8%#'[\];London^-'03  Hussein Chalayan
?@(){}&8%#'[\];London^-'03  Hussein Chalayan
@(){}&8%#'[\];London^-'03  Hussein Chalayan
(){}&8%#'[\];London^-'03  Hussein Chalayan
){}&8%#'[\];London^-'03  Hussein Chalayan
}&8%#'[\];London^-'03  Hussein Chalayan
&8%#'[\];London^-'03  Hussein Chalayan
8%#'[\];London^-'03  Hussein Chalayan
%#'[\];London^-'03  Hussein Chalayan
#'[\];London^-'03  Hussein Chalayan
'[\];London^-'03  Hussein Chalayan
[\];London^-'03  Hussein Chalayan
\];London^-'03  Hussein Chalayan
];London^-'03  Hussein Chalayan
;London^-'03  Hussein Chalayan
London^-'03  Hussein Chalayan
ondon^-'03  Hussein Chalayan
!'"().2001/2002,"*+JAM:Tokyo-Tokyo<=>?@(){}&8%#'[\];London^-'03  Hussein Chalayan
'"().2001/2002,"*+JAM:Tokyo-Tokyo<=>?@(){}&8%#'[\];London^-'03  Hussein Chalayan
().2001/2002,"*+JAM:Tokyo-Tokyo<=>?@(){}&8%#'[\];London^-'03  Hussein Chalayan
).2001/2002,"*+JAM:Tokyo-Tokyo<=>?@(){}&8%#'[\];London^-'03  Hussein Chalayan
.2001/2002,"*+JAM:Tokyo-Tokyo<=>?@(){}&8%#'[\];London^-'03  Hussein Chalayan
2001/2002,"*+JAM:Tokyo-Tokyo<=>?@(){}&8%#'[\];London^-'03  Hussein Chalayan
001/2002,"*+JAM:Tokyo-Tokyo<=>?@(){}&8%#'[\];London^-'03  Hussein Chalayan
01/2002,"*+JAM:Tokyo-Tokyo<=>?@(){}&8%#'[\];London^-'03  Hussein Chalayan
1/2002,"*+JAM:Tokyo-Tokyo<=>?@(){}&8%#'[\];London^-'03  Hussein Chalayan
/2002,"*+JAM:Tokyo-Tokyo<=>?@(){}&8%#'[\];London^-'03  Hussein Chalayan
2002,"*+JAM:Tokyo-Tokyo<=>?@(){}&8%#'[\];London^-'03  Hussein Chalayan
002,"*+JAM:Tokyo-Tokyo<=>?@(){}&8%#'[\];London^-'03  Hussein Chalayan
02,"*+JAM:Tokyo-Tokyo<=>?@(){}&8%#'[\];London^-'03  Hussein Chalayan
2,"*+JAM:Tokyo-Tokyo<=>?@(){}&8%#'[\];London^-'03  Hussein Chalayan
,"*+JAM:Tokyo-Tokyo<=>?@(){}&8%#'[\];London^-'03  Hussein Chalayan
"*+JAM:Tokyo-Tokyo<=>?@(){}&8%#'[\];London^-'03  Hussein Chalayan
*+JAM:Tokyo-Tokyo<=>?@(){}&8%#'[\];London^-'03  Hussein Chalayan
+JAM:Tokyo-Tokyo<=>?@(){}&8%#'[\];London^-'03  Hussein Chalayan
JAM:Tokyo-Tokyo<=>?@(){}&8%#'[\];London^-'03  Hussein Chalayan
AM:Tokyo-Tokyo<=>?@(){}&8%#'[\];London^-'03  Hussein Chalayan    Hussein Chalayan
M:Tokyo-Tokyo<=>?@(){}&8%#'[\];London^-'03  Hussein Chalayan    Airmail dress
:Tokyo-Tokyo<=>?@(){}&8%#'[\];London^-'03  Hussein Chalayan    Photograph: Paul Wetherell
Tokyo-Tokyo<=>?@(){}&8%#'[\];London^-'03  Hussein Chalayan    Graphics: Rebecca and Mike
okyo-Tokyo<=>?@(){}&8%#'[\];London^-'03  Hussein Chalayan    Autumn/winter
kyo-Tokyo<=>?@(){}&8%#'[\];London^-'03  Hussein Chalayan    1999
```

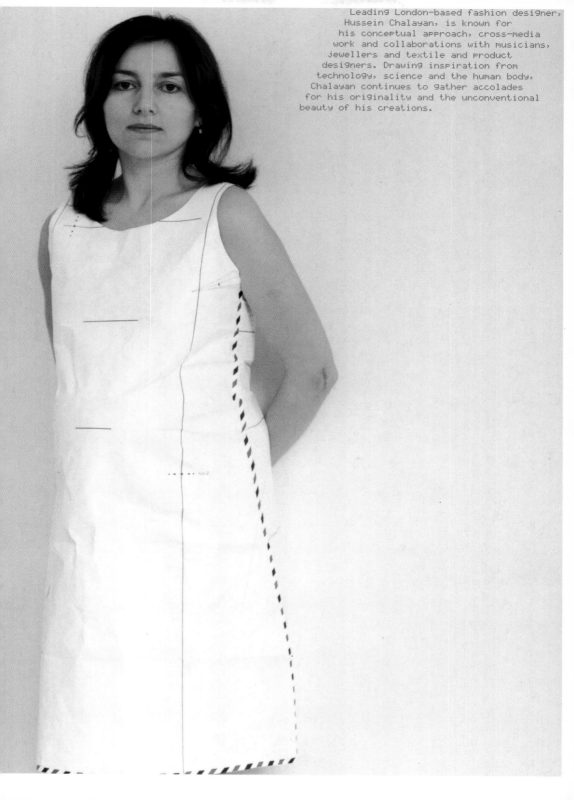

Leading London-based fashion designer, Hussein Chalayan, is known for his conceptual approach, cross-media work and collaborations with musicians, jewellers and textile and product designers. Drawing inspiration from technology, science and the human body, Chalayan continues to gather accolades for his originality and the unconventional beauty of his creations.

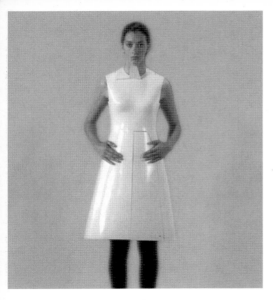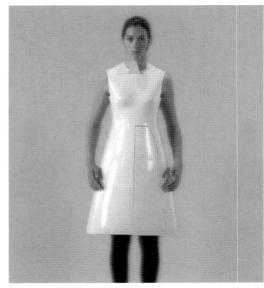
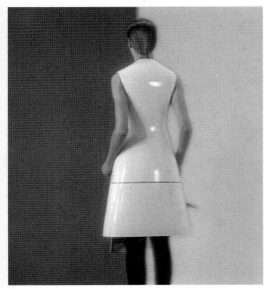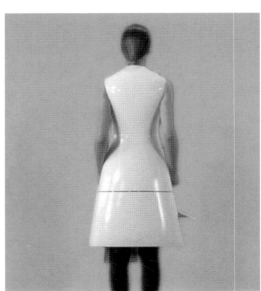

Hussein Chalayan
Aeroplane dress
Video: Marcus Tomlinson
Autumn/winter
1999

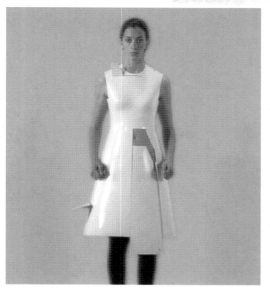
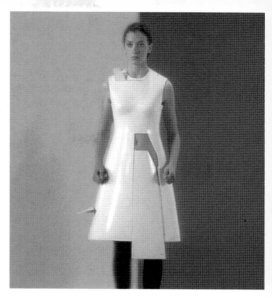
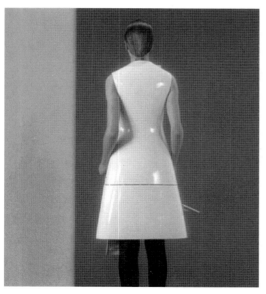
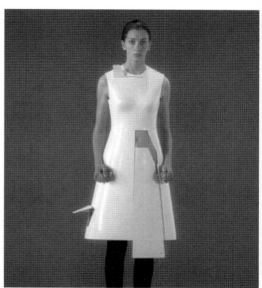

Elaine Constantine has established a reputation as one of Britain's most distinctive fashion photographers. Constantine's approach, which pushes constructed naturalism to virtually surreal extremes, presents women positively, breaking the mould of conventional fashion photography. Her upbeat images of girls enjoying themselves first appeared amidst a backdrop of grunge and computer slickness, and instantly validated her quiet individuality. Similarly, Constantine's career trajectory reads as something of an inspiration to would-be photographers. From Community Programme teacher, to regular contributor in *American Vogue*, Constantine is proof that following your personal vision does pay off.

Elaine Constantine
Girl rolling cigarette
1999

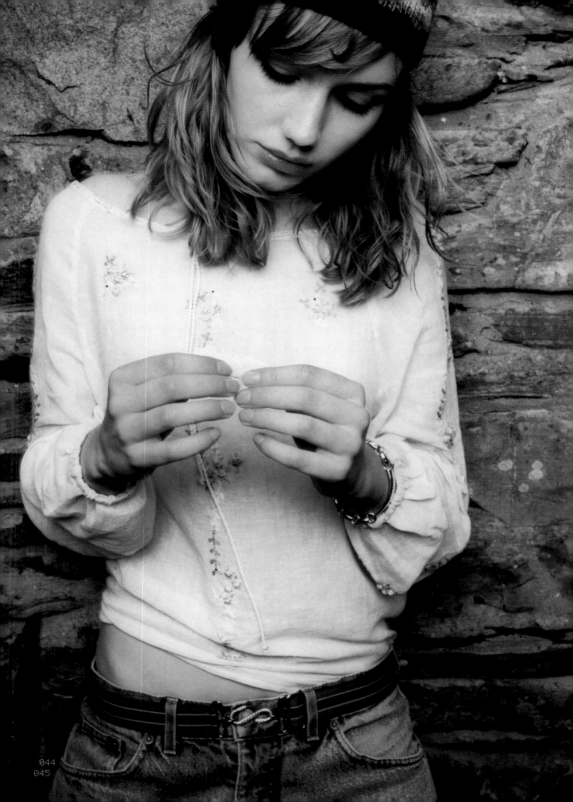

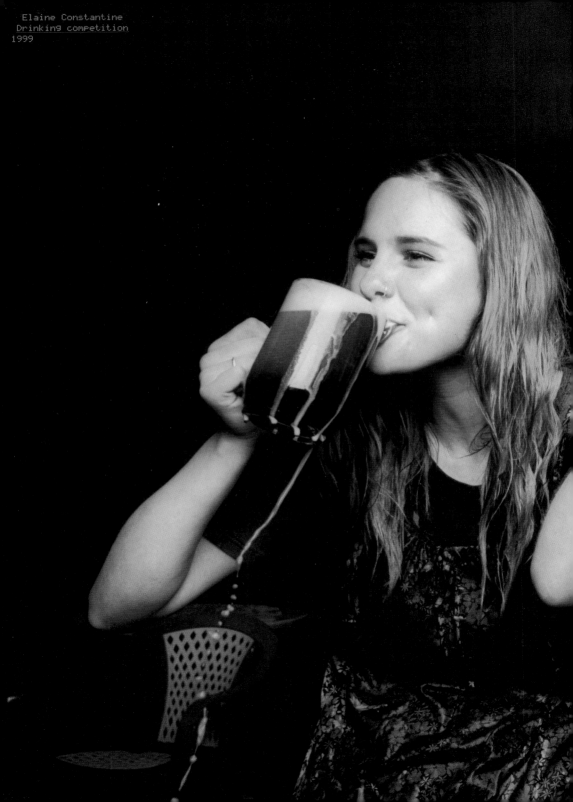
Elaine Constantine
Drinking competition
1999

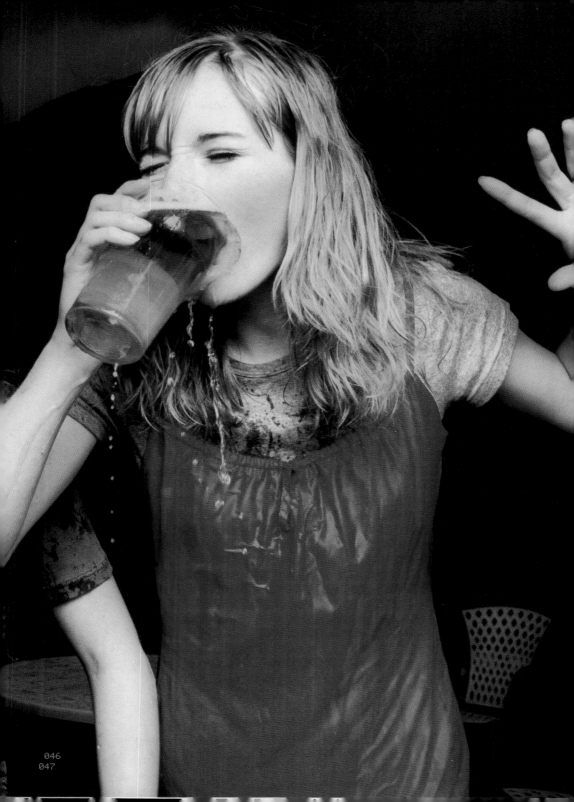

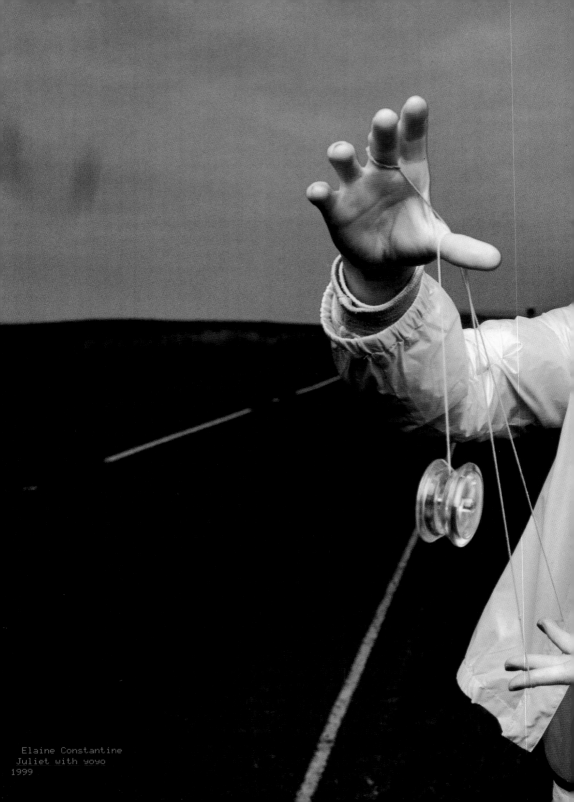

Elaine Constantine
Juliet with yoyo
1999

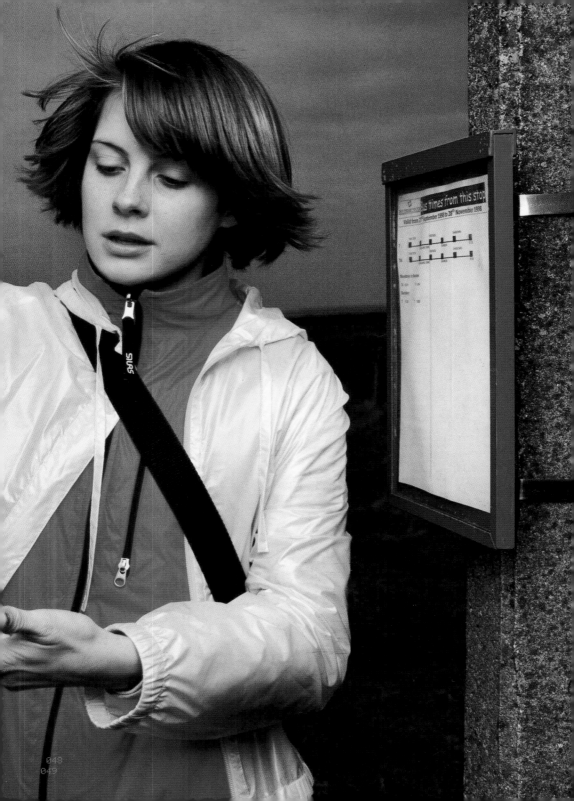

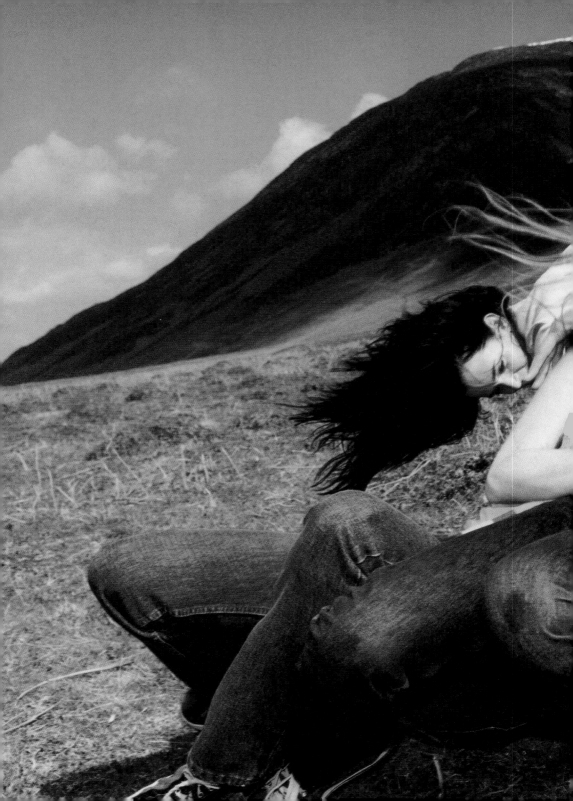

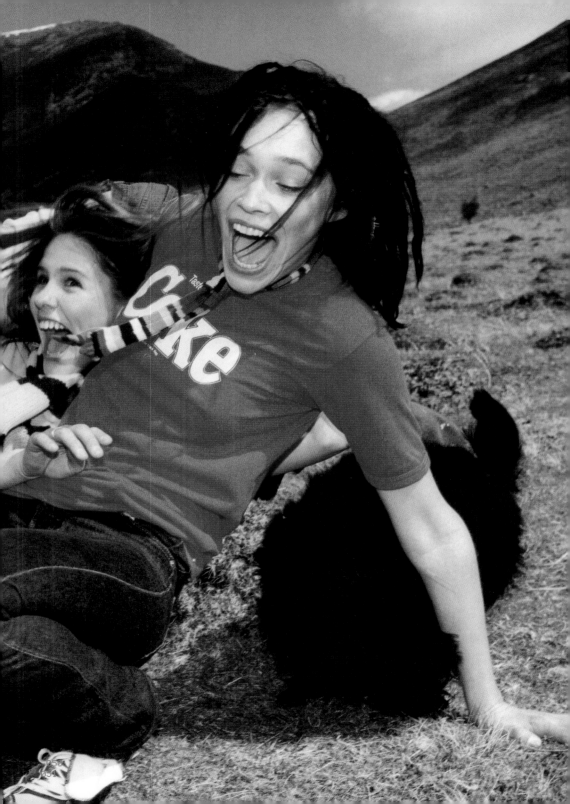

```
� ≥!"().2001/2002,"*+JAM:Tokyo-London<=>?@()&8%#'[\];Tokyo^-'05    Cornelius
!"().2001/2002,"*+JAM:Tokyo-London<=>?@()&8%#'[\];Tokyo^-'05    Cornelius
"().2001/2002,"*+JAM:Tokyo-London<=>?@()&8%#'[\];Tokyo^-'05    Cornelius
().2001/2002,"*+JAM:Tokyo-London<=>?@()&8%#'[\];Tokyo^-'05    Cornelius
).2001/2002,"*+JAM:Tokyo-London<=>?@()&8%#'[\];Tokyo^-'05    Cornelius
.2001/2002,"*+JAM:Tokyo-London<=>?@()&8%#'[\];Tokyo^-'05    Cornelius
2001/2002,"*+JAM:Tokyo-London<=>?@()&8%#'[\];Tokyo^-'05    Cornelius
001/2002,"*+JAM:Tokyo-London<=>?@()&8%#'[\];Tokyo^-'05    Cornelius
01/2002,"*+JAM:Tokyo-London<=>?@()&8%#'[\];Tokyo^-'05    Cornelius
1/2002,"*+JAM:Tokyo-London<=>?@()&8%#'[\];Tokyo^-'05    Cornelius
/2002,"*+JAM:Tokyo-London<=>?@()&8%#'[\];Tokyo^-'05    Cornelius
2002,"*+JAM:Tokyo-London<=>?@()&8%#'[\];Tokyo^-'05    Cornelius
002,"*+JAM:Tokyo-London<=>?@()&8%#'[\];Tokyo^-'05    Cornelius
02,"*+JAM:Tokyo-London<=>?@()&8%#'[\];Tokyo^-'05    Cornelius
2,"*+JAM:Tokyo-London<=>?@()&8%#'[\];Tokyo^-'05    Cornelius
,"*+JAM:Tokyo-London<=>?@()&8%#'[\];Tokyo^-'05    Cornelius
"*+JAM:Tokyo-London<=>?@()&8%#'[\];Tokyo^-'05    Cornelius
*+JAM:Tokyo-London<=>?@()&8%#'[\];Tokyo^-'05    Cornelius
+JAM:Tokyo-London<=>?@()&8%#'[\];Tokyo^-'05    Cornelius
JAM:Tokyo-London<=>?@()&8%#'[\];Tokyo^-'05    Cornelius
AM:Tokyo-London<=>?@()&8%#'[\];Tokyo^-'05    Cornelius
M:Tokyo-London<=>?@()&8%#'[\];Tokyo^-'05    Cornelius
:Tokyo-London<=>?@()&8%#'[\];Tokyo^-'05    Cornelius
Tokyo-London<=>?@()&8%#'[\];Tokyo^-'05    Cornelius
okyo-London<=>?@()&8%#'[\];Tokyo^-'05    Cornelius
kyo-London<=>?@()&8%#'[\];Tokyo^-'05    Cornelius
yo-London<=>?@()&8%#'[\];Tokyo^-'05    Cornelius
o-London<=>?@()&8%#'[\];Tokyo^-'05    Cornelius
-London<=>?@()&8%#'[\];Tokyo^-'05    Cornelius
London<=>?@()&8%#'[\];Tokyo^-'05    Cornelius
ondon<=>?@()&8%#'[\];Tokyo^-'05    Cornelius
ndon<=>?@()&8%#'[\];Tokyo^-'05    Cornelius
don<=>?@()&8%#'[\];Tokyo^-'05    Cornelius
on<=>?@()&8%#'[\];Tokyo^-'05    Cornelius
n<=>?@()&8%#'[\];Tokyo^-'05    Cornelius
<=>?@()&8%#'[\];Tokyo^-'05    Cornelius
=>?@()&8%#'[\];Tokyo^-'05    Cornelius
>?@()&8%#'[\];Tokyo^-'05    Cornelius
?@()&8%#'[\];Tokyo^-'05    Cornelius
@()&8%#'[\];Tokyo^-'05    Cornelius
()&8%#'[\];Tokyo^-'05    Cornelius
)&8%#'[\];Tokyo^-'05    Cornelius
&8%#'[\];Tokyo^-'05    Cornelius
8%#'[\];Tokyo^-'05    Cornelius
%#'[\];Tokyo^-'05    Cornelius
#'[\];Tokyo^-'05    Cornelius
'[\];Tokyo^-'05    Cornelius
[\];Tokyo^-'05    Cornelius
\];Tokyo^-'05    Cornelius
];Tokyo^-'05    Cornelius
;Tokyo^-'05    Cornelius
Tokyo^-'05    Cornelius
okyo^-'05    Cornelius
kyo^-'05    Cornelius
yo^-'05    Cornelius
o^-'05    Cornelius
^-'05    Cornelius
-'05    Cornelius
'05    Cornelius
05    Cornelius
5    Cornelius
    Cornelius
   Cornelius
  Cornelius
Cornelius
ornelius
rnelius
nelius
elius
lius
ius
us
s
```

One of the most influential Japanese
musicians working today, Keigo
Oyamada's first band, Flipper's Guitar,
revolutionised Japanese Pop music and
instigated the Shibuya-kei style of
music. Their final album, "Dr Head's
World Tour", mixed Manchester-style
Dance music and Burt Bacharach Pop to
create an album that is consistently
a critic's choice. Cornelius continues
to work with a wide range of styles
and influences to create the ultimate
post-modern pop. As much an artist as a
musician, Cornelius's releases and live
shows are blends of music, adventure
and design. His collaborations with
Mitsuo Shindo's Contemporary Productions
helped establish the post-modern style
for which Tokyo is known, while a

Cornelius
Limited-edition record player
Design: Kitayama Masakazu
1996-1998

ECO High Fidelit

Tune in
Fantasmatic
Waves

Turn on
Fantasmatic
Sounds

Hall of Sound

Tune in
Fantasmatic
Waves

Turn on
Fantasmatic
Sounds

Hall of Sound

Multiplies
"How Many Good Faces?"

Cornelius
Fantasmatic world tour
travel kit
1997

Paul Davis

Miscellaneous Post-it Note
drawings
2000

Paul Davis draws, lots, and very well.
He collects tart observations,
overheard conversations, satirical
asides, fragments of self-analysis and
cryptic questions in sketch books and
on every bit of paper he can. His work
is funny, irreverent and rooted in the
real world. The things that fascinate
him are sex, relationships, obsessions
and the ludicrousness of it all.
Davis produced commercial illustrations
until he had an exhibition at the
Dazed Gallery, comprising 2500 drawings
on Post-it Notes. The true extent of
Davis's creativity became apparent and
he began a new career phase dictating
his own approach to the work that
came his way. For JAM, Davis includes
a best-of selection, plus a new series
of drawings aimed at the overblown
absurdity of contemporary media culture.
Davis works and lives in East London,
has been featured in countless magazines
and has exhibited his work in Sweden,
New York, Tokyo and London.

APOLOGIES
FOR ANY
EMARRASSMENT
OR DISTRESS.

IMPERFECT DAY

WORK HURT
ROW DIE

PERFECT DAY

SHOP DRINK
EAT BITCH

DRUNK, CRACK,
WHORE.

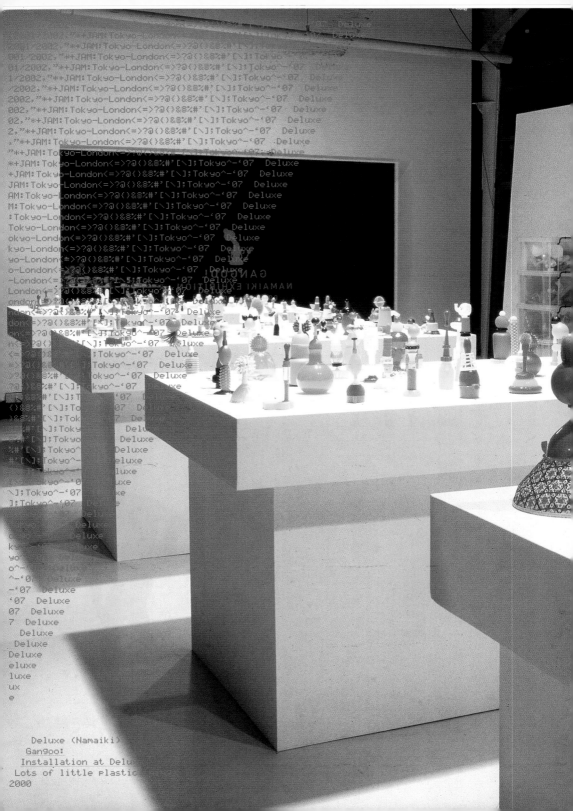

Deluxe (Namaiki)
Gangoo:
Installation at Delux
Lots of little plastic
2000

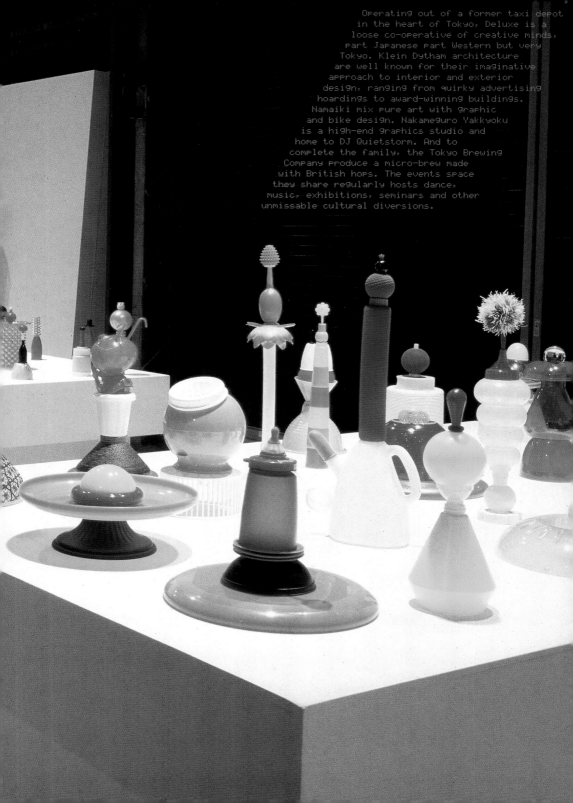

Operating out of a former taxi depot
in the heart of Tokyo, Deluxe is a
loose co-operative of creative minds,
part Japanese part Western but very
Tokyo. Klein Dytham architecture
are well known for their imaginative
approach to interior and exterior
design, ranging from quirky advertising
hoardings to award-winning buildings.
Namaiki mix pure art with graphic
and bike design. Nakameguro Yakkyoku
is a high-end graphics studio and
home to DJ Quietstorm. And to
complete the family, the Tokyo Brewing
Company produce a micro-brew made
with British hops. The events space
they share regularly hosts dance,
music, exhibitions, seminars and other
unmissable cultural diversions.

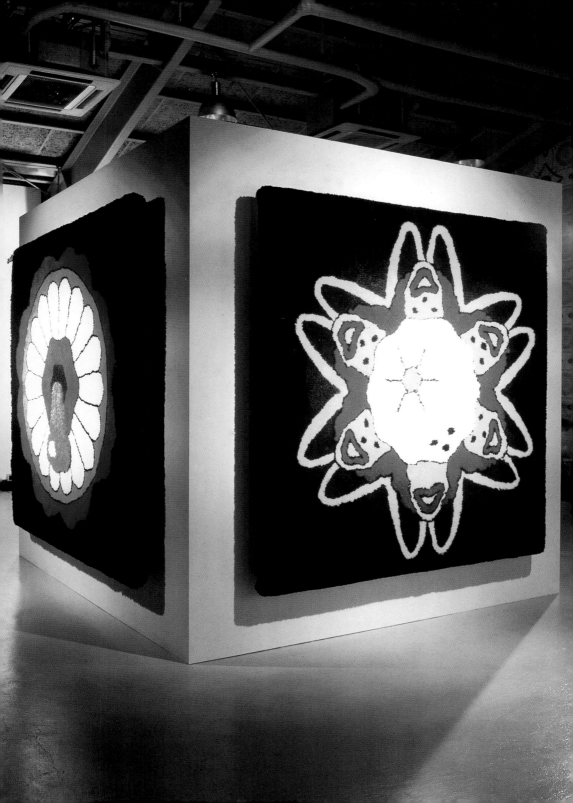

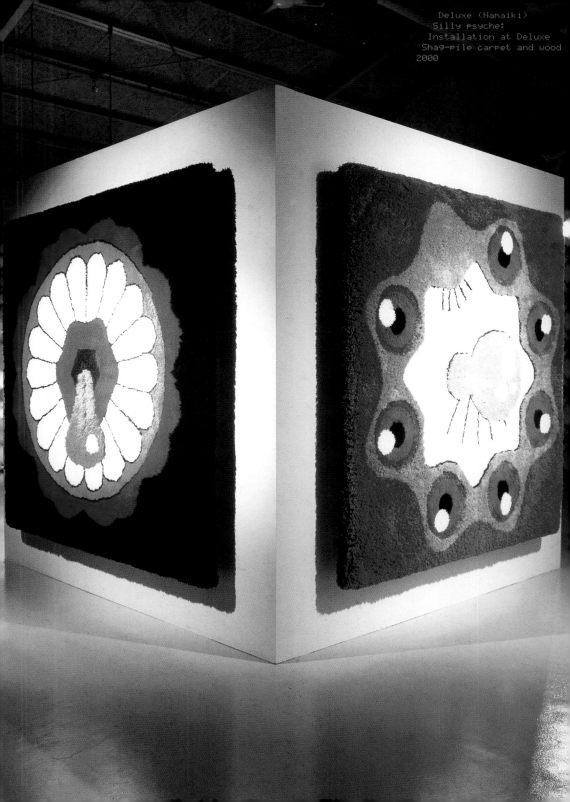

Deluxe (Namaiki)
Silly psyche:
Installation at Deluxe
Shag-pile carpet and wood
2000

Deluxe (Klein Dytham architecture)
Pika pika pretzel
Inflatable construction hoarding
2000

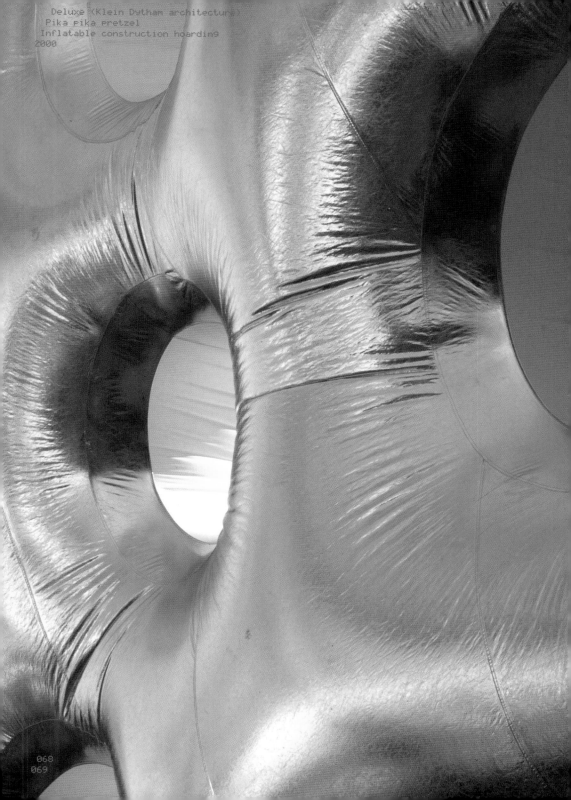

Enlightenment are a design team
composed of Hiro Sugiyama and Tomoyuki
Yonezu, along with a constantly
fluid range of collaborators. Although
Sugiyama thinks of himself as an
illustrator-designer, Hiropon Factory
artist, Takashi Murakami has described
him as a Pop artist in the vein of
the 1960s pioneer Tadanori Yoko.
At the end of the 1980s he and Ichiro
Tanida collaborated on art exhibitions.
Now he is a leading light of
Tokyo's new wave of graphic artists.
Enlightenment work commercially and
on independent book and magazine
projects and exhibitions, which attract
international attention. JAM includes
a selection of their most distinctive
productions, as well as collaborative
film works by Sugiyama and Tanida.

Enlightenment
Portrait "Hair"
2000

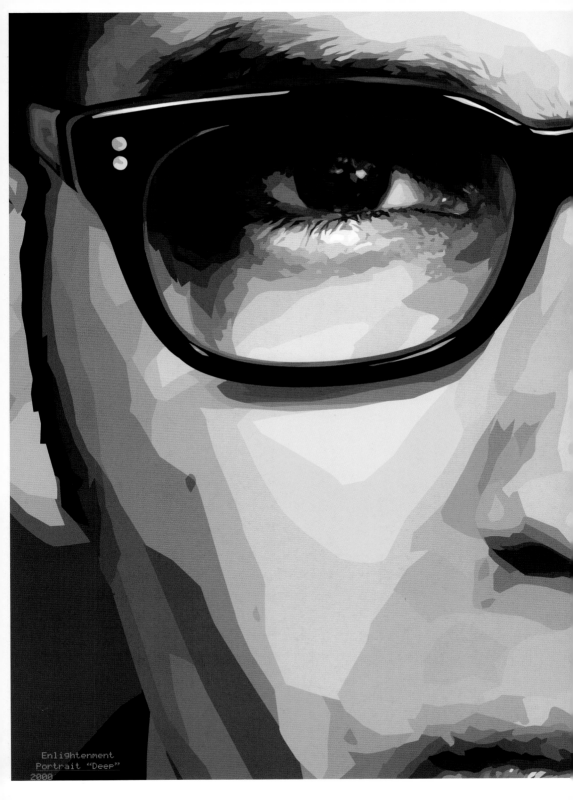

Enlightenment
Portrait "Deep"
2000

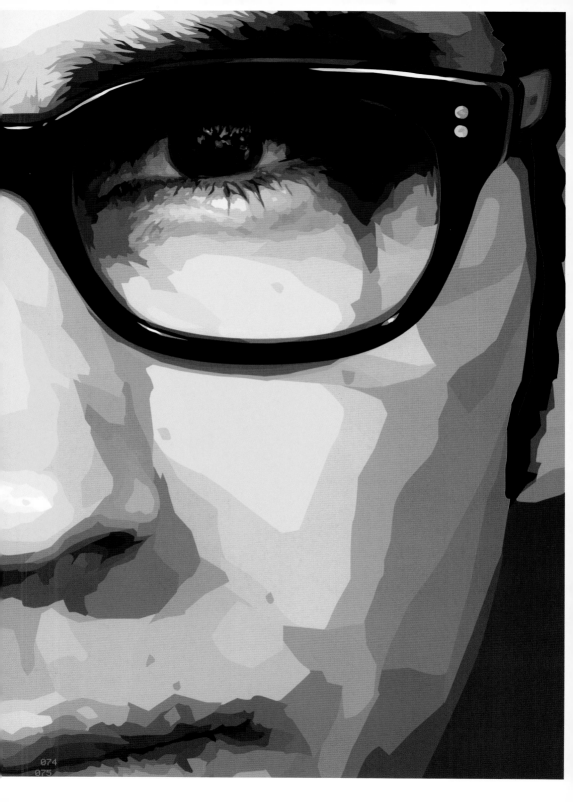

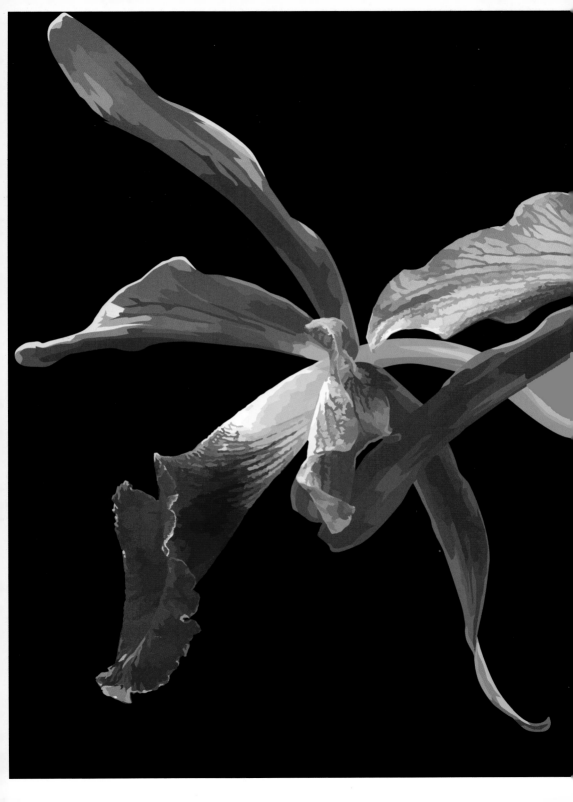

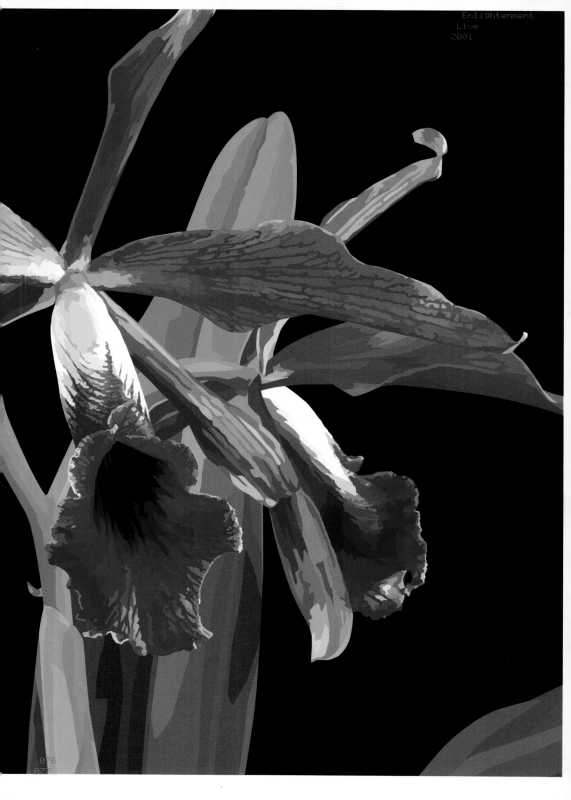

```
2001/2002,"*+JAM:Tokyo-London<=>?@()&%#'[\];London^-'09  Shelley Fox
001/2002,"*+JAM:Tokyo-London<=>?@()&%#'[\];London^-'09  Shelley Fox
01/2002,"*+JAM:Tokyo-London<=>?@()&%#'[\];London^-'09  Shelley Fox
1/2002,"*+JAM:Tokyo-London<=>?@()&%#'[\];London^-'09  Shelley Fox
/2002,"*+JAM:Tokyo-London<=>?@()&%#'[\];London^-'09  Shelley Fox
2002,"*+JAM:Tokyo-London<=>?@()&%#'[\];London^-'09  Shelley Fox
002,"*+JAM:Tokyo-London<=>?@()&%#'[\];London^-'09  Shelley Fox
02,"*+JAM:Tokyo-London<=>?@()&%#'[\];London^-'09  Shelley Fox
2,"*+JAM:Tokyo-London<=>?@()&%#'[\];London^-'09  Shelley Fox
,"*+JAM:Tokyo-London<=>?@()&%#'[\];London^-'09  Shelley Fox
"*+JAM:Tokyo-London<=>?@()&%#'[\];London^-'09  Shelley Fox
*+JAM:Tokyo-London<=>?@()&%#'[\];London^-'09  Shelley Fox
+JAM:Tokyo-London<=>?@()&%#'[\];London^-'09  Shelley Fox
JAM:Tokyo-London<=>?@()&%#'[\];London^-'09  Shelley Fox
AM:Tokyo-London<=>?@()&%#'[\];London^-'09  Shelley Fox
M:Tokyo-London<=>?@()&%#'[\];London^-'09  Shelley Fox
:Tokyo-London<=>?@()&%#'[\];London^-'09  Shelley Fox
Tokyo-London<=>?@()&%#'[\];London^-'09  Shelley Fox
okyo-London<=>?@()&%#'[\];London^-'09  Shelley Fox
kyo-London<=>?@()&%#'[\];London^-'09  Shelley Fox
yo-London<=>?@()&%#'[\];London^-'09  Shelley Fox
o-London<=>?@()&%#'[\];London^-'09  Shelley Fox
-London<=>?@()&%#'[\];London^-'09  Shelley Fox
London<=>?@()&%#'[\];London^-'09  Shelley Fox
ondon<=>?@()&%#'[\];London^-'09  Shelley Fox
ndon<=>?@()&%#'[\];London^-'09  Shelley Fox
don<=>?@()&%#'[\];London^-'09  Shelley Fox
on<=>?@()&%#'[\];London^-'09  Shelley Fox
n<=>?@()&%#'[\];London^-'09  Shelley Fox
<=>?@()&%#'[\];London^-'09  Shelley Fox
=>?@()&%#'[\];London^-'09  Shelley Fox
>?@()&%#'[\];London^-'09  Shelley Fox
?@()&%#'[\];London^-'09  Shelley Fox
@()&%#'[\];London^-'09  Shelley Fox
()&%#'[\];London^-'09  Shelley Fox
)&%#'[\];London^-'09  Shelley Fox
2001/2002,"*+JAM:Tokyo-London<=>?@()&%#'[\];London^-'09  Shelley Fox
001/2002,"*+JAM:Tokyo-London<=>?@()&%#'[\];London^-'09  Shelley Fox
01/2002,"*+JAM:Tokyo-London<=>?@()&%#'[\];London^-'09  Shelley Fox
1/2002,"*+JAM:Tokyo-London<=>?@()&%#'[\];London^-'09  Shelley Fox
/2002,"*+JAM:Tokyo-London<=>?@()&%#'[\];London^-'09  Shelley Fox
2002,"*+JAM:Tokyo-London<=>?@()&%#'[\];London^-'09  Shelley Fox
002,"*+JAM:Tokyo-London<=>?@()&%#'[\];London^-'09  Shelley Fox
02,"*+JAM:Tokyo-London<=>?@()&%#'[\];London^-'09  Shelley Fox
2,"*+JAM:Tokyo-London<=>?@()&%#'[\];London^-'09  Shelley Fox
,"*+JAM:Tokyo-London<=>?@()&%#'[\];London^-'09  Shelley Fox
"*+JAM:Tokyo-London<=>?@()&%#'[\];London^-'09  Shelley Fox
*+JAM:Tokyo-London<=>?@()&%#'[\];London^-'09  Shelley Fox
+JAM:Tokyo-London<=>?@()&%#'[\];London^-'09  Shelley Fox
JAM:Tokyo-London<=>?@()&%#'[\];London^-'09  Shelley Fox
AM:Tokyo-London<=>?@()&%#'[\];London^-'09  Shelley Fox
M:Tokyo-London<=>?@()&%#'[\];London^-'09  Shelley Fox
:Tokyo-London<=>?@()&%#'[\];London^-'09  Shelley Fox
Tokyo-London<=>?@()&%#'[\];London^-'09  Shelley Fox
okyo-London<=>?@()&%#'[\];London^-'09  Shelley Fox
kyo-London<=>?@()&%#'[\];London^-'09  Shelley Fox
yo-London<=>?@()&%#'[\];London^-'09  Shelley Fox
o-London<=>?@()&%#'[\];London^-'09  Shelley Fox
-London<=>?@()&%#'[\];London^-'09  Shelley Fox
London<=>?@()&%#'[\];London^-'09  Shelley Fox
ondon<=>?@()&%#'[\];London^-'09  Shelley Fox
ndon<=>?@()&%#'[\];London^-'09  Shelley Fox
don<=>?@()&%#'[\];London^-'09  Shelley Fox
on<=>?@()&%#'[\];London^-'09  Shelley Fox
n<=>?@()&%#'[\];London^-'09  Shelley Fox
<=>?@()&%#'[\];London^-'09  Shelley Fox
=>?@()&%#'[\];London^-'09  Shelley Fox
>?@()&%#'[\];London^-'09  Shelley Fox
?@()&%#'[\];London^-'09  Shelley Fox
@()&%#'[\];London^-'09  Shelley Fox
()&%#'[\];London^-'09  Shelley Fox
)&%#'[\];London^-'09 Shelley Fox
```

Shelley Fox, a designer of clothes for
women, has just completed her eleventh
collection. Trained in both textile
and fashion design, she demonstrates
a sensitivity to forms and ideas
that consistently pushes boundaries.
Fox's collections take inspiration
from unusual modes of communication,
for example, Braille and Morse Code, but
she's best known for her experimentation
with fabrics and pattern cutting,
which aims to create bold forms for the
body. JAM includes a selection of more
sculptural pieces from her archive.

Shelley Fox
Muslin wadded balloon top
Collection 7, Autumn/winter
1999

Shelley Fox
Plate top, dusky pink
with felt frill
Collection 9, Autumn/winter
2000

```
o-London<=>?@{}&8%#'[\];London^-'10  Friendchip/Multiplex
-London<=>?@{}&8%#'[\];London^-'10  Friendchip/Multiplex
London<=>?@{}&8%#'[\];London^-'10  Friendchip/Multiplex
ondon<=>?@{}&8%#'[\];London^-'10  Friendchip/Multiplex
ndon<=>?@{}&8%#'[\];London^-'10  Friendchip/Multiplex
don<=>?@{}&8%#'[\];London^-'10  Friendchip/Multiplex
on<=>?@{}&8%#'[\];London^-'10  Friendchip/Multiplex
n<=>?@{}&8%#'[\];London^-'10  Friendchip/Multiplex
<=>?@{}&8%#'[\];London^-'10  Friendchip/Multiplex
=>?@{}&8%#'[\];London^-'10  Friendchip/Multiplex
>?@{}&8%#'[\];London^-'10  Friendchip/Multiplex
?@{}&8%#'[\];London^-'10  Friendchip/Multiplex
@{}&8%#'[\];London^-'10  Friendchip/Multiplex
{}&8%#'[\];London^-'10  Friendchip/Multiplex
}&8%#'[\];London^-'10  Friendchip/Multiplex
&8%#'[\];London^-'10  Friendchip/Multiplex
8%#'[\];London^-'10  Friendchip/Multiplex
%#'[\];London^-'10  Friendchip/Multiplex
#'[\];London^-'10  Friendchip/Multiplex
'[\];London^-'10  Friendchip/Multiplex
[\];London^-'10  Friendchip/Multiplex
\];London^-'10  Friendchip/Multiplex
];London^-'10  Friendchip/Multiplex
;London^-'10  Friendchip/Multiplex
London^-'10  Friendchip/Multiplex
ondon^-'10  Friendchip/Multiplex
ndon^-'10  Friendchip/Multiplex
don^-'10  Friendchip/Multiplex
on^-'10  Friendchip/Multiplex
n^-'10  Friendchip/Multiplex
^-'10  Friendchip/Multiplex
-'10  Friendchip/Multiplex
'10  Friendchip/Multiplex
10  Friendchip/Multiplex
0  Friendchip/Multiplex
  Friendchip/Multiplex
 Friendchip/Multiplex
Friendchip/Multiplex
riendchip/Multiplex
iendchip/Multiplex
endchip/Multiplex
ndchip/Multiplex
dchip/Multiplex
chip/Multiplex
hip/Multiplex
ip/Multiplex
p/Multiplex
/Multiplex
Multiplex
ultiplex
ltiplex
tiplex
iplex
plex
lex
ex
x
```
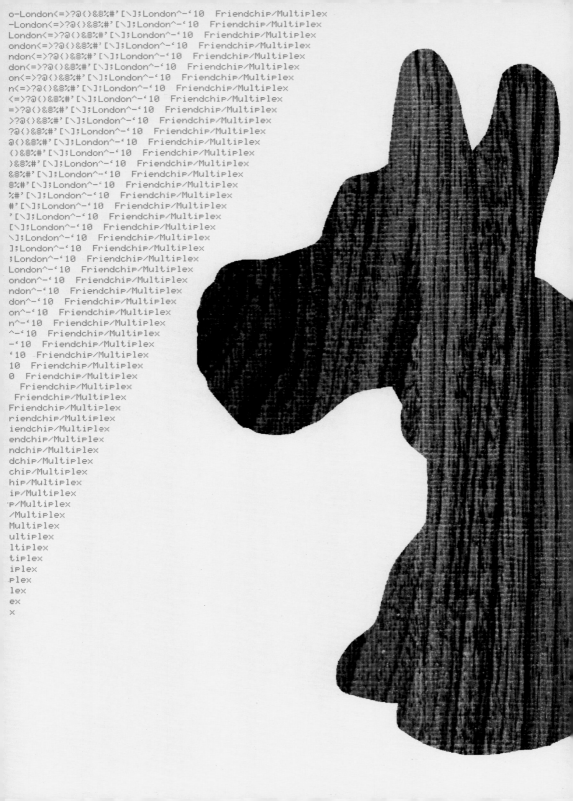

Anthony Burrill is a graphic designer
who brings his uncluttered graphic
aesthetic and an attitude of
playful wit to a variety of creative
collaborations. Friendchip is a new
media project undertaken with Kip
Parker, while Multiplex, is a film-based
partnership with Paul Plowman. The
Friendchip website is widely acclaimed
and cited as influential in bringing
web design back to basics. Equally,
Multiplex's video for "Blanket", showing
a nodding Scottie dog on a small-screen
monitor, works as a tonic to style over
content club visuals. For JAM, Multiplex
have made a new short film, "I'm sorry
I do not understand", and Friendchip,
have produced perhaps the first
artwork to utilise Powerpoint graphics.
Friendchip and Multiplex are also known
for their long-time collaboration with
design duo, Antoni & Alison.

Friendchip
Powerpoint presentation
2001

REGENCY STYLE JACUZZI

TOUCHSCREEN HOOVER

Steven Gontarski
Block III
Photograph: Stephen White
Courtesy: Jay Jopling/
White Cube, London
2000

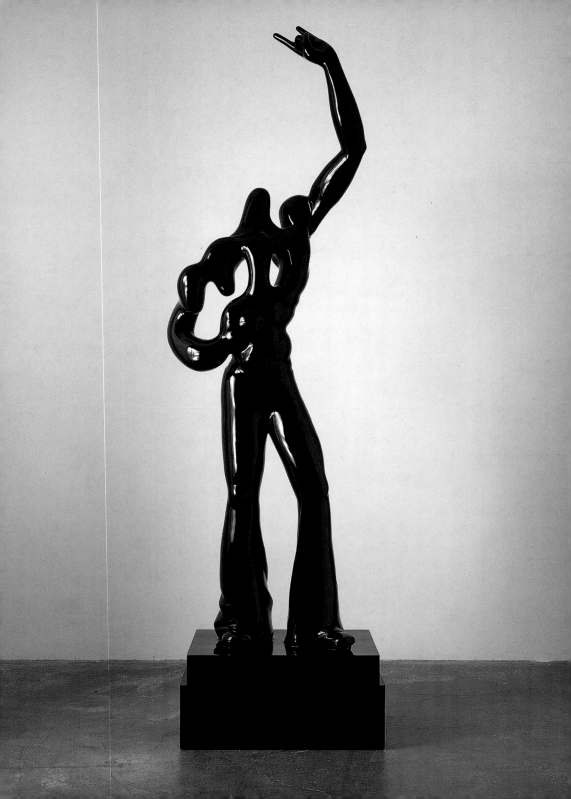

Steven Gontarski
L.A.X. I
Photograph: Stephen White
Courtesy: Jay Jopling/
White Cube, London
2000

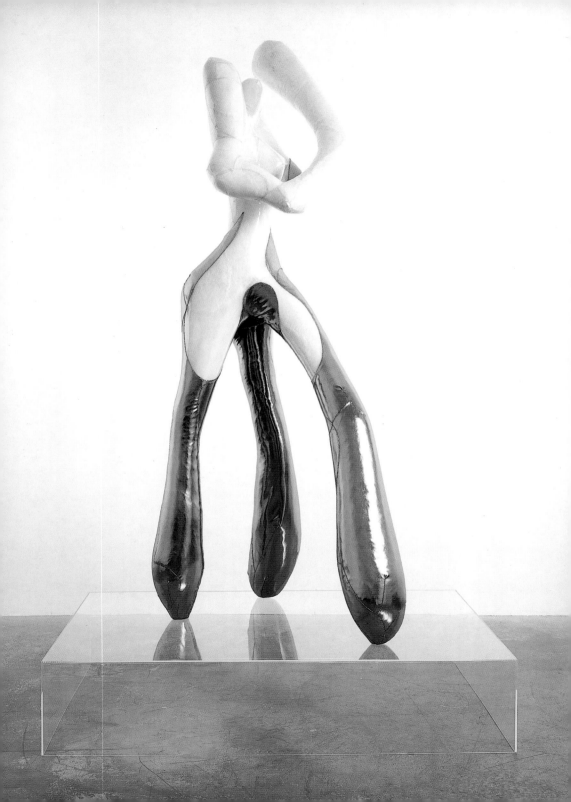

Steven Gontarski
Lady Godiva was a freedom
rider
Photograph: Stephen White
Courtesy: Jay Jopling/
White Cube, London
1999
Lesbians acquiesce
Photograph: Stephen White
Courtesy: Jay Jopling/
White Cube, London
1998

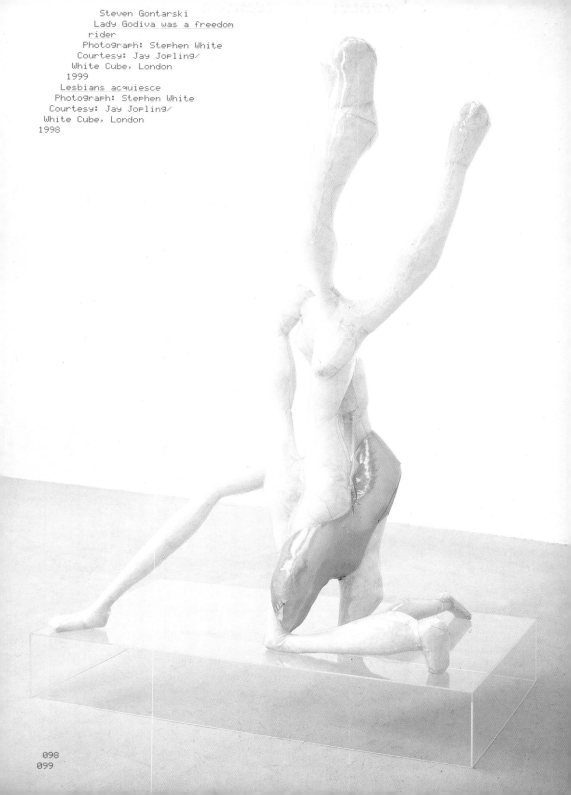

```
2001/2002,"*+JAM:Tokyo-London<=>?@(){}&$%#'[\];Tokyo^-'12  Gorgerous      Gorgerous
001/2002,"*+JAM:Tokyo-London<=>?@(){}&$%#'[\];Tokyo^-'12  Gorgerous     Explode yourself
01/2002,"*+JAM:Tokyo-London<=>?@(){}&$%#'[\];Tokyo^-'12  Gorgerous    1998
1/2002,"*+JAM:Tokyo-London<=>?@(){}&$%#'[\];Tokyo^-'12  Gorgerous
/2002,"*+JAM:Tokyo-London<=>?@(){}&$%#'[\];Tokyo^-'12  Gorgerous
2002,"*+JAM:Tokyo-London<=>?@(){}&$%#'[\];Tokyo^-'12  Gorgerous
002,"*+JAM:Tokyo-London<=>?@(){}&$%#'[\];Tokyo^-'12  Gorgerous
02,"*+JAM:Tokyo-London<=>?@(){}&$%#'[\];Tokyo^-'12  Gorgerous
2,"*+JAM:Tokyo-London<=>?@(){}&$%#'[\];Tokyo^-'12  Gorgerous
,"*+JAM:Tokyo-London<=>?@(){}&$%#'[\];Tokyo^-'12  Gorgerous
"*+JAM:Tokyo-London<=>?@(){}&$%#'[\];Tokyo^-'12  Gorgerous
*+JAM:Tokyo-London<=>?@(){}&$%#'[\];Tokyo^-'12  Gorgerous
+JAM:Tokyo-London<=>?@(){}&$%#'[\];Tokyo^-'12  Gorgerous
2,"*+JAM:Tokyo-London<=>?@(){}&$%#'[\];Tokyo^-'12  Gorgerous
,"*+JAM:Tokyo-London<=>?@(){}&$%#'[\];Tokyo^-'12  Gorgerous
"*+JAM:Tokyo-London<=>?@(){}&$%#'[\];Tokyo^-'12  Gorgerous
*+JAM:Tokyo-London<=>?@(){}&$%#'[\];Tokyo^-'12  Gorgerous
+JAM:Tokyo-London<=>?@(){}&$%#'[\];Tokyo^-'12  Gorgerous
JAM:Tokyo-London<=>?@(){}&$%#'[\];Tokyo^-'12  Gorgerous
AM:Tokyo-London<=>?@(){}&$%#'[\];Tokyo^-'12  Gorgerous
M:Tokyo-London<=>?@(){}&$%#'[\];Tokyo^-'12  Gorgerous
:Tokyo-London<=>?@(){}&$%#'[\];Tokyo^-'12  Gorgerous
Tokyo-London<=>?@(){}&$%#'[\];Tokyo^-'12  Gorgerous
okyo-London<=>?@(){}&$%#'[\];Tokyo^-'12  Gorgerous
kyo-London<=>?@(){}&$%#'[\];Tokyo^-'12  Gorgerous
yo-London<=>?@(){}&$%#'[\];Tokyo^-'12  Gorgerous
o-London<=>?@(){}&$%#'[\];Tokyo^-'12  Gorgerous
-London<=>?@(){}&$%#'[\];Tokyo^-'12  Gorgerous
London<=>?@(){}&$%#'[\];Tokyo^-'12  Gorgerous
ondon<=>?@(){}&$%#'[\];Tokyo^-'12  Gorgerous
ndon<=>?@(){}&$%#'[\];Tokyo^-'12  Gorgerous
don<=>?@(){}&$%#'[\];Tokyo^-'12  Gorgerous
on<=>?@(){}&$%#'[\];Tokyo^-'12  Gorgerous
n<=>?@(){}&$%#'[\];Tokyo^-'12  Gorgerous
<=>?@(){}&$%#'[\];Tokyo^-'12  Gorgerous
=>?@(){}&$%#'[\];Tokyo^-'12  Gorgerous
okyo^-'12  Gorgerous
kyo^-'12  Gorgerous
yo^-'12  Gorgerous
o^-'12  Gorgerous
^-'12  Gorgerous
-'12  Gorgerous
'12  Gorgerous
12  Gorgerous
2  Gorgerous
   Gorgerous
 Gorgerous
Gorgerous
orgerous
rgerous
gerous
erous
rous
ous
us
s
```

BIG STICK

 Gorgerous are an outrageous performance
 duo formed in 1997 by Hiro Matsukage
 and Muneteru Ujino. Matsukage, who is
 an ex-member of the art collective
 Compresso Plastico, is also an
 influential artist and designer in his
 own right. Practically the house band
 at Tokyo's prestigious club, Milk,
 a Gorgerous performance is glamorous,
 dangerous and inspires girls to bare
 their breasts. The aesthetics of their
 performance lie between Glam Rock,
 Liberace and Italian fascism, while
 the pair utilise instruments described
 as "Love Arms", which are morphed
 phalli of Ujino's own making. Gorgerous
 take "Cock Rock" to new levels of
 absurdity and describe what they do
 as "Boosted Elegance".

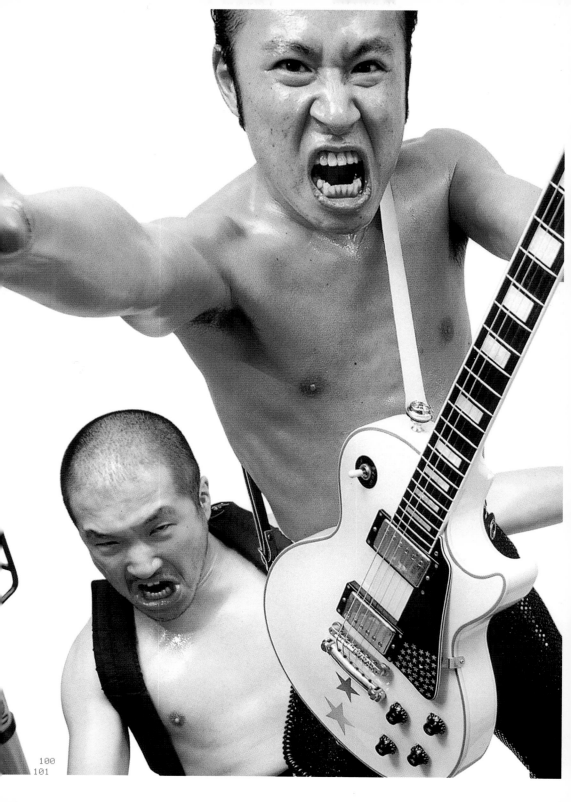

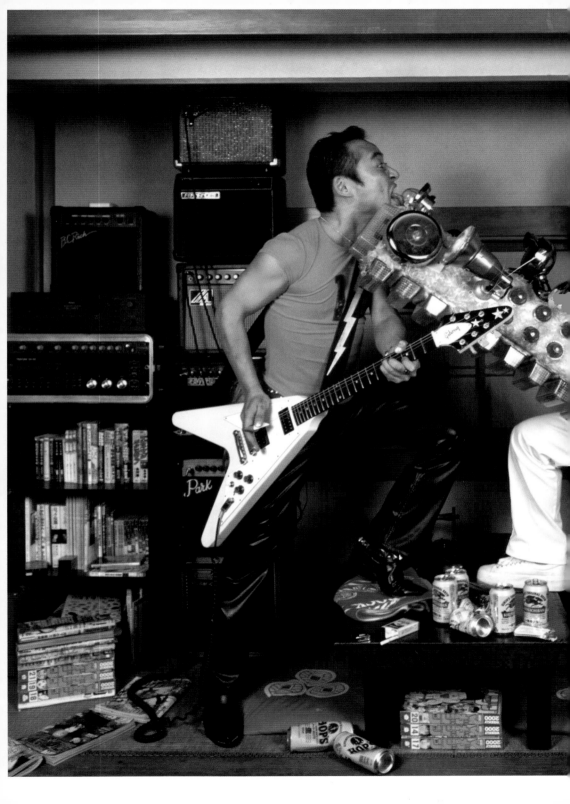

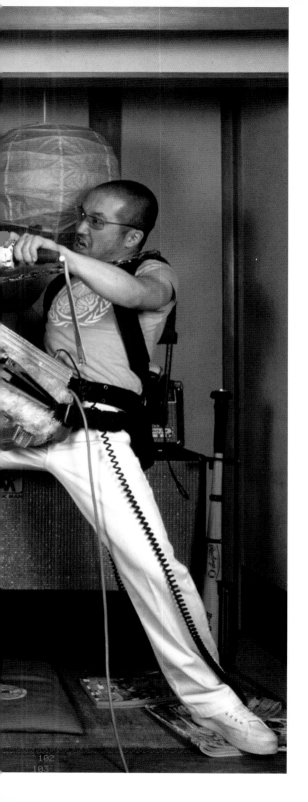

Gorgerous
Untitled
1998

```
=>?@(){}&8%#'[\];Tokyo^-'13  Groovisions          Tokyo^-'13  Groovisions          Groovisions
>?@(){}&8%#'[\];Tokyo^-'13  Groovisions          Tokyo^-'13  Groovisions          Chappie mannequin
?@(){}&8%#'[\];Tokyo^-'13  Groovisions          Tokyo^-'13  Groovisions          bonzaipaint model
@(){}&8%#'[\];Tokyo^-'13  Groovisions           Tokyo^-'13  Groovisions          Photograph: Natsu Tanimoto
(){}&8%#'[\];Tokyo^-'13  Groovisions            Tokyo^-'13  Groovisions          Painted: Bonzaipaint
){}&8%#'[\];Tokyo^-'13  Groovisions             Tokyo^-'13  Groovisions          Styling: Akira Ishikawa
{}&8%#'[\];Tokyo^-'13  Groovisions              Tokyo^-'13  Groovisions          1999
}&8%#'[\];Tokyo^-'13  Groovisions               Tokyo^-'13  Groovisions
&8%#'[\];Tokyo^-'13  Groovisions                Tokyo^-'13  Groovisions
8%#'[\];Tokyo^-'13  Groovisions                 Tokyo^-'13  Groovisions
%#'[\];Tokyo^-'13  Groovisions                  Tokyo^-'13  Groovisions
#'[\];Tokyo^-'13  Groovisions                   Tokyo^-'13  Groovisions
'[\];Tokyo^-'13  Groovisions                    Tokyo^-'13  Groovisions
[\];Tokyo^-'13  Groovisions                     Tokyo^-'13  Groovisions
\];Tokyo^-'13  Groovisions                      Tokyo^-'13  Groovisions
];Tokyo^-'13  Groovisions                       Tokyo^-'13  Groovisions
;Tokyo^-'13  Groovisions                        Tokyo^-'13  Groovisions
Tokyo^-'13  Groovisions                         Tokyo^-'13  Groovisions
okyo^-'13  Groovisions                          Tokyo^-'13  Groovisions
kyo^-'13  Groovisions                           Tokyo^-'13  Groovisions
yo^-'13  Groovisions                            Tokyo^-'13  Groovisions
o^-'13  Groovisions                             Tokyo^-'13  Groovisions
^-'13  Groovisions                              Tokyo^-'13  Groovisions
-'13  Groovisions                               Tokyo^-'13  Groovisions
'13  Groovisions                                Tokyo^-'13  Groovisions
13  Groovisions                                 Tokyo^-'13  Groovisions
3  Groovisions                                  Tokyo^-'13  Groovisions
   Groovisions                                  Tokyo^-'13  Groovisions
 Groovisions                                    Tokyo^-'13  Groovisions
Groovisions                                     Tokyo^-'13  Groovisions
roovisions                                      Tokyo^-'13  Groovisions
oovisions                                       Tokyo^-'13  Groovisions
ovisions                                        Tokyo^-'13  Groovisions
visions                                         Tokyo^-'13  Groovisions
isions                                          Tokyo^-'13  Groovisions
sions                                           Tokyo^-'13  Groovisions
ions                                            Tokyo^-'13  Groovisions
ons                                             Tokyo^-'13  Groovisions
ns                                              Tokyo^-'13  Groovisions
s                                               Tokyo^-'13  Groovisions
                                                Tokyo^-'13  Groovisions
```

Tokyo^-'13 Groovisions Groovisions, an acclaimed multi-
Tokyo^-'13 Groovisions disciplinary design team established
Tokyo^-'13 Groovisions around 1993, is famous for its Chappie
Tokyo^-'13 Groovisions character. Originally the team, headed
Tokyo^-'13 Groovisions by Hiroshi Ito, organised and VJ'd
Tokyo^-'13 Groovisions at club events for which they produced
okyo^-'13 Groovisions flyers as a way of showcasing their
kyo^-'13 Groovisions work. Now their activities include
yo^-'13 Groovisions packaging, fashion, film, web design
o^-'13 Groovisions and art direction. Chappie, the uni-
^-'13 Groovisions sex virtual idol, is also a household
-'13 Groovisions name in Japan. Ageless and genderless,
'13 Groovisions Chappie has appeared in fashion and
13 Groovisions art magazines, and advertised products.
3 Groovisions S/he debuted as a virtual idol singer
 Groovisions in 1994 and released a CD in 1999.
 Groovisions Originally created as a computer game
Groovisions character that allowed you to change
roovisions its clothes, hair and colouring, while
oovisions the features remain the same, Chappie
ovisions first became three-dimensional in 1998.
visions S/he follows all the latest trends and
isions has various manifestations, i.e., as hi-fi
sions speakers, as an interactive version you
ions can draw on and as a pachinko machine
ons (a popular gambling device in Japan).
ns Whereas you could buy Chappie in shops,
s soon s/he will only be available at
 Groovisions exhibitions. Recently spotted
 at Colette in Paris, and as part of
 Murakami's exhibition, "Super Flat",
 in the USA, Chappie makes its UK debut
 at JAM.

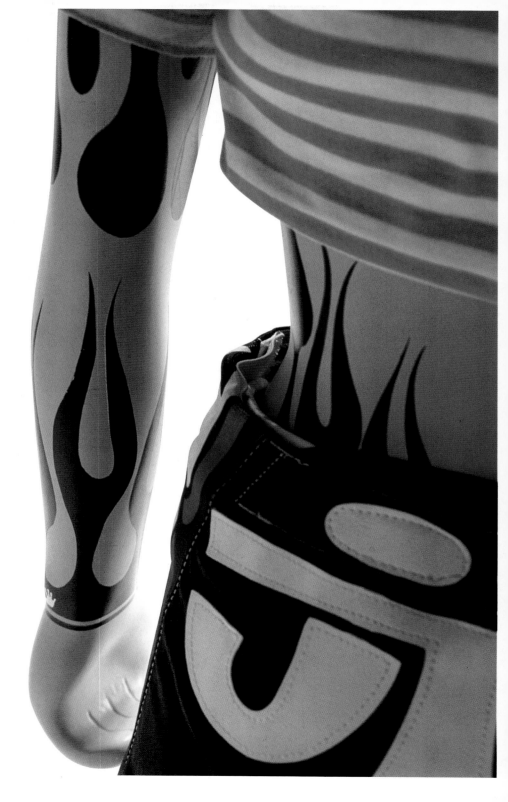

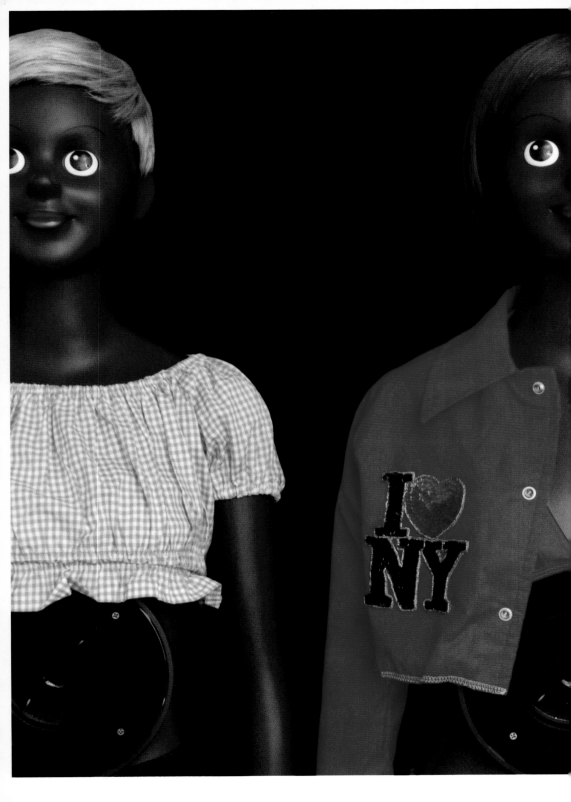

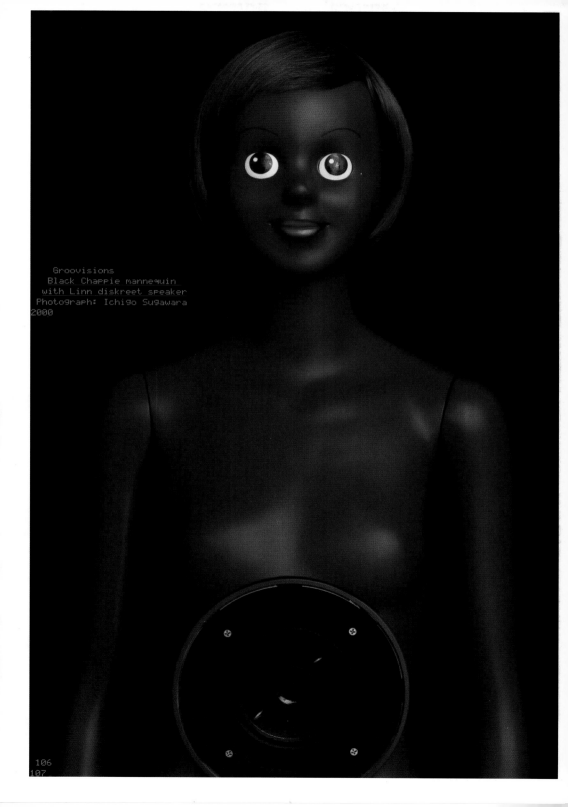

Groovisions
Black Chappie mannequin
with Linn diskreet speaker
Photograph: Ichigo Sugawara
2000

```
ondon<=>?@()&8%#'[\];Tokyo^-'14  Kazuhiko Hachiya
ndon<=>?@()&8%#'[\];Tokyo^-'14  Kazuhiko Hachiya
don<=>?@()&8%#'[\];Tokyo^-'14  Kazuhiko Hachiya
on<=>?@()&8%#'[\];Tokyo^-'14  Kazuhiko Hachiya
n<=>?@()&8%#'[\];Tokyo^-'14  Kazuhiko Hachiya
<=>?@()&8%#'[\];Tokyo^-'14  Kazuhiko Hachiya
=>?@()&8%#'[\];Tokyo^-'14  Kazuhiko Hachiya
>?@()&8%#'[\];Tokyo^-'14  Kazuhiko Hachiya
?@()&8%#'[\];Tokyo^-'14  Kazuhiko Hachiya
@()&8%#'[\];Tokyo^-'14  Kazuhiko Hachiya
()&8%#'[\];Tokyo^-'14  Kazuhiko Hachiya
)&8%#'[\];Tokyo^-'14  Kazuhiko Hachiya
&8%#'[\];Tokyo^-'14  Kazuhiko Hachiya
8%#'[\];Tokyo^-'14  Kazuhiko Hachiya
%#'[\];Tokyo^-'14  Kazuhiko Hachiya
#'[\];Tokyo^-'14  Kazuhiko Hachiya
'[\];Tokyo^-'14  Kazuhiko Hachiya
[\];Tokyo^-'14  Kazuhiko Hachiya
\];Tokyo^-'14  Kazuhiko Hachiya
];Tokyo^-'14  Kazuhiko Hachiya
;Tokyo^-'14  Kazuhiko Hachiya
Tokyo^-'14  Kazuhiko Hachiya
okyo^-'14  Kazuhiko Hachiya
kyo^-'14  Kazuhiko Hachiya
yo^-'14  Kazuhiko Hachiya
o^-'14  Kazuhiko Hachiya
^-'14  Kazuhiko Hachiya
-'14  Kazuhiko Hachiya
'14  Kazuhiko Hachiya
14  Kazuhiko Hachiya
4  Kazuhiko Hachiya
  Kazuhiko Hachiya
 Kazuhiko Hachiya
Kazuhiko Hachiya
azuhiko Hachiya
[\];Tokyo^-'14  Kazuhiko Hachiya
\];Tokyo^-'14  Kazuhiko Hachiya
];Tokyo^-'14  Kazuhiko Hachiya
;Tokyo^-'14  Kazuhiko Hachiya
Tokyo^-'14  Kazuhiko Hachiya
okyo^-'14  Kazuhiko Hachiya
kyo^-'14  Kazuhiko Hachiya
yo^-'14  Kazuhiko Hachiya
o^-'14  Kazuhiko Hachiya
^-'14  Kazuhiko Hachiya
-'14  Kazuhiko Hachiya
'14  Kazuhiko Hachiya
14  Kazuhiko Hachiya
4  Kazuhiko Hachiya
  Kazuhiko Hachiya
 Kazuhiko Hachiya
```

```
Kazuhiko Hachiya    Kazuhiko Hachiya's new media works
azuhiko Hachiya     explore the theme of communication.
zuhiko Hachiya    Over one million people in Japan have
uhiko Hachiya     used his PostPet e-mail characters;
hiko Hachiya    Momo the Pink Teddy Bear, Mippi the
iko Hachiya     Rabbit, Sumiko the Tortoise, Furo the
ko Hachiya    Kitten, Shingo the Mysterious Machine,
o Hachiya    Jinpachi the Big Mouth Hamster, Ushe
 Hachiya     the Pouched Penguin and John the Dog.
Hachiya     PostPet won the Prix Ars Electronica
achiya    1998 Award of Distinction in the
chiya    Net category. Introduced to the UK for
hiya    the first time at JAM, Hachiya has
iya    specially created a CD-ROM that places
ya    Momo and friends in contrasting
a     environments in both London and Tokyo.
```

 Kazuhiko Hachiya
 PostPet characters

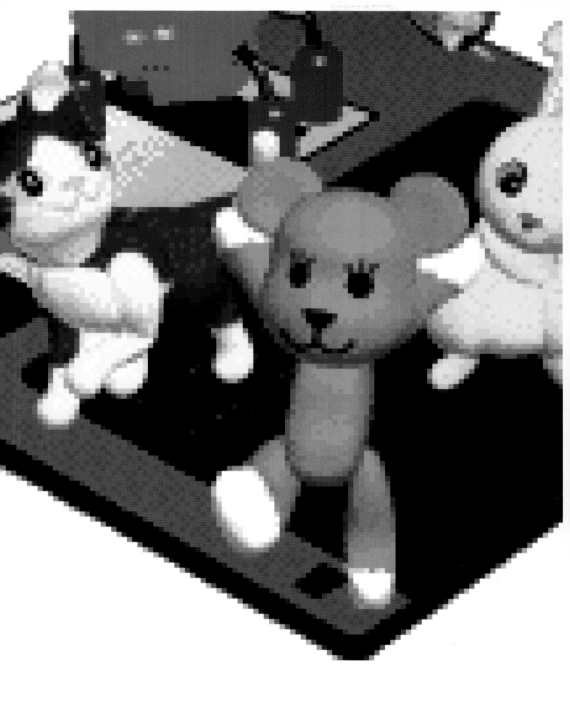

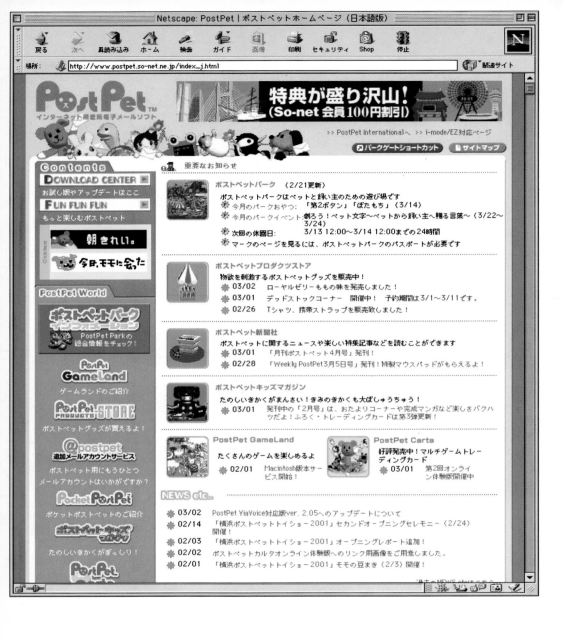

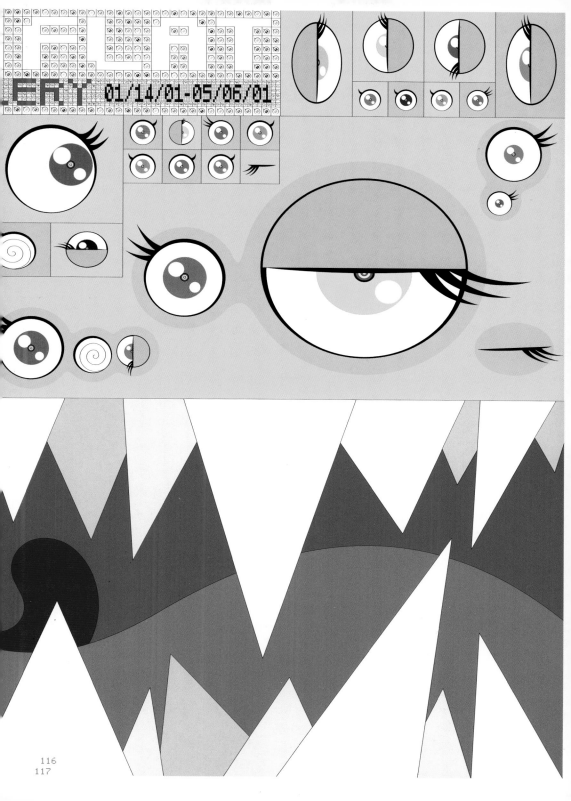

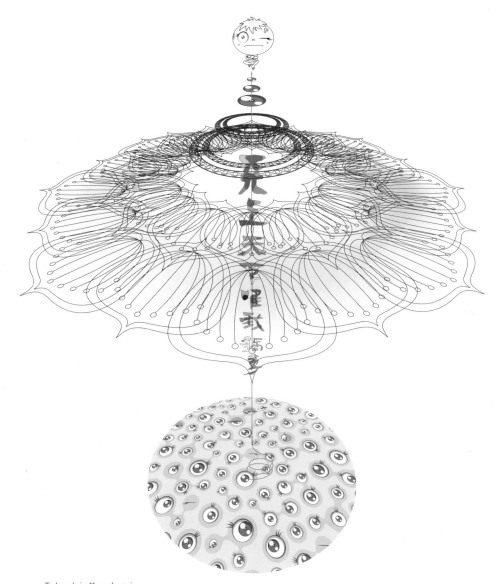

Takashi Murakami
Holy am I alone throughout
heaven and earth
Hiropon Factory Poster
Computer Engineers:
Masaya Irabe & Yuichiro Ichige
(Hiropon Factory)
Eye design courtesy:Issey Miyake Men⁄
Kaie Murakami
"Oval" courtesy Issey Miyake Men
2001

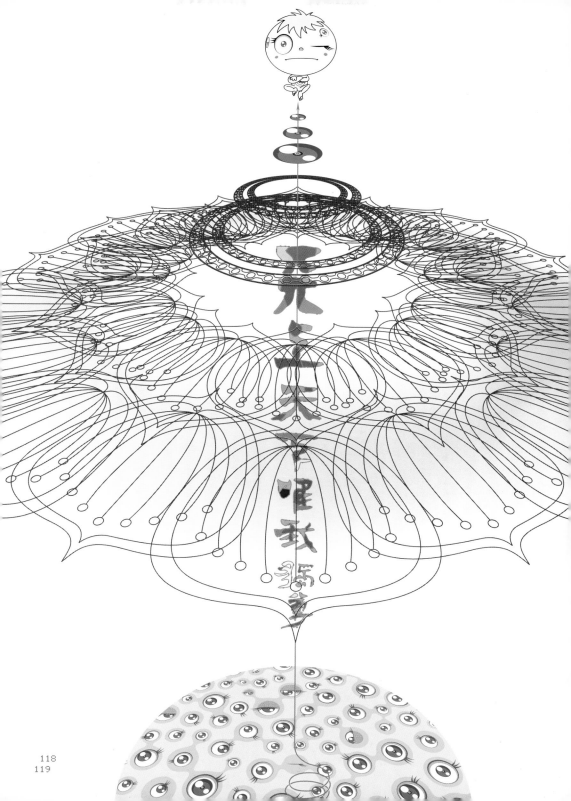

```
M:Tokyo-London<=>?@()&8%#'[\];Tokyo^-'16   Takashi Homma
:Tokyo-London<=>?@()&8%#'[\];Tokyo^-'16   Takashi Homma
Tokyo-London<=>?@()&8%#'[\];Tokyo^-'16   Takashi Homma
okyo-London<=>?@()&8%#'[\];Tokyo^-'16   Takashi Homma
kyo-London<=>?@()&8%#'[\];Tokyo^-'16   Takashi Homma
yo-London<=>?@()&8%#'[\];Tokyo^-'16   Takashi Homma
o-London<=>?@()&8%#'[\];Tokyo^-'16   Takashi Homma
-London<=>?@()&8%#'[\];Tokyo^-'16   Takashi Homma
London<=>?@()&8%#'[\];Tokyo^-'16   Takashi Homma
ondon<=>?@()&8%#'[\];Tokyo^-'16   Takashi Homma
ndon<=>?@()&8%#'[\];Tokyo^-'16   Takashi Homma
don<=>?@()&8%#'[\];Tokyo^-'16   Takashi Homma
on<=>?@()&8%#'[\];Tokyo^-'16   Takashi Homma
n<=>?@()&8%#'[\];Tokyo^-'16   Takashi Homma
<=>?@()&8%#'[\];Tokyo^-'16   Takashi Homma
=>?@()&8%#'[\];Tokyo^-'16   Takashi Homma
>?@()&8%#'[\];Tokyo^-'16   Takashi Homma
?@()&8%#'[\];Tokyo^-'16   Takashi Homma
@()&8%#'[\];Tokyo^-'16   Takashi Homma
()&8%#'[\];Tokyo^-'16   Takashi Homma
)&8%#'[\];Tokyo^-'16   Takashi Homma
&8%#'[\];Tokyo^-'16   Takashi Homma
8%#'[\];Tokyo^-'16   Takashi Homma
%#'[\];Tokyo^-'16   Takashi Homma
#'[\];Tokyo^-'16   Takashi Homma
'[\];Tokyo^-'16   Takashi Homma
[\];Tokyo^-'16   Takashi Homma
\];Tokyo^-'16   Takashi Homma
];Tokyo^-'16   Takashi Homma
;Tokyo^-'16   Takashi Homma
Tokyo^-'16   Takashi Homma
okyo^-'16   Takashi Homma
kyo^-'16   Takashi Homma
yo^-'16   Takashi Homma
o^-'16   Takashi Homma
^-'16   Takashi Homma
-'16   Takashi Homma
'16   Takashi Homma
16   Takashi Homma
6   Takashi Homma
    Takashi Homma
 Takashi Homma
Takashi Homma
akashi Homma
kashi Homma
ashi Homma
shi Homma
hi Homma
i Homma
 Homma
Homma
omma
mma
ma
a
```

Takashi Homma is one of the most
respected photographers working in
Tokyo today. He is best known for his
dispassionate and yet telling studies
of Tokyo suburbia and children.
Homma worked for a while in London
for i-D and other fashion magazines,
but returned to Tokyo to pursue both
personal and commercial projects.
He has exhibited internationally and
is a regular contributor to Purple
and many other international fashion
and culture titles. He is well known
in Tokyo for his encouragement of
young untrained women photographers,
including the internationally
recognised Hiromix. For JAM, Homma
has collaborated with the artist
Yoshitomo Nara.

Takashi Homma
Children of Tokyo
1999

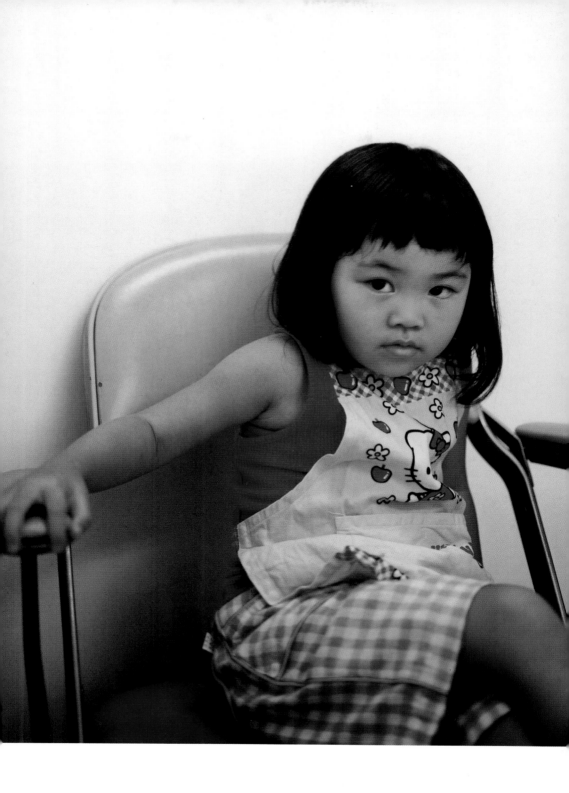

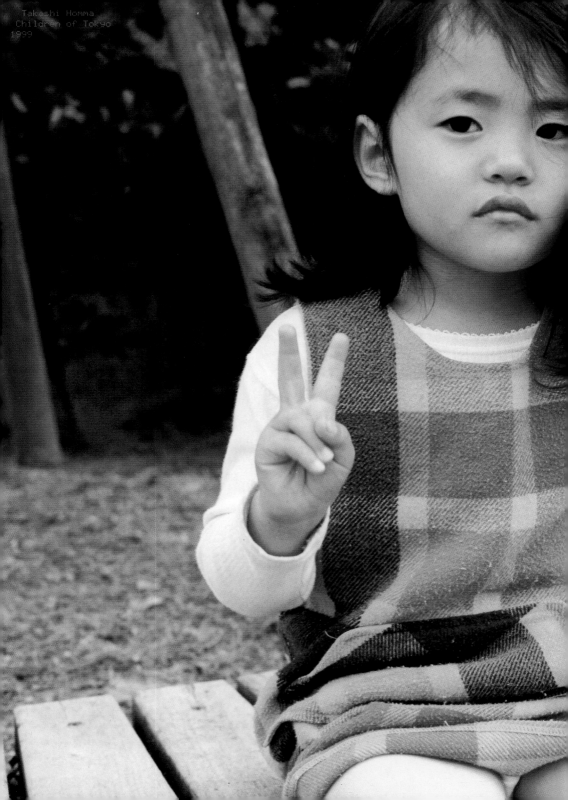

```
@(){8%#'[\];London^-'17  Martina Hoogland-Ivanow
(){8%#'[\];London^-'17  Martina Hoogland-Ivanow
){8%#'[\];London^-'17  Martina Hoogland-Ivanow
&8%#'[\];London^-'17  Martina Hoogland-Ivanow
8%#'[\];London^-'17  Martina Hoogland-Ivanow
%#'[\];London^-'17  Martina Hoogland-Ivanow
#'[\];London^-'17  Martina Hoogland-Ivanow
'[\];London^-'17  Martina Hoogland-Ivanow
[\];London^-'17  Martina Hoogland-Ivanow
\];London^-'17  Martina Hoogland-Ivanow
];London^-'17  Martina Hoogland-Ivanow
;London^-'17  Martina Hoogland-Ivanow
London^-'17  Martina Hoogland-Ivanow
ondon^-'17  Martina Hoogland-Ivanow
ndon^-'17  Martina Hoogland-Ivanow
don^-'17  Martina Hoogland-Ivanow
on^-'17  Martina Hoogland-Ivanow
n^-'17  Martina Hoogland-Ivanow
^-'17  Martina Hoogland-Ivanow
-'17  Martina Hoogland-Ivanow
'17  Martina Hoogland-Ivanow
17  Martina Hoogland-Ivanow
7  Martina Hoogland-Ivanow
   Martina Hoogland-Ivanow
  Martina Hoogland-Ivanow
Martina Hoogland-Ivanow
artina Hoogland-Ivanow
rtina Hoogland-Ivanow
tina Hoogland-Ivanow
ina Hoogland-Ivanow
na Hoogland-Ivanow
a Hoogland-Ivanow
 Hoogland-Ivanow
Hoogland-Ivanow
oogland-Ivanow
ogland-Ivanow
gland-Ivanow
land-Ivanow
and-Ivanow
nd-Ivanow
d-Ivanow
-Ivanow
Ivanow
vanow
anow
now
ow
w
```

Martina Hoogland-Ivanow successfully
combines personal and fashion work
into one career. Swedish by birth,
Hoogland-Ivanow lived and worked in
New York before settling in London.
She sees her task, as a photographer,
to be always curious about the nature
of existence, so her work, which
encompasses portraiture, landscape
and still lives, is marked by a
sensitivity to qualities of light and
dark, texture and colour. A high-point
in her career was showing her series
of Sumo wrestlers at the Dazed
Gallery in 2000. JAM brings together
the various strands of her work.

Martina Hoogland-Ivanow
Phenomena
2001

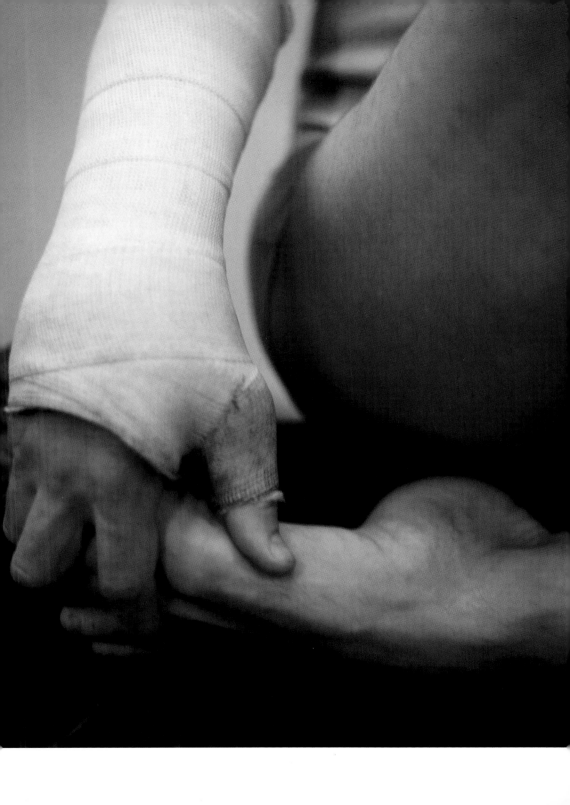

Martina Hoogland-Ivanow
Phenomena
2001

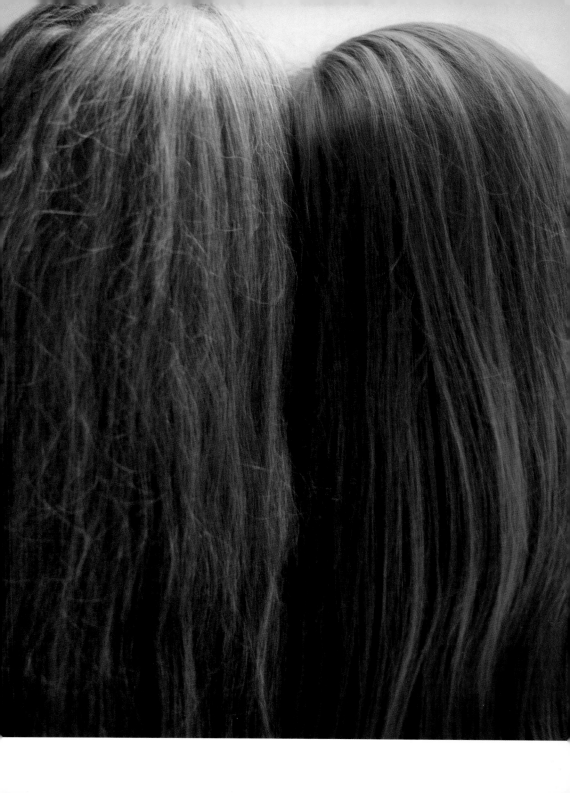

James Jarvis
Martin
Toy, Silas
1998

James Jarvis is an illustrator and cartoonist. Better known in Japan than in Britain, through collaborations with London-based clothing label Silas, for whom he creates graphics, t-shirt images and character toys, his work has appeared in *The Face*, *Nova* and his own comic, *World of Pain*. Displaying a meticulous attention to detail that, as Jarvis readily acknowledges, owes a debt to Herge, his drawings are shot through with witty, knowing playfulness, turning cartoon characters into actors in miniature urban dramas. Jarvis is intent on capturing reality through depicting personal obsessions, such as skateboarding and psychedelic rock, while also confounding it, hence the occasional appearance of a tribe of elves and a lightning bolt-wielding supreme being.

James Jarvis
Evil Martin and Bubba
Toys, Silas
1999
Tattoo-me Keith
Toy, Silas
2000

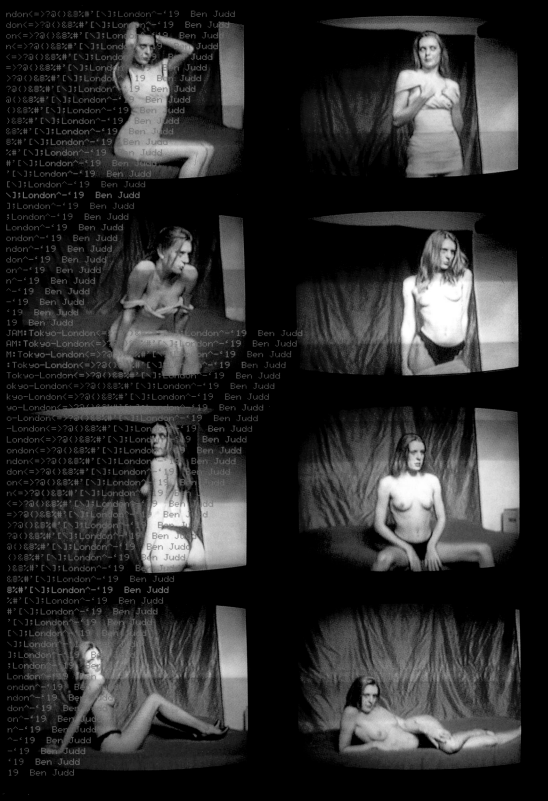

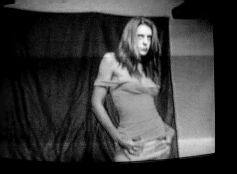
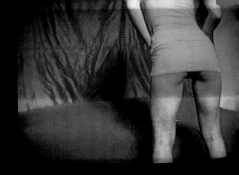
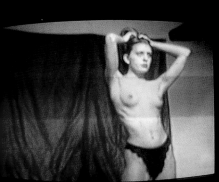

In his video and photographic work
Ben Judd explores what it means
"to look". Judd has created a series
of works made in glamour photographic
studios, where sessions are set up
to enable amateur photographers to
photograph and film semi-naked women.
His anonymous participation in the
group act of looking, and recording
what he sees, lends the work a
performance aspect that blurs the
boundaries of control and the
definition of documentation. By way
of various formal interventions,
Judd's photographs do not permit
the viewer straightforward enjoyment
of the glamour-images, while his
video work blurs the distinctions
between intimacy and the impersonal.
Judd's work has been featured in a
number of group and solo shows in the
UK and Europe.

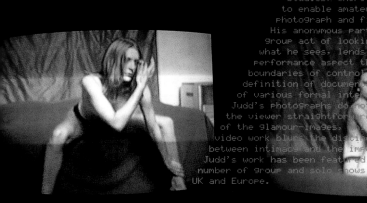
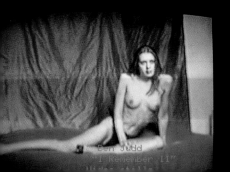
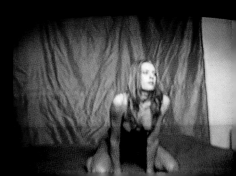

Ben Judd
"I Remember II"

Kyupi Kyupi
Buttocktica, 1999
Video still: "Kyupi Kyupi
one million super deluxe"
2000

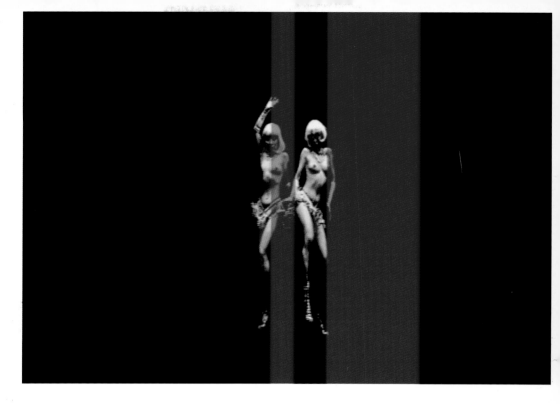

Kyupi Kyupi are a performance group
formed in 1996. The four members
are film maker Ishibashi Yoshimasa,
sculptor Kimura Mazuka, singer and
sculptor Wakeshima Mami, and graphic
designer and painter Koichi Emura.
Kyupi Kyupi is based in Kyoto but is
active nationally via various media
including film, music, live performance
and print. The group's activities
combine contemporary elements — urban
popular culture, manga, pornography
and cartoon characters — with the more
traditional performance practices of
cabaret and theatre. Kyupi Kyupi is
attracting international attention for
its form of expression that symbolises
both entertainment and the hybrid
qualities that are unique to Japan.

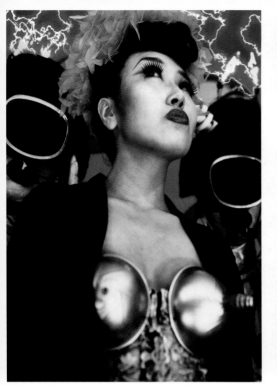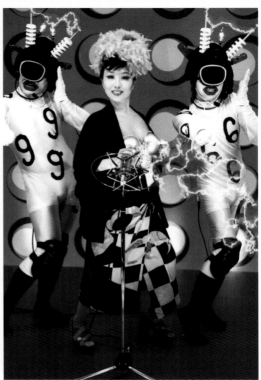

Kyupi Kyupi
Mami Wakeshima and Kayo
dancers, Kayo show, 1998
Video stills: "Kyupi Kyupi
one million super deluxe"
2000
Orga nurse,
Doctor Yakamoto, 1999
Video still: "Kyupi Kyupi
one million super deluxe"
2000

```
ndon<=>?@()&8%#'[\];London^-'21   Chris Morris        Chris Morris
don<=>?@()&8%#'[\];London^-'21   Chris Morris       Blue Jam
on<=>?@()&8%#'[\];London^-'21   Chris Morris     Original images: Jason Joyce
n<=>?@()&8%#'[\];London^-'21   Chris Morris     Digital imaging: Tim Lomas
<=>?@()&8%#'[\];London^-'21   Chris Morris     Courtesy: Warp Records
=>?@()&8%#'[\];London^-'21   Chris Morris      2000
>?@()&8%#'[\];London^-'21   Chris Morris
?@()&8%#'[\];London^-'21   Chris Morris
@()&8%#'[\];London^-'21   Chris Morris
()&8%#'[\];London^-'21   Chris Morris
)&8%#'[\];London^-'21   Chris Morris
&8%#'[\];London^-'21   Chris Morris
8%#'[\];London^-'21   Chris Morris
%#'[\];London^-'21   Chris Morris
#'[\];London^-'21   Chris Morris
'[\];London^-'21   Chris Morris
[\];London^-'21   Chris Morris
\];London^-'21   Chris Morris
];London^-'21   Chris Morris
;London^-'21   Chris Morris
London^-'21   Chris Morris
ondon^-'21   Chris Morris
ndon^-'21   Chris Morris
don^-'21   Chris Morris
on^-'21   Chris Morris
n^-'21   Chris Morris
^-'21   Chris Morris
-'21   Chris Morris
'21   Chris Morris
21   Chris Morris
1   Chris Morris
   Chris Morris
  Chris Morris
Chris Morris
hris Morris
ris Morris
is Morris
s Morris
 Morris
Morris
orris
rris
ris
is
s
```

Chris Morris has made it his mission
to stretch and warp the boundaries
of TV, not soley for the purposes
of satire, although that's what
his programmes are, but primarily in
pursuit of art. With shows such
as "The Day Today", "Brass Eye" and
"Blue Jam", Morris has provided a
relentlessly savage critique of TV
itself. But in doing so, he's also shown
how a popular medium can successfully
explore Dada and Situationist principles.
Morris' programmes disturb and provoke,
but they also offer viewers entry into
a vertiginous space predicated according
to the irrational logic of dreams.
This is TV through the looking glass.

Chris Morris
Blue Jam
Original images: Jason Joyce
Digital imaging: Tim Lomas
Courtesy: Warp Records
2000

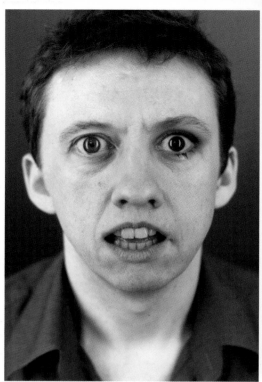

```
001/2002,"*+JAM:Tokyo-London<=>?@(){}&$%#'[\];Tokyo^-'22  Yurie Nagashima
01/2002,"*+JAM:Tokyo-London<=>?@(){}&$%#'[\];Tokyo^-'22  Yurie Nagashima
1/2002,"*+JAM:Tokyo-London<=>?@(){}&$%#'[\];Tokyo^-'22  Yurie Nagashima
/2002,"*+JAM:Tokyo-London<=>?@(){}&$%#'[\];Tokyo^-'22  Yurie Nagashima
2002,"*+JAM:Tokyo-London<=>?@(){}&$%#'[\];Tokyo^-'22  Yurie Nagashima
002,"*+JAM:Tokyo-London<=>?@(){}&$%#'[\];Tokyo^-'22  Yurie Nagashima
02,"*+JAM:Tokyo-London<=>?@(){}&$%#'[\];Tokyo^-'22  Yurie Nagashima
2,"*+JAM:Tokyo-London<=>?@(){}&$%#'[\];Tokyo^-'22  Yurie Nagashima
,"*+JAM:Tokyo-London<=>?@(){}&$%#'[\];Tokyo^-'22  Yurie Nagashima
"*+JAM:Tokyo-London<=>?@(){}&$%#'[\];Tokyo^-'22  Yurie Nagashima
*+JAM:Tokyo-London<=>?@(){}&$%#'[\];Tokyo^-'22  Yurie Nagashima
+JAM:Tokyo-London<=>?@(){}&$%#'[\];Tokyo^-'22  Yurie Nagashima
JAM:Tokyo-London<=>?@(){}&$%#'[\];Tokyo^-'22  Yurie Nagashima
AM:Tokyo-London<=>?@(){}&$%#'[\];Tokyo^-'22  Yurie Nagashima
M:Tokyo-London<=>?@(){}&$%#'[\];Tokyo^-'22  Yurie Nagashima
:Tokyo-London<=>?@(){}&$%#'[\];Tokyo^-'22  Yurie Nagashima
Tokyo-London<=>?@(){}&$%#'[\];Tokyo^-'22  Yurie Nagashima
okyo-London<=>?@(){}&$%#'[\];Tokyo^-'22  Yurie Nagashima
kyo-London<=>?@(){}&$%#'[\];Tokyo^-'22  Yurie Nagashima
yo-London<=>?@(){}&$%#'[\];Tokyo^-'22  Yurie Nagashima
o-London<=>?@(){}&$%#'[\];Tokyo^-'22  Yurie Nagashima
-London<=>?@(){}&$%#'[\];Tokyo^-'22  Yurie Nagashima
London<=>?@(){}&$%#'[\];Tokyo^-'22  Yurie Nagashima
ondon<=>?@(){}&$%#'[\];Tokyo^-'22  Yurie Nagashima
ndon<=>?@(){}&$%#'[\];Tokyo^-'22  Yurie Nagashima
don<=>?@(){}&$%#'[\];Tokyo^-'22  Yurie Nagashima
on<=>?@(){}&$%#'[\];Tokyo^-'22  Yurie Nagashima
n<=>?@(){}&$%#'[\];Tokyo^-'22  Yurie Nagashima
<=>?@(){}&$%#'[\];Tokyo^-'22  Yurie Nagashima
=>?@(){}&$%#'[\];Tokyo^-'22  Yurie Nagashima
>?@(){}&$%#'[\];Tokyo^-'22  Yurie Nagashima
?@(){}&$%#'[\];Tokyo^-'22  Yurie Nagashima
@(){}&$%#'[\];Tokyo^-'22  Yurie Nagashima
(){}&$%#'[\];Tokyo^-'22  Yurie Nagashima
Tokyo^-'22  Yurie Nagashima
okyo^-'22  Yurie Nagashima
kyo^-'22  Yurie Nagashima
yo^-'22  Yurie Nagashima
o^-'22  Yurie Nagashima
^-'22  Yurie Nagashima
-'22  Yurie Nagashima
'22  Yurie Nagashima
22  Yurie Nagashima
2  Yurie Nagashima
  Yurie Nagashima
 Yurie Nagashima
Yurie Nagashima
urie Nagashima
rie Nagashima
ie Nagashima
e Nagashima
 Nagashima
Nagashima
agashima
gashima
ashima
shima
hima
ima
ma
a
```

Yurie Nagashima made a sensational debut at the age of 20 with a series of nude photographs of her family. After living in the USA for three years she returned to Japan in 1999. Since her early work, in which she was critically acclaimed as a "girl photographer", Nagashima has matured beyond the stereotype. Although Nagashima continues to document her immediate environment, her vision has expanded to embrace the vast landscapes of the USA, skateboard culture and urban scenes. Nagashima was a recipient of the Kimura Ihei Photography Award in 2001.

Yurie Nagashima
Self-portrait with brother #2
1993

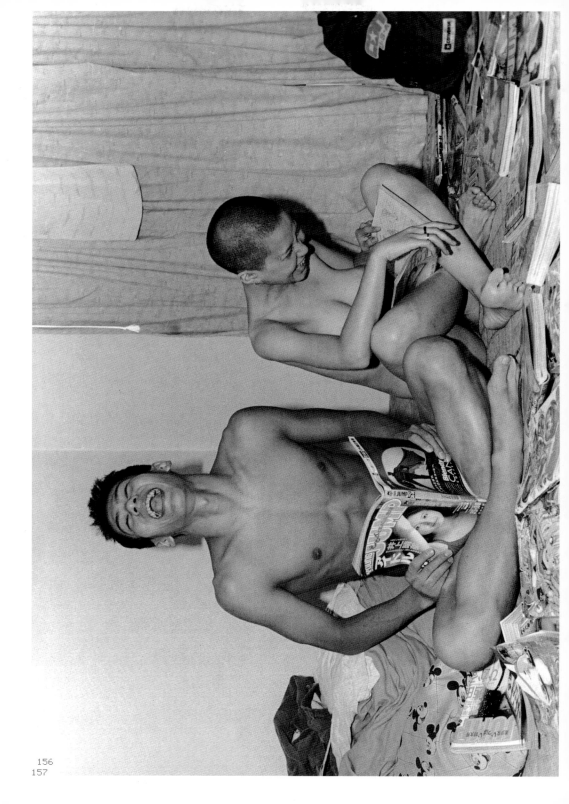

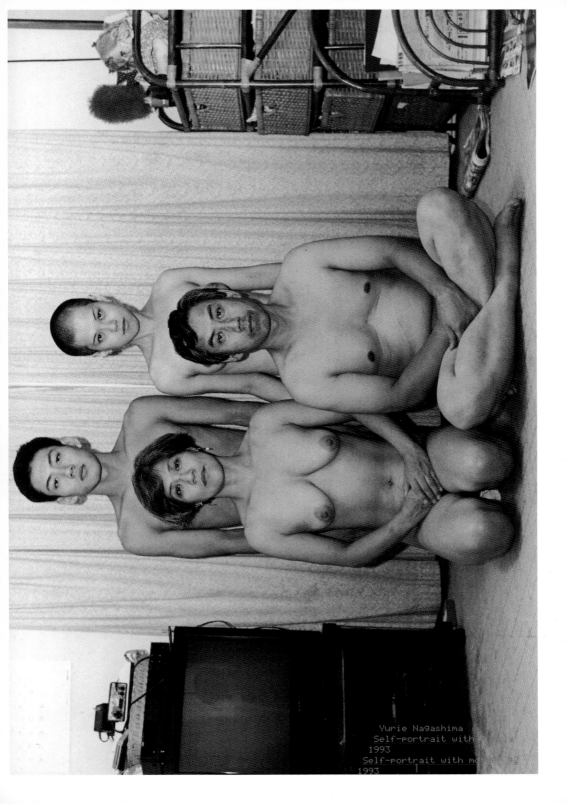

Yurie Nagashima
Self-portrait with
1993
Self-portrait with m?
1993

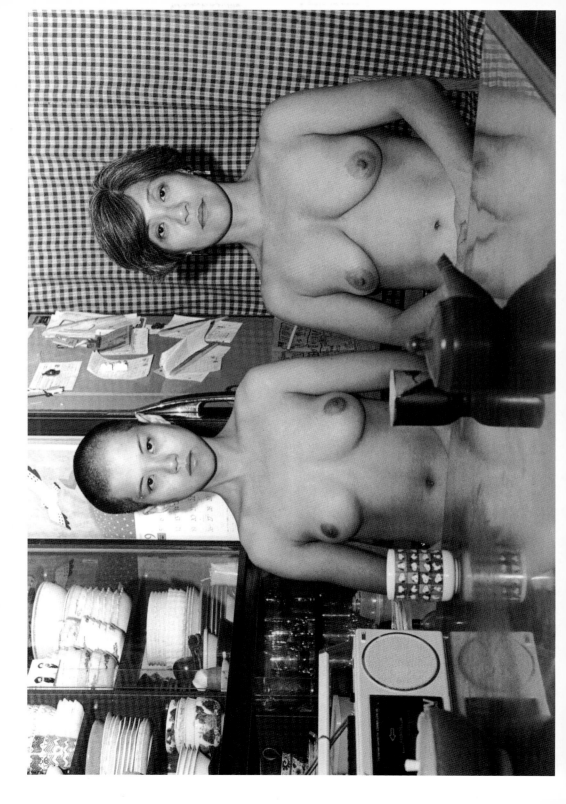

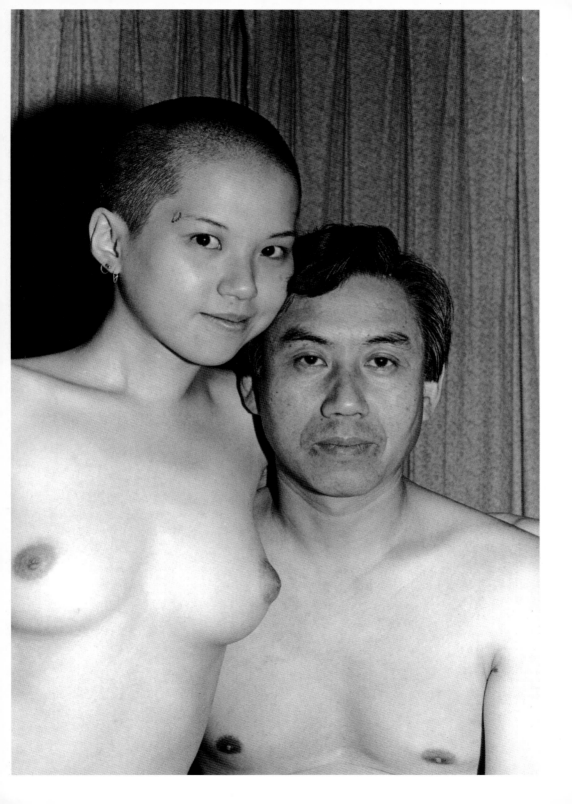

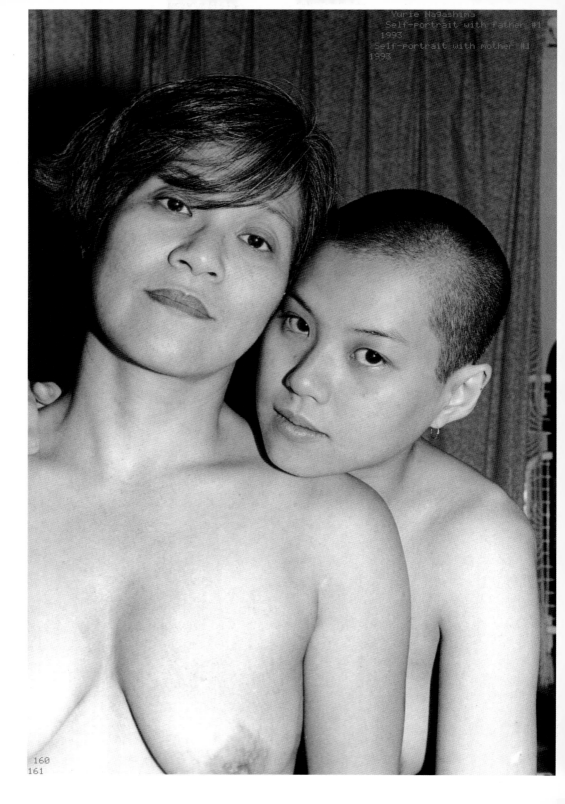

Yurie Nagashima
Self-portrait with father #1
1993
Self-portrait with mother #1
1993

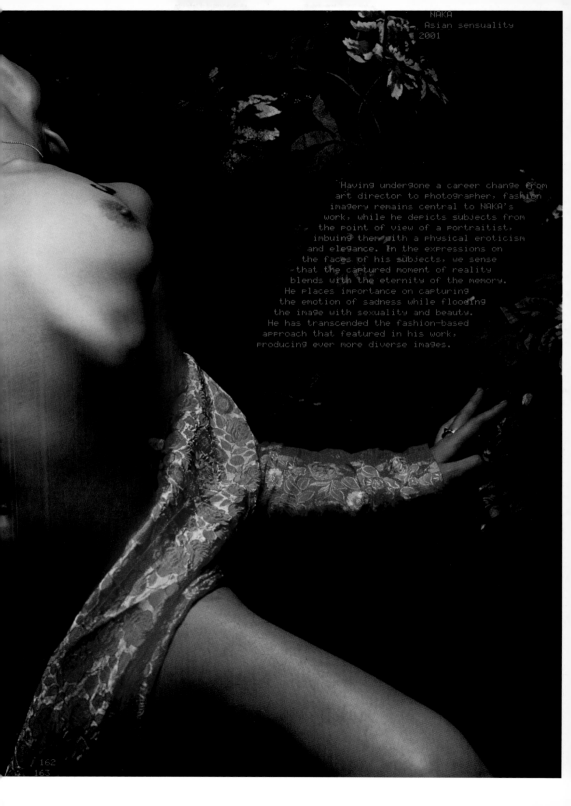

Having undergone a career change from
art director to photographer, fashion
imagery remains central to NAKA's
work, while he depicts subjects from
the point of view of a portraitist,
imbuing them with a physical eroticism
and elegance. In the expressions on
the faces of his subjects, we sense
that the captured moment of reality
blends with the eternity of the memory.
He places importance on capturing
the emotion of sadness while flooding
the image with sexuality and beauty.
He has transcended the fashion-based
approach that featured in his work,
producing ever more diverse images.

NAKA
Shéna Ringo
2000

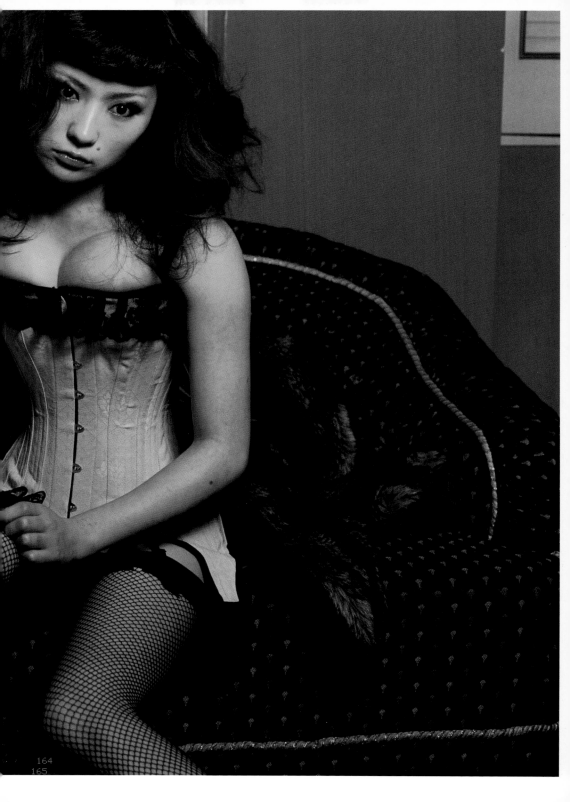

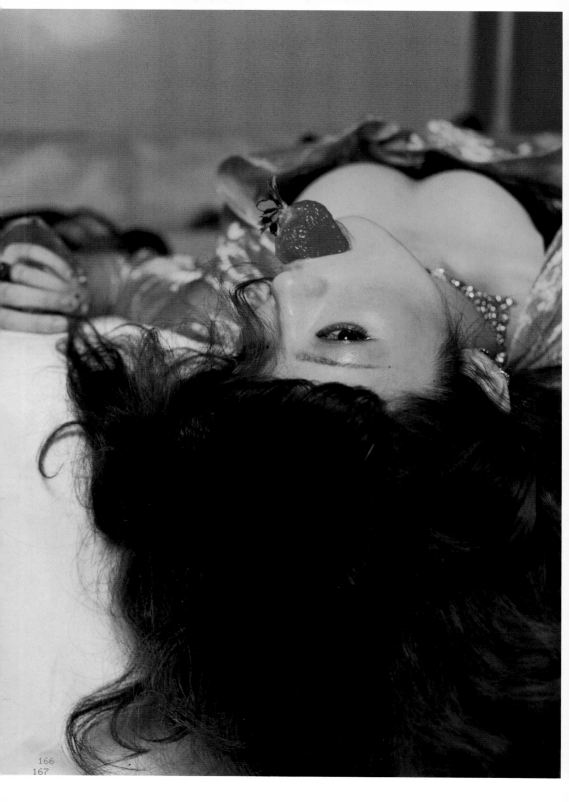

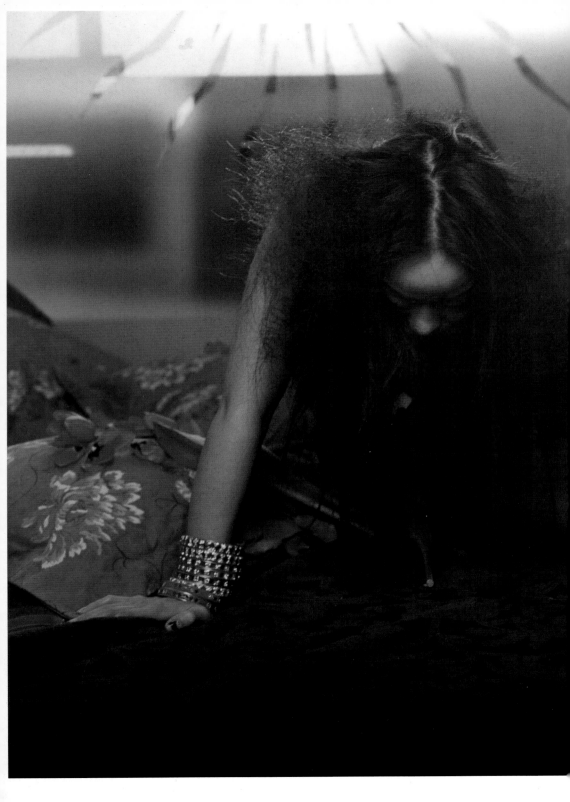

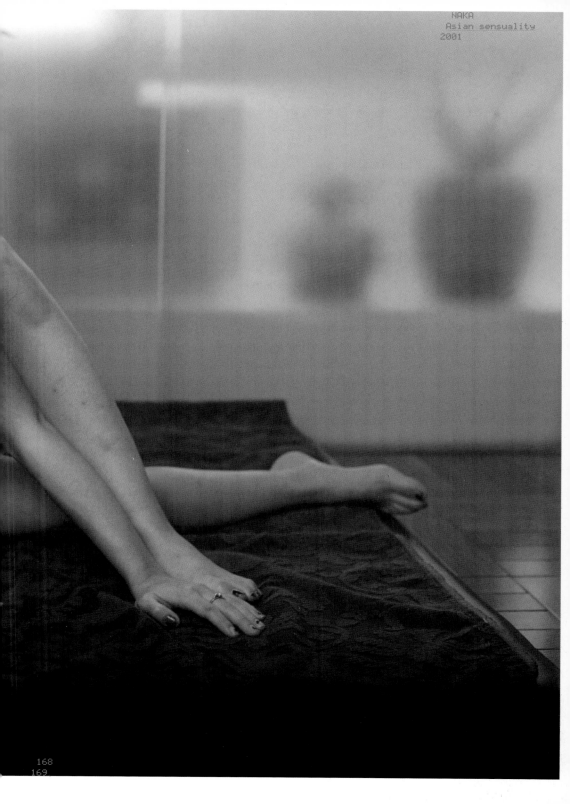

```
>?@()&8%#'[\];Tokyo^-'24  Yoshitomo Nara          Tokyo^-'24  Yoshitomo Nara
?@()&8%#'[\];Tokyo^-'24  Yoshitomo Nara           Tokyo^-'24  Yoshitomo Nara
@()&8%#'[\];Tokyo^-'24  Yoshitomo Nara           Tokyo^-'24  Yoshitomo Nara
()&8%#'[\];Tokyo^-'24  Yoshitomo Nara            Tokyo^-'24  Yoshitomo Nara
)&8%#'[\];Tokyo^-'24  Yoshitomo Nara             Tokyo^-'24  Yoshitomo Nara
&8%#'[\];Tokyo^-'24  Yoshitomo Nara             Tokyo^-'24  Yoshitomo Nara
8%#'[\];Tokyo^-'24  Yoshitomo Nara              Tokyo^-'24  Yoshitomo Nara
%#'[\];Tokyo^-'24  Yoshitomo Nara               Tokyo^-'24  Yoshitomo Nara
#'[\];Tokyo^-'24  Yoshitomo Nara                Tokyo^-'24  Yoshitomo Nara
'[\];Tokyo^-'24  Yoshitomo Nara                 Tokyo^-'24  Yoshitomo Nara
[\];Tokyo^-'24  Yoshitomo Nara                  Tokyo^-'24  Yoshitomo Nara
\];Tokyo^-'24  Yoshitomo Nara                  Tokyo^-'24  Yoshitomo Nara
];Tokyo^-'24  Yoshitomo Nara                   Tokyo^-'24  Yoshitomo Nara
;Tokyo^-'24  Yoshitomo Nara                    Tokyo^-'24  Yoshitomo Nara
Tokyo^-'24  Yoshitomo Nara                    Tokyo^-'24  Yoshitomo Nara
okyo^-'24  Yoshitomo Nara                    Tokyo^-'24  Yoshitomo Nara
kyo^-'24  Yoshitomo Nara                     Tokyo^-'24  Yoshitomo Nara
yo^-'24  Yoshitomo Nara                     Tokyo^-'24  Yoshitomo Nara
o^-'24  Yoshitomo Nara                      Tokyo^-'24  Yoshitomo Nara
^-'24  Yoshitomo Nara                       Tokyo^-'24  Yoshitomo Nara
-'24  Yoshitomo Nara                        Tokyo^-'24  Yoshitomo Nara
'24  Yoshitomo Nara                         Tokyo^-'24  Yoshitomo Nara
24  Yoshitomo Nara                         Tokyo^-'24  Yoshitomo Nara
4  Yoshitomo Nara                          Tokyo^-'24  Yoshitomo Nara
  Yoshitomo Nara                          Tokyo^-'24  Yoshitomo Nara
 Yoshitomo Nara                           Tokyo^-'24  Yoshitomo Nara
Yoshitomo Nara                           Tokyo^-'24  Yoshitomo Nara
oshitomo Nara                            Tokyo^-'24  Yoshitomo Nara
shitomo Nara                            Tokyo^-'24  Yoshitomo Nara
hitomo Nara                             Tokyo^-'24  Yoshitomo Nara
itomo Nara                              Tokyo^-'24  Yoshitomo Nara
tomo Nara                               Tokyo^-'24  Yoshitomo Nara
omo Nara                                Tokyo^-'24  Yoshitomo Nara
mo Nara                                 Tokyo^-'24  Yoshitomo Nara
o Nara                                  Tokyo^-'24  Yoshitomo Nara
 Nara                                   Tokyo^-'24  Yoshitomo Nara
Nara                                    Tokyo^-'24  Yoshitomo Nara
ara                                     Tokyo^-'24  Yoshitomo Nara
ra                                      Tokyo^-'24  Yoshitomo Nara
a                                       Tokyo^-'24  Yoshitomo Nara
                                         Tokyo^-'24  Yoshitomo Nara
                                        Tokyo^-'24  Yoshitomo Nara
                                       Tokyo^-'24  Yoshitomo Nara
                                      Tokyo^-'24  Yoshitomo Nara
                                     Tokyo^-'24  Yoshitomo Nara
                                    Tokyo^-'24  Yoshitomo Nara
okyo^-'24  Yoshitomo Nara
kyo^-'24  Yoshitomo Nara
yo^-'24  Yoshitomo Nara
o^-'24  Yoshitomo Nara
^-'24  Yoshitomo Nara
-'24  Yoshitomo Nara
'24  Yoshitomo Nara
24  Yoshitomo Nara
4  Yoshitomo Nara
  Yoshitomo Nara
 Yoshitomo Nara
Yoshitomo Nara
oshitomo Nara
shitomo Nara
hitomo Nara
itomo Nara
tomo Nara
omo Nara
mo Nara
o Nara
 Nara
Nara
ara
ra
a
```

Yoshitomo Nara is one of the most internationally acclaimed Japanese artists. The young girls with large heads that symbolise his work depict an innocence and immorality that coexist in today's youth, and this aspect, together with the cartoon character cuteness, which informs much of Japan's contemporary art, has resulted in this artist's solid popularity. However, Nara, the fashionable phenomenon, has not been totally subsumed by consumer culture. Instead, through his collaboration with Banana Yoshimoto in literary forms of expression, and in designing CD covers, Nara is achieving the status of an artist who embodies his zeitgeist. Recently, Nara left Cologne, where he lived for many years, to return to Japan, but continues to be actively involved in overseas projects.

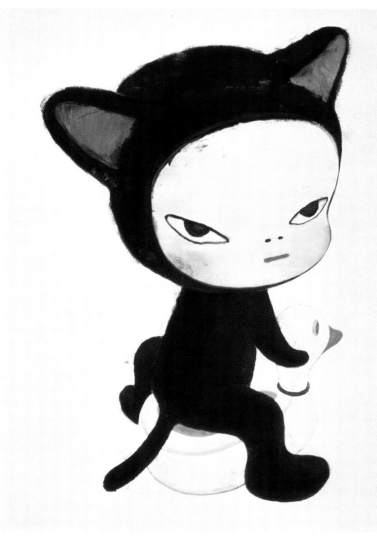

Yoshitomo Nara
Harmless kitty
Photograph: Alister Overbruck
Courtesy: Tomio Koyama Gallery
1994

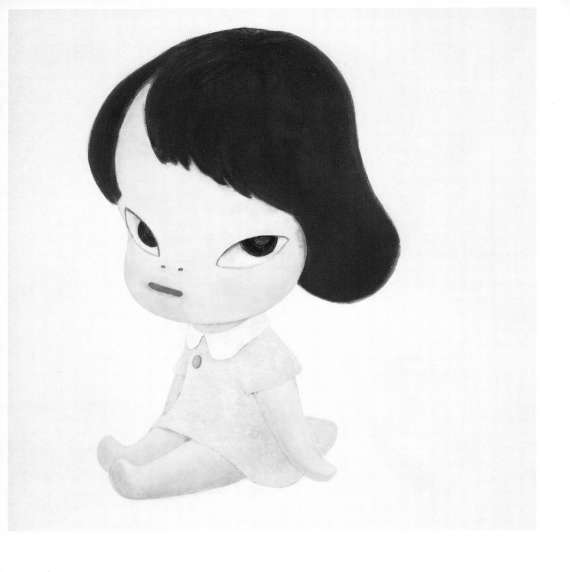

Yoshitomo Nara
Hothouse doll
Photograph: Hiromu Narita
Courtesy: Private collection
1995
Little Ramona
"Dengeki Bop/A tribute to
The Ramones"
Drawing for CD cover
2001

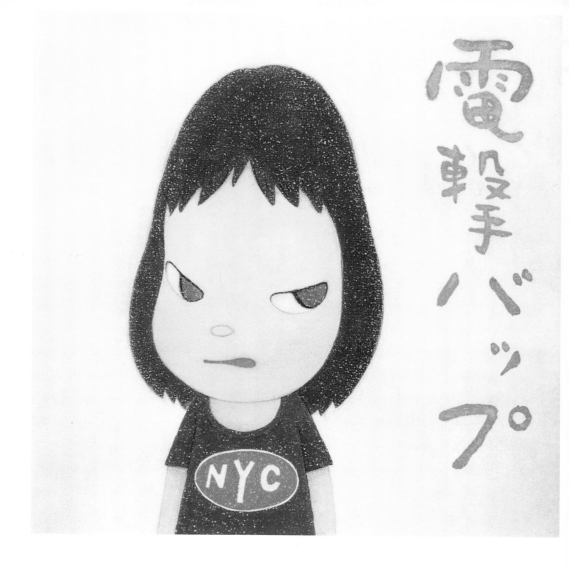

電撃手バップ

```
)&8%#'[\];Tokyo^-'24  Yoshitomo Nara/Banana Yoshimoto
&8%#'[\];Tokyo^-'24  Yoshitomo Nara/Banana Yoshimoto
8%#'[\];Tokyo^-'24  Yoshitomo Nara/Banana Yoshimoto
%#'[\];Tokyo^-'24  Yoshitomo Nara/Banana Yoshimoto
#'[\];Tokyo^-'24  Yoshitomo Nara/Banana Yoshimoto
'[\];Tokyo^-'24  Yoshitomo Nara/Banana Yoshimoto
[\];Tokyo^-'24  Yoshitomo Nara/Banana Yoshimoto
\];Tokyo^-'24  Yoshitomo Nara/Banana Yoshimoto
];Tokyo^-'24  Yoshitomo Nara/Banana Yoshimoto
;Tokyo^-'24  Yoshitomo Nara/Banana Yoshimoto
Tokyo^-'24  Yoshitomo Nara/Banana Yoshimoto
okyo^-'24  Yoshitomo Nara/Banana Yoshimoto
kyo^-'24  Yoshitomo Nara/Banana Yoshimoto
yo^-'24  Yoshitomo Nara/Banana Yoshimoto
o^-'24  Yoshitomo Nara/Banana Yoshimoto
^-'24  Yoshitomo Nara/Banana Yoshimoto
-'24  Yoshitomo Nara/Banana Yoshimoto
'24  Yoshitomo Nara/Banana Yoshimoto
24  Yoshitomo Nara/Banana Yoshimoto
4  Yoshitomo Nara/Banana Yoshimoto
  Yoshitomo Nara/Banana Yoshimoto
 Yoshitomo Nara/Banana Yoshimoto
Yoshitomo Nara/Banana Yoshimoto
oshitomo Nara/Banana Yoshimoto
shitomo Nara/Banana Yoshimoto
hitomo Nara/Banana Yoshimoto
itomo Nara/Banana Yoshimoto
tomo Nara/Banana Yoshimoto
omo Nara/Banana Yoshimoto
mo Nara/Banana Yoshimoto
o Nara/Banana Yoshimoto
 Nara/Banana Yoshimoto
Nara/Banana Yoshimoto
ara/Banana Yoshimoto
ra/Banana Yoshimoto
a/Banana Yoshimoto
/Banana Yoshimoto
Banana Yoshimoto
anana Yoshimoto
nana Yoshimoto
ana Yoshimoto
na Yoshimoto
a Yoshimoto
 Yoshimoto
Yoshimoto
oshimoto
shimoto
himoto
imoto
moto
oto
to
o
```

Yoshitomo Nara/Banana Yoshimoto
The Life of Daisy
Illustration: Yoshitomo Nara
Novel: Banana Yoshimoto
Design: Hideki Nakajima

CUT, No.79
Chapter 1, Dreaming of the
house on the cliff
1998

Banana Yoshimoto is the second daughter
of the philosopher Takaaki Yoshimoto.
She was an avid reader of Fujio
Fujiko's manga at an early age, feeding
an imagination that turned her into a
successful novelist. Since her debut
novel, *Kitchen*, Yoshimoto has continued
to write best-sellers, achieving the
status of an author who represents
contemporary Japan along with the manga
artists, musicians and designers of
her generation. Many of her novels deal
with everyday life in Tokyo, but it is
the universal sensibilities that inform
Yoshimoto's work that have led to her
popularity in Europe, particularly
Italy. Her work has been translated and
published in over 30 countries.

連載小説 第4回
「ひな菊の人生」
第3章 居候生活
文・吉本ばなな
画・奈良美智

Yoshitomo Nara/Banana Yoshimoto
CUT, No.82
Chapter 3, My life as a hanger-on
1999
CUT, No.87
Chapter 4, Rebirth
1999

連載小説 第8回
「ひな菊の人生」
第4章 再生
文・吉本ばなな
画・奈良美智

Yoshitomo Nara/Banana Yoshimoto
CUT, No.90
Chapter 6, Rain
1999

「ひな菊の人生」

第6章　雨

文・吉本ばなな
画・奈良美智

Yoshitomo Nara/Banana Yoshimoto
 CUT, No.91
 Chapter 6, Rain
 1999
CUT, No.92
Chapter 6, Rain
1999

連続小説 第12回

「ひな菊の人生」

第6章　雨

文・吉本ばなな

画・奈良美智

代の姉さんって別のに帰った後にもここを去ると思ふも、階段の段数を数えてくるからくる

の内部を持っていたのだが、これからはこの調を探すのだまる、と思った。

何か確かめていないかと身悲して認識に入ったが、特に変わったことはなかった。電波をつける、闇しいものの認知になった。

高さや細子に関係があれば、したら認識がしていたのか聞けそんな、高の内部にあるよくより作・の名サイツ

でもた内にに確し、かの記憶をじた間以かり、そういうものがあったその1といっていたの。

あーん、と私は見し、クマアの写真のばさんばさった生を知くに振った。

認知の中にほしいものの一つ現れ、胸に痛みや気びも押えた。

確のにとしても生を残る、この間のテベでを痛かは認に活いた。

私はあっまった。わからなくなんてではない、その例のだ。低調にならば世界がこのように一人にていたのだけ、常しものがらそこではない低。

だから、特別ではない。それに見されていないが何も訳なくないたのだ。ナラアになるとか3間が少し、くらい代にれてくれるよりから

でもなかった。それにしていたてもなからかった記憶を断つかもいたのだけ、ナラのにはならなかった、それを取に、みんなそのさ子がり作っ

たくさんいないけだ、うと少してもなからかった私たるがの見判財能を断つがけけ、クマラのばたか数かいだけだ、まえなどものらしがれ

けをあていた、何をよせるば、変とをそに。代多身やれえ、そのなもにそれもよくのばだ、まろほどに認いへ。

なかったとしても、変調をだしたりた聞くては、私のことをるんとに認えにし、サい人にくいあとへにしていたのにこち

とれてしたらり名知温高のばなんに願いし私の心々か、間の断やのりいく一端を頼がしたった、前の数かていきたるりが、月

さいくてなかのふつしふ新に、かたっしいとしはいて、雨の話もて入びうものに、間になかまのとのように見えるものにものこしっ

代、雨が軽の小さみなしくまれてきた、わの見るものとりに、私はよの認に見つめるのように見え数かていたばなんにだのなには、月

降のたれていた。

G

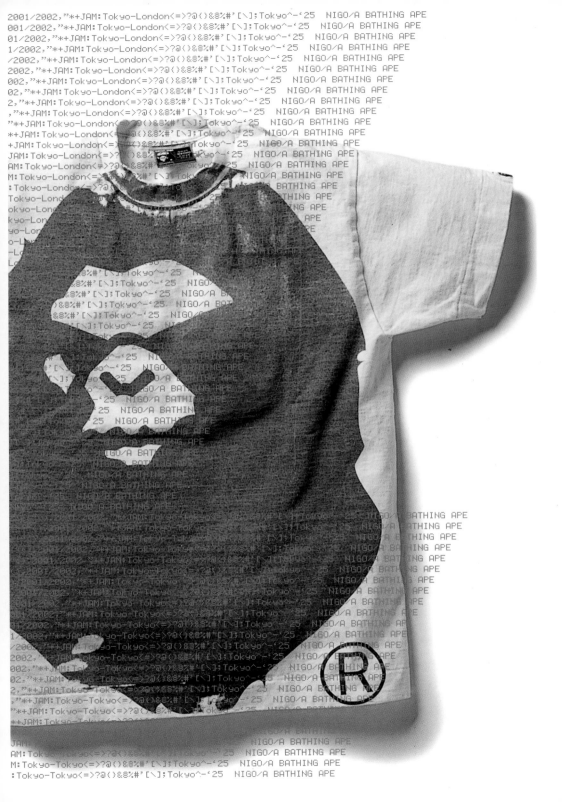

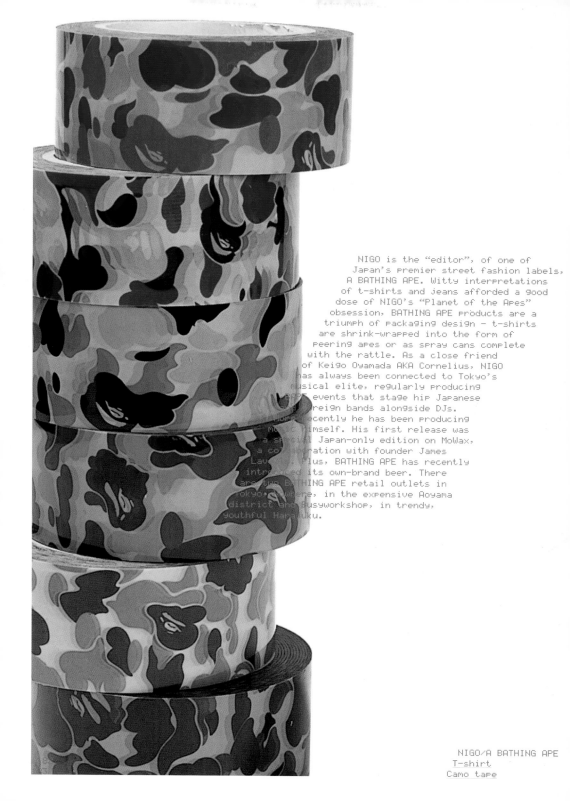

NIGO is the "editor", of one of
Japan's premier street fashion labels,
A BATHING APE. Witty interpretations
of t-shirts and jeans afforded a good
dose of NIGO's "Planet of the Apes"
obsession, BATHING APE products are a
triumph of packaging design – t-shirts
are shrink-wrapped into the form of
peering apes or as spray cans complete
with the rattle. As a close friend
of Keigo Oyamada AKA Cornelius, NIGO
has always been connected to Tokyo's
musical elite, regularly producing
BAPE events that stage hip Japanese
and foreign bands alongside DJs.
More recently he has been producing
music himself. His first release was
a special Japan-only edition on MoWax,
a collaboration with founder James
Lavelle. Plus, BATHING APE has recently
introduced its own-brand beer. There
are two BATHING APE retail outlets in
Tokyo, anywhere, in the expensive Aoyama
district and Busyworkshop, in trendy,
youthful Harajuku.

NIGO/A BATHING APE
T-shirt
Camo tape

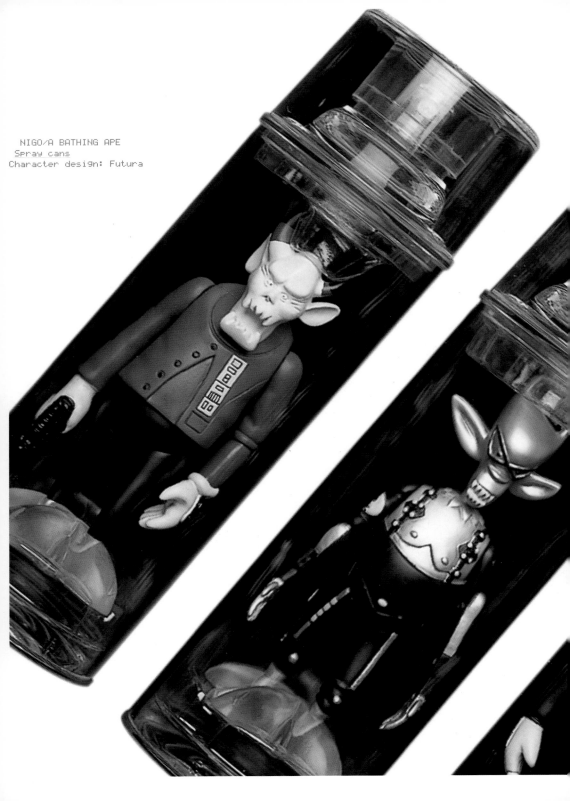

NIGO/A BATHING APE
Spray cans
Character design: Futura

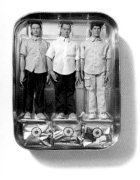

NIGO/A BATHING APE
T-shirts
NIGO/Ape sounds CD
Artwork design: Futura
Action figures
Beastie Boys figures
BAPE beer
Camo shoes
Action toys
Camo jacket
T-shirts
Camo sofa

Jessica Ogden is one of the most
individual clothing designers of her
generation. She cites her success
as partially resulting from her lack
of formal training and the freedom
that gave her to explore techniques
emphasising the hand-made. Ogden is
known for her use of found textiles
with which she creates uncompromisingly
modern forms that are modest and
yet powerful. For a recent British
Fashion Week presentation, six
actresses changed clothes on stage
accompanied by a soundtrack on which
Ogden's friends and family talked
about their favourite pieces of
clothing. JAM includes a selection
from Ogden's archive, personally
chosen to demonstrate her development
as a designer.

Jessica Ogden
Denim and fine hessian
wrap skirt
Autumn/winter
2000

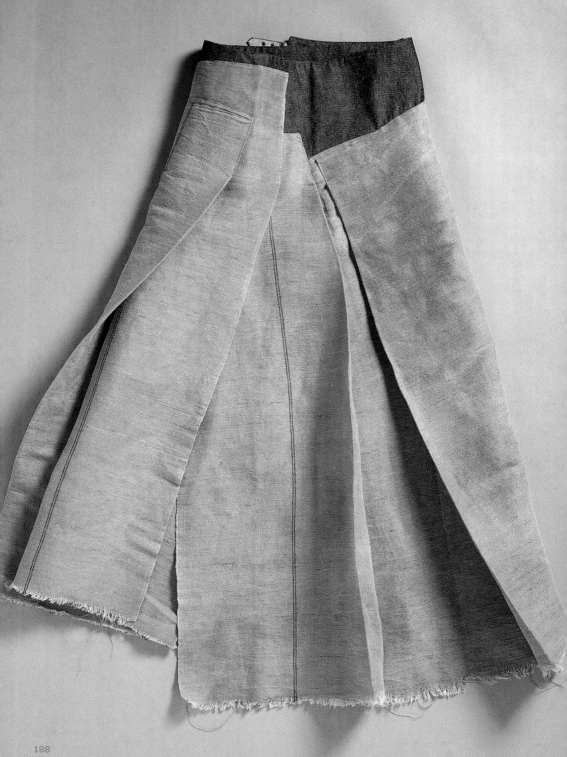

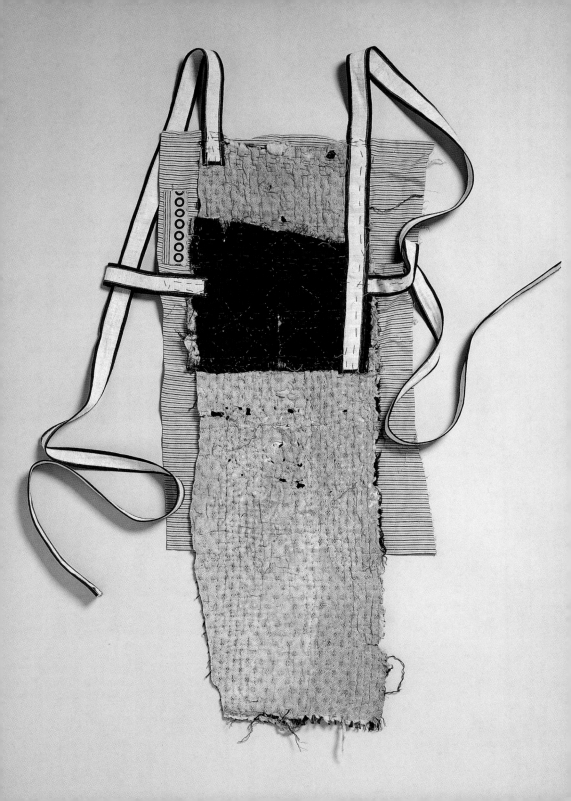

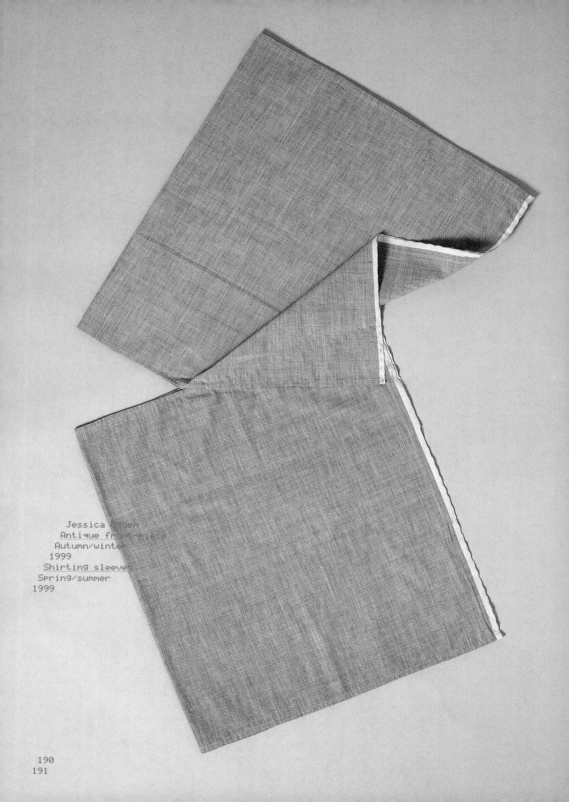

Jessica Ogden
Antique front-piece
Autumn/winter
1999
Shirting sleeves
Spring/summer
1999

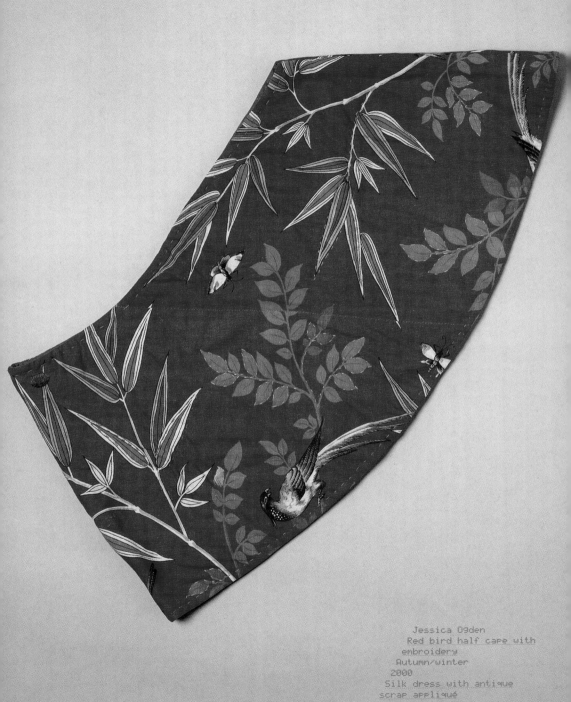

Jessica Ogden
Red bird half cape with
embroidery
Autumn/winter
2000
Silk dress with antique
scrap appliqué
Spring/summer
2000

```
London^-'27  Graham Rounthwaite
ondon^-'27   Graham Rounthwaite
ndon^-'27   Graham Rounthwaite
don^-'27   Graham Rounthwaite
on^-'27   Graham Rounthwaite
n^-'27   Graham Rounthwaite
^-'27   Graham Rounthwaite
-'27   Graham Rounthwaite
'27   Graham Rounthwaite
27   Graham Rounthwaite
7  Graham Rounthwaite
  Graham Rounthwaite
 Graham Rounthwaite
Graham Rounthwaite
raham Rounthwaite
aham Rounthwaite
ham Rounthwaite
am Rounthwaite
m Rounthwaite
 Rounthwaite
Rounthwaite
27  Graham Rounthwaite
7  Graham Rounthwaite
  Graham Rounthwaite
 Graham Rounthwaite
Graham Rounthwaite
raham Rounthwaite
aham Rounthwaite
ham Rounthwaite
am Rounthwaite
m Rounthwaite
 Rounthwaite
Rounthwaite
ounthwaite
unthwaite
nthwaite
thwaite
hwaite
waite
aite
ite
te
e
```

Designer and illustrator Graham Rounthwaite grew up in the suburbs of Birmingham, yet his work illustrates his fascination with London and more specifically with the people of London. His pictures are a hyper-realised representation of the acutely image-conscious club-goers and fashion followers of Hoxton, East London, where Rounthwaite has lived for several years. Detailing their clothes and attitude, his work is a stylised homage to urban cool and a carefully rendered documentation of contemporary style, a visual history of London dressed up and going out after dark. Now, as art editor of *The Face*, and with his images appearing in fashion advertising and on club flyers, Rounthwaite has become an important contributor to the scene.

 Graham Rounthwaite
 Flyer artwork, Off-centre
2000

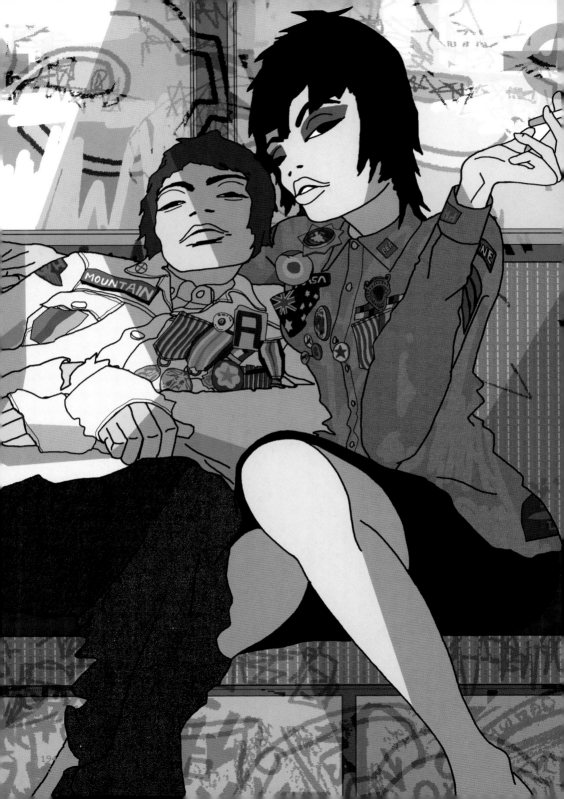

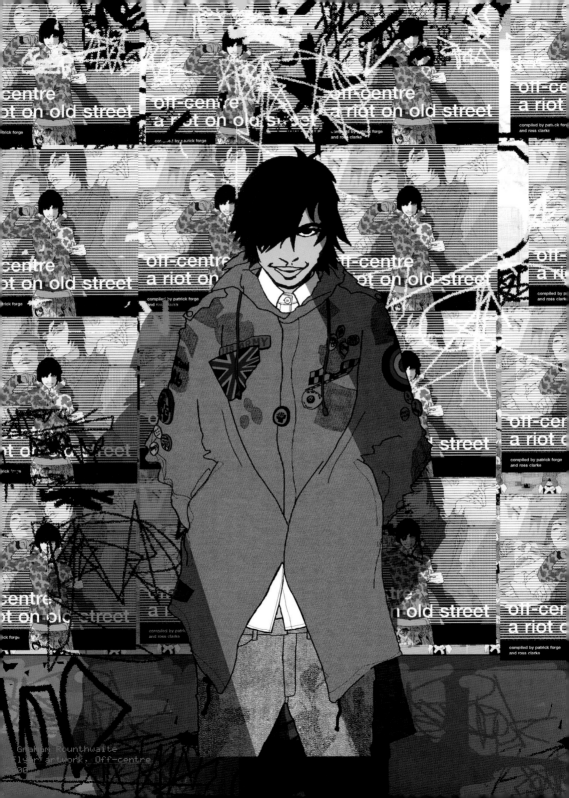

Graham Rounthwaite
Flyer artwork, Off-centre
2000

```
2002,"*+JAM:Tokyo-London<=>?@()&8%#'[\];Tokyo^-'28  Masafumi Sanai      Masafumi Sanai
002,"*+JAM:Tokyo-London<=>?@()&8%#'[\];Tokyo^-'28  Masafumi Sanai       33
02,"*+JAM:Tokyo-London<=>?@()&8%#'[\];Tokyo^-'28  Masafumi Sanai       2001
2,"*+JAM:Tokyo-London<=>?@()&8%#'[\];Tokyo^-'28  Masafumi Sanai
,"*+JAM:Tokyo-London<=>?@()&8%#'[\];Tokyo^-'28  Masafumi Sanai
"*+JAM:Tokyo-London<=>?@()&8%#'[\];Tokyo^-'28  Masafumi Sanai
*+JAM:Tokyo-London<=>?@()&8%#'[\];Tokyo^-'28  Masafumi Sanai
+JAM:Tokyo-London<=>?@()&8%#'[\];Tokyo^-'28  Masafumi Sanai
02,"*+JAM:Tokyo-London<=>?@()&8%#'[\];Tokyo^-'28  Masafumi Sanai
2,"*+JAM:Tokyo-London<=>?@()&8%#'[\];Tokyo^-'28  Masafumi Sanai
,"*+JAM:Tokyo-London<=>?@()&8%#'[\];Tokyo^-'28  Masafumi Sanai
"*+JAM:Tokyo-London<=>?@()&8%#'[\];Tokyo^-'28  Masafumi Sanai
*+JAM:Tokyo-London<=>?@()&8%#'[\];Tokyo^-'28  Masafumi Sanai
+JAM:Tokyo-London<=>?@()&8%#'[\];Tokyo^-'28  Masafumi Sanai
JAM:Tokyo-London<=>?@()&8%#'[\];Tokyo^-'28  Masafumi Sanai
AM:Tokyo-London<=>?@()&8%#'[\];Tokyo^-'28  Masafumi Sanai
M:Tokyo-London<=>?@()&8%#'[\];Tokyo^-'28  Masafumi Sanai
:Tokyo-London<=>?@()&8%#'[\];Tokyo^-'28  Masafumi Sanai
Tokyo-London<=>?@()&8%#'[\];Tokyo^-'28  Masafumi Sanai
okyo-London<=>?@()&8%#'[\];Tokyo^-'28  Masafumi Sanai
kyo-London<=>?@()&8%#'[\];Tokyo^-'28  Masafumi Sanai
yo-London<=>?@()&8%#'[\];Tokyo^-'28  Masafumi Sanai
o-London<=>?@()&8%#'[\];Tokyo^-'28  Masafumi Sanai
-London<=>?@()&8%#'[\];Tokyo^-'28  Masafumi Sanai
London<=>?@()&8%#'[\];Tokyo^-'28  Masafumi Sanai
ondon<=>?@()&8%#'[\];Tokyo^-'28  Masafumi Sanai
ndon<=>?@()&8%#'[\];Tokyo^-'28  Masafumi Sanai
don<=>?@()&8%#'[\];Tokyo^-'28  Masafumi Sanai
on<=>?@()&8%#'[\];Tokyo^-'28  Masafumi Sanai
n<=>?@()&8%#'[\];Tokyo^-'28  Masafumi Sanai
<=>?@()&8%#'[\];Tokyo^-'28  Masafumi Sanai
=>?@()&8%#'[\];Tokyo^-'28  Masafumi Sanai
kyo^-'28  Masafumi Sanai
yo^-'28  Masafumi Sanai
o^-'28  Masafumi Sanai
^-'28  Masafumi Sanai
-'28  Masafumi Sanai
'28  Masafumi Sanai
28  Masafumi Sanai
8  Masafumi Sanai
   Masafumi Sanai
  Masafumi Sanai
Masafumi Sanai
asafumi Sanai
safumi Sanai
afumi Sanai
fumi Sanai
umi Sanai
mi Sanai
i Sanai
  Sanai
Sanai
anai
nai
ai
i
```

 Masafumi Sanai's body of work includes
 everyday scenes and subjects as well
 as portraits, but makes no attempt
 to capture a climactic or remarkable
 moment; instead looking at the
 seemingly ordinary scenarios that
 make up his personal life. For Sanai,
 the act of pressing the shutter is
 a confirmation of his intention.
 The highly personal relationship that
 exists between Sanai and the ordinary
 occurrences he captures is something
 that only he can understand. Sanai
 also writes prose that reflect his
 everyday life, which he then adds to
his photographs.

Masafumi, Samai
Keyaki (Zelkova tree)
2000
Co
2000

London^-'29 Norbert Schoerner
ndon^-'29 Norbert Schoerner
don^-'29 Norbert Schoerner
on^-'29 Norbert Schoerner
n^-'29 Norbert Schoerner
^-'29 Norbert Schoerner
-'29 Norbert Schoerner
'29 Norbert Schoerner
29 Norbert Schoerner
9 Norbert Schoerner
 Norbert Schoerner
 Norbert Schoerner
Norbert Schoerner
orbert Schoerner
rbert Schoerner
bert Schoerner Born in Munich and based in London,
ert Schoerner Norbert Schoerner began his career as
rt Schoerner a landscape photographer before moving
t Schoerner into fashion. Although he has worked
 Schoerner extensively with major labels, Schoerner
Schoerner insists that his approach to fashion
choerner lies in constant questioning. Indeed,
hoerner rather than aiming to represent beauty
oerner or glamour his work has an unsettling
erner quality that suggests images raised
rner from the subconscious. An image-maker
ner of extreme technical proficiency,
er Schoerner often takes photographs of
r subjects in the studio then pastes them
 onto different backgrounds via computer.
 The resultant juxtaposition is deliberately
 jarring and hypnotic, as though by
 reordering reality Schoerner produces
his own definition of beauty.

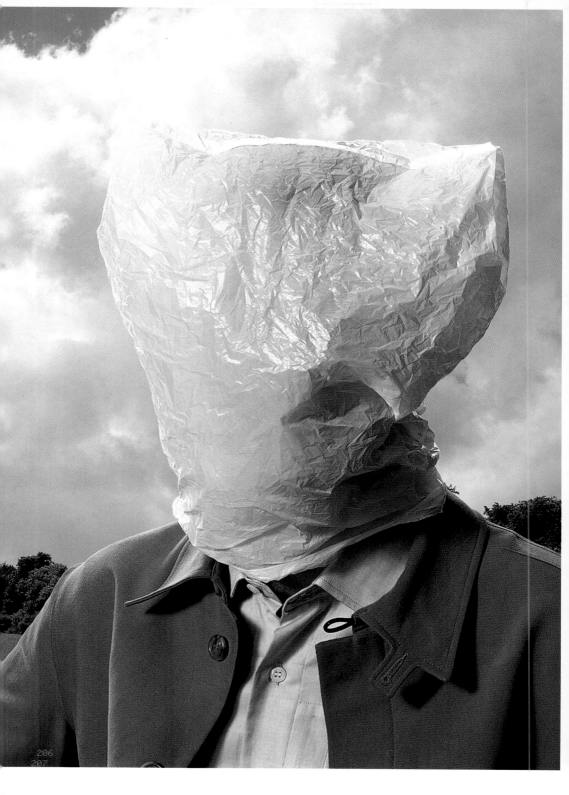

Norbert Schoerner
The picture I never took
1999

Norbert Schoerner
La cienaga and pico
Collaboration: Anika Yi
1999

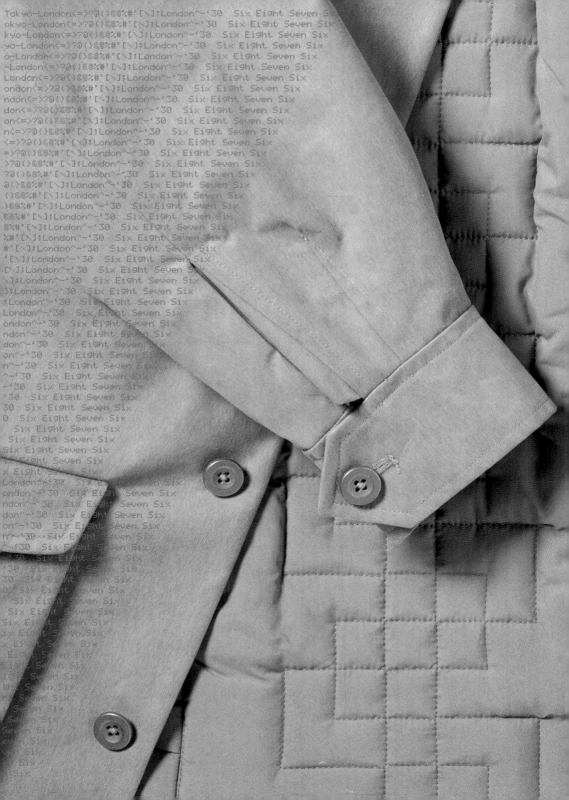

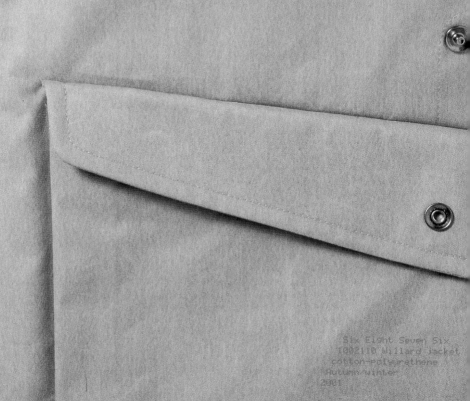

Six Eight Seven Six was formed in
1995 by Kenneth MacKenzie as a direct
challenge to corporate branding and
its market dominance. MacKenzie
aims to present a different vision of
what a clothing company, especially
a menswear one, can be by way of
creating an authentic form of low-tech
modern design with a humanist and
evolving aesthetic. The clothing is
intended to be interesting and well
designed, utilising the latest fabrics
and production techniques while
refusing to indulge in the easy option
of overt branding via visible logos.
Rejecting the catwalk and other
traditional forms of presentation,
Six Eight Seven Six display their wares
and attitude through a website, art
installations and via collaborations
with artists and designers. Since
forming, Six Eight Seven Six has
increased its distribution throughout
Europe, USA and Japan while continuing
to develop its product by working
with directional fabric and garment
technologists in Italy.

Six Eight Seven Six
1002110 Willard Jacket
cotton-polyurethene
Autumn/winter
2001

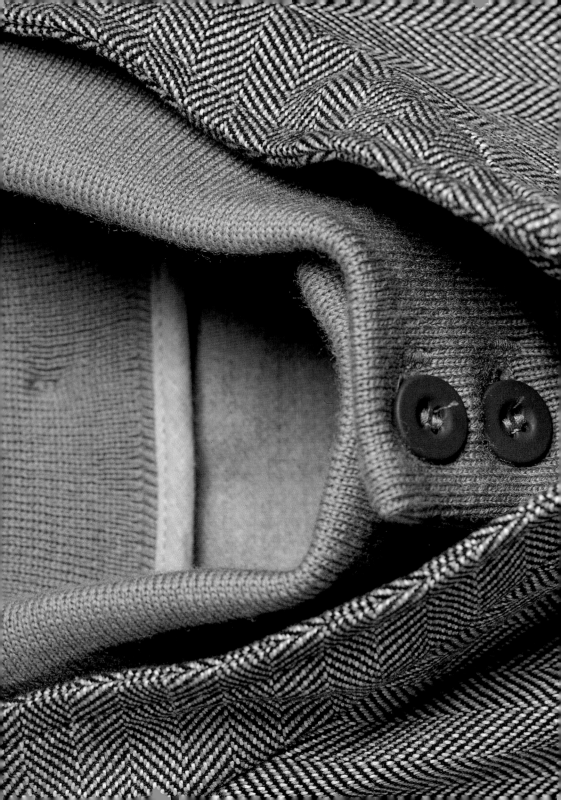

```
.2001/2002,"*+JAM:Tokyo-London<=>?@(){}&8%#'[\];London^-'31  Ewen Spencer
2001/2002,"*+JAM:Tokyo-London<=>?@(){}&8%#'[\];London^-'31  Ewen Spencer
001/2002,"*+JAM:Tokyo-London<=>?@(){}&8%#'[\];London^-'31  Ewen Spencer
01/2002,"*+JAM:Tokyo-London<=>?@(){}&8%#'[\];London^-'31  Ewen Spencer
1/2002,"*+JAM:Tokyo-London<=>?@(){}&8%#'[\];London^-'31  Ewen Spencer
/2002,"*+JAM:Tokyo-London<=>?@(){}&8%#'[\];London^-'31  Ewen Spencer
2002,"*+JAM:Tokyo-London<=>?@(){}&8%#'[\];London^-'31  Ewen Spencer
002,"*+JAM:Tokyo-London<=>?@(){}&8%#'[\];London^-'31  Ewen Spencer
02,"*+JAM:Tokyo-London<=>?@(){}&8%#'[\];London^-'31  Ewen Spencer
2,"*+JAM:Tokyo-London<=>?@(){}&8%#'[\];London^-'31  Ewen Spencer
,"*+JAM:Tokyo-London<=>?@(){}&8%#'[\];London^-'31  Ewen Spencer
"*+JAM:Tokyo-London<=>?@(){}&8%#'[\];London^-'31  Ewen Spencer
*+JAM:Tokyo-London<=>?@(){}&8%#'[\];London^-'31  Ewen Spencer
+JAM:Tokyo-London<=>?@(){}&8%#'[\];London^-'31  Ewen Spencer
JAM:Tokyo-London<=>?@(){}&8%#'[\];London^-'31  Ewen Spencer
AM:Tokyo-London<=>?@(){}&8%#'[\];London^-'31  Ewen Spencer
M:Tokyo-London<=>?@(){}&8%#'[\];London^-'31  Ewen Spencer
:Tokyo-London<=>?@(){}&8%#'[\];London^-'31  Ewen Spencer
Tokyo-London<=>?@(){}&8%#'[\];London^-'31  Ewen Spencer
okyo-London<=>?@(){}&8%#'[\];London^-'31  Ewen Spencer
kyo-London<=>?@(){}&8%#'[\];London^-'31  Ewen Spencer
yo-London<=>?@(){}&8%#'[\];London^-'31  Ewen Spencer
o-London<=>?@(){}&8%#'[\];London^-'31  Ewen Spencer
-London<=>?@(){}&8%#'[\];London^-'31  Ewen Spencer
London<=>?@(){}&8%#'[\];London^-'31  Ewen Spencer
ondon<=>?@(){}&8%#'[\];London^-'31  Ewen Spencer
ndon<=>?@(){}&8%#'[\];London^-'31  Ewen Spencer
don<=>?@(){}&8%#'[\];London^-'31  Ewen Spencer
}&8%#'[\];London^-'31  Ewen Spencer
&8%#'[\];London^-'31  Ewen Spencer
8%#'[\];London^-'31  Ewen Spencer
%#'[\];London^-'31  Ewen Spencer
#'[\];London^-'31  Ewen Spencer
'[\];London^-'31  Ewen Spencer
[\];London^-'31  Ewen Spencer
\];London^-'31  Ewen Spencer
];London^-'31  Ewen Spencer
;London^-'31  Ewen Spencer
London^-'31  Ewen Spencer
ondon^-'31  Ewen Spencer
ndon^-'31  Ewen Spencer
don^-'31  Ewen Spencer
on^-'31  Ewen Spencer
n^-'31  Ewen Spencer
^-'31  Ewen Spencer
-'31  Ewen Spencer
'31  Ewen Spencer
31  Ewen Spencer
1  Ewen Spencer
  Ewen Spencer
 Ewen Spencer
Ewen Spencer
wen Spencer
en Spencer
n Spencer
 Spencer
Spencer
pencer
encer
ncer
cer
er
r
```

Ewen Spencer brings a documentary photographer's vision to his images of London night-life and street culture, citing Richard Frank and William Klein as inspiration. After just three years as a professional photographer Spencer has made a considerable impression with images that speak variously of desire, pride and aspiration. In editorial work for *The Face* and *Sleaze Nation*, he explores various club scenes, including UK Garage, Nu-metal and Northern Soul, and has travelled further afield documenting life and style in Moscow, Uruguay and Turkey. As well as representing his club-based work, JAM includes images from his ongoing series about teenagers.

Ewen Spencer
Teenagers, Rossendale,
Lancashire
2000

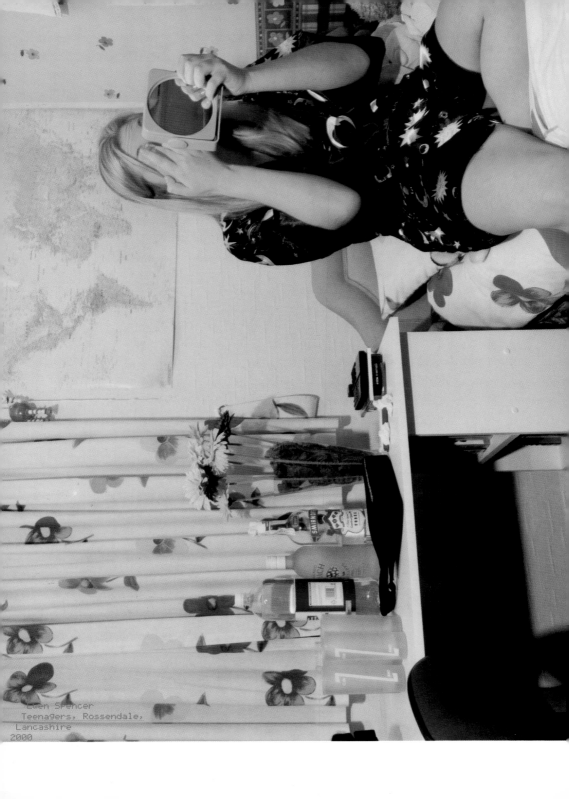

Ewen Spencer
Teenagers, Rossendale,
Lancashire
2000

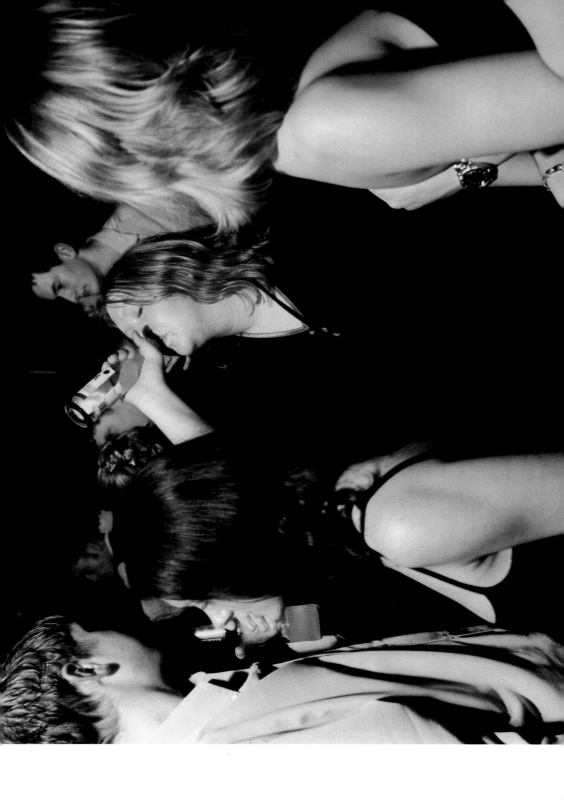

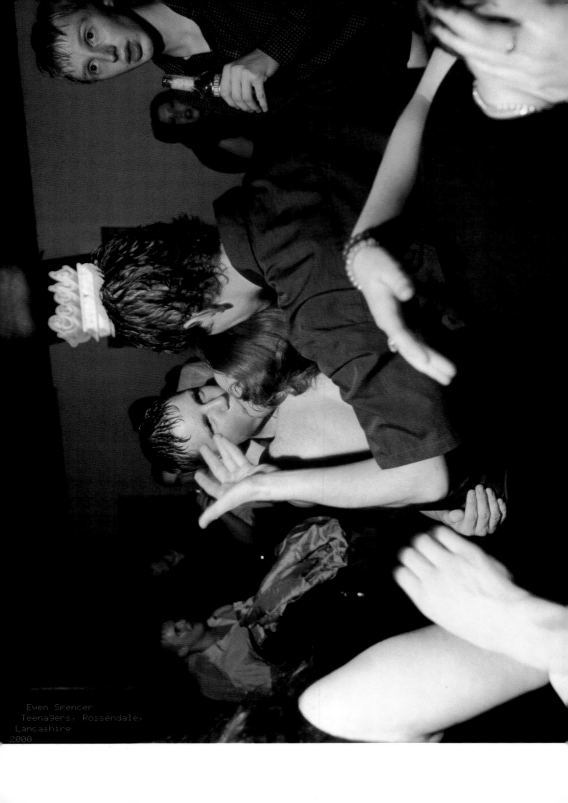

Ewen Spencer
Teenagers, Rossendale,
Lancashire
2000

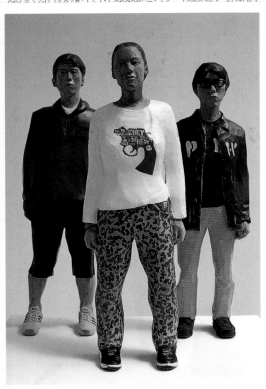

Tomoaki Suzuki
Tomo, Emma, Satoru
Painted Poplar wood
Courtesy: Donald and Mera Rubell,
Miami; and Paul Morrison, London
1999
Satoru, Emma, Yasuyo, Tomo
Painted Poplar wood
Courtesy: Donald and Mera Rubell,
Miami; and Paul Morrison, London
1999

Tomoaki Suzuki
Yasuyo
Painted Poplar wood
Courtesy: Donald and Mera Rubell,
Miami
1999
Satoru, Emma, Tomo, Yasuyo
Painted Poplar wood
Courtesy: Donald and Mera Rubell,
Miami; and Paul Morrison, London
1999

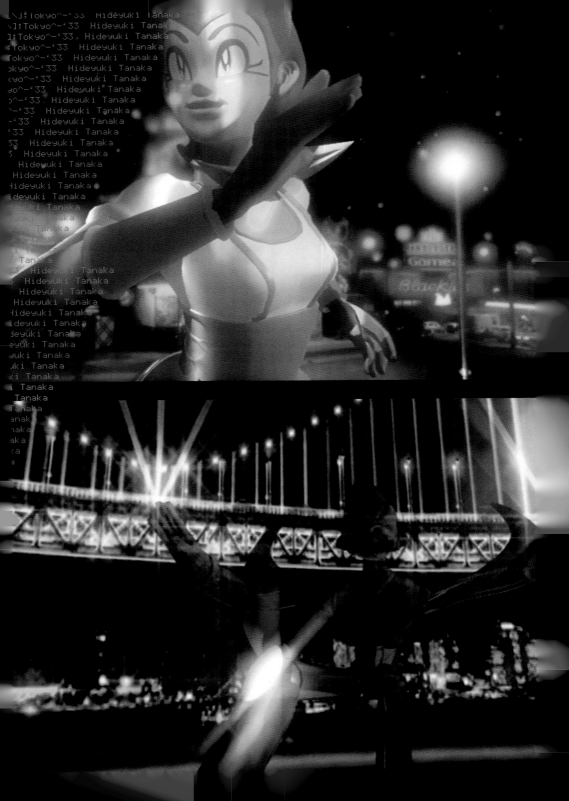

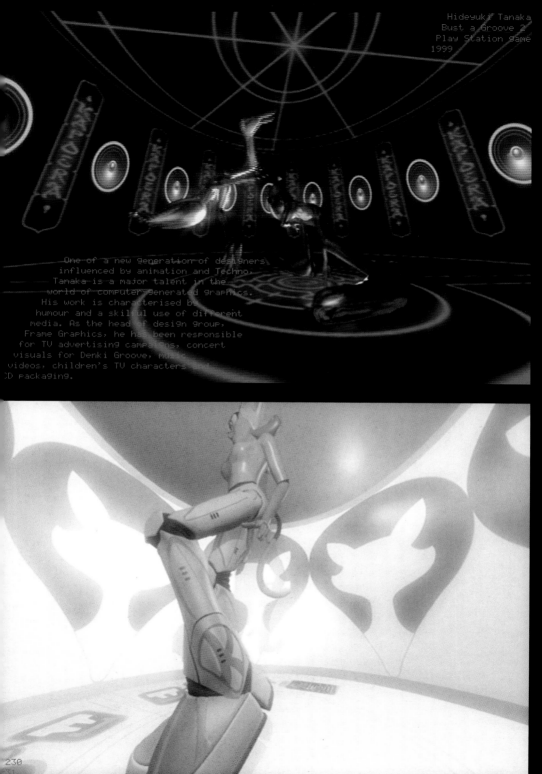

Hideyuki Tanaka
Bust a Groove 2
Play Station game
1999

One of a new generation of designers
influenced by animation and Techno,
Tanaka is a major talent in the
world of computer-generated graphics.
His work is characterised by
humour and a skilful use of different
media. As the head of design group,
Frame Graphics, he has been responsible
for TV advertising campaigns, concert
visuals for Denki Groove, music
videos, children's TV characters, and
CD packaging.

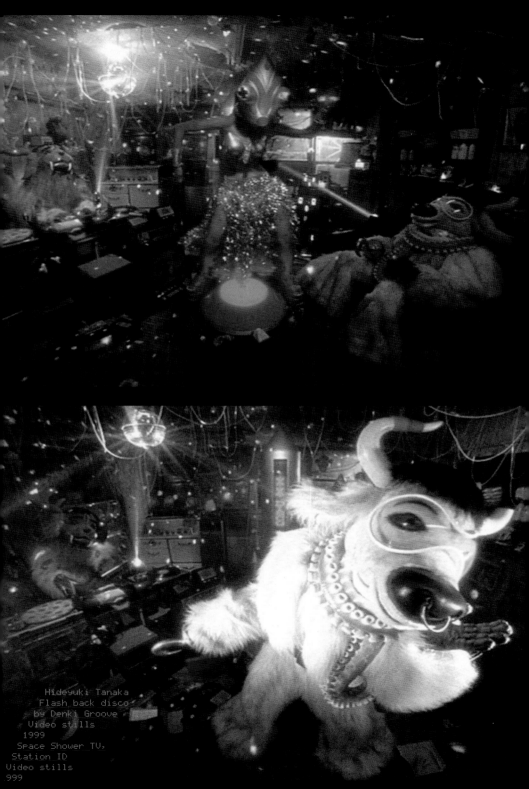

Hideyuki Tanaka
Flash back disco
by Denki Groove
Video stills
1999
Space Shower TV,
Station ID
Video stills
999

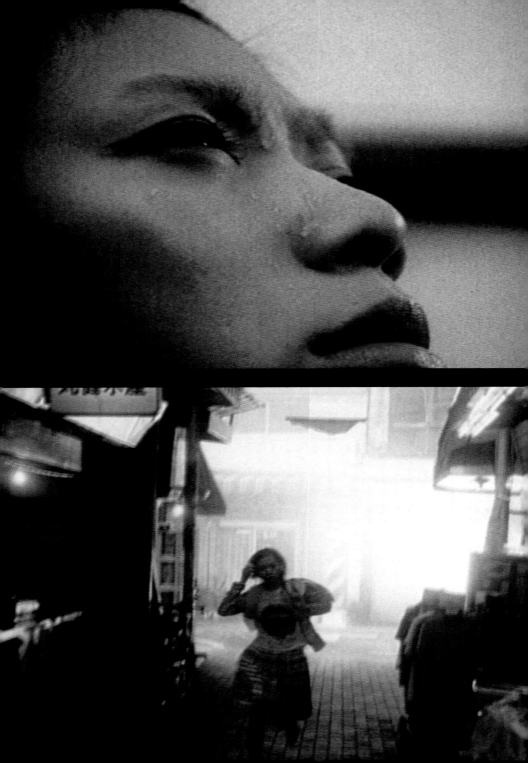

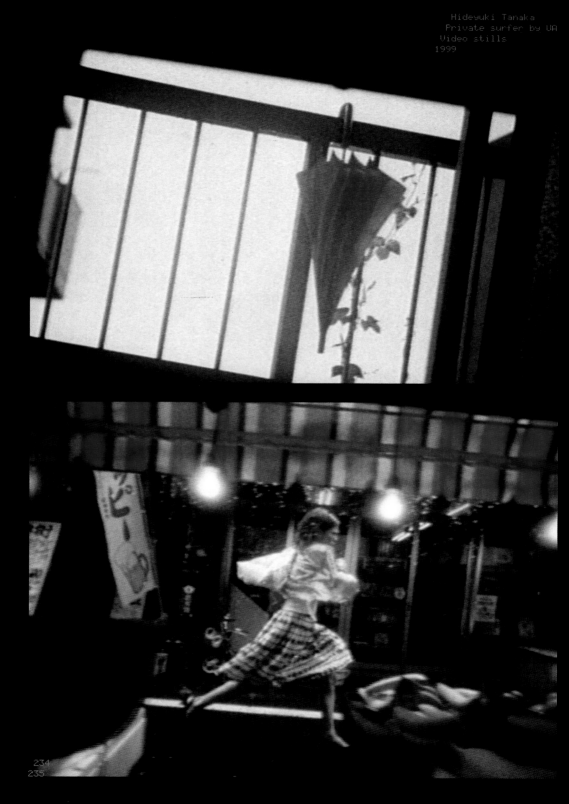

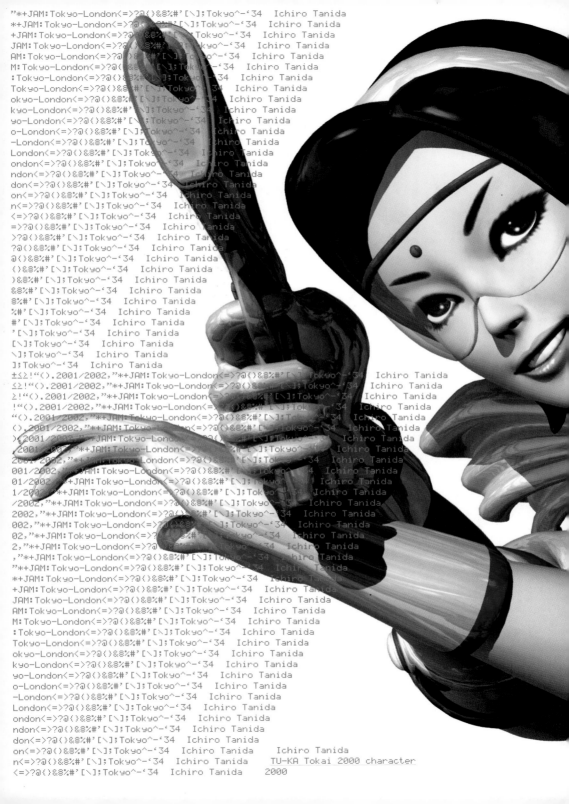

From working in graphic design in
the mid-1980s, artist Ichiro Tanida
continues to be involved in a wide
range of activities in various
media. Although primarily a director
of commercials, his work, which
encompasses editorial, advertising,
video, computer games, painting
and drawing, reflects his changing
methods of expression and expanding
repertoire. The characters and film
images he creates, using sophisticated
digital technology, are filled with
pop futurism and street-inspired
attitude. These aspects, combined
with the speed of his work, mean that
Tanida is one of the creative artists
who most successfully embodies the
"feel" of Tokyo.

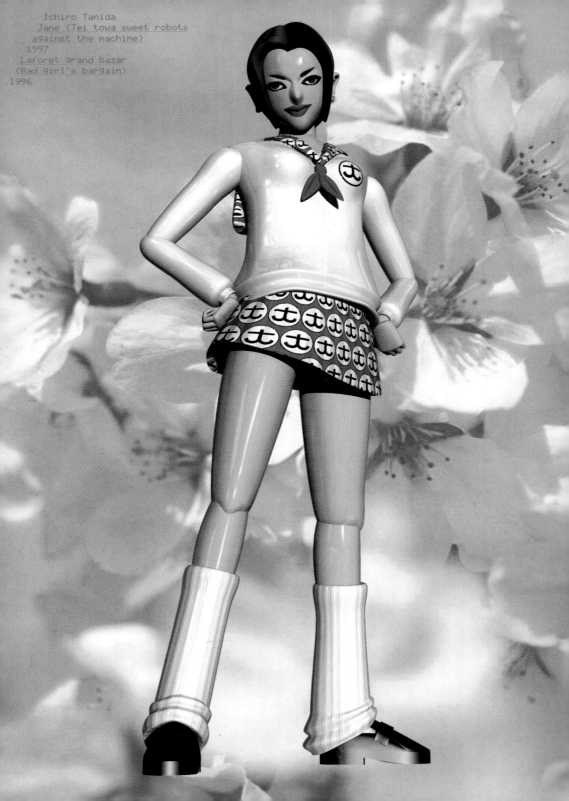

Ichiro Tanida
Jane (Tei towa sweet robots
against the machine)
1997
Laforet grand bazar
(Bad girl's bargain)
1996

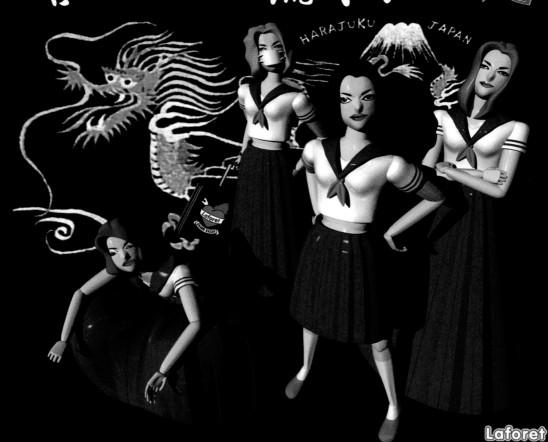

```
<=>?@()&8%#'[\];London^-'35  Simon Thorogood
=>?@()&8%#'[\];London^-'35  Simon Thorogood
>?@()&8%#'[\];London^-'35  Simon Thorogood
?@()&8%#'[\];London^-'35  Simon Thorogood
@()&8%#'[\];London^-'35  Simon Thorogood
()&8%#'[\];London^-'35  Simon Thorogood
)&8%#'[\];London^-'35  Simon Thorogood
&8%#'[\];London^-'35  Simon Thorogood
8%#'[\];London^-'35  Simon Thorogood
%#'[\];London^-'35  Simon Thorogood
#'[\];London^-'35  Simon Thorogood
'[\];London^-'35  Simon Thorogood
[\];London^-'35  Simon Thorogood
\];London^-'35  Simon Thorogood
];London^-'35  Simon Thorogood
;London^-'35  Simon Thorogood
London^-'35  Simon Thorogood
ondon^-'35  Simon Thorogood
ndon^-'35  Simon Thorogood
don^-'35  Simon Thorogood
on^-'35  Simon Thorogood
n^-'35  Simon Thorogood
^-'35  Simon Thorogood
-'35  Simon Thorogood
'35  Simon Thorogood
35  Simon Thorogood
5  Simon Thorogood
   Simon Thorogood
  Simon Thorogood
Simon Thorogood
imon Thorogood
mon Thorogood
on Thorogood
n Thorogood
 Thorogood
Thorogood
horogood
orogood
rogood
ogood
good
ood
od
d
```

Fashion designer Simon Thorogood
has chosen to follow an untypical
career path, creating bespoke
clothing for women. His reasoning is,
it allows him the freedom to produce
uncompromising work outside the
commercial restraints of the ready
to wear industry. Thorogood combines
traditional tailoring skills with
forms influenced by the futuristic
design of contemporary aircraft
engineering and the experimental
processes of musicians such as John
Cage, who, in common with Thorogood,
is fascinated by systems, chance
and formula. For JAM, Thorogood
teamed-up with Spore members,
Suzanna Lee and Benedict Sheehan,
to create an installation utilising
slide projections and ambient sound.

Simon Thorogood
Pages from sketch book
1999

Simon Thorogood
Pages from sketch book
1999
Overleaf:
Pages from sketch book
1997

Kosuke Tsumura
FINAL HOME
Autumn/winter 2000
Photographs: Takashi Homma
2000

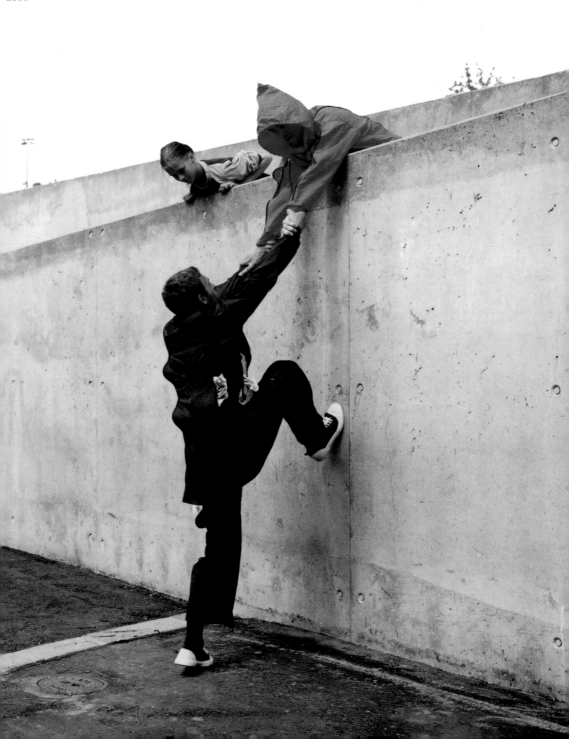

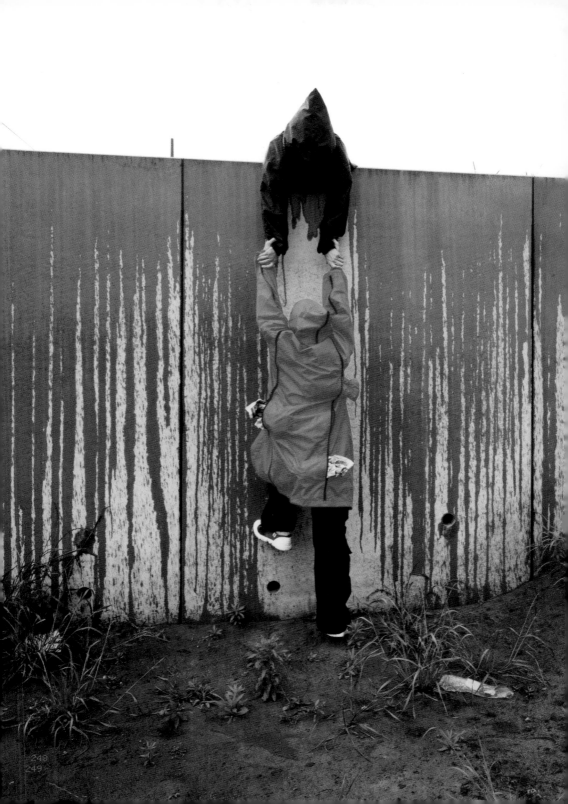

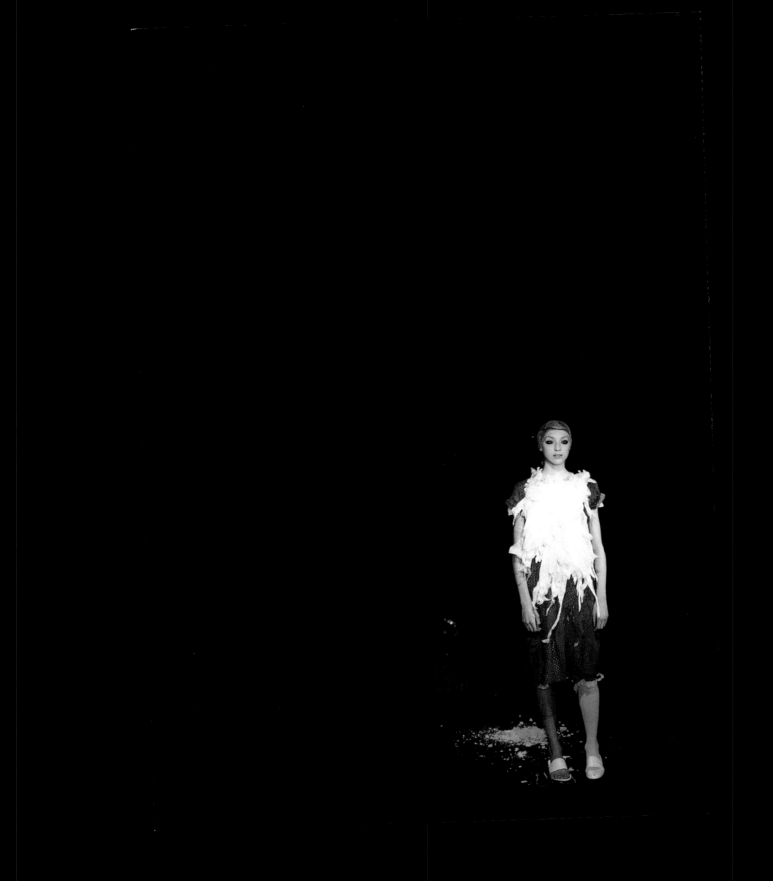

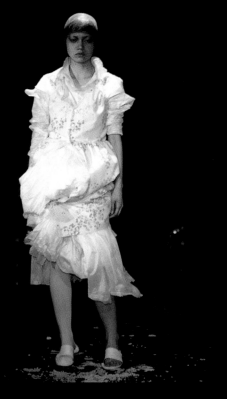
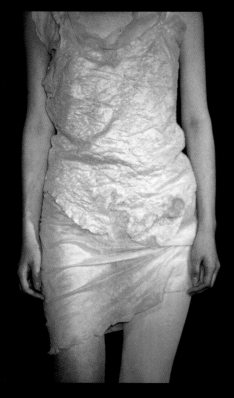

Kosuke Tsumura
Tissue wear
Spring/summer 2001
Photographs: Kentaro Shibuya
2001

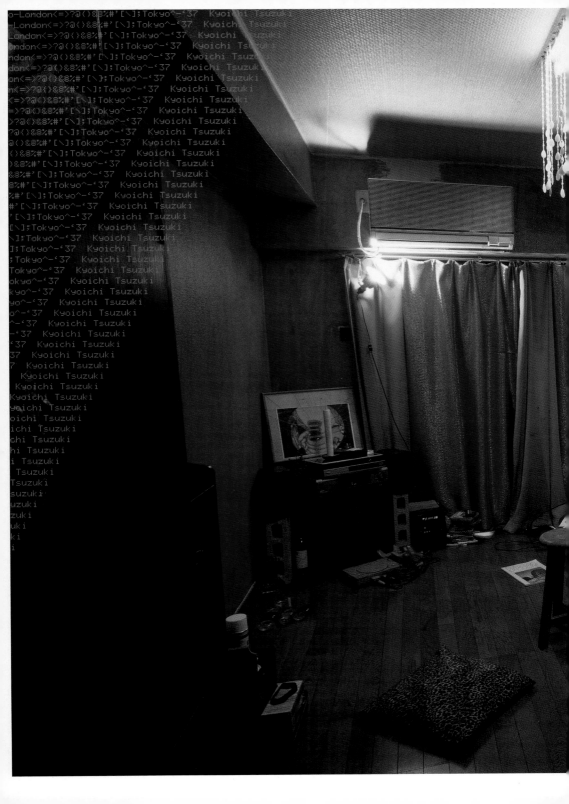

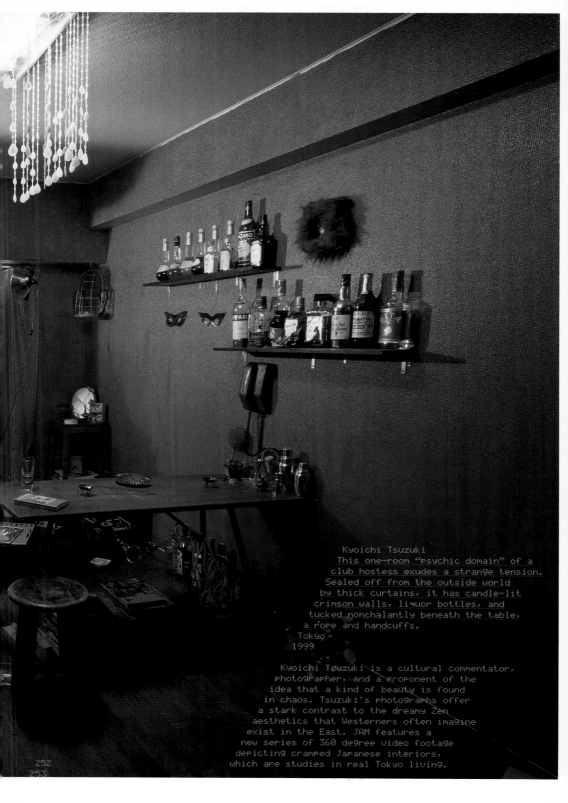

Kyoichi Tsuzuki
This one-room "psychic domain" of a
club hostess exudes a strange tension.
Sealed off from the outside world
by thick curtains, it has candle-lit
crimson walls, liquor bottles, and
tucked nonchalantly beneath the table,
a rope and handcuffs.
Tokyo
1999

Kyoichi Tsuzuki is a cultural commentator,
photographer, and a proponent of the
idea that a kind of beauty is found
in chaos. Tsuzuki's photographs offer
a stark contrast to the dreamy Zen
aesthetics that Westerners often imagine
exist in the East. JAM features a
new series of 360 degree video footage
depicting cramped Japanese interiors,
which are studies in real Tokyo living.

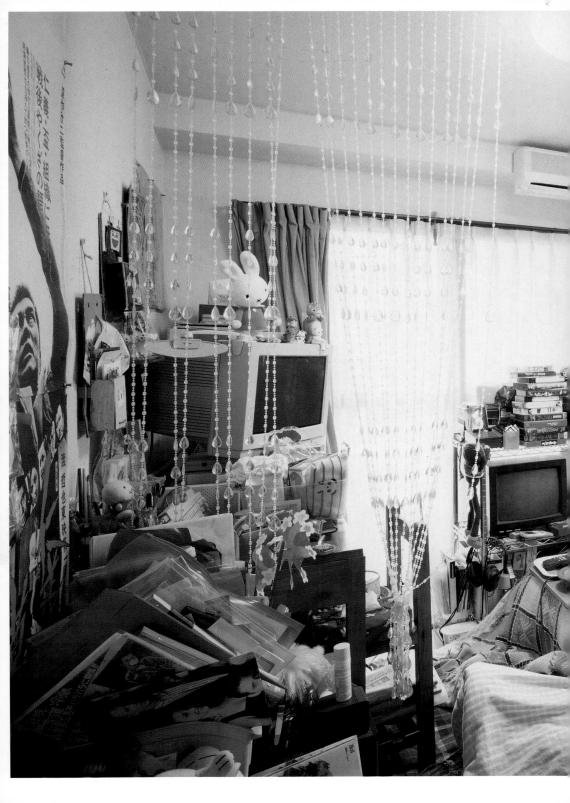

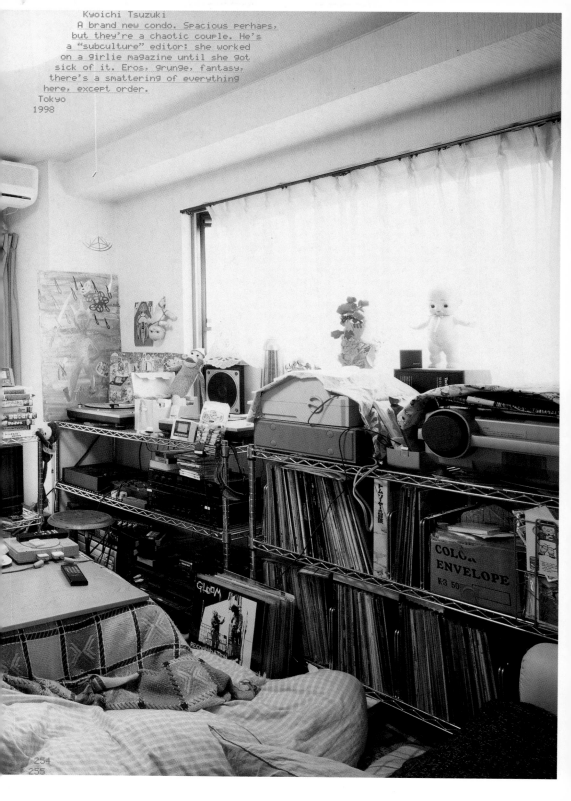

Kyoichi Tsuzuki
A brand new condo. Spacious perhaps,
but they're a chaotic couple. He's
a "subculture" editor; she worked
on a girlie magazine until she got
sick of it. Eros, grunge, fantasy,
there's a smattering of everything
here, except order.
Tokyo
1998

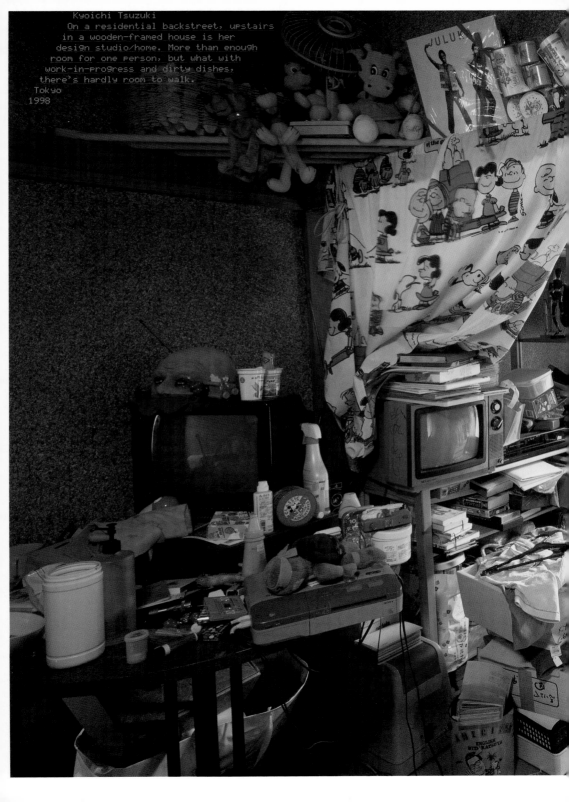

Kyoichi Tsuzuki
On a residential backstreet, upstairs
in a wooden-framed house is her
design studio/home. More than enough
room for one person, but what with
work-in-progress and dirty dishes,
there's hardly room to walk.
Tokyo
1998

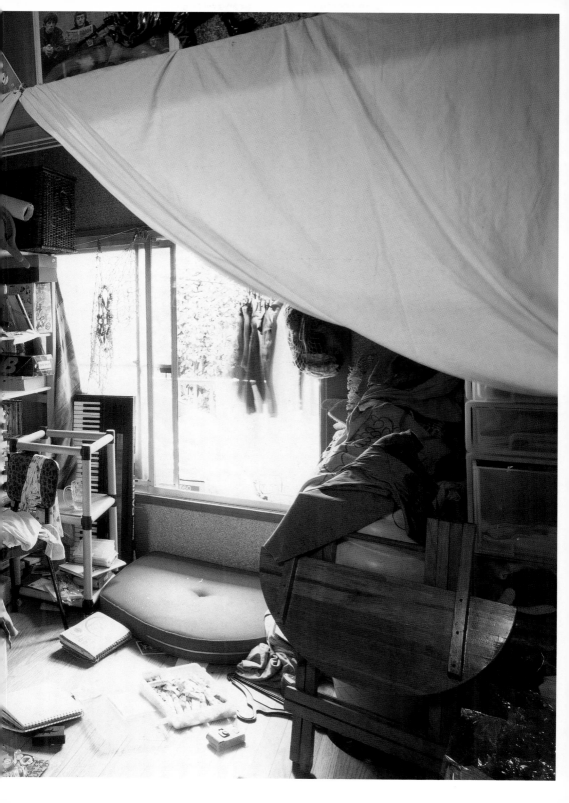

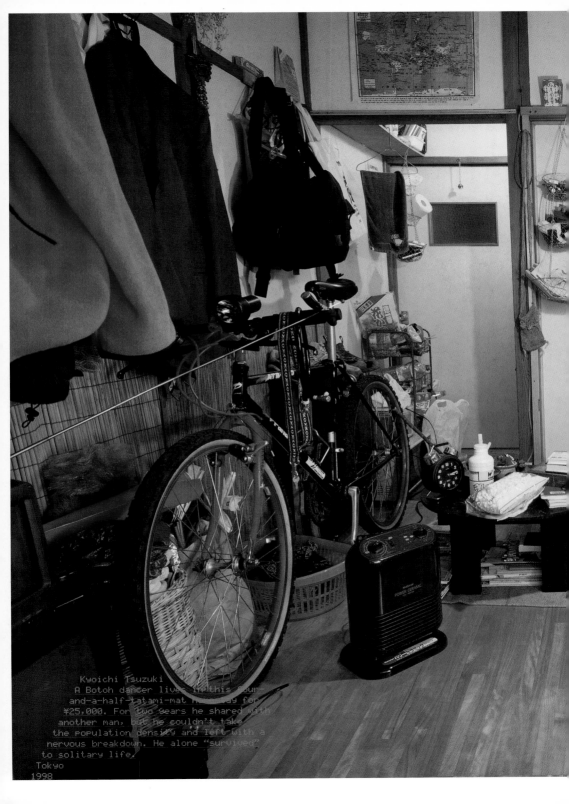

Kyoichi Tsuzuki
A Botoh dancer lives in this four-
and-a-half-tatami-mat room, paying for
¥25,000. For two years he shared with
another man, but he couldn't take
the population density and left with a
nervous breakdown. He alone "survived"
to solitary life.
Tokyo
1998

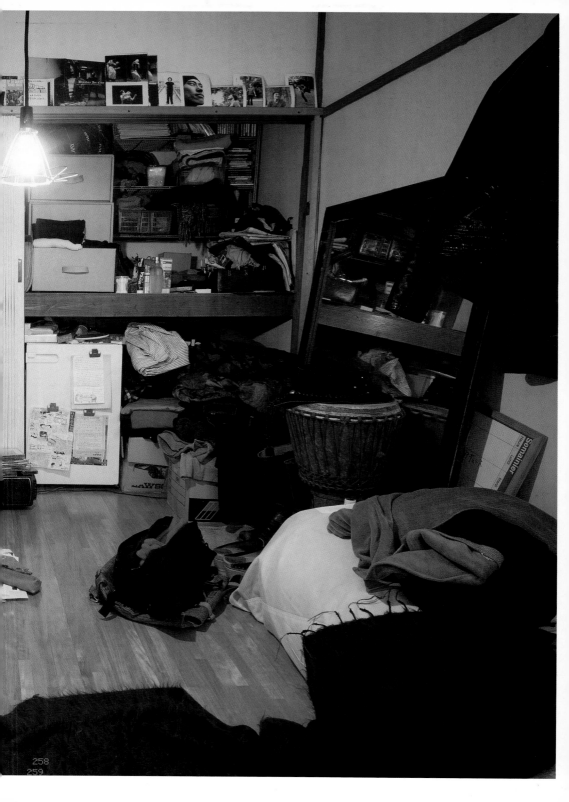

```
n<=>?@()&8%#'[\];Tokyo^-'38  Naohiro Ukawa              Tokyo^-'38  Naohiro Ukawa
<=>?@()&8%#'[\];Tokyo^-'38  Naohiro Ukawa               Tokyo^-'38  Naohiro Ukawa
=>?@()&8%#'[\];Tokyo^-'38  Naohiro Ukawa                Tokyo^-'38  Naohiro Ukawa
>?@()&8%#'[\];Tokyo^-'38  Naohiro Ukawa                Tokyo^-'38  Naohiro Ukawa
?@()&8%#'[\];Tokyo^-'38  Naohiro Ukawa                 Tokyo^-'38  Naohiro Ukawa
@()&8%#'[\];Tokyo^-'38  Naohiro Ukawa                  Tokyo^-'38  Naohiro Ukawa
()&8%#'[\];Tokyo^-'38  Naohiro Ukawa                   Tokyo^-'38  Naohiro Ukawa
)&8%#'[\];Tokyo^-'38  Naohiro Ukawa                   Tokyo^-'38  Naohiro Ukawa
&8%#'[\];Tokyo^-'38  Naohiro Ukawa                   Tokyo^-'38  Naohiro Ukawa
8%#'[\];Tokyo^-'38  Naohiro Ukawa                   Tokyo^-'38  Naohiro Ukawa
%#'[\];Tokyo^-'38  Naohiro Ukawa                    Tokyo^-'38  Naohiro Ukawa
#'[\];Tokyo^-'38  Naohiro Ukawa                    Tokyo^-'38  Naohiro Ukawa
'[\];Tokyo^-'38  Naohiro Ukawa                    Tokyo^-'38  Naohiro Ukawa
[\];Tokyo^-'38  Naohiro Ukawa                    Tokyo^-'38  Naohiro Ukawa
\];Tokyo^-'38  Naohiro Ukawa                     Tokyo^-'38  Naohiro Ukawa
];Tokyo^-'38  Naohiro Ukawa                      Tokyo^-'38  Naohiro Ukawa
;Tokyo^-'38  Naohiro Ukawa                      Tokyo^-'38  Naohiro Ukawa
Tokyo^-'38  Naohiro Ukawa                       Tokyo^-'38  Naohiro Ukawa
okyo^-'38  Naohiro Ukawa                       Tokyo^-'38  Naohiro Ukawa
kyo^-'38  Naohiro Ukawa                        Tokyo^-'38  Naohiro Ukawa
yo^-'38  Naohiro Ukawa                         Tokyo^-'38  Naohiro Ukawa
o^-'38  Naohiro Ukawa                          Tokyo^-'38  Naohiro Ukawa
^-'38  Naohiro Ukawa                          Tokyo^-'38  Naohiro Ukawa
-'38  Naohiro Ukawa                          Tokyo^-'38  Naohiro Ukawa
'38  Naohiro Ukawa                          Tokyo^-'38  Naohiro Ukawa
38  Naohiro Ukawa                           Tokyo^-'38  Naohiro Ukawa
8  Naohiro Ukawa                            Tokyo^-'38  Naohiro Ukawa
  Naohiro Ukawa                             Tokyo^-'38  Naohiro Ukawa
 Naohiro Ukawa                              Tokyo^-'38  Naohiro Ukawa
Naohiro Ukawa                               Tokyo^-'38  Naohiro Ukawa
aohiro Ukawa                               Tokyo^-'38  Naohiro Ukawa
ohiro Ukawa                                Tokyo^-'38  Naohiro Ukawa
hiro Ukawa                                 Tokyo^-'38  Naohiro Ukawa
iro Ukawa                                  Tokyo^-'38  Naohiro Ukawa
ro Ukawa                                   Tokyo^-'38  Naohiro Ukawa
o Ukawa                                    Tokyo^-'38  Naohiro Ukawa
 Ukawa                                     Tokyo^-'38  Naohiro Ukawa
Ukawa                                      Tokyo^-'38  Naohiro Ukawa
kawa                                       Tokyo^-'38  Naohiro Ukawa
awa                                        Tokyo^-'38  Naohiro Ukawa
wa                                         Tokyo^-'38  Naohiro Ukawa
a                                          Tokyo^-'38  Naohiro Ukawa
                                           Tokyo^-'38  Naohiro Ukawa
                                          Tokyo^-'38  Naohiro Ukawa
                                         Tokyo^-'38  Naohiro Ukawa
                                        Tokyo^-'38  Naohiro Ukawa
                                       Tokyo^-'38  Naohiro Ukawa
                                      Tokyo^-'38  Naohiro Ukawa
Tokyo^-'38  Naohiro Ukawa
okyo^-'38  Naohiro Ukawa
kyo^-'38  Naohiro Ukawa
yo^-'38  Naohiro Ukawa
o^-'38  Naohiro Ukawa
^-'38  Naohiro Ukawa
-'38  Naohiro Ukawa
'38  Naohiro Ukawa
38  Naohiro Ukawa
8  Naohiro Ukawa
  Naohiro Ukawa
 Naohiro Ukawa
Naohiro Ukawa
aohiro Ukawa
ohiro Ukawa
hiro Ukawa
iro Ukawa
ro Ukawa
o Ukawa
 Ukawa
Ukawa
kawa
awa
a
```

Naohiro Ukawa
The Boredoms, "Rebore vol.2 compiled
and mixed by Ken Ishii"
Artwork: Naohiro Ukawa and Ausgang
Design: Naohiro Ukawa
(C) Warner Music Japan Inc.
2001

Naohiro Ukawa is an artist who
typifies a truly cross-media border-
less approach. He makes art and runs
his own music label, as well as
making music himself. More recently he
has begun directing films and writing.
A series of happy and mysterious
accidents, such as a friend giving
Ukawa a million yen, and a professional
thief giving him a projector, put
Ukawa firmly on the creative path;
many such stories surround Ukawa. His
limited edition CD cover for "Vision-
Creation-Newsun", is based on the
birth of life; as the package is opened
a sensor activates a singing frog,
while a separate digital mechanism
allows the track titles to be read and
beautiful scenery to emerge. The pack
has been acquired by the San Francisco
Acid Museum.

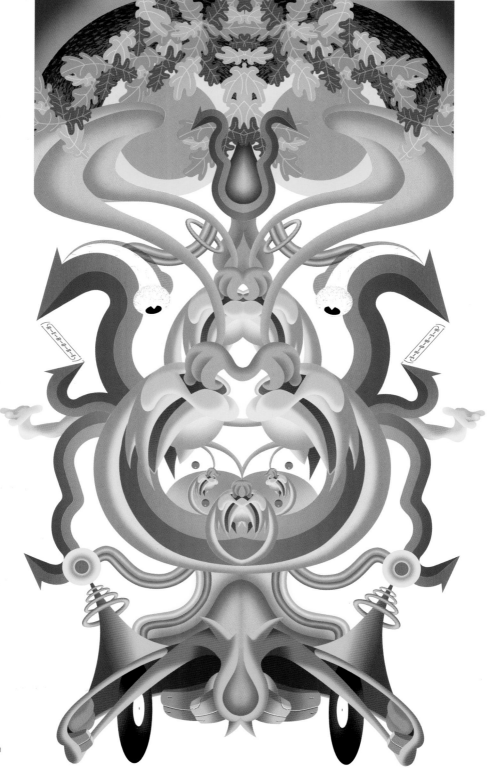

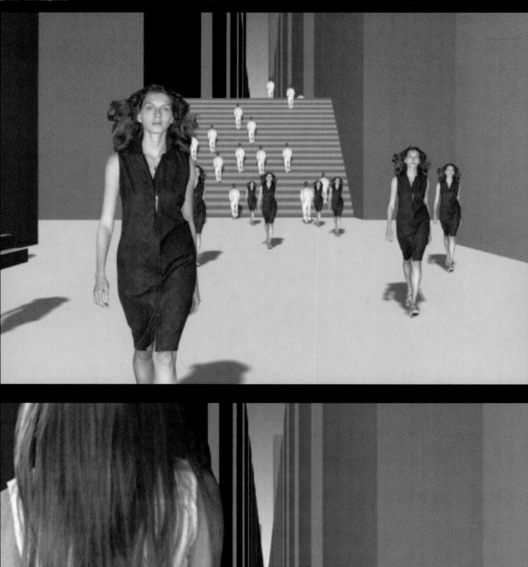
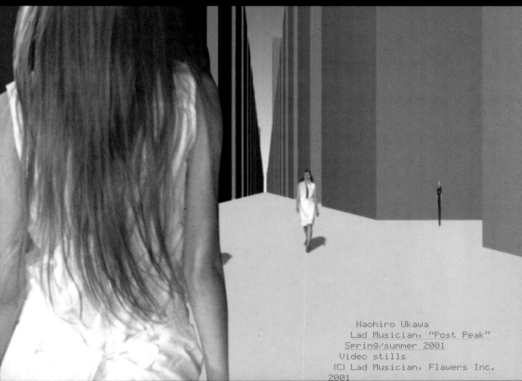

Naohiro Ukawa
Lad Musician, "Post Peak"
Spring/summer 2001
Video stills
(C) Lad Musician, Flawers Inc.
2001

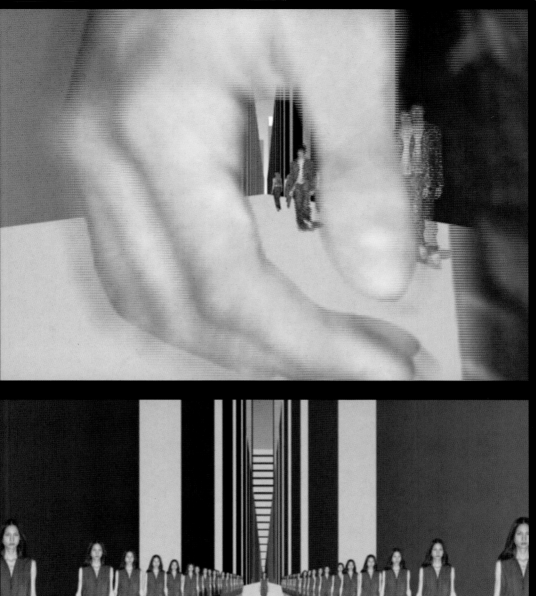

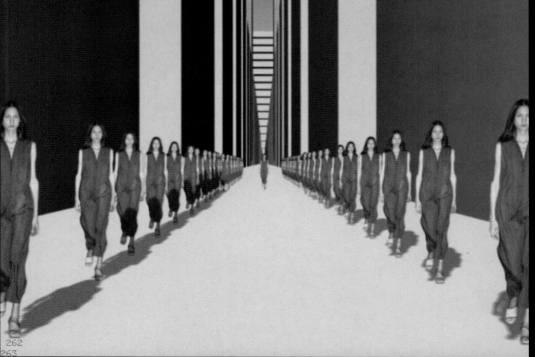

```
<=>?@()&8%#'[\];Tokyo^-'39  UNDER COVER
=>?@()&8%#'[\];Tokyo^-'39  UNDER COVER
>?@()&8%#'[\];Tokyo^-'39  UNDER COVER
?@()&8%#'[\];Tokyo^-'39  UNDER COVER
@()&8%#'[\];Tokyo^-'39  UNDER COVER
()&8%#'[\];Tokyo^-'39  UNDER COVER
)&8%#'[\];Tokyo^-'39  UNDER COVER
&8%#'[\];Tokyo^-'39  UNDER COVER
8%#'[\];Tokyo^-'39  UNDER COVER
%#'[\];Tokyo^-'39  UNDER COVER
#'[\];Tokyo^-'39  UNDER COVER
'[\];Tokyo^-'39  UNDER COVER
[\];Tokyo^-'39  UNDER COVER
\];Tokyo^-'39  UNDER COVER
];Tokyo^-'39  UNDER COVER
;Tokyo^-'39  UNDER COVER
Tokyo^-'39  UNDER COVER
okyo^-'39  UNDER COVER
kyo^-'39  UNDER COVER
yo^-'39  UNDER COVER
o^-'39  UNDER COVER
#'[\];Tokyo^-'39  UNDER COVER
'[\];Tokyo^-'39  UNDER COVER
[\];Tokyo^-'39  UNDER COVER
\];Tokyo^-'39  UNDER COVER
];Tokyo^-'39  UNDER COVER
;Tokyo^-'39  UNDER COVER
Tokyo^-'39  UNDER COVER
okyo^-'39  UNDER COVER
kyo^-'39  UNDER COVER
yo^-'39  UNDER COVER
o^-'39  UNDER COVER
^-'39  UNDER COVER
-'39  UNDER COVER
'39  UNDER COVER
39  UNDER COVER
9  UNDER COVER
   UNDER COVER
 UNDER COVER
UNDER COVER
NDER COVER
DER COVER
ER COVER
R COVER
 COVER
COVER
OVER
VER
ER
R
     UNDER COVER
    Melting pot
  Autumn/winter 2000
 Photograph: Mamoru Miyazawa
 2000
```

UNDER COVER is the label of leading streetwear designer, Jun Takahashi. The prototype for UNDER COVER was first conceived by Takahashi in 1989 when he was still a fashion student. He launched his first collection at 22 and has gone from strength to strength producing innovative clothing, the essence of which is contemporary and free-spirited. Aspiring to more than just producing clothes for an appreciative public, Takahashi seeks to influence the thinking of people who wear his range. He aims to produce outside traditional manufacturing systems so as to reflect the chaos that is Tokyo. The main UNDER COVER shop is in the same building as NIGO's A BATHING APE in Tokyo's Aoyama district.

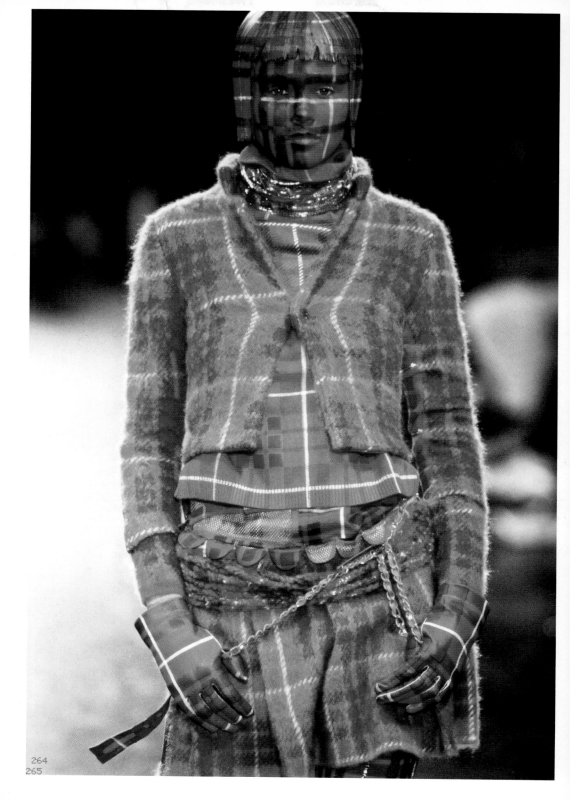

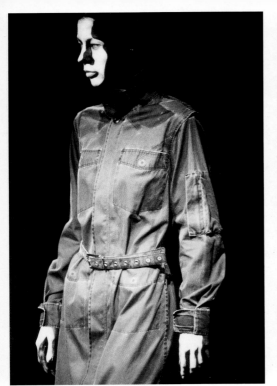

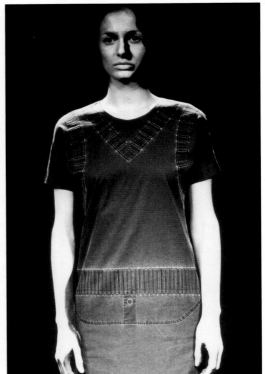

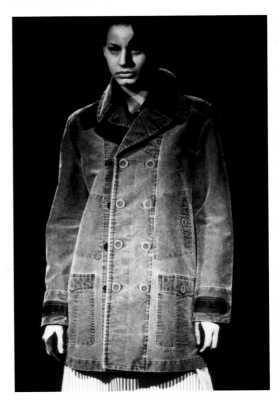

UNDER COVER
Relief
Spring/summer 1999
Photographs: Mamoru Miyazawa
1999

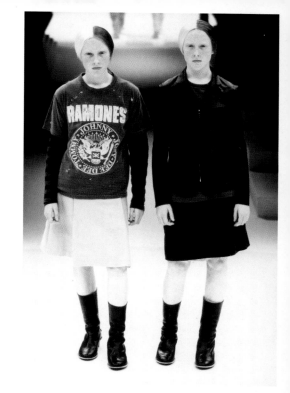

UNDER COVER
Ambivalence
Autumn/winter 1999
Photographs: Mamoru Miyazawa
1999

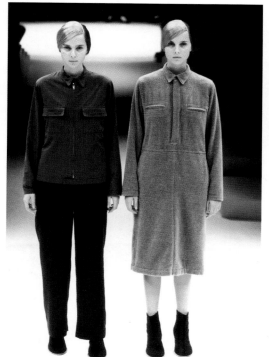

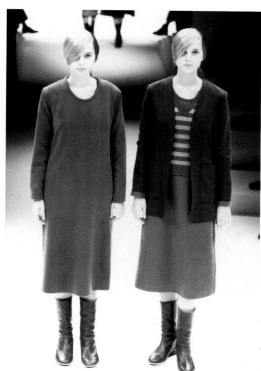

```
2001/2002,"*+JAM:Tokyo-London<=>?@(){}&8%#'[\];London^-'40  World Design Laboratory
001/2002,"*+JAM:Tokyo-London<=>?@(){}&8%#'[\];London^-'40  World Design Laboratory
01/2002,"*+JAM:Tokyo-London<=>?@(){}&8%#'[\];London^-'40  World Design Laboratory
1/2002,"*+JAM:Tokyo-London<=>?@(){}&8%#'[\];London^-'40  World Design Laboratory
/2002,"*+JAM:Tokyo-London<=>?@(){}&8%#'[\];London^-'40  World Design Laboratory
2002,"*+JAM:Tokyo-London<=>?@(){}&8%#'[\];London^-'40  World Design Laboratory
002,"*+JAM:Tokyo-London<=>?@(){}&8%#'[\];London^-'40  World Design Laboratory
02,"*+JAM:Tokyo-London<=>?@(){}&8%#'[\];London^-'40  World Design Laboratory
2,"*+JAM:Tokyo-London<=>?@(){}&8%#'[\];London^-'40  World Design Laboratory
,"*+JAM:Tokyo-London<=>?@(){}&8%#'[\];London^-'40  World Design Laboratory
"*+JAM:Tokyo-London<=>?@(){}&8%#'[\];London^-'40  World Design Laboratory
*+JAM:Tokyo-London<=>?@(){}&8%#'[\];London^-'40  World Design Laboratory
+JAM:Tokyo-London<=>?@(){}&8%#'[\];London^-'40  World Design Laboratory
JAM:Tokyo-London<=>?@(){}&8%#'[\];London^-'40  World Design Laboratory
AM:Tokyo-London<=>?@(){}&8%#'[\];London^-'40  World Design Laboratory
M:Tokyo-London<=>?@(){}&8%#'[\];London^-'40  World Design Laboratory
:Tokyo-London<=>?@(){}&8%#'[\];London^-'40  World Design Laboratory
Tokyo-London<=>?@(){}&8%#'[\];London^-'40  World Design Laboratory
okyo-London<=>?@(){}&8%#'[\];London^-'40  World Design Laboratory
kyo-London<=>?@(){}&8%#'[\];London^-'40  World Design Laboratory
yo-London<=>?@(){}&8%#'[\];London^-'40  World Design Laboratory
o-London<=>?@(){}&8%#'[\];London^-'40  World Design Laboratory
-London<=>?@(){}&8%#'[\];London^-'40  World Design Laboratory
London<=>?@(){}&8%#'[\];London^-'40  World Design Laboratory
ondon<=>?@(){}&8%#'[\];London^-'40  World Design Laboratory
ndon<=>?@(){}&8%#'[\];London^-'40  World Design Laboratory
don<=>?@(){}&8%#'[\];London^-'40  World Design Laboratory
on<=>?@(){}&8%#'[\];London^-'40  World Design Laboratory
n<=>?@(){}&8%#'[\];London^-'40  World Design Laboratory
<=>?@(){}&8%#'[\];London^-'40  World Design Laboratory
=>?@(){}&8%#'[\];London^-'40  World Design Laboratory
>?@(){}&8%#'[\];London^-'40  World Design Laboratory
?@(){}&8%#'[\];London^-'40  World Design Laboratory
@(){}&8%#'[\];London^-'40  World Design Laboratory
(){}&8%#'[\];London^-'40  World Design Laboratory
){}&8%#'[\];London^-'40  World Design Laboratory
}&8%#'[\];London^-'40  World Design Laboratory
&8%#'[\];London^-'40  World Design Laboratory
8%#'[\];London^-'40  World Design Laboratory
%#'[\];London^-'40  World Design Laboratory
#'[\];London^-'40  World Design Laboratory
'[\];London^-'40  World Design Laboratory
[\];London^-'40  World Design Laboratory
\];London^-'40  World Design Laboratory
];London^-'40  World Design Laboratory
;London^-'40  World Design Laboratory
London^-'40  World Design Laboratory
±≤≥!"(),2001/2002,"*+JAM:Tokyo-Tokyo<=>?@(){}&8%#'[\];London^-'40  World Design Laboratory
≤≥!"(),2001/2002,"*+JAM:Tokyo-Tokyo<=>?@(){}&8%#'[\];London^-'40  World Design Laboratory
≥!"(),2001/2002,"*+JAM:Tokyo-Tokyo<=>?@(){}&8%#'[\];London^-'40  World Design Laboratory
!"(),2001/2002,"*+JAM:Tokyo-Tokyo<=>?@(){}&8%#'[\];London^-'40  World Design Laboratory
"(),2001/2002,"*+JAM:Tokyo-Tokyo<=>?@(){}&8%#'[\];London^-'40  World Design Laboratory
(),2001/2002,"*+JAM:Tokyo-Tokyo<=>?@(){}&8%#'[\];London^-'40  World Design Laboratory
),2001/2002,"*+JAM:Tokyo-Tokyo<=>?@(){}&8%#'[\];London^-'40  World Design Laboratory
,2001/2002,"*+JAM:Tokyo-Tokyo<=>?@(){}&8%#'[\];London^-'40  World Design Laboratory
2001/2002,"*+JAM:Tokyo-Tokyo<=>?@(){}&8%#'[\];London^-'40  World Design Laboratory
001/2002,"*+JAM:Tokyo-Tokyo<=>?@(){}&8%#'[\];London^-'40  World Design Laboratory
01/2002,"*+JAM:Tokyo-Tokyo<=>?@(){}&8%#'[\];London^-'40  World Design Laboratory
1/2002,"*+JAM:Tokyo-Tokyo<=>?@(){}&8%#'[\];London^-'40  World Design Laboratory
/2002,"*+JAM:Tokyo-Tokyo<=>?@(){}&8%#'[\];London^-'40  World Design Laboratory
2002,"*+JAM:Tokyo-Tokyo<=>?@(){}&8%#'[\];London^-'40  World Design Laboratory
002,"*+JAM:Tokyo-Tokyo<=>?@(){}&8%#'[\];London^-'40  World Design Laboratory
02,"*+JAM:Tokyo-Tokyo<=>?@(){}&8%#'[\];London^-'40  World Design Laboratory
2,"*+JAM:Tokyo-Tokyo<=>?@(){}&8%#'[\];London^-'40  World Design Laboratory
,"*+JAM:Tokyo-Tokyo<=>?@(){}&8%#'[\];London^-'40  World Design Laboratory
"*+JAM:Tokyo-Tokyo<=>?@(){}&8%#'[\];London^-'40  World Design Laboratory
*+JAM:Tokyo-Tokyo<=>?@(){}&8%#'[\];London^-'40  World Design Laboratory
+JAM:Tokyo-Tokyo<=>?@(){}&8%#'[\];London^-'40  World Design Laboratory
JAM:Tokyo-Tokyo<=>?@(){}&8%#'[\];London^-'40  World Design Laboratory
AM:Tokyo-Tokyo<=>?@(){}&8%#'[\];London^-'40  World Design Laboratory
M:Tokyo-Tokyo<=>?@(){}&8%#'[\];London^-'40  World Design Laboratory        World Design Laboratory
:Tokyo-Tokyo<=>?@(){}&8%#'[\];London^-'40  World Design Laboratory        Dress
Tokyo-Tokyo<=>?@(){}&8%#'[\];London^-'40  World Design Laboratory        2000
```

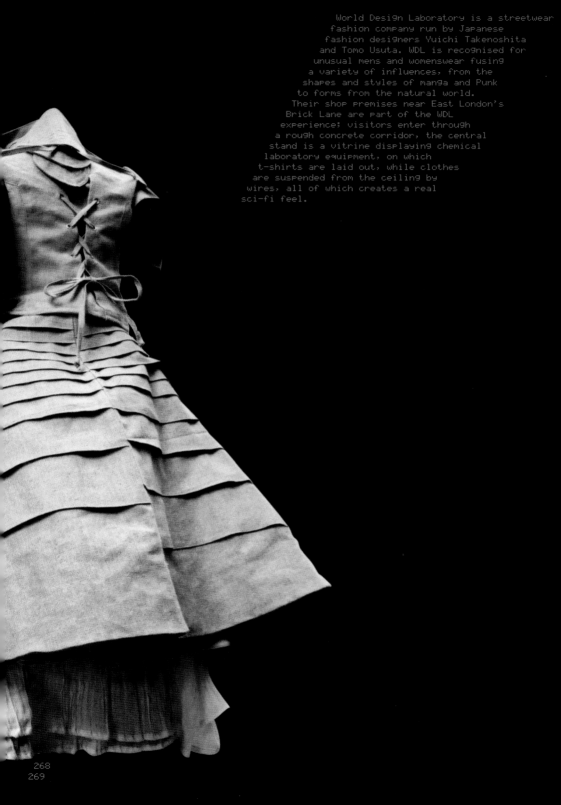

World Design Laboratory is a streetwear
fashion company run by Japanese
fashion designers Yuichi Takenoshita
and Tomo Usuta. WDL is recognised for
unusual mens and womenswear fusing
a variety of influences, from the
shapes and styles of manga and Punk
to forms from the natural world.
Their shop premises near East London's
Brick Lane are part of the WDL
experience: visitors enter through
a rough concrete corridor, the central
stand is a vitrine displaying chemical
laboratory equipment, on which
t-shirts are laid out, while clothes
are suspended from the ceiling by
wires, all of which creates a real
sci-fi feel.

World Design Laboratory
Shop interior,
Brick Lane, London
2000

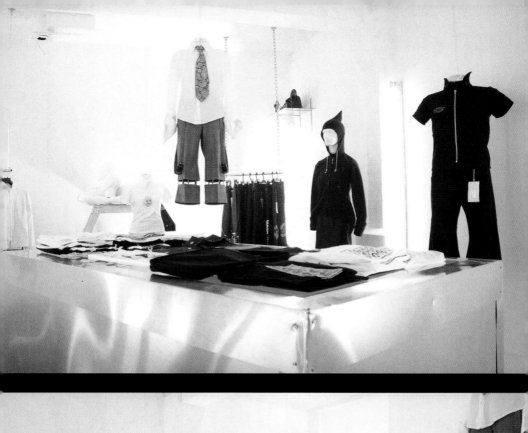

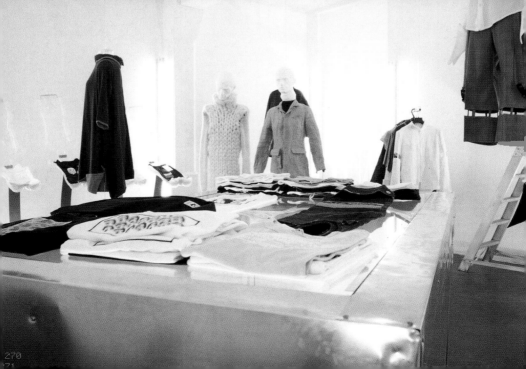

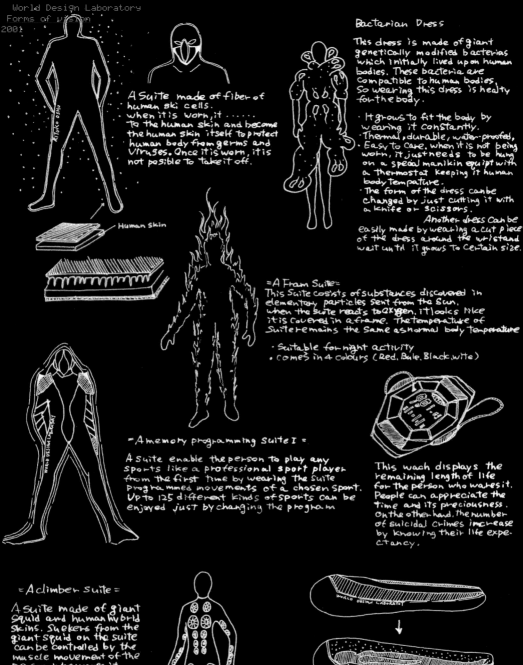

Atsuko Oshu

A Suite made of fiber of human ski cells. when it is worn, it To the human skin and become the human skin itself to protect human body from germs and Viruses. Once it is worn, it is not possible to take it off.

Human Skin

Bacterian Dress

This dress is made of giant genetically modified bacterias which initially lived up on human bodies. These bacteria are compatible to human bodies, so wearing this dress is healty for the body.

· It grows to fit the body by wearing it constantly.
· Thermal, durable, water-proofed,
· Easy to care. when it is not being worn, it just needs to be hung on a special manikin equipt with a thermostat keeping it human body temperature.
· The form of the dress can be changed by just cutting it with a knife or scissors.

Another dress can be easily made by wearing a cut piece of the dress around the wrist and wait until it grows to certain size.

=A Fram Suite=
This Suite cosists of substances discovered in elementary particles sent from the Sun, when the suite reacts to oxygen, it looks like it is covered in a frame. The temperature of Suite remains the same as normal body temperature

· Suitable for night activity
· comes in 4 colours (Red, Bule, Black, wite)

WORLD DESIGN LABORATORY

=A memory programming Suite I =

A Suite enable the person to play any sports like a professional sport player from the first time by wearing the Suite programmed movements of a chosen sport. Up to 125 different kinds of sports can be enjoyed just by changing the program

This wach displays the remaining length of life for the person who wares it. People can appreciate the time and its preciousness. On the other hand, the number of suicidal crimes increase by knowing their life expectancy.

= A climber Suite =

A Suite made of giant squid and human hybrid skins. Suckers from the giant squid on the suite can be controlled by the muscle movement of the person who wares it. Suitable for rock climbing. water-proofed.

WORLD DESIGN LABORATORY

= A bacteria body bag =

This bag was developed to stop a plague caused by a mass disaster after a war. This bag is made of fibres which is bacteria themselves, so this bag can decompose the body to the soil within 24 hours.

= An atom Suite =

This Suite enables a person to travel freely any where while wearing it, by dividing the human body into atomic levels.

• This epochal miracle suite enables a person to go through any object, and also to travel in space by using an accessory. (can elementary particle kit)

H: 80 mm
W: 150 mm
weight: 0g

= A Gas Suite =

A Suite made of gas organisms found in Jupiter. These gas organisms can be controlled to activate around the energy of the human body using a control box.

A control box
H: 120 mm
W: 50 mm
D: 28 mm

• An air charged battery using the static electricity in the air
• It controls colour, shap, density and temperature in 3D display

= A Sound Suite =

A Suite made of a material where fibers work as a speaker enabling the person to perceive the sounds with entire body.

= A Camouflage Suite =

A suite made of hybrid human skin and chameleon skin. A micro-computer worn around the persons' wrist controls the colour of the Suite to adapt and blend with the surrounding colours
It takes only 0.1 of a second to change from one colour to another. So the Suite stays in constant disguise.
The surface temperature of the Suite also matches to the surrounding temperature not to be heat censored.

• There also is a camouflage warp which can be folded into a little space. Any object can be camouflaged using this camouflage wrap.

= Saturn =

This Jewelry is made of tiny astroids which orbit around Saturn. Once orbit is set around a certain thing it continues orbit.

= Ancient plant dress =

A parasitic plant discovered 380M deep under the ice which is 8 hundred million years old. The surface looks like pine tree skin, however the whole thing is a leaf. It grows by photosynthesis with a help of sun light and carbon dioxide. (approximately 60cm per a year) Another dress can be easily made by wearing a cut piece of the dress

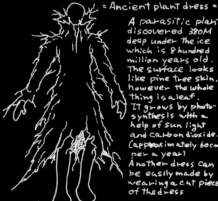

• Germination takes about a week under the temperature between 35c–40c.

= An entering the atmosphere suite =

This suite was developed as a shelter for the possible accident when entering the atmosphere Is is used by the people who enjoy atmospheric sky diving.

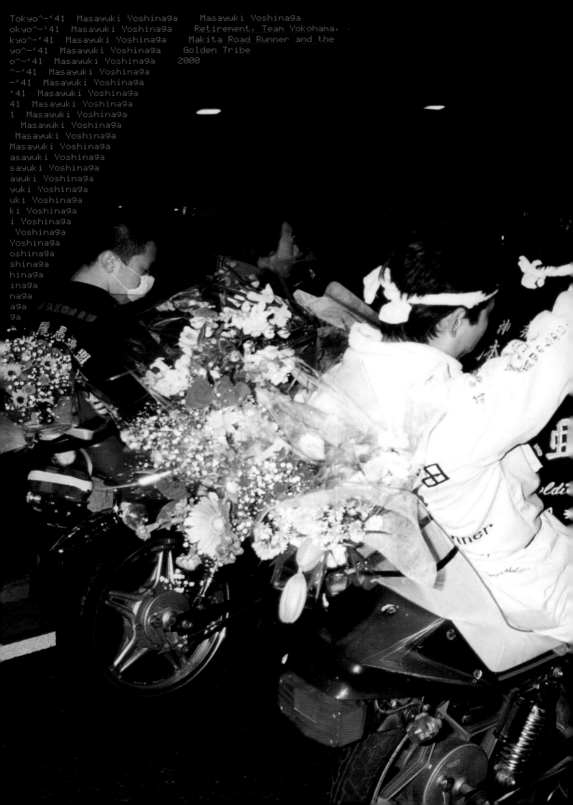

Tokyo^-'41 Masayuki Yoshinaga
okyo^-'41 Masayuki Yoshinaga
kyo^-'41 Masayuki Yoshinaga
yo^-'41 Masayuki Yoshinaga
o^-'41 Masayuki Yoshinaga
^-'41 Masayuki Yoshinaga
-'41 Masayuki Yoshinaga
'41 Masayuki Yoshinaga
41 Masayuki Yoshinaga
1 Masayuki Yoshinaga
 Masayuki Yoshinaga
 Masayuki Yoshinaga
Masayuki Yoshinaga
asayuki Yoshinaga
sayuki Yoshinaga
ayuki Yoshinaga
yuki Yoshinaga
uki Yoshinaga
ki Yoshinaga
i Yoshinaga
 Yoshinaga
Yoshinaga
oshinaga
shinaga
hinaga
inaga
naga
aga
ga

Masayuki Yoshinaga
Retirement, Team Yokohama,
Makita Road Runner and the
Golden Tribe
2000

Masayuki Yoshinaga depicts the
underbelly of Tokyo's contemporary
cultural scene, including the
"bosozoku" biker gangs, the "kogyaru"
girls of Shibuya and members of the
yakuza. However, Yoshinaga's images
do not dwell on the negative and dark
aspects of these subcultures. On the
contrary, his images are filled with
warmth and tolerance, as the artist
attempts to accept the everyday lives
of these young people as they search,
amidst the confusion of the city,
for a sense of belonging. His images
depict the frankness and seriousness
of these teenagers who are continually
and severely policed but still live
life to the full.

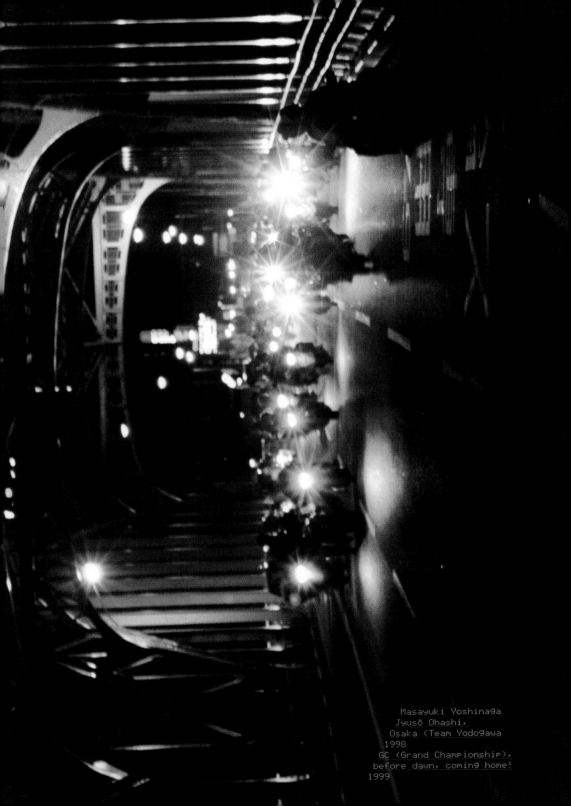

Masayuki Yoshinaga
Jyusō Ohashi,
Osaka (Team Yodogawa
1998
GC (Grand Championship),
before dawn, coming home!
1999

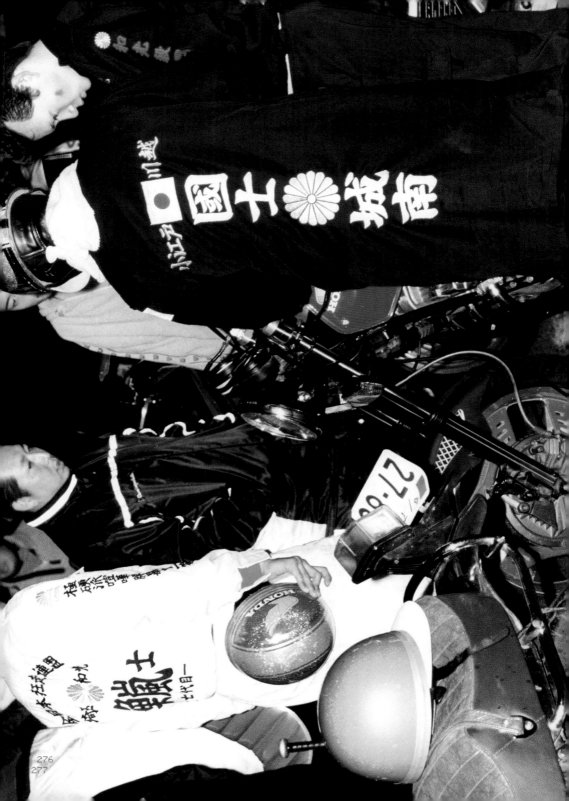

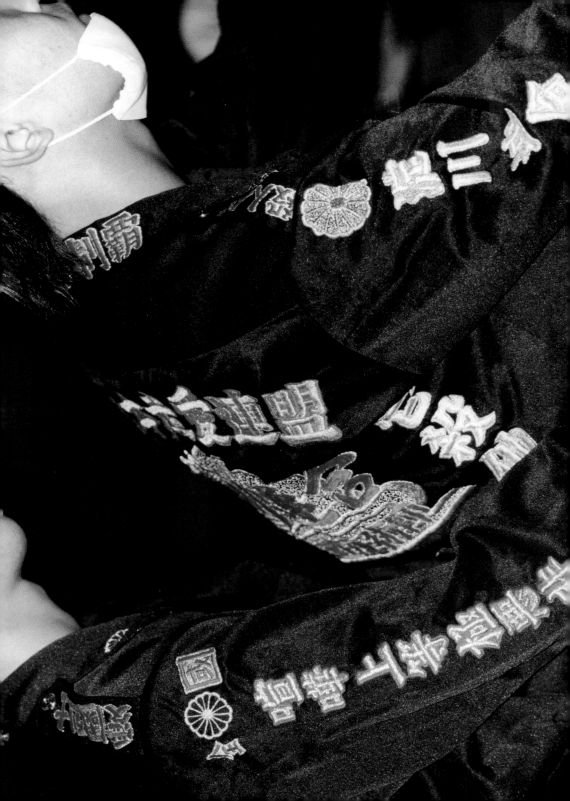

Masayuki Yoshinaga
GC, Blizzard
1999

JAM:Tokyo-London Interviews
JAM:Tokyo-London Interviews
JAM:Tokyo-London Interviews
JAM:Tokyo-London Interviews
JAM:Tokyo-London Interviews
JAM:Tokyo-London Interviews
JAM:Tokyo-London Interviews
JAM:Tokyo-London Interviews
JAM:Tokyo-London Interviews
JAM:Tokyo-London Interviews
JAM:Tokyo-London Interviews
JAM:Tokyo-London Interviews

Interview 01 Airside
Interview 01 Airside
Interview 01 Airside
Interview 01 Airside
Interview 01 Airside
Interview 01 Airside
Interview 01 Airside
Interview 01 Airside
Interview 01 Airside
Interview 01 Airside
Interview 01 Airside

Catherine Wood Can you explain how your different backgrounds have fed into Airside?

Fred Deakin We are from three very different disciplines, unlike most web companies that are either purely technical or graphics-led. We have a spread of skills. I've got a background in graphic design, running clubs and making music. Nat has looked at the human-computer interface, even before the web, because she studied psychology at university.

Nat Hunter And Alex has trained as an architect.

Catherine Wood In terms of explaining what Airside is, on the one hand you make websites that are accessible and user-friendly. And on the other hand, you make game-style sites that seem to play on the inherent frustration of using computers, but in a creative way.

Nat Hunter It depends on the kind of experience you want to give someone. From running night-clubs, Fred thinks about the experience of entering the club building, what you see the minute you get in the door and what you're going to experience during the course of the evening, with differing impact in various rooms. I've worked with interactive performers on the way they interface with technology. So it doesn't matter whether you're doing the obscure stuff like the John Paul Jones project, or if it's something really corporate, you've just got to get your head around who the user is and who the client is.

Catherine Wood So you're building environments?

Fred Deakin Yes, it's experiential design. And the joy of working on the internet is that there are very few media that give you that degree of control. Reading a book or looking at a piece of art is a very tabulated media, but the web is somewhere you can destroy that and create a real life experience, the same as you can in a club. It's amazing how many similarities there are.

Alex Maclean If people respond well, they engage with it. It's also a sort of game; and they're hooked.

Fred Deakin It's the same with clubbing, if people are bored they'll leave. So once they're in the club you have to make them do things. There has to be a hook, a carrot. The same is true of the web; you can have the best design in the world and a great concept, but if you arrive at the website and there's no hook, you don't explore, you're just going to go somewhere else.

Catherine Wood So it has to anticipate every move that the viewer might make?

Fred Deakin Yes, it's a real dialogue. Our philosophy has always been that in order to get that kind of exciting interactivity, you need to work on the website from the ground up. We don't do window dressing. We won't come along to a site that's already been designed and make it look nice. Because of the nature of the data flow, ideas are much more important than resources and technology. This may sound fiercely non-commercial, but I think all the stuff that is really good, and feels right, is stuff that people are putting up themselves.

Nat Hunter We work best when we've got a good client that we really click with because then there's synergy, and we've got good clients mainly in the Arts and Entertainment.

Fred Deakin If you get a good client it's a bit like an artistic collaboration.

Catherine Wood How do you see the position of websites in the creative industries? Is the internet just a tool or is it an end in itself?

Fred Deakin Corporations are desperately trying to gain control of the internet. There's talk about people buying sections of the internet, but at the moment, its still the Wild West, it's anyone's game.

Catherine Wood Why have you chosen to work on the internet?

Nat Hunter Partly because you can do what you want and have a lot of control. Also, it's a way to make money at the moment. What we like to do is make things like animation, and t-shirts, but you can't make much money doing that.

Catherine Wood Why does the internet appeal more than making a TV programme or a film?

Alex Maclean It's the idea of a world network where people get lost in their own 3-D environment.

Nat Hunter Like with a chat-room, the most amazing coincidences happen every day. It makes the world so much smaller.

Fred Deakin It's the sense that you can do something exciting and it will have an audience of as many people as can find it. It's like clubbing, but on an international scale, a global club. Plus, we can realise our ambitions very quickly on the web.

Catherine Wood Do you see the freedom that the web has given you feeding into the creative community in London as a whole?

Nat Hunter We like making in-roads into the wider London community. Our t-shirt service is a very good example of that. Every year, and this is the third year, we get some people to do us a design for a t-shirt. Then we put a flyer out saying give us £70 or £80, and you'll get four t-shirts. This year we've got Graham Rounthwaite, as well as Pete Fowler and Tom Hingston designing for us.

Catherine Wood And people trust your choice because they know your aesthetic.

Fred Deakin We tell them who has designed the t-shirts, and buyers usually know their work, but they don't know what they're actually going to get. In order to reward people for trusting us with their money the deal is we'll never reprint the t-shirt. We only print the right amount. Then when people ask, where did you get that t-shirt, they can say, I got it in the Airside t-shirt club, but you can't get one!

Nat Hunter People have been offered hundreds of pounds for them.

Fred Deakin It's an example of an experiential and interactive idea that has nothing to do with the internet. We haven't done it on the internet. We do it with flyers and postcards. It's taking the idea of a website, but it's not realised as a website. It's about the way we think. Website, t-shirt club, nightclub, they all operate on the same level.

Catherine Wood The web community is so expansive in contrast with the local community of a club. For Airside, what role does word of mouth play in both?

Alex Maclean We've started looking at who is visiting our website and found that 400-500 people look at it every day.

Fred Deakin We're not trying to run it as a huge, spectacular commercial operation like a dot.com. At some point, websites will start making money but they don't at the moment, because the heart of the web is low-fi. It's "punk rock art rock", why not make a website about anything.

Catherine Wood What do you feel about visual artists who are known for other types of work who then make web-based work?

Fred Deakin Some people get it right, we've seen some interesting stuff, some good webcams.

Nat Hunter Some people use the technology of the web very well. There's a piece with four webcams set up around the world, called something like "Public Safety Watch".

Hunter The idea is that if you see a crime being committed, you fill out the crime report on screen and it is automatically faxed to the nearest police station.

Fred Deakin FAT had a webcam site with cameras around the world, and the image refreshed every six seconds.

Nat Hunter It wasn't technologically complicated, but the content was really funny.

Catherine Wood Which artists working in London do you like? And do you feel that there is a connection between Tokyo and London?

Fred Deakin We particularly like Anthony Burrill and Graham Rounthwaite, who are our mates. I think there's an irreverent attitude and a change of order going on. We can feel it, and the democratising that's happening via the internet isn't only confined to that, it's having an effect in the design community as a whole. In terms of design and culture in London, there was a big change when activity shifted to the East End from the West End. It was almost like the Emperor's New Clothes. As for Japan, Japanese culture had a big influence on London's club culture about ten years ago and it hasn't gone away. We like to think that the Japanese slavishly write down everything Londoners do and copy that, but it's not true! It's a two-way street.

Alex Maclean There seems to be a shared sense of humour that creates links between the UK and Japan.

Catherine Wood Perhaps because our culture is becoming more visual; that enables us to have more of a relationship with Japan despite the language barrier.

Fred Deakin Yes, it's all about imagery.

Alex Maclean It's also about process, in terms of design, furniture, products and architecture. Japanese style, that pared down, elegant minimalism, has been lapped up here.

Nat Hunter Plus the Japanese understood club culture in a way that Americans are only just beginning to. They spotted it right away, and were coming over here saying, this is cool! Japanese business people would come into our studio every couple of months and say, give me everything you have, and pay us in cash!

Interview 02 Bump
Interview 02 Bump
Interview 02 Bump
Interview 02 Bump
Interview 02 Bump
Interview 02 Bump
Interview 02 Bump
Interview 02 Bump
Interview 02 Bump
Interview 02 Bump
Interview 02 Bump
Interview 02 Bump

Catherine Wood When did you first meet?

Jon Morgan At the Royal College of Art in 1995.

Mike Watson We set up when we won a bursary in a competition.

Jon Morgan It came from a merchant bank, they gave us some money to buy a computer. We borrowed a business plan from a friend, his dad was the chairman of the Chartered Institute of Accountants. So we knew it was watertight and we just changed the names and the numbers a bit. It was originally for gardeners. And we got money for our first computer kit, which we all sat around, it was hilarious.

Catherine Wood Who was involved back then?

Mike Watson There were three of us, including a girl called Nicky Gray.

Jon Morgan She left to have a baby, and didn't want to come back.

Mike Watson It's a shame in one way and it's good in another way, because our work changed completely after that.

Catherine Wood What did you do before?

Mike Watson We did very serious, tight graphics. Because, when we left college all the other graphics students said we wouldn't last long. So we thought, we'll do serious graphics. But we didn't really know what we were doing. And then Nicky left, and we went out and just mucked around all the time, and we realised, it's actually fun to do that stuff rather than sit there all day thinking, mmm, I've got to do this! So, we mucked around and realised that was part of our work.

Catherine Wood At college, were you just mucking around and that's why the other students said you wouldn't last?

Mike Watson Yeah. And there was that kind of attitude of, people don't like you because you've won a competition. We started to do lots of different work. And we took on illustration work. The first illustration was for *The Face*.

Jon Morgan We didn't want do any illustration, we just wanted to do graphics. And then somebody asked us to draw combat trousers, and from there it all changed, and lots of people started commissioning illustrations from us, including new women's magazines in America. They'd just phone up.

Catherine Wood What work had *The Face* seen?

Mike Watson I don't know.

Catherine Wood How did they know of you?

Jon Morgan It came via a friend of a friend.

Mike Watson They knew what we did but they hadn't seen our work before. They got us in and asked, can you do this? and we said, yes, we can do that.

Catherine Wood That was in 1995?

Mike Watson Yeah. We drew the figures in a style of soldiers - a sniper, a hand grenade thrower and a guy kneeling down at a machine gun. Then an American magazine called and asked, would you like to draw stuff for us, and we said, yeah! and they said, make-up? and we said, NO! But then we thought, we will do it... I probably wouldn't do it now but then it was perfect because it made us experiment and try working in different ways with the computer. And we needed the money as well.

Catherine Wood Do you draw those lines on the computer?

Mike Watson Yes, everything is drawn on the computer. We scan images and draw other them. We just cheat, we can't draw.

Jon Morgan Then we started drawing little cards.

Catherine Wood And did you give them away?

Mike Watson Yeah, our phone number is on them. If we thought someone's work was good, we would leave a card at their exhibition, or we would send a different one to someone we didn't like. It was quite good fun. We call them "The set of six" and we started by illustrating six different words.

Catherine Wood And at the time you were also doing freelance work?

Mike Watson Anything at all.

Catherine Wood And then you started doing corporate branding jobs?

Mike Watson That was quite early on.

Catherine Wood Do you like commissions like that?

Mike Watson Yeah.

Catherine Wood It seems really different from your earliest work.

Mike Watson Why differentiate between illustration, graphics and fine art? You do a piece of work well and enjoy it. I can see the difference though because the commercial world is shit but it's part of society and you can't really get away from that.

Jon Morgan You put different hats on. You've got that nice flat cap...

Mike Watson With bells on. You know, that big London one...

Jon Morgan Oh, God! We could sell those!

Mike Watson You could make funny hats. We don't normally show every client every single piece of work because, if we do a corporate job we do it through an advertising agency such as League Delaney, so they wouldn't show their clients certain things. If they showed the cards with people weeing and pooing, they would just say, ahh, thank you, goodbye.

Catherine Wood Do you consider that there are two main strands to your work; the funny stuff and then the branding?

Mike Watson It's one very big wide river... and then we did film work...

Jon Morgan A lot of tiny identities for digital channels.

Catherine Wood So you're doing films and performance and illustration and graphic design.

Mike Watson Yeah, and bank robberies and weekend jobs at the fish and chip shop.

Jon Morgan We did some stuff for fashion.

Mike Watson We love fashion.

Catherine Wood Why? That's quite a pertinent question for JAM.

Mike Watson I just like squeezing my privates in my trousers...

Jon Morgan I like squeezing you and your trousers... We did some fashion shoots for magazines. But it's completely unpaid.

Catherine Wood Who was it for?

Mike Watson The art director at *Tank*. And we made it quite dark with designer glasses looking through the cat flap. They're quite sinister images. I don't mind fashion. Some fashion is rubbish but it's like everything, isn't it?

Jon Morgan We don't choose any of the clothes.

Catherine Wood Which other artists do you like?

Mike Watson Laurel and Hardy.

Jon Morgan Eric Morecambe.

Catherine Wood So, it's mostly...

Mike Watson Comedians.

Jon Morgan I like Fluxus, because they've done everything.

Mike Watson Every piece of work we think about doing, we can find a piece that's been done by Fluxus, and better.

Catherine Wood But their work wasn't funny.

Mike Watson Some of it looks funny, like the hand and glove letter and envelope sets, they're lovely.

Jon Morgan You find them in the Tate Gallery these days.

Catherine Wood What's the hand and glove thing?

Mike Watson It's these envelope sets. You write on the piece of paper and then you put it in the envelope, so when you pull it out it makes a naked woman in a fur coat.

Catherine Wood That does sound funny. What artists do you like in London now?

Mike Watson I like Gavin Turk. I like his Sid Vicious wax work. I also like Jacques Tati. He was an absolute genius. Just the way he makes a cellar door open again and again, it makes you laugh over and over until you cry. It's amazing stuff. But designers are all rubbish, there's no designer who's any good, except Peter Saville and Graham Wood. Peter did some work for the British Council exhibition we designed and he was the last person to deliver his artwork. So, to get a work out of him I thought, right, I'm going to ring that guy. I rang, and after an hour put the phone down. John asked, did you get the work? and I said, no, but we're going out for tea!

Jon Morgan He's a genius and an amazing talker, you just kind of sit there...

Mike Watson And he's passionate about what he's done. He loves it. He loves the way he looks, the way he lives. I also like Anthony Pollack's work. It's just really beautiful.

Jon Morgan Michael Marriott is our favourite furniture designer.

Mike Watson Yes, we love him because his work is quite similar to ours. It's very English, very rubbish but not rubbish.

Interview 02 Shoreditch Twat
Interview 02 Shoreditch Twat
Interview 02 Shoreditch Twat
Interview 02 Shoreditch Twat
Interview 02 Shoreditch Twat
Interview 02 Shoreditch Twat
Interview 02 Shoreditch Twat
Interview 02 Shoreditch Twat
Interview 02 Shoreditch Twat
Interview 02 Shoreditch Twat
Interview 02 Shoreditch Twat

Catherine Wood How did the *Shoreditch Twat*, which is designed by Bump, come into being?

Neil Boorman On a very basic level, the *Shoreditch Twat* originated as a marketing tool for 333. The venue's style, content and attitude was very different to that of most other London clubs. The majority of venues in London were becoming more mainstream in their aesthetics with slick interiors and flyers, and big money DJ line-ups. 333 was bucking the trend with its shabby interior, local promoters and esoteric programming. We wanted to reflect that in our marketing, so the *Twat*, with its sloppy design, hit and miss content and poor production values was initially used to voice our alternative. More importantly though, I was personally frustrated with the way that club and youth culture was being represented by the Dance music and lifestyle press. They all seemed to be toeing the same line, never forwarding any sort of critique. Nobody was prepared to be political, to say, this or that is bollocks. So I used the *Twat* to have a pop at subjects most magazines and advertisers wouldn't touch with a barge pole. The *Twat* looks and pretty much is, a load of rubbish, but there is a serious sentiment behind the jokes.

Catherine Wood Can you say something about the participants. How and why did you all start working together?

Neil Boorman It isn't easy finding contributors who will stick their necks out and actually make a statement. It's even harder doing it with a sense of humour. We get sent stuff anonymously, some writers contribute under pseudonyms; writers moonlight for us, slagging off the very people that employ them. We rarely edit pieces and almost no subject is taboo. I suppose that our contributors are attracted by the freedom of expression. I'm proud of the quality of work we get in and I'm amazed at the effort some people put in for such low financial returns.

Catherine Wood What, if anything, do you think is culturally exciting in London now?

Neil Boorman Despite its gradual commercialisation, I still think that London's club scene is something to be proud of. Take a trip to any big city, and you realise how diverse, how sophisticated London's clubs are in comparison; from the styling to the visuals to the sheer range of music on offer. People in London are too cynical to realise what a good thing we've got going here. It's interesting to see the arts slowly embrace street culture in London; DJs at the ICA, touring exhibitions of club visuals, performance art and films at some events. I think the art world has more to gain from the link than clubs do, but it's interesting to watch the boundaries blur.

Interview 03 Hussein Chalayan

Interview 03 Hussein Chalayan
Interview 03 Hussein Chalayan
Interview 03 Hussein Chalayan
Interview 03 Hussein Chalayan
Interview 03 Hussein Chalayan
Interview 03 Hussein Chalayan
Interview 03 Hussein Chalayan
Interview 03 Hussein Chalayan
Interview 03 Hussein Chalayan
Interview 03 Hussein Chalayan
Interview 03 Hussein Chalayan

Fumiya Sawa Is London still inspiring?

Hussein Chalayan I think London is an accommodating place for ideas and for meeting people. It is where different disciplines melt into each other more than most cities in the world. We have music, fashion, art, interior design and architecture. I think they are close here. Also it is very cosmopolitan, which makes London interesting as it creates more texture. In that sense, it is a nice place to be.

Fumiya Sawa I have seen some interesting obsessions in your collections. Are you obsessed with anything right now?

Hussein Chalayan I don't think I am an obsessive person. I have interests in certain things. I have always been interested in technology, and there are elements of technology in my clothes. And I work in a cross-disciplinary way with people in other fields who contribute to what I am doing. I am also interested in forms generally, not just in clothing but other things too. But I wouldn't say I am an obsessive person.

Fumiya Sawa But you are full of curiosity...

Hussein Chalayan Yes, I am definitely a curious person. I am very curious about everything. When I find something interesting I have to find out more. I may be obsessive in that sense, but that is not necessarily reflected in my work.

Fumiya Sawa What aspect of technology are you interested in?

Hussein Chalayan I'm principally interested in the philosophy of science, in understanding how it affects our lives. I am also interested in how you can use technology to achieve forms.

Fumiya Sawa Are you a functionalist?

Hussein Chalayan Up to a point, yes. But that is part of Modernism as well in a way. At the same time, I like decoration too, if there is a good reason for it.

Fumiya Sawa Are you inspired by other arts and science as well, because your work seems to relate more to fine art or performance than fashion?

Hussein Chalayan It is a natural evolution of my work. I am not really that up to date with what is going on in the art world or the performance world. I go to see exhibitions from time to time, but not obsessively. I just do what is good for my work. I know you don't mean it this way, but because I am a designer, it doesn't mean I don't have other ideas! I don't think people should be surprised if designers also have other ideas connected to their work, it's a natural progression for me. It's not coming from what I have seen.

Fumiya Sawa But the music that you use for your shows is very interesting, for example.

Hussein Chalayan I use it because I am inspired by it. That is enough. I like my music very much, and the music I use suits my work too. It has been an evolutionary thing. I have always had live music, but perhaps one day I won't.

Fumiya Sawa I'm very excited by your shows, but do buyers get it?

Hussein Chalayan When I put on a show buyers aren't my main concern, but one of my concerns. The show is about creating spirit and atmosphere within the space, how I expand the idea through the space and how the girls use that space.

Fumiya Sawa You sound like an artist using clothes and bodies rather than a fashion designer.

Hussein Chalayan I am an ideas person. At the moment I am working on clothes and will work on clothes for a long, long time. I am a designer with ideas, not an artist using clothes. You don't necessarily have to call someone an artist if he is inspired by something and makes something based on an idea.

Fumiya Sawa Then what is the fascination with using clothes to develop your ideas?

Hussein Chalayan I am interested in form and clothes and the way that evolves around the body. I enjoy the craftsmanship of clothes. Also, there is a spatial aspect. You alter the way the body comes across the space, and then the body alters the clothes within the space. I've been interested in this for for many years.

Fumiya Sawa Are you fed up with being compared with Belgian and Japanese designers?

Hussein Chalayan No. Although our works are very different, we share a similar spirit. My work is a little bit more body conscious than some Japanese designers. They often use their own culture but I don't really use my culture as a point of reference. Perhaps I did a couple of times, but abstracted it so that you couldn't trace it. They seem so far ahead of me anyway, because they have been doing it for so many years and I still have so much to learn. So it is rather a compliment for me to be compared to certain designers. Culturally speaking, Turkic, but not Turkish, culture has its roots in the Mongolian mountains. So our clothes have Oriental elements like big sleeves and kimono-like shapes. There are lots of cross-overs. In Turkish Cyprus, you don't see many people wearing traditional clothes even in the rural areas though. Our costume culture is now evident only in folklore culture, whereas in Japan you still see many people wearing kimono for special occasions such as weddings and festivals. I may use the Turkic culture again as a reference for my design.

Fumiya Sawa Traditional clothes have certain effects on the shape and movement of the body. They impose a social or cultural code onto the body. Sometimes it is promoted by men's desire to make women look more graceful. Do you think about the physical or psychological effects that wearing your clothes has on a person?

Hussein Chalayan At certain times in history there were elements of societal restrictions embodied in traditional clothing. But these days those restrictions don't apply, as women's roles have changed totally. Yashmak were worn by Arab women so as to be protected from men because the population of women was so small. Now the population has evened out, so those garments don't have the same function anymore, they simply relate to history. It may be a good thing because they help you remember traditions or the past. The body, in some respects, is the biggest symbol of tradition. That is why I am interested in re-animating certain thoughts around the body, because you can alter the idea of the body in the way you present it.

Fumiya Sawa What are you most curious about right now?

Hussein Chalayan It is very abstract, but I am interested in how sound relates to form or the way smell relates to form, and how abstract thoughts relate to real life, such as looking at somebody's face and trying to imagine what kind of person they are. This idea of whether form has anything to do with the spirit fascinates me a lot. It is hard to explain... I think verbal language is too dominant and is too limited for explaining sensations such as smell or pleasure. So, I think my expression through clothes is a kind of language too.

Interview 04 Elaine Constantine
Interview 04 Elaine Constantine
Interview 04 Elaine Constantine
Interview 04 Elaine Constantine
Interview 04 Elaine Constantine
Interview 04 Elaine Constantine
Interview 04 Elaine Constantine
Interview 04 Elaine Constantine
Interview 04 Elaine Constantine
Interview 04 Elaine Constantine
Interview 04 Elaine Constantine
Interview 04 Elaine Constantine

Jane Alison What inspired you to become a photographer?

Elaine Constantine It wasn't really an idea it was a series of accidents. At school I was good at drawing so I wanted to end up doing something artistic. I was given a camera by an aunt who was going blind and I went to a camera club and, by a series of accidents, I ended up doing jobs, such as being a technician and an assistant to a museum photographer until I ended up teaching.

Jane Alison What made you come to London?

Elaine Constantine I started teaching in an HND Design department with students studying graphic design and fashion design; and the students collaborated to make brochures for their final collections. I got involved doing the photography and really enjoyed the creative process of recording the students' fashion projects. Seeing those final printed pieces gave me the inspiration to try to be a fashion photographer. I used to do tests at night with one of the college's fashion lecturers, he'd style and I'd photograph and we'd bring together ideas. At that time I didn't have much confidence or vision and I would go along with what everybody wanted to do and there are very few images that I actually like from that period. Then this person who had been doing my job before me and was on maternity leave, came back to work part time, and she was really great. Her husband had taught Nick Knight and she knew that he was looking for an assistant to do the Natural History Museum project. And I had been an assistant to a museum photographer plus I had a fashion background, so I came to London for an interview and he gave me the job. So that's how I ended up in London.

Jane Alison What did that major life change feel like?

Elaine Constantine The actual time spent assisting was pretty horrific; there was a steep learning curve. But to be privy to that experience let me know at exactly what level I could get into this business. I don't like the word arrogance, but I had a knowledge of fashion and technique from working in Manchester. So, I would sit in a lab developing Nick's stuff and see what else was coming through and being paid for and think, this is shit, I can do better!

Jane Alison You're known for taking a particular type of photograph, how did you find your own style?

Elaine Constantine I didn't find my style until I started to do fashion images rather than portraits or documentary shots. Because you've only got five minutes in a portrait session with someone famous, you just go around doing whatever they want to do and then the image comes back looking nothing like you intended.

Jane Alison Is that what you started out by doing?

Elaine Constantine That's what the magazines give you before they try you on fashion. But I kept going back to fashion ideas and eventually *The Face* introduced me to a couple of freelance stylists who they weren't taking very seriously at the time; and I came into that category too. I met three stylists who were all the same age as me and we had very similar experiences. We were all interested in youth culture and were sick of that grungy squat-style imagery. Even though that imagery had been inspirational, the level that it had got to by 1993-1994 was that people who hadn't even initiated it were just repeating it in a really crass, thoughtless way. I know it completely changed the way that people look at fashion, but it had had its impact already. Also, I'd been a Mod as a young person and was quite repelled by the idea of grungy clothes, I was into

ironed stand-up collared shirts, so it was an anti-culture for me. And I had grown up in a big family, in a very small house, and that anti-attitude wasn't what I aspired to. I was inspired by things that were more glorious and beautiful, they might be ordinary but never dowdy. I met the stylist Polly Banks who had a similar upbringing to me. We were exactly the same age and we went to *The Face*, with loads of ideas. But it took them a long, long time to commission us — not until 1996. We did the South Coast story in 1997, with the seagull and the bikes, and by then I'd worked out exactly what kind of imagery to aspire to.

Jane Alison The South Coast story was the one that got you noticed?

Elaine Constantine On a wider level yes, because people who didn't read *The Face* knew about it and wanted those images; there was a bit of a buzz. People sent letters saying it was the best thing they'd ever seen.

Jane Alison You've said that fashion photography is what you do and that is all you want to do because it's what you're good at. How do you think your career will develop?

Elaine Constantine I was talking about it in commercial terms, but I don't know if I can keep doing more stories for commercial or other mainstream magazines. I've proven that I can do it, perhaps now I should just calm down and do advertising, but at the same time I still have creative ambitions. I may take a break and work on some images that are not commercial because I've never really done that. There are ideas that are slightly more ongoing than a fashion story that takes a week to shoot. In terms of success, I feel that I've achieved everything I wanted to. I don't intend to be the next Mario Testino or Steven Meisel, because I can't shoot that amount of work. I find it compromising, boring, soul destroying. I have been on trips where I have had three consecutive shoots that have lasted fours weeks and by week two I'm at the end of my tether. It's not a physical thing, it's a mental thing. It's just not the way I want to work, it doesn't give me any warmth or satisfaction. But, equally, I have absolutely no qualms about earning shit loads of money, because it liberates you and it makes all the working hours worthwhile. It allows you to build your dreams. Anyone who says they don't like the money is bloody lying.

Jane Alison Of the pictures in the exhibition, which are you particularly proud of?

Elaine Constantine I really like "Juliet with the yoyo" because it expresses that kind of obsession and concentration you have when you get into something. The people who get into yoyos normally skateboard; they're into all those kinds of physical tricks. Juliet is from a sporty background, she was a champion skateboarder and it comes out in her character. I don't normally try to get somebody's character but I think I managed it in that image.

Jane Alison Do you feel like a lone figure, as a successful woman photographer in London?

Elaine Constantine There are people I collaborate with who are quite similar to me, but to be honest I don't really go out so I don't meet many people who work in this industry. I've got friends, who aren't involved in art or fashion, who I go to all-nighters with and they are really good people, so I don't feel alone. My girlfriends have different types of jobs, aren't obsessed with the latest craze, and have opinions without being in any political parties.

Interview 05 Cornelius
Interview 05 Cornelius
Interview 05 Cornelius
Interview 05 Cornelius
Interview 05 Cornelius
Interview 05 Cornelius
Interview 05 Cornelius
Interview 05 Cornelius
Interview 05 Cornelius
Interview 05 Cornelius
Interview 05 Cornelius
Interview 05 Cornelius
Interview 05 Cornelius

Suzannah Tartan What is the essence of Cornelius?

Cornelius It differs from time to time. There used to be a mix of influences, but now I am

ornelius trying to make it simpler, so that instead of a jumble of things, I want it to
rnelius be more seamless or blended. Until now there were so many factors in my music that
nelius sometimes I got confused. From now on I want there to be connections between each
elius piece of information.

Suzannah Tartan What inspires you?

Cornelius The things I see when I walk to the studio or when I am eating or having tea.
ornelius There are at least three times a day when I find something especially inspiring and
rnelius I try to grab these moments. For instance, when I was eating yoghurt and ice-cream,
nelius that was very inspiring. They are both white so mixing them up wasn't weird. After I
elius discovered it was good, I ate it everyday for two weeks.

Suzannah Tartan What aspects of Tokyo influence what you do?

Cornelius I'm not really conscious of it because I've always lived here, though I think it
ornelius might have some influence.

Suzannah Tartan What is special about the Tokyo music scene? Are there any similarities to
uzannah Tartan what is going on in London?

Cornelius I can't really generalise because there are so many different things happening
ornelius in Tokyo. Perhaps the voltage is higher in the UK, and the lights on stereos are
rnelius brighter there. Perhaps there are some distinct sounds that people overseas might
nelius pick up because of the different voltage.

Suzannah Tartan What is the relationship between your music, products and design?

Cornelius I have a vague image of the concept at the start, but I make the music first so
ornelius there are a whole set of images that are then actualised into goods.

Suzannah Tartan What is your process for producing music?

Cornelius I get to the studio, buy milk-tea from the vending machine, smoke cigarettes,
ornelius do some pull-ups from a bar in the studio, and then play with some instruments for
rnelius a while and depending on what I'm feeling at that moment and what kind of instrument
nelius I'm using, I put something on tape. After a while, I get hungry so I go out and eat —
elius which is very important — and then I come back and read the newspaper. Then I go out
lius to the veranda and exercise. After that I play back the tape again and over-dub with
ius other instruments. Then I eat yoghurt and ice-cream and watch the news; that takes about
us an hour. After that I go up to the studio again. Then I get sleepy and go home. This has
s been going on for over one hundred days.

Suzannah Tartan What makes a sound interesting?

Cornelius When I have a habit and then I get bored, it gives me a new perspective.
ornelius For example, everyday we leave the studio and go to the convenience store and it
rnelius always has the same products so I began to mix yoghurt and ice-cream and that was
nelius a fresh discovery. I think finding sounds is something like that. Sometimes in my
elius studio, I get bored and then I get crazy ideas like holding the bass upside down or
lius changing the gauge of the strings.

Suzannah Tartan How would you define Pop?

Cornelius Yoghurt and ice-cream; that's Pop.

Suzannah Tartan Could you live without music?

Cornelius I think I could.

Suzannah Tartan Happily?

Cornelius That might be a bit difficult.

Interview 06 Paul Davis
Interview 06 Paul Davis
Interview 06 Paul Davis
Interview 06 Paul Davis
Interview 06 Paul Davis

Interview 06 Paul Davis
Interview 06 Paul Davis
Interview 06 Paul Davis
Interview 06 Paul Davis
Interview 06 Paul Davis
Interview 06 Paul Davis
Interview 06 Paul Davis

Fumiya Sawa What is your new project for JAM all about?

Paul Davis I've been doing a lot of drawings about new technology using old technology to see if people understand it. Lots of people I have been talking and listening to are involved in new media, e-commerce, virtual reality and other associated businesses. That inspired me to choose this as my subject matter. New media is a money-making exercise. It was supposed to be educational, but it is just full of vacant promises, geeks and boredom, apart from pornography, which are the most visited sites; great democracy. When I use pencils, pens and paints, I think it lends a nice sweet naiveté to the subject and I love doing it.

Fumiya Sawa You used to want a computer. So have you had enough of new technology?

Paul Davis I got a computer because I could mail my work out to lots of people electronically, which is very useful. Shame about couriers though. The other thing is colour. You can tweak colours so finely. I hope my colour sense has improved because of computers. It's still my eyes and brain making the decisions, but it helps me enormously.

Fumiya Sawa Has your computer changed your style of drawing?

Paul Davis No, I don't draw with it. I just scan my drawings. It's purely a tool, mate!

Fumiya Sawa Do you have two jobs, illustrator and artist?

Paul Davis Yes. If you are an artist and also working in a pub, you are an artist and a barman. Why not be an artist and an illustrator? I realise that there is a huge difference between art and illustration. Illustration is usually based on someone else's idea. You illustrate to try to make an audience interested in the article or the product. When you come up with your own idea and realise it, that is art. Illustration is not the genesis of the project, it is the second or third stage. I preferred working as an artist, but I was so poor, and didn't know what to do. I had always drawn people so I decided to get involved in drawing fashion. As designers' collections change four times a year, I felt there would probably always be work. It worked. Unbelievable! This led to other things. Art and fashion are closely linked, anyway. They hang out together.

Fumiya Sawa I was impressed with the way you work as a fashion drawer. You once sent drawings of naked bodies to magazines in Stockholm and Hong Kong so that their stylists could choose the clothes and then you "dressed" them with drawings. But at the same time, I think you sometimes draw like casual-style photographers in Tokyo. Do you relate to them at all?

Paul Davis Absolutely! A similarity is that I consider the drawings that I do to be based on things I overhear, to be decisive moments. The difference is that I use words. But photography with words rarely works. The more you draw with the intent of trying to make someone understand what you are saying without words, the better it is. But the subjects I choose seem to have words in them. So, am I a writer or an artist or an illustrator? Am I French or English? I don't know. Do I care? Not really.

Fumiya Sawa As an artist, are you mostly inspired by observing people?

Paul Davis It never fails to amaze me how wonderful things can be if your eyes and ears are open. I live in a city with millions of others. Why do people live here when cities can be the loneliest places? But look at Shoreditch, packed with new technologists who are developing things. They are socialising and networking every night; it's a satirist's paradise.

Fumiya Sawa London is obviously important to you?

Paul Davis Any city is. I went to Los Angeles recently and asked people what they thought of

Paul Davis England and the English, and I had such a good time doing that. It was so simple;
I hired a huge Harley-Davidson and rode all over California interviewing people.
It was like documentary drawing.

Fumiya Sawa You have worked for the Japanese fashion designer Yohji Yamamoto, the musician
Ryuichi Sakamoto and for the comedians Yoshimoto, as well as for Sony and various
clothes shops. Why do you think you are understood by the Japanese so well?

Paul Davis It is probably my scurrilous sense of humour. We, in England, have nothing else
to offer the world. I don't know why it works in Japan, though. It's difficult to
talk about the whole nation or even a city, because they're so different. But there
is a tradition of drawing in Japan, which is much more prevalent than in this
country. I see adults reading graphic novels on trains and I think that's great.
Unfortunately, I don't understand them. But they seem quite serious.

Fumiya Sawa Does the visual language of Japan overcome the language barrier?

Paul Davis Yes, line and colour. It's very simple, boiled down to its essence. Perfect line
with poetry is enough. I quite like minimal stuff. The better the idea, the less
you have to do. But less is not necessarily more. Enough is enough.

Fumiya Sawa Is there anything that photography can do that your drawings cannot?

Paul Davis Loads. Photography is important. Everyone uses a camera. Nobody says, do you want
to see my holiday drawings? Technology is important, but the person who is holding
the camera is more important. If you have the brain of a grasshopper, you cannot
decide when to take photographs. It is up to us. But a camera does lie. There are so
many ways of looking at scenes. Two different photographs of the same scene can tell
completely different stories, especially now with image manipulation. So photography
isn't necessarily real. Having said that, it is possible to capture a moment with a
camera, but impossible to catch it with a pencil. It takes 250th of a second with a
camera and 25 minutes for me with a pencil. I'm using a camera for my project at the
Ridley Road Market to do the overhearing stuff. Sometimes I feel like a parasite. But it
makes me laugh. Life is absurd, and that cheers me up.

Interview 07 Deluxe
Interview 07 Deluxe
Interview 07 Deluxe
Interview 07 Deluxe
Interview 07 Deluxe
Interview 07 Deluxe
Interview 07 Deluxe
Interview 07 Deluxe
Interview 07 Deluxe
Interview 07 Deluxe
Interview 07 Deluxe
Interview 07 Deluxe

Suzannah Tartan How and why did you all come together to form Deluxe?

Namaiki We all had similar perspectives and could see the merits of cross-pollination.

Klein Dytham architecture We thought it would be cool to share a bigger office, not just
because we were working together on several projects but because
there was definitely a strong synergy and crossover. The key was
not to step on each other toes, so there is only one office per
discipline. KDa – architecture; Spin Off – interior design; Namaiki –
art direction and graphic design; Rob and Nakameguro Yakkyoku – high-end
computer graphics and DJing; DoReMi – sound composition and production;
and to lubricate the wheels, Tokyo Brewing Company. As someone once said
when they were walking round Deluxe, the only thing we were missing was
weapons and we could start a revolution!

Suzannah Tartan If "deluxe" is better than standard, or superior, what is especially deluxe
about Deluxe?

Namaiki Apart from deluxe being a piss-take on the decrepit state of this building when we
took it over, it just summed up how we were feeling at the time.

Klein Dytham architecture Deluxe is kind of universal and can be added to any era of design or any type of design. It's sort of that "alpha plus" bit extra, but it also indicates richness, an excess, irony and humour. Some deluxe products are ridiculous yet cool and kind of tongue in cheek. Our space is deluxe because it is a real luxury in Tokyo to have such a huge space where we can meet, exhibit, party or kick back. It doesn't matter whether it's fitted out with cool finishes or not, in Tokyo it's the fact that you have space that matters.

Suzannah Tartan Is there a commonality of approach amongst the group despite working in different, though related, fields? In other words, is Deluxe about more than just sharing a space?

Namaiki The range of people that come through this place is amazing. Musicians, artists, engineers, graffiti writers, architects, skaters, brewers. That's a very important part of the opportunity of shared space. Also, the fact that the people involved are successful in their respective fields and not conflicting with other members.

Klein Dytham architecture One of the main reasons for moving in with different disciplines was to generate crossovers, very much like our experiences at the Royal College of Art in London, where we were able to study in different departments. We all see our work as multi-disciplinary within our own fields, and Deluxe has allowed this to flourish in unexpected ways.

Suzannah Tartan How does being a foreigner effect what you do? Do you think you relate differently to the creative tumult of Tokyo because you are foreigners? What is particularly challenging, dynamic or annoying about working in Tokyo as compared to other cities?

Namaiki Tokyo is an excellent city. The range of opportunity here is enormous despite what CNN claims. People are funny and creative, despite what CNN claims. If you can accept that you're living in Disneyland, it's fine.

Klein Dytham architecture I think we all feel the same in Deluxe, it's that commonality of approach again! We don't see our office as Japanese or Western. It is a product of a group of interesting people in an interesting city – it just happens that we are here.

Suzannah Tartan How does your work interact with, respond to, ignore, or generally relate to the constantly morphing world of Japanese youth and subcultures?

Namaiki We work with interesting people who are doing interesting things. This sometimes coincides with the "constantly morphing world of Japanese youth and subcultures", but it isn't an intentional thing. The pace of Tokyo is very fast, so if you're trying to cater to a constantly changing market, you're constantly reinventing yourself. I think this approach misses the point of art, which is to explore personal uniqueness.

Klein Dytham architecture In Tokyo anything goes, and there is little need to follow the pack. Sure, boom and bust fads happen all the time, but everyone seems to respect what other people are doing, even if they don't like it. There is an insatiable thirst and acceptance of the new that we find incredibly stimulating. Nothing stands still, nothing is permanent in Tokyo, even the buildings. There are no classics because there is always room for improvement or refinement here. This makes for a very fertile design scene, which keeps us on our toes.

Interview 08 Enlightenment
Interview 08 Enlightenment
Interview 08 Enlightenment
Interview 08 Enlightenment
Interview 08 Enlightenment
Interview 08 Enlightenment
Interview 08 Enlightenment
Interview 08 Enlightenment
Interview 08 Enlightenment
Interview 08 Enlightenment
Interview 08 Enlightenment

Toru Hachiga What is the most important aspect of working under the title of "Enlightenment" rather than as Hiro Sugiyama, the illustrator?

Enlightenment Probably that I am a director, in that I look at what the other members of Enlightenment are creating from the point of view of an art director, and make appropriate decisions on our direction. And this applies to both Enlightenment and Hiro Sugiyama the individual, but it's important to aim for a positive form of expression and to be excited by what is being created.

Toru Hachiga There is an attention to detail unique to print media in the free papers *TRACK* and *Display*, but what was the reason for starting these two papers, and what did you most want to communicate and express through these two papers?

Enlightenment To create a vehicle or medium for expressing ourselves. We are constantly searching for new forms of expression, and these are then presented to the public. We've discovered that these two free papers are very effective vehicles. We want to show the world what most interests us at the moment. Thinking of ideas and then creating something after being commissioned for a job is not what we want to do. We relate what we are doing to each new job.

Toru Hachiga You had an exhibition at Colette in Paris in January 2000, and at Parco in Tokyo in October of the same year. Were there any differences between Japan and Europe in how people responded to your work?

Enlightenment There was no real difference in response. And, thanks to the internet, there is no longer any difference in the time it takes for people, both overseas and in Japan, to respond to our work.

Toru Hachiga Enlightenment's work is based in Tokyo at present. Do you think there are any differences in the graphic arts produced in London and Tokyo? If there are, what are they?

Enlightenment I don't really know what the situation is in London, so I can't say if there's any difference. But as far as Tokyo is concerned, I think graphic art is reaching saturation point. These days, anyone with a Mac can become a graphic designer, and non-individuality reigns. Everyone reads the same magazines, sees the same movies, listens to the same music and we're all living inside the same information base, and I think this situation makes it difficult for anyone with outstanding individuality to emerge.

Toru Hachiga I think what's so new and interesting about Enlightenment is its success in incorporating artistic concepts and approaches into the medium of graphic art, but are you conscious of graphics per se? Do you think there are any differences between graphic art and art?

Enlightenment Many different things in contemporary art inspire us. I think contemporary art has always been at the forefront of graphics, although the system and the mechanism of art and graphic art are completely different, I don't differentiate between the two when it comes to the actual creative process. We don't create something after receiving a brief from a client, but instead we use media such as *TRACK* and *Display* to convey our own work to the world, and as far as we are concerned, this is no different to showing work at a gallery.

Toru Hachiga You seem to be producing a lot of portraits recently. Why is this?

Enlightenment Although it very much depends on the subject's personality and his or her expression at the time, in my view, a finished portrait has a significance that is different to that of a still life. There are so many different expressions in a portrait, and there are new discoveries to be made each time. I've recently started using a digital camera to take pictures of people. By painting people that I've actually met and photographed, I can achieve a stronger sense of reality in my work. Reality is a theme that is important to us.

Interview 09 Shelley Fox
Interview 09 Shelley Fox
Interview 09 Shelley Fox
Interview 09 Shelley Fox
Interview 09 Shelley Fox
Interview 09 Shelley Fox

Interview 09 Shelley Fox
Interview 09 Shelley Fox
Interview 09 Shelley Fox
Interview 09 Shelley Fox
Interview 09 Shelley Fox
Interview 09 Shelley Fox

Jane Alison How important to you are the abstracted, formal qualities of your clothes? And at what point does the idea that bodies are going to inhabit the clothes influence your designs?

Shelley Fox The research, ideas and concepts come first and then, it's a bit like being an architect, I look at the minimum requirements. In the case of an architect it's to construct a building. With a garment, it has to go over the head or round the head; the arms have to come through and be able to move, same with the legs. In a way those are my only constraints. There's going to be other limitations later on, so I try and get rid of them in the beginning. Like a house needs a door, you need to get in and out, and after that it is how it's achieved that is open to interpretation.

Jane Alison So experimentation is very much part of your process?

Shelley Fox Yes but it's important to remember that people will wear these clothes. I think there's a balance. What I don't do is theatre, although, perhaps in the presentation it's OK.

Jane Alison Your clothes are very innovative and forward looking. You don't seem at all interested in retro styles, and you have a conceptual basis for the way you work. What inspires and influences your work?

Shelley Fox I think being in touch with fabric development has been really important. And a lot of the ideas that I've used – whether it's Braille or Morse Code or burning fabrics – they may come from one photographic image or a feeling. And you can get those ideas and feelings across in the presentation. I did some research at the Wellcome Institute's medical library, and just being in that building and looking at all the old books, which were really odd, was incredible.

Jane Alison Some of the ideas that you're interested in, to do with bandaging, healing and communication, seem very close to the conceptual nature of clothing itself. Does wrapping appeal particularly because it is a way of dressing the body but not in a conventional fashion way?

Shelley Fox I think seeing parts of the body wrapped, and the rest not, was a way of focusing on certain parts of the body. For the Braille collection it was interesting to go into the Institute for the Blind's product shop, because it was a cross between a shop and museum. All the objects that they sold were so basic and everyday and that was so fascinating. They sold things like an A4 block of paper with lines across it so you can feel when to stop writing. Looking at all these everyday objects designed to help people that can't see made me think more about how we take things for granted. One of my favourite things is a kit of Braille buttons for sewing inside clothing, to tell you what colour something is. For me, working with colour but not knowing what colour you are wearing, that's interesting.

Jane Alison Clothing itself is a signifier, it communicates something about the person who wears it, but you are also interested in other unusual means of communication.

Shelley Fox Yes. When I was looking at Morse Code, it seemed that the idea of it was obsolete. We were trailing around the Imperial War Museum archives, which is empty apart from BBC researchers. But it's the type of place where there is an enormous amount of information to be found. Morse Code is very basic but it's an alternative to coding; you don't need a special machine, you can do it just with a piece of wood. I found the hidden ideas in code really fascinating. Those idea's aren't taken literally into the clothing but they are a spark that sets me off on a pathway. They're starting points to the collection.

Jane Alison What ideas underpin your most recent collection and how were they translated into clothing?

Shelley Fox So many ideas were used. I've worked with an idea around pearl beading, but taking it away from what you would normally associate it with. We use them as

elley Fox kinetic highlighting or to disguise something else. We are also working on a
pleating idea that defies gravity because I'm always trying to make something look
effortless but not contrived, which is really hard work.

Jane Alison Are you constantly taking risks and are there commercial anxieties attached to
being so adventurous?

Shelley Fox Some things are seen as non-commercial, not so saleable, and I'm usually really
shocked because that's the stuff that sells. I have to analyse why it does, and
it's because I presented something a bit stronger. It's an interesting thing;
recently I read that you mustn't work out what is meant by saleable or commercial.
It's a fine line because people want to spend on things that are special. And that's
why I like to have time to sit down with a collection and re-edit it before Paris,
because we do our selling there, and after the show I can see more clearly. The
presentation is a very nerve-wracking experience. And then comes the media and buying
feedback. But we're on to our next collection by then and it's almost a year after
designing to getting customer feedback. That's why I was advised to always keep my style
and identity, and not to have too many ideas at once because you need to digest ideas in
order to create a recognisable style. But I need a starting point for a collection.

Jane Alison Are you aware of what other designers are doing? Do you feel part of a design
community and does that influence you?

Shelley Fox I am aware of what's going on but I feel completely outside it because, at the
moment, what's happening is very stylist- and magazine-led and not designer-led.

Jane Alison So how do you feel about stylists mixing your clothes with, say a pair of jeans,
or on the other hand, a photo shoot that goes for a pure look?

Shelley Fox I think if they're a good stylist, what they're good at is taking something that
a designer does, in its purest form, and turning it into another reality, which
is really interesting. And sometimes I see my clothes and think, that's amazing,
I would never have thought of putting it together like that. When I do a show,
that is my way of presenting it and it's really interesting to have that different
feedback you get when a good stylist works with you. And, actually, it gives me ideas.

Jane Alison This show is happening in London and Tokyo. Have Japanese designers been an
influence at all?

Shelley Fox Yes, even thinking back to when I was at school and made my own clothes, probably
very badly! What was influential was the attitude: do you have to wear a jacket
like that, or does it have to be finished in that way? And I think Japanese
designers really turned fashion around and are still doing so. Very few companies
can sustain that radical edge for as long as they have, and their influence comes
through in the sense that you have to keep pushing forward, to keep questioning.
Sometimes, immediately after a show, I have an idea of where the next show is going
to pick up. Then I go and research on my own and that's lovely because after two months
of being in the studio all day, all night, every day, it's actually nice to be alone.

Interview 10 Friendchip/Multiplex
Interview 10 Friendchip/Multiplex
Interview 10 Friendchip/Multiplex
Interview 10 Friendchip/Multiplex
Interview 10 Friendchip/Multiplex
Interview 10 Friendchip/Multiplex
Interview 10 Friendchip/Multiplex
Interview 10 Friendchip/Multiplex
Interview 10 Friendchip/Multiplex
Interview 10 Friendchip/Multiplex
Interview 10 Friendchip/Multiplex

Jane Alison You each work independently and come together on specific projects. The quality
of the work suggests that these are happy partnerships. Can you say something
about how you work together and what each of you bring to the projects?

Anthony Burrill It's dependent on what comes along really. We get asked to do lots of
different things.

Paul Plowman We try to keep the way we work together fairly direct. So, a job might come from somebody Anthony has done design work for, but there's a film or video piece needed for a commercial. Or, sometimes it's the other way around, where a job would start off as a TV piece and end up being web-based. The work is usually from somebody who has seen previous work.

Jane Alison So you found that you complement each other?

Anthony Burrill We have a sort of common interest. We like to keep things simple and direct, but not laboured. We don't like to spend too long on anything, because we like things fresh.

Jane Alison Is there an anti-technology attitude in your work?

Kip Parker We've got an aversion to technology for technology's sake. We're using computers to make things but you wouldn't necessarily know that something has been made on a computer. It doesn't look digital, it's not virtual reality, but it's quite a weird reality. I also think that technology has grown up and the tools are quite subtle so it doesn't have to look like vector, pixel and digital stuff. We're in love with computers but we don't have to like the way they make things look.

Jane Alison Your website is central to what you do; do ideas come together on it?

Kip Parker We like that sort of non-linear, interactive thing. You can only watch a video one-way, but this stuff, it's still one-way but there are three different routes you can take on the path.

Anthony Burrill It works because it doesn't have anything to do with anything else; it has a strong idea of itself; it doesn't look hard to operate and it makes you laugh.

Jane Alison Where does your sense of humour come from and how would you describe it?

Kip Parker I suppose it is best described as finding humour in the mundane and everyday. We laugh for hours about a cereal packet, instruction leaflet or amusing computer beep.

Anthony Burrill Being without humour is to be inhuman.

Jane Alison Are you trying to achieve a balance between personal and commercial work, or is it just happening?

Paul Plowman I suppose, we have to make money to live, to pay for equipment and the studio, but what we usually find is that the better work feeds back into the personal work. So, it crosses over eventually with the commercial work, but the research and development is personal. Often a job that we enjoy the most is "freer" so we can try things out and haven't got any constraints. We did a job for Habitat that was really nice and had total freedom. GTF, the designers who commissioned us, knew what we did and said, do what you want. It was an amazing brief. Basically, doing personal stuff is like setting up a stall and saying, this is possible, this is how things could be.

Jane Alison What are your influences?

Kip Parker Now that computers can display millions of colours, 3-D rendering and so on, it's been forgotten how beautiful a flat red square can look on a monitor screen. The Japanese have always been at the forefront of computer game design, so I think we've been influenced by that.

Anthony Burrill Kraftwerk; early computer games; brutalist architecture and mid-70s BBC sitcoms.

Jane Alison Are you inspired by London?

Kip Parker We always utilise urban subjects; high-rises, motorways, road signs, in our work. I can't imagine doing the work we do anywhere other than in a big city.

Jane Alison What are your aspirations for the future?

Anthony Burrill To carry on creating interesting work with interesting clients.

Interview 11 Steven Gontarski
Interview 11 Steven Gontarski
Interview 11 Steven Gontarski
Interview 11 Steven Gontarski
Interview 11 Steven Gontarski
Interview 11 Steven Gontarski
Interview 11 Steven Gontarski
Interview 11 Steven Gontarski
Interview 11 Steven Gontarski
Interview 11 Steven Gontarski
Interview 11 Steven Gontarski
Interview 11 Steven Gontarski

Catherine Wood The theme of JAM is art, fashion, music. How do you relate to that mix?

Steven Gontarski I liked the idea of this show because in the past I've been in exhibitions with a generation of sculptors or painters that curators love to group. I'm more interested in the mood or attitude of the whole thing and I think it's more appropriate to look at music, fashion and creative design because I'm probably influenced by them more than by other art.

Catherine Wood Do you keep up to date with that stuff in a conscientious way, or do you absorb it by walking around the city and looking at what people wear?

Steven Gontarski Yes, through daily life. When I was a teenager I would read magazine letter's pages and these other people would be into exactly the same bands as me, and I'd start to feel, they're my soul mates, we are part of the same thing! In that kind of way, I'm really adolescent. I'm interested in moodiness and in getting across a certain kind of playfulness or fantasy.

Catherine Wood Is that the way you dissolve the boundaries between creative disciplines?

Steven Gontarski I feel that certain artists take on particular ideas that I relate to, such as Ines Van Lansweerde, I really like her art. In graphic design, Peter Saville has always been a huge influence. I feel that I get what these people are on about and what's driving them. Or a Super Furry Animals' album — I get really excited when I feel they've just got it right with a certain amount of moodiness and fantasy.

Catherine Wood And are those the same things that you like about fashion; not the craft or couture, but the spectacle and drama?

Steven Gontarski The 100% attitude. Perhaps that's why I was drawn to Ines when I met her. She liked my work, I liked her work and her scene, because she's so involved in fashion. I love a lot of photographers in London. I don't believe in the pureness of fine art, but I do believe in a pureness of attitude.

Catherine Wood In Japan that distinction is completely broken down and fashion occupies a major place in culture; it's taken pretty seriously. Do you feel closer to that mix of artistry, and what do you think is fashion's role in UK culture?

Steven Gontarski All I know about Japan is what I've read in magazines and seen on TV. But I think it's fantastic that fashion in Japan is so much a part of the lifestyle, and it's not restricted to just girls either. I love how they get excited by the latest trends and that fashion designers are like rock stars. What doesn't thrill me is the way that so much of it is based on copying. I'm talking about teenagers on the street that I've seen in Japanese style magazines, and it's striking how the kids follow it so religiously and are perfectly decked out in outfits that look so similar. What is fashionable has become homogeneous, and they have to keep up with such fast changes. That part has to do with accepted ideas, it doesn't seem to be a virtue to stand out, whereas in American culture it's applauded to do something different, as long as you get past the ridicule.

Catherine Wood Where did you live in America and what made you come to London?

Steven Gontarski Philadelphia. And it was a desire for a life change that made me move. I went to a liberal arts college, I didn't have a proper art school training until later, which in retrospect I'm happy about. I moved to New York in 1994

and the art market was a bit down because of the recession; it was a sucky time to graduate. We were all talented, smart people but we worked in cafes and had shit jobs. I worked in an alternative gallery where I saw a lot of cool art from around the world. But I wanted to put my energy into making art, to take that seriously. So I thought the only way to do it was to go back to school because that allows you the time, space and money to produce work. Then I thought, I'm going to have to take out a huge loan so I might as well go wherever, and chose London because I loved British style. I arrived in 1996.

Catherine Wood What kind of work did you make when you started at Goldsmiths College?

Steven Gontarski A lot of it was sewn work; hybrid animal and human objects covered in fabrics and fake hair. I am still interested in the animal-human hybrid. They became more polished and larger when I came to London.

Catherine Wood So you never used computers to morph forms? Would you say that computer technology has fed into the appearance of your work?

Steven Gontarski Absolutely. The look I go for is influenced by the computer graphics we see in movies, but in terms of making an object, for me it's more natural to work traditionally. What I love about sculpture is that it's such a physical art, it's a body in space.

Catherine Wood The viewer feels a physical relationship with it...

Steven Gontarski I refer to it as a corporeal. I like sculpture because it's about the materials and how you manipulate them. Firstly, I sketch on paper. Then I sew wadding around a wooden frame that I've constructed. The shape is decided then. Once it's the way I like it, it's just a matter of making it hard with plaster and filler materials poured and painted on, then sanded smooth. Or if it's sewn, draping fabric over it and pulling it tight around the figure.

Catherine Wood Can you say something about the development from the graffiti bases up to the more classical figures?

Steven Gontarski I think that although they do go off on different tangents or concentrate on different aspects of the story, everything is telling the same story. I'm interested in a fantasy life, just as I feel that a lot of fans position themselves in a certain kind of world, which tends to be romantic. I think I'm a part of that same world. It's a romantic idea of what is realistic.

Catherine Wood So why use the graffiti?

Steven Gontarski I try to make things that don't exist or form a better and more fantastic version of things that do exist. But you have to ground it in reality. That's why I've used socks in the past, or bits of clothing, because it's a reminder of reality, like Dorothy's shoes from "The Wizard of Oz". You can be on a flight of fantasy but you are reminded of something else. A lot of graffiti artists are artists in their own right and I've been asked how can I justify using their work in my own work. It's not my graffiti... graffiti artists have done the work for me. But for me it's no different from the fact that I don't actually cast the pieces either.

Catherine Wood You're employing someone else, or taking their graffiti as a ready-made.

Steven Gontarski I love the look and the feel of graffiti. Certain things are so charged. I remember growing up and if a place had too much graffiti you were scared to enter it.

Catherine Wood It's quite a daring thing to have done, invite someone else to graffiti on your work. Have you ever asked the graffiti artist to work on the sculpture itself?

Steven Gontarski No, I didn't want that because, like an outdoor sculpture with a pedestal that's been graffitied, when graffiti artists do their thing they have frames. They choose a blank space and aren't really into going over someone else's tag. There is a protocol, a way of doing graffiti and I wanted to stay within that. The way I see it is if a musician asks another person to rap;

Gontarski it's still that musician's song but they've added a different texture. Obviously the way that texture is added is under the control of the person making the song.

Catherine Wood Does it matter where you live?

Steven Gontarski It has to be a city with lots of people; with a dynamic about it. The life that I live in London probably isn't much different from how I'd live in New York. My friends are a mix of people from all over the place, but there are certain things that you can't get anywhere else. I think the British relationship to style and fashion is unique; it's a commodity that's exported. I'm specifically interested in the masculine relationship to style, the dandies and all these subcultures, such as the Mods. That couldn't happen in America. Men have such a different relationship to style there that if you dressed like that you'd look like a fag. Americans don't shave and go on a date wearing the same clothes they've been wearing for a week. I'm fascinated by the way English men see themselves. When I first came here I couldn't believe the guys that you were meant to find intimidating out on the street, the guys into football, I couldn't believe they were "lads" because they took such care with gelling their hair and wearing earrings and slim-fitting clothing. It's why New Romanticism worked here, and Goth, which is a whole way of thinking, not just the white make-up and black, sprayed-up hair and clothes. I love people who are truly Goth and very individual about it because it's a whole way of thinking.

Interview 12 Gorgerous

Suzannah Tartan What is Gorgerous?

Matsukage Gorgerous is gorgeous, dangerous, glamorous and sometimes scandalous.

Suzannah Tartan Is Gorgerous "Rock"?

Matsukage If you were going to categorise what Gorgerous is, you could call it "art", but we decided that what we do is "Rock". But we found that the Rock we do is Rock as a signifier. The manner or the form is Rock, but when we put forward this image it is a little misleading because what we consider to be rock is completely different from the mainstream conception of Rock.

Ujino Rock as it is now, is about an audience and a performer accepting the same set of rules. But what we find interesting is stuff that is more on the verge. Unlike Rock, which has become antique, we are interested in something that is not so fixed.

Matsukage Rock should be transcendent and ecstatic. "The Way of the Man" — for Gorgerous, that is what Rock is.

Suzannah Tartan What is the Gorgerous concept of masculinity?

Matsukage For us, the collaboration itself is masculine, and the relationship becomes a hierarchical one if it is not about a man versus another man on the same plane. For this, you must have a kind of strength. Men or boys are always enemies at first; they struggle, then they get to know each other.

Suzannah Tartan What is the relationship between masculinity and decoration as it is expressed in the "Love Arms"?

Ujino It goes back to the libido and to the possibility of violence in the male libido. If you take the idea of masculine decoration to its logical absurdity, it ends up resembling a fascist aesthetic. I want to keep it young and fun; to make it rock. In Rock, there are guitar riffs that manifest themselves again and again; they have become

the "kata" (set patterns) of Rock. I'm interested in exploring masculinity by creating masculine kata. Men are essentially big and hairy so perhaps it's not beautiful, but it is humorous and intriguing. The basic idea of the "Love Arm" is to make tools or instruments for performance. However, tools and instruments must have an element of pleasure. For me, the most fundamental tools have fundamental forms and the creation of these tools is a pleasurable act. The phallus is the basic male tool.

Suzannah Tartan Explain what you mean by "Boosted Elegance".

Matsukage When men tell a joke there is a tendency to overdo it, to make it powerful enough to reach many people. Even in a conversation with a lover, a man can overdo it, but that is the male aesthetic. This is not in fact violence, but the male sense of beauty.

Ujino Boosted elegance is like a peacock.

Matsukage The male peacock decorates himself, spreading his tail to attract the female. It's actually another expression of the phallic object. The male libido often manifests itself in a violent form. We want to recreate the male libido as something beautiful, hence boosted elegance. But without the female, boosted elegance wouldn't exist. But it's not about fucking. Boosted elegance is about making love all night long.

Interview 13 Groovisions

Toru Hachiga What is the present format of the unit Groovisions?

Hiroshi Ito Groovisions is fundamentally a design group formed by several designers. At present, Groovisions is mainly involved in graphic design and motion graphics. We are also developing a project around a character called "Chappie". Also, we are unusual for a design group because we collaborate with major Japanese corporations, release CDs and present our work within a fine art context.

Toru Hachiga Are there any aspects of Groovisions that depend on it being a group?

Hiroshi Ito We are conscious of the anonymity in design, and so from this point of view, being a group suits our purpose. And working as a small group enables each design activity to be handled as a project in itself. There are many advantages in working as a group; we're able to maintain the unique colour that Groovisions has, and to go in various directions depending on the concept.

Toru Hachiga Does Groovisions have a particular theme?

Hiroshi Ito We are very much aware of anonymity, functionality, instrumentation and tangibility... many different things. Groovisions frequently uses Helvetica, and I think that of all the sans serif typefaces, Helvetica manages to convey a sense of anonymity and functionality best. Paradoxically, it is the complete elimination of characteristics unique to a font that has resulted in the creation of the strong symbol of anonymity. I also think that this is in keeping with Groovisions' design style as well.

Toru Hachiga Groovisions uses "the exhibition" as a venue for presenting its creative work, and uses various media at each exhibition as an avenue of expression. What is the significance of the exhibition to Groovisions?

Hiroshi Ito I think that holding exhibitions is significant in two major ways. The first is, naturally, to have your work seen by others. The second is that it provides the opportunity to heighten the group's motivation and to confirm what it is doing.

If anything, it is the latter that makes the exhibition format so important to Groovisions. It enables us to reclaim the roots of our activities so that we don't get swept away by the everyday routine of the design world. Because installations are carried out within a spatial framework, they are very different from a graphic arts framework, and so from this aspect, there has always been a sense of newness.

Toru Hachiga Chappie is a highly original character and yet has a strong sense of anonymity. What led to the creation of Chappie?

Hiroshi Ito We needed a "Pop" element that would act as an "agent" and in turn enable us to make a social commitment without destroying our structural ideas. And for Groovisions, this happened to take the form a young person, that is, Chappie. When classifying the medium, if a young person could be one media category, then we felt that Chappie could embody fashion, music and art. In other words, our original idea for Chappie wasn't to create a character as such.

Toru Hachiga The fact that you made Chappie into a mannequin is very interesting, but why did you decide to do this?

Hiroshi Ito The concept of size as computer data, is something that is extremely diverse. When we considered the issue of size and scale, the concept that we came up with was to make something life-size, real scale. And the end result of this was a life-sized mannequin. Naturally, one aspect of Chappie's development was to create something 3-D out of the 2-D, but the mannequin actually is the result of an issue concerning scale.

Toru Hachiga Groovisions' activities seem to be primarily in film, graphics and exhibitions, but what are the differences between these three areas?

Hiroshi Ito I think each is very different. Each medium has a frame, and for exhibitions, this would be the space or the period that the exhibition is held, while for film this would be time and rhythm, and for graphics, it would be the literal frame. And working out how to deal with each frame is typical of the way Groovisions works. Many of our works are developed in the soil or context from which the work will grow, regardless of changes in the medium that we use.

Toru Hachiga Until four years ago, Groovisions' activities were based in Kyoto, after which you moved to Tokyo. What is your opinion of Tokyo today?

Hiroshi Ito When we were based in Kyoto, the information that we received from Tokyo was always packaged in some way. But living in Tokyo, I think we're directly exposed to information. I also think there's too much information, and I mean this in both a negative and a positive sense. However, as Tokyo has no particular significance for us, we often relate more to people who have a common world-view rather than because of a regional or linguistic sense of proximity. I felt this particularly strongly when we exhibited our work at Colette in Paris and at the MOCA in Los Angeles early in 2001.

Toru Hachiga What do you think of London?

Hiroshi Ito I lived in London for several months in 1991, and I found it a really comfortable city to live in, although the economy was pretty sluggish at the time. There is a real edge to London, but it can also be very unrefined, and I found I could really relate to the fact that London has these two sides, and they coexist. But all I really did was go to record shops, clubs and galleries. It is a city that heavily influenced my own personal development. Although I'm not really sure how it is today, I have the feeling that it's much more aesthetically pleasing than it used to be. Of all the cities in the world, I think London most resembles Tokyo in feel.

Interview 14 Kazuhiko Hachiya
Interview 14 Kazuhiko Hachiya
Interview 14 Kazuhiko Hachiya
Interview 14 Kazuhiko Hachiya
Interview 14 Kazuhiko Hachiya
Interview 14 Kazuhiko Hachiya
Interview 14 Kazuhiko Hachiya
Interview 14 Kazuhiko Hachiya
Interview 14 Kazuhiko Hachiya
Interview 14 Kazuhiko Hachiya

Interview 14 Kazuhiko Hachiya

Nobuko Shimuta Tell me what first gave you the idea for "PostPet", your e-mail software with a virtual pet that delivers mail?

Kazuhiko Hachiya A major theme of my work is to create a tool for communication. Usually my works are one-off creations, but I wanted to make something that would reach lots of people but not be expensive, so I thought that I'd make something digital. One night toward the end of 1995, because of a dream I had in which a teddy bear brought me my mail, I started to seriously consider designing this weird e-mail software. Incidentally, when we explain the role of the pet in PostPet in English, we often call it a "silly agent", because it doesn't increase efficiency, but it acts as a mediator between people.

Nobuko Shimuta I understand that this virtual pet finally dies. What significance does death have in the software?

Kazuhiko Hachiya Actually, that's not quite correct. There is no death for the pet, but there is loss. In other words, the pet becomes "gone". I define the pet in PostPet to be, a postage stamp that has been given substance. The pet's life-span is reduced little by little by having it transport your mail. But, if you never use it, then your pet will live forever. I wanted to implant some kind of value into the mail that the pet delivers. It was my idea that value is generated by that which, at some point, disappears.

Nobuko Shimuta What concept applied to the design of the PostPet characters?

Kazuhiko Hachiya In PostPet, there is a somewhat preposterous aspect, it's a software that sends off mail arbitrarily. I thought that unless there was an entity that sends off mail arbitrarily, the user wouldn't understand that aspect. The designer gave this entity form, and my brief was simply, don't make it too intelligent-looking, nor too cute. Apart from that, it was left up to the designer, Manabe Namie. She used to work at Sega and was accustomed to dealing with such characters.

Nobuko Shimuta Although originally created as art, the PostPet character has taken off and been developed into an array of character products. Was this something you intended from the start and how do you view this development?

Kazuhiko Hachiya To some extent it was intentional. For example, I thought that I would want there to be stuffed animals and costumes, but the current state far surpasses any of my expectations. Sales of the software and character products amount to a cumulative market scale of approximately ten billion yen. Of course, this is still only one-hundredth of what Pokemon is worth. There was a time that I was troubled by this whole thing blowing up beyond the category of an art project, but now, I just admire Momo for becoming a part of so many people's lives.

Nobuko Shimuta Until now, art was distributed within a limited market, but PostPet is being consumed as a general product on an entirely different level from works of art. Do you think that in the future artists will inevitably have to distribute their products this way?

Kazuhiko Hachiya I don't think that it is inevitable, I don't think that all artists need to do this sort of thing. I wanted to prove that an artist could also make a hit product. Before I was an artist, I worked in consulting and marketing, so I had a certain amount of confidence that I would be able to do it. Although I am not really in a position to make any statements about the distribution of art, my own view is, why not just use anything that's available? If it fits the work, it should be OK to exploit the usual methods of distributing products, or the established channels of galleries, and if necessary, I think the artist may also sell directly over the net.

Nobuko Shimuta For your work as an artist as a whole, not just with PostPet, is Tokyo a significant place for you? Does the culture and community of Tokyo inspire you?

Kazuhiko Hachiya I live in Tokyo, so I am accustomed to working here, but personally, I think what is most significant is that Akihabara is in Tokyo. For those of us who work with electronic devices, Akihabara is an extremely convenient

uhiko Hachiya
hiko Hachiya
iko Hachiya
ko Hachiya neighbourhood. Also, there are many engineers, designers and game manufacturers in Tokyo. When working in collaboration with such people, Tokyo is a very convenient place to be. As to whether or not the city inspires me, it does of course, but I don't think it is so different from any other town or city.

Nobuko Shimuta
obuko Shimuta Do you feel you are strongly influenced by everyday subcultures, such as manga and technology?

Kazuhiko Hachiya
azuhiko Hachiya
zuhiko Hachiya
uhiko Hachiya
hiko Hachiya
iko Hachiya Both manga and technology have a great influence on my work. To give one example, PostPet is strongly influenced by manga such as *Jojo no Kimyo na Boken* by Araki Hirohiko, *Watashi wa Shingo* by Umezu Kazuo and *Isshokenmei Kikai* by Yoshida Sensha. And the name "Momo" from PostPet was taken from Michael Ende's Momo. Of course, it also refers to Momo's colour, pink. This is because PostPet is an e-mail software for battling the time robber.

Interview 15 Hiropon Factory
Interview 15 Hiropon Factory
Interview 15 Hiropon Factory
Interview 15 Hiropon Factory
Interview 15 Hiropon Factory
Interview 15 Hiropon Factory
Interview 15 Hiropon Factory
Interview 15 Hiropon Factory
Interview 15 Hiropon Factory
Interview 15 Hiropon Factory
Interview 15 Hiropon Factory
Interview 15 Hiropon Factory

Mami Kataoka
ami Kataoka
mi Kataoka Can you explain the relationship between Murakami Takashi, the artist and Hiropon Factory, the artists' group? Also, what are your thoughts regarding the artists performing as a unit?

Takashi Murakami
akashi Murakami It is something that was obvious from an historical point of view and remains obvious today.

Mami Kataoka
ami Kataoka When was Hiropon Factory formed? After its formation, what personal changes did you and the other artists experienced?

Takashi Murakami Seven years ago. And things have become much easier.

Mami Kataoka How does Tokyo or the urban environment influence Hiropon Factory's activities?

Takashi Murakami
akashi Murakami It originates from the marketing reality of having a 0% share of the art market.

Mami Kataoka
ami Kataoka Can you explain, in simple terms, the concept of "Super Flat", which you mention within the context of contemporary Japanese culture?

Takashi Murakami A detailed chant of a future image with no exit.

Mami Kataoka
ami Kataoka
mi Kataoka
i Kataoka As we see in the Super Flat exhibition that you organised, the phenomenon of the blending of different forms of expression, such as visual art, graphics and fashion and the increasingly blurred boundaries between each discipline appears to be a global phenomenon. What are your views on this?

Takashi Murakami
akashi Murakami
kashi Murakami
ashi Murakami
shi Murakami I think it's unnatural to even consider that such boundaries exist at all in Tokyo where contemporary art has no significance. If this is seen as a global phenomenon, then it simply means that there are no longer any people who can successfully spread the faith that is contemporary art, or that the neglect on the part of the believers has become exposed.

Mami Kataoka
ami Kataoka
mi Kataoka JAM is in part an attempt to present the influence of street culture and subcultures of London and Tokyo in an exhibition format. Have you ever been influenced by the art, design and music that has come out of London?

Takashi Murakami Yes, the Aphex Twin.

Mami Kataoka What are you most interested in at the moment?

Takashi Murakami The beautiful body of a naked woman.

Interview 16 Takashi Homma
Interview 16 Takashi Homma
Interview 16 Takashi Homma
Interview 16 Takashi Homma
Interview 16 Takashi Homma
Interview 16 Takashi Homma
Interview 16 Takashi Homma
Interview 16 Takashi Homma
Interview 16 Takashi Homma
Interview 16 Takashi Homma
Interview 16 Takashi Homma

Fumiya Sawa The field of photography in Japan seems to have a lower quality threshold in comparison to that of Britain. How do you yourself, as someone with experience working in both countries, view this difference?

Takashi Homma Put differently, I guess you could say that it's more democratic here in Japan. I think that produces both good aspect and bad aspects. So I think that all I can do is to go ahead and take advantage of whatever those good aspects are. I base my work in Tokyo, and there are lots of things about Tokyo that I dislike. But at the same time, I also like Tokyo very much. Perhaps it's this situation of feeling both love and hate that breeds more energy, because there would be no need to be creative if you had a situation that was 100% good.

Fumiya Sawa What are some of those points that you like and dislike?

Takashi Homma Because the threshold is low, it is easy to get published and make your debut. So, both good things and bad things are jumbled up and the standard for what is truly good becomes vague. In Britain, fewer people want to be photographers in the first place. Then those people are sifted and weeded out. Then they gain experience, and there is a recognition of rank and authority, for instance with Wolfgang Tillmans winning the Turner Prize. There isn't anything like that in Japan. This is a negative aspect, but in Britain on the other hand, there might be some really great person who gets eliminated during the learning stage. For example, I think that HIROMIX wouldn't have made it if she were in Britain. It's because she was in Japan that she was able to debut in the way that she did and progress as far as she has. So that lower threshold does have its good side of being democratic.

Fumiya Sawa I find it very interesting that you, a conceptual artist, which is rare in Japan, are positioned half-way between the more casual styles of Araki Nobuyoshi and Hiromix, and that you championed Hiromix.

Takashi Homma I think Japanese photography and literature are identical. In the end, they're all "first-person". You know how they say that Japan has no background? But I think there is one, and it's that sort of feminine private-life novel, I think. My perspective is on the conceptual side, but since my background is Japanese, naturally, I have that aspect too. In Japan, I would be considered conceptual and Araki would not, but in the larger world-view, I think my own position would probably be somewhere in between the conceptual and the private-life novel. I want to effectively mix the two and create a new genre of photography, one that's neither first-person, nor conceptual.

Fumiya Sawa It seems to me that there is the private-life Homma Takashi, as well as the Homma Takashi stepping back to let others step into the perspective, as if you're editing yourself.

Takashi Homma Yes. But more like documenting than editing. I stand exactly in the middle between Araki and Hiromix. So I'm in the advantageous position of being able to relate to either side in the same way. Furthermore, on a parallel axis are people like Wolfgang, as well as certain American artists, so I think my position is a very good one. For this reason, I want to take all of it in. My intention is to document all these things.

Fumiya Sawa Does this aim ever expand, so that you connect or feel affinity toward people in the areas of art, fashion or music?

Takashi Homma I do feel that there are people thinking in the same way. Of course, that's only occasionally, around the world. When I was in my 20s, I thought, why

doesn't anybody understand me? But now I see that there are people throughout the world who do. Not just photographers, people in music and novelists too. Even if you don't discuss this, you realise that you understand each other when you occasionally get together with such people, or when you meet them for the first time. I don't know if this means that I've arrived at a certain level of consciousness, or if more people understand.

Fumiya Sawa What do you think of contemporary culture in London?

Takashi Homma When I was in London, some people, like at *i-D*, had the attitude that London was the best. But now, people at *Dazed and Confused* don't have that kind of outlook. London is great, but Tokyo is pretty interesting too. There's a clear contrast between creative people in London now and those that came before, and I think the contrast is really stark. So in that sense, it's become a lot more internet-like, and I guess that's good; there's less and less difference. And there's no more need for the extra people that used to be in the middle. The walls have disappeared.

Fumiya Sawa What is the relationship between architecture and children in your work?

Takashi Homma The suburbs of Tokyo are all-inclusive; there are children, there is landscape and there is architecture. But there are clear choices that I make there, such as with the kids I photograph. They are the kids of friends in the business, or those who are generally thought to be bad kids who hang around arcades. So I only shoot photos of truly today's kids. The architecture and the kids, they are consistently suburban. I'm not trying to say which is better, but for example, the kids that Araki portrays are nostalgic; kids with runny noses.

Interview 17 Martina Hoogland-Ivanow

Jane Alison You mentioned to me that honesty is something you aspire to.

Martina Hoogland-Ivanow Honesty, by way of being an open observer, but also, what I find interesting was recreating things that I've seen in reality, like the Northern Lights or a desert, in miniature inside a studio. You can create your own natural phenomena or disaster. There's something surreal about that.

Jane Alison Potentially you can create something mysterious...

Martina Hoogland-Ivanow ...and suggestive. We don't believe photography is telling the truth anymore. But it can be truthful of a state of mind. And now, when we talk about reality in photography, it has to be realistic and snapshot, whereas it's very hard to say what someone's reality is exactly, because what you see is so individual, and what you imagine is your reality. I always thought it was funny, that "ugly and real" style; that to be realistic you had to have people doing drugs in a back-room somewhere.

Jane Alison Is your work a reaction to that sort of photography?

Martina Hoogland-Ivanow No, I just don't think that's my reality.

Jane Alison It seems like you are using photography as a medium for exploring your interior self as well as for exploring exterior phenomena.

Martina Hoogland-Ivanow What really amazes me is that there are all these things going on that we take for granted in daily life. But to stop and give that moment or situation or object attention, that is what the medium does.

A Photographer stops and says, this thing is really important, I'm going to photograph it. When you put it together, you realise it's actually quite a vision. Someone else might stop in the street and say, that's beautiful, how come I didn't see that before? There is always traditional beauty, but what I find needs attention is something that is really sad, lonely, or harsh but something that has beauty as well. And it's important that people don't take things for granted.

Jane Alison You seem interested in the movement of bodies, and how they tell us something. Are you aware of that?

Martina Hoogland-Ivanow Sometimes I'm not aware until afterwards when I conceptualise things and see patterns. But the way I put things together tells a story.

Jane Alison Do you ever find it difficult to take photographs?

Martina Hoogland-Ivanow No, never. But I have to make sure that I'm constantly inspired, so it's actually hard work and I don't shoot all the time. I travel, to experience things, and see where my mind is at. That's just as important as taking the pictures. I want to create an emotion and because it's such a clinical medium it's hard to go beyond that surface. With the subjects I choose, I have to be really open, as I'm taking something from them.

Jane Alison But your work is so considered and selective...

Martina Hoogland-Ivanow Some things are planned, drawn and researched and I spend time trying to find the people and all the different ingredients. Originally I was really posed and organised in the studio and only did landscapes on the side but never took them seriously. Then someone really liked them and I realised, what I might find effortless is still a reflection of my efforts, of seeing what I'm open to.

Jane Alison Do you feel that your work is becoming increasingly about you?

Martina Hoogland-Ivanow Every photographer is taking pictures about the world and how they see it. The subject matter is not them, but it's always going to have an angle of that personality. I'm fascinated by phenomena or unreal situations that are actually real. And there are some amazing phenomena within ourselves that we take for granted: the phenomena of ageing, the fact that hair can change colour, the fact that you can heal, the speed that babies grow.

Jane Alison I think your work reflects an acute sensitivity to light. Is that true?

Martina Hoogland-Ivanow I'm really interested in colours and tones that are muted or soft. So I always spend more time in the dark room than actually shooting. I definitely think that colour effects the viewer and that light is really important for this kind of low contrast stuff. I don't work with real colours, it's more like how you might dream something. Some of my photographs are just light, nothing else.

Jane Alison You also seem very interested in abstraction, with tight cropping so things aren't quite what they seem...

Martina Hoogland-Ivanow I ask a lot from the viewer. But it's also a way to give to the viewer. I'm always drawn to music or different kinds of art that don't tell me too much, that give me space to find my own end result. I have a tendency to simplify things, because I do think that the basic concepts that have been repeated in history are the most important things and will always be powerful.

Jane Alison Is your ideal to be constantly exploring and growing as a photographer? Obviously, the fact that you are in demand in London as a fashion photographer must be useful.

Martina Hoogland-Ivanow It has been really good because I was set in one way of doing things and now I'm more flexible. It has also been good to work with other people in a group. The only dangerous thing in the fashion world is,

tina Hoogland-Ivanow everything is always beautiful and great, and you don't actually have to
ina Hoogland-Ivanow express yourself or question what you're doing because it's all accepted
na Hoogland-Ivanow and looks good. So, I think it can be really limiting.

Jane Alison What about London, do you like being here?

Martina Hoogland-Ivanow Yes, I've been lucky to be in London, it's been great, and much more
artina Hoogland-Ivanow open than New York, which is more commercial. New York is really
rtina Hoogland-Ivanow comfortable, whereas here, you have to struggle a bit more, but I think
tina Hoogland-Ivanow that makes people sharper. And now there are less boundaries between
ina Hoogland-Ivanow one medium and another, that seems more honest in a way.

Interview 18 James Jarvis
Interview 18 James Jarvis
Interview 18 James Jarvis
Interview 18 James Jarvis
Interview 18 James Jarvis
Interview 18 James Jarvis
Interview 18 James Jarvis
Interview 18 James Jarvis
Interview 18 James Jarvis
Interview 18 James Jarvis
Interview 18 James Jarvis
Interview 18 James Jarvis

Ekow Eshun How would you describe your illustrations?

James Jarvis Modernist cartoon characters. I've been led to this style by an intellectual
ames Jarvis process. I didn't want to draw people because I didn't want to be that connected
mes Jarvis to reality, partly because I think people aren't that appealing and partly because
es Jarvis if you draw people you're going to say things about race and looks and so on.
s Jarvis I wanted to make something more amorphous.

Ekow Eshun Where did you first start this work?

James Jarvis I did a degree at Brighton University and an MA in illustration at the Royal
ames Jarvis College of Art. My degree show work, which was the first portfolio I took around
mes Jarvis after graduating, was cartoon characters in urban surroundings looking miserable.
es Jarvis My professional career started off with the skateboarding scene in London, doing
s Jarvis adverts and t-shirts for Slam City Skates and later for Sofia Prantera and Russell
Jarvis Waterman who left to start their own label, Silas. They were the only people who
Jarvis would commission me because I was drawing these amorphous characters. If I went to a
arvis children's book publisher they'd say they were too adult. If I went to a magazine
rvis publisher, they'd say the characters were too childish. But through that work, I got
vis the endorsement of a mainstream magazine, *The Face*. Half the illustrations I seemed to
is do for them were, draw a room and fill it with cool objects, such as the right trainers.
s After doing that for a while and for other magazines and companies round the world,
James Jarvis I thought, why am I doing this, do I want to be endorsing these objects?
ames Jarvis And I thought, not really. So I figured out how all those things could fit into
mes Jarvis the world of my characters, which became the comic I produced, *World of Pain*.
es Jarvis The name doesn't really mean anything, it's just a catchy title, and it's simply
s Jarvis a vehicle for all my concerns.

Ekow Eshun What sort of concerns?

James Jarvis Consumerism, that kind of thing. I was asked to do an exhibition in Japan and
ames Jarvis instead of compiling a retrospective, I wanted to do something that was more
mes Jarvis about me, so I made the comic. It took about a month and it's quite limited
es Jarvis because I'm quite obsessive and worried about making something perfect. I wish I
s Jarvis was like Charles Shultz who could churn things out without worrying about a wobbly
Jarvis line here or there. Making a comic takes ages. But it was an opportunity to start
Jarvis defining my private illustration.

Ekow Eshun You're much more popular in Japan than in Britain. What is it about your work
kow Eshun that they appreciate?

James Jarvis I suppose my work is less easy to latch onto than some other illustrators,
ames Jarvis where you know the world they're describing and exactly what it all means.
mes Jarvis In Japan, people are into the drawn image, because their writing system is based

on it. They don't worry that this character has no nose, they're quite accepting of it. And they don't decide to like illustration because it's cool and new. Also, I've got more commissions from France than in England, which I think is to do with their comic book culture.

Ekow Eshun Would you like your work to be seen as illustration or as art in its own right?

James Jarvis For me, the most pure way to express a thought is to make a drawing. It's the most efficient, dynamic and quick process. However much photography seems more modern I think getting a pen and a piece of paper is more direct. And for me, the content of what I do has always been important. My characters are just actors; they've been made to sit in a room on trendy sofas and they're not really into it. They aren't endorsing that lifestyle, which is why they're looking a bit moody.

Ekow Eshun What are they feeling?

James Jarvis Despair at the pain of existence (laughs)! Obviously I'm exaggerating, but if I look at all the things that inform what I do they are kind of angsty. My favourite books are John Updike's series about Rabbit. He's a pretty nasty character but I find his outrageousness quite funny. I like writers who particularise things and write about the "microcosmic" aspects of everyday life. On the other hand I like Tolkein because I'm into the idea of creating a whole universe and that's where *World of Pain* comes from.

Ekow Eshun Are your characters innocents or irredeemably tainted by modern life?

James Jarvis I think they're innocent, just by the fact that they're cartoon characters means they have an innocence to them. Every time they see something bad it brings them down, then the next minute they're happy again.

Interview 19 Ben Judd

Catherine Wood What is the theme behind your work?

Ben Judd It's about the combination of something being simultaneously natural and constructed, or intimate and distant. The photographic studio seems to be the ideal setting in which to play around with this idea; it's a place that produces the physical embodiment of this dichotomy, and a very particular look and aesthetic. When I photograph in amateur photography studios, I try and save something that would otherwise have been thrown away.

Catherine Wood Explain what you mean by that?

Ben Judd The pathetic aesthetic, the blandness of representation, what is considered to be tasteful or realistic. You wouldn't normally notice or even think about high street photographic studios or glamour studios. I wanted to try and find something beautiful in a look that is usually considered to be completely trashy.

Catherine Wood We see versions of your photographs, of fake backdrops and Disneyfication, in fashion and advertising, but we're probably not even aware of it, yet we all buy into the fantasy, don't we?

Ben Judd I like to show both sides of that, to fool somebody but for them to be aware that they are being fooled at the same time.

Catherine Wood How did you start working in this way?

Ben Judd Originally, I was using re-photographed, idealised imagery. After a while I wanted

to take the photographs first hand so as to increase my personal involvement with the work. I started looking at advertising imagery in magazines from the 1970s and 1980s and became fascinated by the adverts for furniture or whatever in which the way the product was sold was completely unrelated to its function. For example, using a sexy, female model to sell a desk or an item of street furniture. I was interested in the idea of there being a thinly constructed narrative in order to sell something, or in order to push an idea. Then I started looking in amateur photography magazines and found adverts for glamour studios. It seemed a logical progression for me to go along and take photographs myself.

Catherine Wood So you are fascinated with how people suspend disbelief. What you said about advertising comes round to the same thing that I found interesting about your video, "I Remember (Cindy Sherman)", that projection that makes someone into what you want them to be. Your video of the model in the glamour studio, in "I Remember II", seems sensitive to the girl in a different way than just commenting on what is going on. Is there some level of sincerity?

Ben Judd Yes. When I go to the studios I want to take the best photograph or video that I can. I don't see myself going there as an outsider to comment on what's going on, and to produce something that looks like a documentary. I feel like I'm there to participate on an equal level with the other people, and I look at the photographs they take and get inspiration from those as well. Much of the time it felt incredibly uncomfortable, because even though I'm saying that on the one hand I'm going there to participate, I'm also aware that I am an artist and I will be showing my photographs and videos in a different context.

Catherine Wood There's something about the idea of a gap in your work. Is this represented by your projections onto the image, for example by your voice-over in "I Remember II".

Ben Judd There is a gap between what I say and what the model does.

Catherine Wood Yes, and it hints at you being intimate with her in some way, but you know that you are not and that it's a projection. You put yourself in the position of being the one who can't get to her. I don't think it is as straight-forward as "exploitation".

Ben Judd No, exactly. I think there is a sort of awkwardness about it, and that comes from the question of who is in control. It's not about gender issues or the male gaze.

Catherine Wood The act of being a documentary photographer or a tourist with a camera can be quite aggressive.

Ben Judd Absolutely. I think the idea of being a tourist is very close to what I do, and something I've always been fascinated by. When you're a tourist there's an illusion that you know something about where you are; that you've connected with the place, as though you possess it. You think you have an overview of something through the act of taking a photograph, or through looking at a map or climbing up a high building and looking down. That's the kind of thing that I'm interested in; the question of whether there is a connection or not with something or somewhere, and if there is then how real is that connection.

Interview 20 Kyupi Kyupi
Interview 20 Kyupi Kyupi
Interview 20 Kyupi Kyupi
Interview 20 Kyupi Kyupi
Interview 20 Kyupi Kyupi
Interview 20 Kyupi Kyupi
Interview 20 Kyupi Kyupi
Interview 20 Kyupi Kyupi
Interview 20 Kyupi Kyupi
Interview 20 Kyupi Kyupi
Interview 20 Kyupi Kyupi
Interview 20 Kyupi Kyupi

Mami Kataoka Briefly describe how the unit Kyupi Kyupi was formed in 1996, what the aim is behind it and who are the four members?

Kyupi Kyupi The group was formed with the aim of carrying out various creative activities

including film, music, live performance and print without being restricted to a particular genre. The four members are film-maker Ishibashi Yoshimasa, sculptor Kimura Mazuka, singer Wakeshima Mami and graphic designer and painter Emura Koichi.

Mami Kataoka How do you define the forms of expression within the context of your activities that mix diverse elements of popular culture?

Kyupi Kyupi It is important for us to use various forms of expression and that our creative activities remain unrestricted, because forms of expression such as video and performance have elements that are both effective and ineffective.

Mami Kataoka Kyupi Kyupi is active internationally, presenting various works and performances. Do you feel that there is a difference in the reaction to your work overseas, compared to the reaction in Japan?

Kyupi Kyupi Although different works are popular in different countries, we haven't perceived a fundamental difference in audience reaction.

Mami Kataoka The phenomenon of the blending of different forms of expression such as visual art, performance, graphics and fashion and the increasingly blurred boundaries between each discipline appears to be happening globally. Do you agree?

Kyupi Kyupi We think it's only natural that there are no boundaries in actual expression itself, but I don't think we can avoid categorising the media that we use to present our work. What's important in terms of Kyupi Kyupi's activities is that we use a form of expression appropriate to each medium.

Mami Kataoka JAM is an attempt to capture the urban energy of two cities, London and Tokyo, through an exhibition format. Have you ever been influenced by the art, design and music that comes out of London?

Kyupi Kyupi Yes, by Torture Garden.

Mami Kataoka The relationship between high art and subcultures in London seems to have become diluted here in Tokyo. What are your thoughts about this? Also, how would you define the city of Tokyo within the context of Japan, from the point of view of Kyupi Kyupi's activities?

Kyupi Kyupi High art is art, and subculture is culture, and art equals culture, so there is no boundary. Tokyo is simply a city suited to doing business.

Interview 21 Chris Morris

Interview 22 Yurie Nagashima

Mami Kataoka How would you describe your feelings at the time when you were taking nude photographs of your family?

Yurie Nagashima At the time, I was concerned with what would be most interesting visually, and initially I thought that it would be pretty amazing if my family was naked in the house. Although I was no longer living with my family, when I think about it, it was probably a manifestation of the complex feelings that I was experiencing as I stood on the boundary between childhood and adulthood, attempting to go out into the world. It's only natural to be naked with members of the family when you're a child, but once you reach puberty, it becomes embarrassing. At the same time, it's during this stage in our lives that we find ourselves naked in front of a man, who we don't know at all as well as our families. So I was thinking about the reasons behind feeling embarrassed and ashamed at being naked, and of the feeling of vulnerability that we experience as we change, and how those feelings are gradually directed towards strangers, rather than family members.

Mami Kataoka After gaining public attention with this series, you went to the USA. Was there a change in your point of view, as far as photography is concerned, after you lived overseas?

Yurie Nagashima I lived in Seattle for nearly a year and then in California for two years. Most of my time was taken up with photography, but I believe that it becomes difficult to take photographs if you are too obsessed with it. It's not so much that my photographs changed after living overseas, but I myself changed. I was influenced by the way Americans think, how they express themselves clearly, by visiting the vast terrain of the USA and by experiencing the slow passage of time. This could have contributed to the change in my work, and during this period of change, I wasn't able to take any photographs. I didn't take any photographs for a year after getting into CalArts.

Mami Kataoka JAM introduces to the public the raw energy of the street through a variety of media. Are you influenced by other genres in the arts such as music and fashion?

Yurie Nagashima As a photographer, I have to say that I'm not influenced by other photographers. I like movies, and it is because of movies that my initial photographs were all horizontal. Movies have been very influential in my work. As far as music is concerned, the only effect it's had on my work is that I photograph friends who are influenced by music. However, I am heavily influenced by skateboarding, to the extent that I use fish-eye lenses to photograph skateboarders. I skateboard myself.

Mami Kataoka Have you ever collaborated with other artists?

Yurie Nagashima I've done CD covers, but that's about it. It's only recently that people who are my age and with careers have started to appear around me, so I could become involved with these people in the future. I don't think collaborations that involve photography are such an easy thing. For example, even if I took photographs of Yoshitomo Nara's work, it is highly likely that these photographs would be seen as information about the work. Rather than doing that, it would be better if I photographed Nara himself, as there would be a greater sense of the image being mine. You see, the closer a photograph is to a "reproduction", the more difficult it becomes. Nor do I like it when people use their computers to alter photographs that I've taken. I think the ideal situation would be to do something with people who share the same interests I have. However, I recently collaborated with a poet.

Mami Kataoka This exhibition reveals two different cultural scenes, those of London and Tokyo. Is London a city that you have a special interest in?

Yurie Nagashima The photograph of me as a backpacker in my book *Pastime Paradise* was taken just as I was leaving for London. I was interested in London because I loved Acid Jazz at the time. I was 18 when I first went to London. I think I've been five or six times since then.

Mami Kataoka What do you like about London?

Yurie Nagashima Compared to the USA, I think London is more like Japan. And, if you go to London, you can visit other European countries. But as far as photographers in London go, I don't actually know very many. When I went to London, I ended up buying CDs and just hanging around, not doing much.

Mami Kataoka You mentioned that, at the moment, you really enjoy taking photographs.

Yurie Nagashima
urie Nagashima
rie Nagashima
ie Nagashima
e Nagashima
Nagashima
Nagashima
agashima
gashima
ashima
shima
hima I've always enjoyed taking photographs, but I also believed that there were other things. There was so much that I wanted to do. I was making clothes and I was also interested in contemporary art, so I had my doubts whether I should just be taking photographs. I was also passionate about skateboarding. Then I found that I couldn't be bothered taking photographs. And when people around me started creating this image of my works as girl photographs, I felt constricted, and that my image was determined by others. So I felt really negative about photography. But as time passed, I met all sorts of people through photography, and I felt that more and more possibilities were being presented to me. And also, by showing my work, people were beginning to understand me. I have never been very good with people, so my work provided a way to communicate. And now, I no longer feel that photography is reducing my potential, and that's why I still continue.

Interview 23 NAKA
Interview 23 NAKA
Interview 23 NAKA
Interview 23 NAKA
Interview 23 NAKA
Interview 23 NAKA
Interview 23 NAKA'
Interview 23 NAKA
Interview 23 NAKA
Interview 23 NAKA
Interview 23 NAKA
Interview 23 NAKA

Mami Kataoka Did you begin taking photographs when you were working as an art director?

NAKA Well, that's a pretty ambiguous area for me, because I'm not really aware of having actually taken photographs back then. But I've always enjoyed photographs. It's just that one day, the situation arose when I, as the art director, had to take some photographs, so I did. Because I've worked with so many different photographers, it was simply a natural impulse to want to look through the lens myself.

Mami Kataoka So, as a profession, it was something that happened by accident?

NAKA For me, it's more to do with sensibility rather than design. I think I had a strong desire to photograph something. It wasn't so much wanting to take photographs of people, or to create something by working with people, but what I really wanted to do at the time was create the image that would form the basis of the photograph. And I might have also become bored with design.

Mami Kataoka Do you consider yourself a fashion photographer or a portrait photographer?

NAKA A portrait photographer. Although there are some aspects of the fashion photographer in me, but I have yet to see the work of fashion photographers in Japan that reflect this way of thinking. They work in fashion but they're not really fashion photographers. I most enjoy doing portraits, and my approach tends to be influenced by fashion because I worked for many years in a clothing store.

Mami Kataoka Does that means you're more interested in people than clothes?

NAKA To put it bluntly, I think I'm interested in myself. Even when I'm involved in commercial work, my work expresses the emotions that I'm feeling before I take the photograph, as well as my personal life at the time. But I think there is also another type of hurdle. No matter what kind of work you do, this aspect always remains, and I think this is what people see as my view of photography. I've never taken a positive, cheerful photograph. I'm more interested in something resembling sadness.

Mami Kataoka What I like about your photographs is your awareness of transience; the sad look or the happy look that we see only lasts for a moment. But there is a contradiction in that the memory of that moment is fixed. And if one were to ask whether that was truth, then there is another contradiction in that the image was something that took place a long time ago. I have the feeling that you are very aware of this transience.

NAKA Well, it makes me really happy knowing that my photographs are seen like that by people, and they understand them. Also, because of the kind of work I used to do, I might have a stronger sense of obligation to finish a photograph properly. Because I can see, to some

A extent, the final destination, it can become incredibly stressful if I have the attitude
 to my work that, it isn't good enough.

Mami Kataoka Do you think your work is influenced by Tokyo's urban environment?

NAKA I live in Tokyo, and you know that feeling you have when it even seems too far to walk
AKA around to the local convenience store. Tokyo is a very personal kind of place for me,
KA and that includes where I'm living at the moment and the fact that I get around by car.
A I might have travelled a lot if I could speak English and was the sort of person who could
 get around easily.

Mami Kataoka Do you ever look at your photographs and think, this photo is very Tokyo?

NAKA I'm not terribly aware of that. Because I'm Japanese and was born in Tokyo and continue
AKA to live here, Tokyo is my background, so I'm not really conscious of it.

Mami Kataoka What are the advantages and drawbacks, on an international level, of being
ami Kataoka involved in photography in Tokyo?

NAKA The advantage is that there are many people who love photography in this city. And I
AKA include creative people as well when I say this, but there really is nothing wrong with
KA the culture of Tokyo. I think it's wonderful. The drawback is that people in Europe and
A New York aren't very interested in Tokyo's creative people.

Mami Kataoka Where does the indecent aspect of your photographs come from?

NAKA From desire. It's not that I like indecency as such. I think it's because there is a
AKA desire inside me.

Mami Kataoka Have you ever been influenced by the music and art that comes out of London?

NAKA Punk and David Bowie and in art, David Hockney. The sense of noise that I see in his
AKA work stays with me. It bothers me. He's gay, isn't he? Perhaps he is applying a gay
KA style to his subject, but to me, his work is very contemporary and very personal.
A When it comes to photography, I think Nick Knight is a genius. London has an amazing power,
 and is extremely developed both culturally and as a base for information. Looking from
 Tokyo, I think there is a lot more information coming out of London than from New York.

Mami Kataoka Where do you think the possibilities of creativity lie in Tokyo?

NAKA There are some outstanding art directors and creative directors, and I love being able
AKA to meet so many varied people. And when there are people who want to push beyond the
KA boundaries, a workplace can become filled with energy. I believe that possibilities are
A presented to us because of people like this. But it would be good if locations for
 photography could be made more available, because there are a lot of places where we can't
 take photographs.

 Interview 24 Yoshitomo Nara
 Interview 24 Yoshitomo Nara
 Interview 24 Yoshitomo Nara
 Interview 24 Yoshitomo Nara
 Interview 24 Yoshitomo Nara
 Interview 24 Yoshitomo Nara
 Interview 24 Yoshitomo Nara
 Interview 24 Yoshitomo Nara
 Interview 24 Yoshitomo Nara
 Interview 24 Yoshitomo Nara
 Interview 24 Yoshitomo Nara
 Interview 24 Yoshitomo Nara

Fumiya Sawa You have relocated from the ascetic environment of your studio in Cologne,
umiya Sawa where you could concentrate fully on your work, to Tokyo, which has the Japanese
miya Sawa food and youth culture that you love so well. But do you still regard Tokyo as a
·iya Sawa "dangerous" city, full of desire?

Yoshitomo Nara I think that regarding Tokyo as dangerous was a kind of defence mechanism I
oshitomo Nara used to protect myself. No matter how stoic an environment I may create for
shitomo Nara myself, now that I know that such a place would be little more than a sheltered
hitomo Nara sanctuary, Tokyo is really not dangerous at all. I always want to be directing

itomo Nara my line of sight outside these walls, no matter where I am. Of course, where I'm living now is practically two hours away from central Tokyo, so I'm still looking at Tokyo from this room. Unless I open the door, this place is nothing more than "my room", and this sensation is the same as when I was in Cologne. I am looking at Tokyo, Los Angeles, Cologne and London from here.

Fumiya Sawa You have been embraced by curators in Europe and America who know nothing of youth culture, as well as by children in Japan, and it seems to me that some kind of physiological energy is at work. It is almost like observing people looking at a religious painting. What do you think this is?

Yoshitomo Nara It is a mystery to me, but I think that it perhaps acts upon the audience's memory; but individual memory, rather than something like the context of contemporary society. But I have never thought too deeply about it.

Fumiya Sawa For example, at www.happyhour-jp.com, the fervour of people who have been drawn to your work has mounted to an amazing level. One feels a completely different sort of vitality from the usual one-way relationship of artist and audience. Do you find yourself being stimulated there?

Yoshitomo Nara Rather than a stimulation in terms of creating things, I get a sense of encouragement to keep moving on. It's almost like I am one of the many people visiting HH, with little sense that it is my own website.

Fumiya Sawa By the way, where does that little girl with the iconic knife, and the other children, come from?

Yoshitomo Nara Most of them are brought forth from personal memory. Then past and present mingle, and I think they undergo their own transformations.

Fumiya Sawa The emotions of the audience are sometimes unsettling and encouraging.

Yoshitomo Nara I think that there are few differences between people in terms of the spiritual or physical experience, so I think a kind of rediscovery occurs in each of them by viewing my works and identifying with them. How something is perceived depends on that person. It may appear to some that she intends to hurt someone with that knife, or she may be surrounded by adults with even bigger knives who are trying to hurt her.

Fumiya Sawa It appears to me that the sense of distance and awareness of the world is quite different now than when you were travelling in Europe and living in Germany. Has your perspective of the world, and the manner in which you present your work, changed at all due to the differences in circumstances?

Yoshitomo Nara While a student in Japan I studied Western Art History, but I feel now that classification by region is basically irrelevant except in respect to living customs. Even within the single category of Western Art, long ago England and Italy were mutually much more foreign, and in its long history, the appearance of America is quite recent. So for me, Western and Eastern Art Histories are no more than relics of the past. We probably need some other name for what is now ongoing in the world. For my own works too, it would seem incomplete to represent them only in the context of Japan and Asia, but of course they cannot be discussed in terms of the West either. There are more and more things that cannot be categorised by country or race.

Fumiya Sawa Are you a kind of delegate for those unable to be categorised?

Yoshitomo Nara It's because I want to think in terms of the smallest unit, the individual, that I create things the way I do. All people in this world are different from one another, and no two people are ever of the same mind. But one thing that we share is that each of us is a person, and respect is probably born from there. We are all different, but we all have parts that overlap. Of course, there are even overlaps between non-humans; there are the distant memories of when we were cats or fish.

Fumiya Sawa You were saying that London will be an increasingly key place for your activities in the future?

Yoshitomo Nara The artists that I love in London have something different from America.

I can sense a kind of spirit that screams "Destroy!" from them. Also, the media in London is sophisticated, and I felt that there was much I could believe in. The sense of a fad that will fizzle out, versus something real and truly taking root are clearly differentiated and asserted. In other words, there are people on the transmitting side of things who do perceive the difference between what is good and what isn't. Also, something I like about London is the growing presence of coffee shops and the dwindling tea tradition. Of course tradition and formality are fine and beautiful, but nothing new is born if you remain bound to them. That's my idea of Destroy!

Interview 24 Banana Yoshimoto
Interview 24 Banana Yoshimoto
Interview 24 Banana Yoshimoto
Interview 24 Banana Yoshimoto
Interview 24 Banana Yoshimoto
Interview 24 Banana Yoshimoto
Interview 24 Banana Yoshimoto
Interview 24 Banana Yoshimoto
Interview 24 Banana Yoshimoto
Interview 24 Banana Yoshimoto
Interview 24 Banana Yoshimoto

Fumiya Sawa *Hinagiku no Jinsei* (The Life of Daisy) is a collaboration between you, a novelist, and the artist Yoshitomo Nara. What is it about him that attracted you to collaborate?

Banana Yoshimoto What is wonderful about Nara-kun is that while bearing a certain amount of social sensibility, he is extremely dedicated to his talent and to nurturing what he wants to do. He persistently devotes an admirable amount of energy, to thinking things through, without which it would be impossible for his motifs to be as focused as they are.

Fumiya Sawa Is Japan a difficult place for an artist to have high aspirations? And what sort of reckless things do you do?

Banana Yoshimoto In Japan, it is true that creativity is difficult to nurture. I always recall a class where we were making fish from clay, and I made the fish twist in order to give it movement. When I did that, the children around me said I was wrong for doing it differently from everyone else, that fish ought to be made like this, and showed me the shape of a fish that one would commonly see. What everyone said to me sounded as incomprehensible as another language. No matter how much conviction you may have, if this occurs again and again, it probably wears one down. And in a similar manner, the kind of creator who is co-operative with others, adhering to the budget and the deadline, is welcomed in Japan. What I refer to as recklessness is that when one feels that the work itself is of greater significance than such things, one goes ahead and does as one wants, and I think that Nara-kun has such tendencies.

Fumiya Sawa The work seems to be set in daily life, in the current Tokyo, but how deep is the connection with this city?

Banana Yoshimoto I do not want to write about things that I don't know about, so for the sake of convenience, the setting is vaguely Tokyo, but I think that what I write isn't much different from the folk tale, or fable, or something like the oral myths of the Native Americans. In the sense that it is something that young people experience sometime, somewhere in this wide world. Even if there is no connection, I think that anything, when pursued deeply, will eventually arrive at the same place. It seems to be a trait of mine to observe deeply and closely what goes on inside and around me, and wherever I am, to try to decipher some mechanism of this world from it.

Fumiya Sawa Compared to musicians and visual artists, when reaching overseas, a writer faces more complicated difficulties such as translation, and differences in social and cultural backgrounds. Do you think that the people in London who read your books share the same experience?

Banana Yoshimoto There are those who you might see every day in school with who you share no connection, and those you meet and instantly connect with, no matter how

nana Yoshimoto
ana Yoshimoto
na Yoshimoto
a Yoshimoto
Yoshimoto
Yoshimoto
oshimoto
shimoto
himoto
imoto
moto
far away they were born, and how differently they may have been raised. In the same way, I know that my work instantly communicates to and is sought by a certain kind of people. I feel that nationality is irrelevant in that. In such a situation I feel that we don't share cultural common ground, but we do share many different things, and I always feel that my writing is reaching them. In a certain sense, all people lead an urban lifestyle in this age, and the speed of time flowing, as well as the intensity of money worship bears down impossibly upon the individual. In such a state, securing freedom, which is something that is difficult to begin with, becomes extremely difficult. People desperately seek a moment of peace, to rest and recharge, to free their spirit. I feel that my work is able to offer something in such an environment.

Fumiya Sawa
umiya Sawa
Fumiya Sawa You pretend to be a weary city dweller, tricking your readers in order to lead them where?

Banana Yoshimoto
anana Yoshimoto
nana Yoshimoto
ana Yoshimoto
na Yoshimoto
a Yoshimoto
Yoshimoto
Yoshimoto
oshimoto
shimoto
himoto
imoto
Banana Yoshimoto I think the only place to go is into nature. It is the experience of melding into some transformation much bigger than oneself, such as nightfall or darkness, or calm and wind. However, in urban life, there is no way to experience the flow or energy of nature in your bones except by travelling, so I think people have the desire to feel something flowing, moving violently, changing, settling, becoming calm, somewhere in their senses. My greatest interest lies in tracing such sensations subtly in writing, and I believe this is possible to some extent. I think that by just becoming caught up in a story, through which one can witness the flow of something, enables one to experience a faint brush of freedom. Of course, music and film and paintings exist for us to closely examine the similarities and differences of the enormous power of nature and the power of humanity, so that we might catch a glimpse of some essence of life.

Interview 25 NIGO/A BATHING APE
Interview 25 NIGO/A BATHING APE
Interview 25 NIGO/A BATHING APE
Interview 25 NIGO/A BATHING APE
Interview 25 NIGO/A BATHING APE
Interview 25 NIGO/A BATHING APE
Interview 25 NIGO/A BATHING APE
Interview 25 NIGO/A BATHING APE
Interview 25 NIGO/A BATHING APE
Interview 25 NIGO/A BATHING APE
Interview 25 NIGO/A BATHING APE
Interview 25 NIGO/A BATHING APE

Suzannah Tartan
uzannah Tartan
Suzannah Tartan How would you define A BATHING APE; as a fashion house, a brand, a personal art project or a concept?

NIGO
IGO
GO
NIGO It's a new kind of production that has never existed before. A BATHING APE is not restricted within the boundaries of fashion, but aims to continue expanding without limit into all other areas such as toys, sound, etc.

Suzannah Tartan
uzannah Tartan
Suzannah Tartan How would you define what you do; are you an editor, designer, brand manager or all of the above?

NIGO
IGO
NIGO I am the executive producer. All items, sound and events with the BATHING APE name are passed through my own filter in order to gain shape.

Suzannah Tartan
Suzannah Tartan What constitutes the BATHING APE style?

NIGO
IGO
GO
O
NIGO There is not really any way to pin down style. It's my opinion that the formation of style is ultimately dependent on the interpretation of the person on the receiving end. Even if I offer and define an ideal of style, I cannot of course choose the people who come to buy BATHING APE.

Suzannah Tartan
uzannah Tartan
Suzannah Tartan How does the energy of Tokyo street culture influence what you do? Why do you think Tokyo has arguably become the most style-conscious city in the world?

NIGO
IGO
GO
O
NIGO I think that BATHING APE exists because of the fact that I've lived in Tokyo. It's also an extremely important factor that things and information from all cities around the world flow into Tokyo. A new generation of people who have been influenced by elder generations in Japan, as well as American and European cultures, are currently creating contemporary Tokyo style.

Suzannah Tartan Do you have ties with many of the youth culture leaders around the world?
How do such connections influence the direction of A BATHING APE?

NIGO I don't think there is any influence on the direction, but whether they are famous or
not, my friends are a most important presence for both myself and A BATHING APE. This is
what is meant by "APE SHALL NEVER KILL APE", the theme of BATHING APE.

Suzannah Tartan Outside Japan, BATHING APE goods are considered rare and thus ultimately
cool. This is somewhat true in Japan also. Do you strive to make your goods
collectable?

NIGO Short-run production is a basic concept of BATHING APE.

Suzannah Tartan You always seem to be deeply influenced by music and now you are making
music yourself. What is the connection between music and the fashion of
A BATHING APE?

NIGO Just as Mod culture had the sound of The Who and Small Faces, and Hip-Hop culture has
Rap, BATHING APE has the BATHING APE sound, that is, the APE sound.

Suzannah Tartan There is a strong sense of playfulness in A BATHING APE goods. Is this
something you strive for?

NIGO I might be conscious of this in an unconscious way. Inspiration and playfulness are
what make BATHING APE.

Interview 26 Jessica Ogden

Jane Alison You take found fabrics and clothes and rework them to make contemporary garments,
because your interest is in reinvigorating them in some way. How does your design
process achieve this?

Jessica Ogden I'm not interested in just duplicating a costume or studying history, for me,
it's just a piece of fabric and it doesn't matter if it's from 1902 or 1501.
I don't look at it for its preciousness but for its beauty.

Jane Alison Tell me about the process by which you select fabrics.

Jessica Ogden The reason why I find an antique quilt that's in tatters so charming or amazing
is because it experienced a life to get that way. If I try to duplicate that
age on a new garment, it's going to take me a long time. It's the process that
it's gone through that I find amazing to look at. It's not so much the fact that
a garment is from a particular period in time, but the fact that it's from a long
time ago and has accumulated that amount of life.

Jane Alison But the shapes you use are very modern. So perhaps their success as clothes is
due to the contrast between the period quality of the textiles and the cut, which
feels very new?

Jessica Ogden The shape or design, as opposed to the textiles, is very straightforward and,
in my mind that's why they're easy to read. You can understand that there are
just two seams. When I'm making a garment, I try to trick the body or trick its
shape. I put the seam there, so that means I give it a slight curve. I'm thinking
about the process of wearing. If I make three rectangles, that gives me that
outline. Then, if I put the tie around that, that gives me the body. I'm just trying
to understand how the different parts of the body have movement. And then I'm more
interested with what happens in the creases (pointing to underarm area).

Jane Alison So it's like an intuitive exploration of how cloth works with a body. You seem to take an inordinate pleasure in looking at and handling fabrics, as though there's something almost magical happening. Do you think of the process in those terms?

Jessica Ogden In some ways, and that's because of my lack of training. I think my approach is about just wanting to do this. It's not logical, it's a bit more flowing and I'm not trying to make a system. It's just something that I've got to do. I don't understand quite how I got into what I am doing but I'm here now and intrigued and thrilled by the fact that I can make a garment and it works on a body.

Jane Alison Your clothes are feminine but in a strong, positive way. Is that something you aspire to?

Jessica Ogden I'm not interested in blatant sexuality but in something far more subtle. So, if a collar bone is slightly showing, it's that unclothed touch that, for me, is feminine. But the shapes are still robustly basic and the tie is trying to show the waist. I'm a little bit boyish, and when I was a child, I liked to fight... so I think that even tiny feminine touches are enough.

Jane Alison Your garments seem very inclusive too. Do you see them being worn by people of all ages and cultures? Does that relate to the way you choose fabrics and put the clothes together?

Jessica Ogden Again, there's some lack of what I would call proper knowledge here. When I'm choosing clothes, if something fascinates me it doesn't matter where it comes from. And working with different ages and also different cultures... well, I'm from three different cultures and I'm fascinated by Japan and Eastern cultures, which I've yet to explore. It's not just people who are interested in fashion who wear the clothes. I want my mum to be able to wear them, for her to feel that they're real and not too precious or designed.

Jane Alison Are your clothes art or fashion? Is it important to show your work in the context of an installation outside the commercial fashion world?

Jessica Ogden It sounds a bit strange, but I think of my clothing as clothing. If they end up in a gallery, then I'm really interested in that and if they are in a fashion magazine that's also good. They fit in either place. I don't see all my pieces as everyday wear, instead they're an experiment about layering or something. One day I'd put a piece around my waist, then on another, I'd wear it flat or it may just be an object that works without a body in it.

Jane Alison JAM includes an archive of your clothes: a personal selection of key pieces that you've kept. Tell me how the pieces relate to each other?

Jessica Ogden I was interested in looking at years of making clothes and showing that there is progression but also a stability, a continuing aesthetic. When you're involved in making new garments every six months there isn't enough time to digest that moment. It's only with time that you understand what you were trying to achieve. And perhaps, in that original moment you didn't quite achieve it and that's why it comes back around again.

Jane Alison You live and work in London. Has the culture and creativity here been an inspiration to you?

Jessica Ogden Definitely. It's about energy. When I was a teenager it was my dream to be in a town... Now I have dreams of collaborative work. It doesn't necessarily need to be a vocal conversation, just some sort of link. If I meet someone creative who understands that line without me having to explain it, you both just relate to it, and then you collaborate and understand each other through the thing that you produce. A place like London draws people together.

Jane Alison You often mention how important it is to make clothes that make you feel happy and are beautiful. Are they the two most important things in your work?

Jessica Ogden The idea of happiness isn't just about trying to satisfy myself, but the wearer as well. Coming back to my own happiness, it's the idea of being positive and able to do something creative that you put emotion into. And, feeling very grateful for being given an opportunity and achieving a feeling of accomplishment.

ica Ogden / And then the idea of beauty is... I guess you don't really understand why you find
ca Ogden a particular thing beautiful.

Jane Alison Where do you think your positivity comes from?

Jessica Ogden I remember when I first started making clothes, there was a very direct link
essica Ogden between making clothes and knowing that I had a frustration in my life. When I
ssica Ogden didn't make clothes I didn't feel the way I thought I should feel. So I started
sica Ogden to make clothes. I wanted to feel comfortable and a piece of bought clothing
ica Ogden which didn't fit, that's not me! I didn't know how to find what I thought was my
ca Ogden identity, so I said, try and create that identity. I think that's why it takes me
a Ogden so long to design. The process involves giving it time to find out whether it's me
Ogden or not. Sometimes it's too quick, and I put something out and then later I think,
Ogden no, that didn't settle, that's still on the surface and I haven't understood it yet.
gden That's what I do with the process of making clothes; try and settle it.

 Interview 27 Graham Rounthwaite
 Interview 27 Graham Rounthwaite
 Interview 27 Graham Rounthwaite
 Interview 27 Graham Rounthwaite
 Interview 27 Graham Rounthwaite
 Interview 27 Graham Rounthwaite
 Interview 27 Graham Rounthwaite
 Interview 27 Graham Rounthwaite
 Interview 27 Graham Rounthwaite
 Interview 27 Graham Rounthwaite
Interview 27 Graham Rounthwaite
Interview 27 Graham Rounthwaite

Ekow Eshun Have you always drawn people, and how did you develop your style?

Graham Rounthwaite Yes, I've always drawn people. Drawing people is one of the hardest things
raham Rounthwaite to do. I started doing illustration at Chelsea College of Art. I was doing
aham Rounthwaite a graphic design degree but ended up just doing paintings, almost graphic
ham Rounthwaite paintings of abstract elements and type. Then I put other things in, and then
am Rounthwaite people. Eventually, I took everything else out and just kept the people.
m Rounthwaite I realised that what I wanted to do was paint pictures of young people, of my
 Rounthwaite generation. At that time, in 1991, Basquiat was massive in the art schools;
Rounthwaite it was all graffiti-esque, New York influences. And I decided I'd do better work
ounthwaite if I drew pictures of people in London. I think that people shape everything
unthwaite around them and that's what I focused on.

Ekow Eshun And it's always people in urban settings?

Graham Rounthwaite London is where I live, but it's also got a lot to do with where I grew
raham Rounthwaite up, on the edge of Birmingham in the suburbs. I was absolutely fascinated
aham Rounthwaite by the city when I was growing up. I felt a part of it but not — my suburb
ham Rounthwaite was boring and there was nothing to do. I was so excited to be in London
am Rounthwaite and going out. Rave and Acid House were big when I arrived in 1989 and I felt
m Rounthwaite like I was really part of something.

Ekow Eshun Did you feel like you could document those times?

Graham Rounthwaite You only think like that in hindsight. I was aware that it was important
raham Rounthwaite for me to do work with what I saw and the places I went to, because my work
aham Rounthwaite would be based on first hand experience.

Ekow Eshun The people you illustrate are always very image-conscious, very hip.

Graham Rounthwaite I wanted to do something I had experience of and they were the kind of
raham Rounthwaite people that excited and inspired me. It's a big thing going out and seeing
aham Rounthwaite people who you think are genuinely cool.

Ekow Eshun Did you or do you still have an outsider's eye on London?

Graham Rounthwaite The truthful answer is I'm probably as much a part of it as anyone, apart
raham Rounthwaite from the fact I'm not beautiful or cool or super trendy. I do this work but
aham Rounthwaite I haven't striven to be like that — I've been intrigued enough by it though
ham Rounthwaite to want to record it.

Ekow Eshun Is there an idealised world in your images or an attempt to capture what you truly encounter?

Graham Rounthwaite It's a hyper-real world. I'm recording a part of London, a place I know fairly well – Hoxton and Shoreditch – but I was blowing it up, making it more exaggerated. I wanted to make cool pictures.

Ekow Eshun But then you worked for two years creating advertising for Levi's in America.

Graham Rounthwaite It was interesting for me. I couldn't record London people anymore. In the first year I had to do New York people, and the second, West Coast people. And I had no idea what they looked like. So I went out there and hung out and got paid for it and took a load of photos and commissioned a load of research and had stylists reporting on the trends because we wanted the ads to talk to real people.

Ekow Eshun You were one of the first illustrators during the mid 90s to have a well-known signature style. When you look at the resurgence of illustration that is happening now, in magazines and advertising, do you feel your work has been influential?

Graham Rounthwaite I hope it was somehow. I think a few people were doing some well-exposed work and other people have since.

Ekow Eshun Having said that, are we in danger of graphics overload right now, with so much illustration around, and if so, where does that leave you?

Graham Rounthwaite I just want to do good work about subjects I enjoy, whether as a designer, illustrator or artist. For me I don't feel that it's the style that is important as much as the desire to do good work I'm enthusiastic about.

Interview 28 Masafumi Sanai
Interview 28 Masafumi Sanai
Interview 28 Masafumi Sanai
Interview 28 Masafumi Sanai
Interview 28 Masafumi Sanai
Interview 28 Masafumi Sanai
Interview 28 Masafumi Sanai
Interview 28 Masafumi Sanai
Interview 28 Masafumi Sanai
Interview 28 Masafumi Sanai
Interview 28 Masafumi Sanai
Interview 28 Masafumi Sanai

Masa Sugatsuke How did you start taking photographs?

Masafumi Sanai It was important for me to become involved in something that I could do on my own. I was in a rock band, but it wasn't very successful. I also decided to resign from my job and concentrate on producing quality work. I was about 24 at the time. Before that I was working in industrial machinery and sales.

Masa Sugatsuke I find that hard to imagine.

Masafumi Sanai I don't remember those days very well, but I was pretty serious. I'd told myself that I would commit myself to the job for three years. I'd decided that I was going to work and look after my mother until she died. And after she died, I would do what I really wanted to. And that's how I took up photography.

Masa Sugatsuke Did you ever work for a studio or as someone's assistant?

Masafumi Sanai I once joined a food photography studio, so I'm pretty good at taking photos of food. I then left, and came to Tokyo. I learnt more about photography, started printing my work, and had my own studio. After arriving in Tokyo I started photographing landscapes.

Masa Sugatsuke When did *Ikiteiru* (Living) come out, and would you describe it as a single work?

Masafumi Sanai 1997, but the photographs were taken in 1995 and 1996. Putting together a collection of photographs was more difficult than I'd anticipated. Landscape

photography wasn't popular at the time. But a part of me is drawn towards extremes, and I believed that the simple act of taking a photograph was the principle behind photography. All I wanted to do was to start taking photographs with the attitude of wanting to take them; just to take photographs without any intention, simply to experience the impact of taking a photograph. *Ikiteiru* is a series of photographs that I put together in a "Pop" style.

Masa Sugatsuke Is the sense of anti-climax communicated by *Ikiteiru* and *Wakaranai* (Don't know) something that you strive for?

Masafumi Sanai I actually become quite effected by the subjects as I photograph them. But it's never easy, partly because simply photographing the subject doesn't satisfy me. I want to include something else during the process. People that see my work may feel that I'm not particularly effected or involved in the subject, but as far as I'm concerned, I am.

Masa Sugatsuke The art director, Hideki Nakajima, described your photographs as being, "photographs in Japanese". I think he's right, what do you think?.

Masafumi Sanai I believe in my own experiences and I've never lived overseas, so there is a sense that I am pressing the shutter on my own sense of nostalgia as well as on the present. I don't press the shutter thinking how nostalgic the image is, but because it feels in the moment. That might be where the Japanese quality comes through.

Masa Sugatsuke You don't like anything that's too obviously cool, do you?

Masafumi Sanai I think Louis Vuitton's advertisements are very cool. But I don't like half-measures. The coolness that people usually sense is what's expressed when they say, hey, that's cool! But something isn't cool to me unless I can almost fall in love with it.

Masa Sugatsuke So the subject isn't that important to you?

Masafumi Sanai I'm just waiting for a chance to press the shutter, and the timing of that moment is what's important. The subject gives me the opportunity to press the shutter, and so I try not to let that opportunity get away. I go to places I've never been to and I also go to places I'm familiar with, and I wait for an opportunity to press the shutter. And I might think, that person's eyeballs are really dark. The other day, I came across an old person whose eyeballs were quite dark and I thought he might have been a gremlin of some sort. But unfortunately I wasn't prepared and so I couldn't take a photo.

Masa Sugatsuke Is your work influenced by the urban environment of Tokyo?

Masafumi Sanai There is a direct influence, and it could be the people or buildings. But if you asked me to explain it, I couldn't.

Masa Sugatsuke What are the advantages of taking photographs in Tokyo?

Masafumi Sanai There's work here. I'm working in fashion photography, music, advertising and magazines. This provides me with a living. Also, my friends live here and there are people that I respect here.

Masa Sugatsuke If you were to assess Tokyo from a global perspective, what would be the interesting aspects, and what would be less interesting?

Masafumi Sanai Japan is interesting when it comes to animation. As for overseas... I like food with coriander. I like that sort of thing (laughs).

Masa Sugatsuke Have you ever been influenced by the music, art or photography that comes out of London?

Masafumi Sanai The Beatles, Punk, but I don't know anything about the photography. I really like London. I like Maida Vale. I've been there before, and I'd like to go back again.

Masa Sugatsuke How would you like people to view your work at the London exhibition?

Masafumi Sanai
asafumi Sanai
safumi Sanai
afumi Sanai
fumi Sanai
umi Sanai
mi Sanai
i Sanai
Sanai
Sanai In whatever way they want to look at it; after all, I know nothing about them. I am very serious about my work, but if I was asked to describe in detail what I am photographing, I wouldn't know. I wonder what it is I'm photographing, and unless I accept what I'm doing, I can't take the next step. So when I put out a collection of photographs I make sure that I have conviction in the work, and that there are no uncertainties. I think the reason it's hard to describe my work is because I take photographs that can't be explained. I'm not able to feel secure about my work simply by verbalising. Taking photographs makes me feel secure, because it's something I can't explain in words, and I'd like the people who see my work to be able to read into it.

Interview 29 Norbert Schoerner
Interview 29 Norbert Schoerner
Interview 29 Norbert Schoerner
Interview 29 Norbert Schoerner
Interview 29 Norbert Schoerner
Interview 29 Norbert Schoerner
Interview 29 Norbert Schoerner
Interview 29 Norbert Schoerner
Interview 29 Norbert Schoerner
Interview 29 Norbert Schoerner
Interview 29 Norbert Schoerner

Ekow Eshun When did you first start taking photographs?

Norbert Schoerner When I left school in Munich and finished the German equivalent of A-levels my dad gave me a camera as a present. Before that I never thought of taking photographs because I wanted to be a film-maker. I made my first short films at 16, but it went horribly wrong and I got myself into a lot of debt, so I thought photography would allow me to keep talking in a visual language. I became a photographer's assistant in Munich. He mainly did beer and hamburgers and tyres and things like that and that's how I learnt all the technique. Then I spent a year travelling, doing landscape photography, made a portfolio and thought about finding a publisher, which was what brought me to London in 1989.

Ekow Eshun It's fair to say that you're better known as a fashion photographer than landscape photographer. How did you make that transition?

Norbert Schoerner I didn't think I'd be a photographer straight away, for economic reasons and the language barrier. But two months after I arrived, I ran into Phil Bicker (then art director of *The Face*) and he gave me a job, which was one of the reasons I'd come to London in the first place, because I was inspired by *The Face* in the 1980s. So I became a photographer, and that's when the struggle began (laughs)! I always had a thing for landscape, I was inspired by environmental textures because I thought they were a reflection of the human element, but I wasn't very good at the human element itself. Working for *The Face* and *i-D* brought me in touch with that much more and I discovered that I wanted to make images with people, which gradually led me into fashion.

Ekow Eshun Some would say that fashion photography is just about surface imagery...

Norbert Schoerner That's what it often is but in my naiveté I didn't realise that, which is why I don't think I'm a key player in the fashion scene or ever will be. I'm interested in introducing an antagonistic element to it, in questioning the aesthetic rather than feeding it. The prime motivation for most people to look at and produce fashion imagery is because they think it is a contemporary revelation of beauty. For me there's always something else. In the past ten years, fashion photography's taken on a role of being a feeding process for commercial industry. I think it's lost the cultural challenge it used to have.

Ekow Eshun Can you critique culture while making beautiful images?

Norbert Schoerner I think my work is very coded. I see beauty in things that perhaps a Conde Nast picture editor wouldn't. My work relates to a multi-layered absorption of being an individual in our times, ranging from whatever expresses our identity – the environment we live in, the clothes we wear, the music we listen to – to our social, sexual and commercial behaviour. Although you might

have a very hard time extracting that from my images, that's the thought process that goes into it. I start from a very complex process and funnel it down to one image.

Ekow Eshun What do you take photos of; what you see or what can be?

Norbert Schoerner What can be, and what has been and what will be. That sounds very esoteric but I don't think my photos ever claim to represent a moment in time, where with most other photography, the makers really claim that. Photography has been pushed into this role of representing reality; like what Cartier-Bresson shot was reality, whereas he was just an editor like anyone else. I never claim to represent a moment in time, I'm not interested in that, it's much more complex. Anyone who would claim to represent reality has got a very narrow view of what really goes on.

Ekow Eshun Some people may suggest that all you're interested in is exploring fantasy?

Norbert Schoerner No. It's dealing, more than anything, with the subconscious process. In the end, my work is based on instinct. I think all the inspiration and knowledge that I acquire from other sources, gets fed into my work. The things that I read become a much bigger catalyst than visual references.

Ekow Eshun Your work seems almost to be describing a submerged world.

Norbert Schoerner Yes, I totally agree. Perhaps that world should stay where it is but it's quite intriguing to extract little items sometimes.

Interview 30 Six Eight Seven Six

Ekow Eshun How did you come to start Six Eight Seven Six, and what, if anything, do the numbers stand for?

Kenneth McKenzie I started the company six years ago. I was working in fashion and it was OK, but I wanted to do something in my own way that involved more than just clothing; things like websites and films, which could bring in my peculiar obsessions. I was trying to make an interesting product rather than a huge brand and I didn't want to have my name on everything, so the idea of numbers came along. I thought, I'm going to do something that some people will connect with and some people will hate. That was Six Eight Seven Six, which just happened to be two things that I was into – Paris '68 and Punk '76. There was quite a lot of humour involved but, to the outside world, it came over as austere. Our first collections were stark, grey and utilitarian. But I thought it was funny that some people couldn't remember the numbers and some people thought it was pretentious. That was the idea, for it to be confusing! The first announcement we sent out was Situationist graphics on a postcard with no information. Then we did t-shirts with Situationist slogans such as, "Retour a la normalle" and a picture of a flock of sheep, which was a bit of the jibe at the fashion industry, and "We're all undesirables", because fashion people want to be lovely and beautiful. It's very amusing having thousands of these t-shirts out there sporting hard-core political images. I thought that authentic revolutionaries would say we were belittling them but I met a university professor who thought it was totally superb and in the true spirit of the original idea.

Ekow Eshun Six years on, are you as interested in taking the label beyond clothes into other areas, like film, or is that less of an issue?

Kenneth McKenzie All the things that we do are part of our company philosophy. Now we're growing up a bit and trying to get to a level where we keep doing films, rather than have to stop because we've got production difficulties or

neth McKenzie whatever. It's how we exist to be different from the other companies. You want to make the best clothes the best way and you want to be ahead of it all and that's good, but if we don't have the other part there's that worry that it'll just bland out. If you're only doing clothing it can drive you crazy, especially in London, where there's this style thing. Everyone is so obsessed with being stylish and having the right kind of look - it's very "coffee table book". Some people probably think we're really hard work because we believe that we add little things in there that'll make people think. But what's always inspired me is we've always just wanted to do some good things.

Ekow Eshun So can fashion change the way we look at issues?

Kenneth McKenzie I think we're coming into an era where everything is so documented and trend-oriented that music, art and fashion will just be enjoyed for what they are and people will look for change at a much deeper level. People are so obsessed with finding the next Punk or Acid House, and I don't think there will be one. I might just be getting older, but the explosion of music and youth culture that has come every ten years, I think it's over. What has music and fashion got to do with the riots in Seattle? Now it's a separate thing. Britain was such an old-fashioned, un-media-oriented country when Punk happened, but now we're full-tilt the other way and that's why nothing like that will happen again.

Ekow Eshun Do the graphics and slogans just become window-dressing?

Kenneth McKenzie We don't advertise and we don't put on catwalk shows. Even if we had the money we wouldn't get involved in that whole circus. We do films, we do events, we try and make things interesting for people. That's where we try and have some integrity; it's non-marketing. Rather than shooting the clothes on models and not being able to compete financially with bigger companies, we thought we wouldn't compete at all, we would just create a feeling. The first film we did was with the photographer Norbert Schoerner, who is a friend, who just understood what we were trying to do. It's another way of throwing people off the scent but also encouraging people into understanding.

Interview 31 Ewen Spencer
Interview 31 Ewen Spencer
Interview 31 Ewen Spencer
Interview 31 Ewen Spencer
Interview 31 Ewen Spencer
Interview 31 Ewen Spencer
Interview 31 Ewen Spencer
Interview 31 Ewen Spencer
Interview 31 Ewen Spencer
Interview 31 Ewen Spencer
Interview 31 Ewen Spencer
Interview 31 Ewen Spencer

Ekow Eshun When did you start taking photographs?

Ewen Spencer It was 1994. I was 23 and fed up with doing very little, manual work mainly. I'd left school at 16 and later decided to do an Arts Foundation Course at Newcastle College, which was where I discovered photography. That was definitely it for me. I went to the University of Brighton to do a degree in Editorial Photography and it just took off. From the start I was interested in reportage and the documentary photographers from the 1970s and 1980s, such as Graham Smith and Chris Killip, who did an amazing book on the de-industrialisation of the North East of England.

Ekow Eshun But your degree show was made up of pictures of the Northern Soul scene...

Ewen Spencer That was something I was passionate about. Visually I thought it needed resurrecting and I wanted to do it justice. All the images I'd seen of Northern Soul showed guys in baggy pants slipping on the dance floor, but it's not about that. It's about escapism; it's a social thing and a class thing. There's an old Mod cliché that applies to it: Clean living under difficult circumstances.

Ekow Eshun Clean living under difficult circumstances. Does that sum up club culture?

Ewen Spencer It definitely does for UK Garage. It's the same aesthetic as Mod and Northern

Soul. It's another aspirational scene, which really attracts me. People are going out into a room with 500 other people and they're going to have fun no matter what. It's all about escapism, letting loose, enjoying yourself, but there are darker aspects, as well as the bright ones. Some people are less fortunate than others and the scene is a reflection of what's out there on the streets of London and Britain, you can see that even when people are dressed up to go out. Inner city Britain is a dreary old place but there is an ostentatious, almost 1980s, living large feel to UK Garage.

Ekow Eshun You spend a lot of time shooting photographs in clubs.

Ewen Spencer Yes, it's a problem. I'm going to get labelled as a club photographer, which is something I'm worried about.

Ekow Eshun What's wrong with that?

Ewen Spencer It's just me being impatient. There will be other projects in the future less to do with clubbing. Bt at the moment I'm interested in youth culture and that's where you find it. One of my first breaks was doing club photos for *Sleaze Nation*. After a while, I used to try and push things and be a bit more adventurous in the type of clubs I photographed. I went to the only club in Europe run by disabled people, the Beautiful Octopus in London's Kings Cross. There were people with learning difficulties and people in wheelchairs. Usually you see all these strappy, beautiful people in clubs who can barely heave themselves out of their pretensions to have a good time, but there I saw people who are severely disabled and... it was a fucking brilliant club night, just awesome.

Ekow Eshun You mentioned working with *Sleaze Nation*. Has being involved with certain magazines been important?

Ewen Spencer *Sleaze Nation* was brilliant for making me go out and take pictures. Instead of going out and just shooting pictures for myself I was shooting regularly and getting the best of it in a magazine. It was a great way to train my eye, and it was the beginning as far as I'm concerned. Just recently, I've been in Moscow, Uruguay, Turkey, the USA, back and forth a lot. Now I'd like to do more long-term essay work that's not club-based. Ten or 15 years ago, the guys I like — Killip, Paul Graham, Martin Parr — they were working for the Sunday newspapers. I'm not going to belittle the style magazines but those papers provided an outlet for more serious projects, which isn't the case anymore.

Ekow Eshun Can you capture a transient moment in a club, the one fleeting moment that flares up and then disappears almost instantly?

Ewen Spencer You can, definitely. When you go out clubbing you have special moments that you may be embarrassed about the next day, or you wake up and remember them with a surge of excitement. That keeps you wanting to go out again and again and again, and I think those moments are the sort of thing I can capture. That's why people commission me (laughs)!

Ekow Eshun What are you looking for when you're out shooting at night, or even during the day, in London?

Ewen Spencer I remember what a college tutor said to me once: you can go across the world and take photos in trouble spots in Africa or India or anywhere, and it's easier to make images out there because they're visually more shocking to our eyes. But if you can make images in your own back yard, then you're a photographer. Originally I thought photography was about glossy fashion images, but when I started looking at it in book shops and college libraries and I saw Robert Frank and William Klein, who produced great iconic images that stand the test of time. Fashion images have got a shelf life, so forget it! In 20 years time I'll still be looking at Eugene Richards' images and I'll still be knocked out.

Catherine Wood Why did you come to study in London?

Tomoaki Suzuki I first came to London in 1998 and stayed for three weeks just sightseeing. London's culture was very popular in Japan at that time, book shops were selling lots of books and magazines about London and what was happening. London looked so powerful to me; the economy was good and music and films were so nice, and the art world was strong, with people such as Damien Hirst.

Catherine Wood Did you study art in Tokyo?

Tomoaki Suzuki Yes, I studied sculpture for five years at the Tokyo Zokei University.

Catherine Wood You studied at Goldsmiths College in London; did you find any differences in comparison to the university in Japan?

Tomoaki Suzuki Yes, it was completely different. In Japan I studied the basic skills for making sculpture, because the Japanese art education is based on skill and technique. Only later do you develop your own idea or concept. But, at Goldsmiths, it was completely different; ideas or concepts are the main thing.

Catherine Wood Did you have problems at Goldsmiths?

Tomoaki Suzuki I quite enjoyed it, but I was confused when I started the course. I had a lot of tutorials and seminar discussions with other artists, and I hadn't had those kinds of discussions in Japan. Teachers teach skills, and students just accept their ideas, especially at the Tokyo Zokei University. In Goldsmiths, artists have to talk about their own work and criticise each other. It's deadly. Some opinions are quite supportive but others are really critical.

Catherine Wood Apart from Goldsmiths, what is it about London that influences what you make?

Tomoaki Suzuki If I had continued living in Tokyo perhaps I wouldn't be creative. In London there are lots of provocative things, for example, a lot of different races – black, white, Asian, etc. – it is really surprising.

Catherine Wood Are you interested in your work focusing on people, and there are more different kinds of people in London?

Tomoaki Suzuki Yes, that is very interesting. I never get bored when I am watching people, which is important for making sculpture.

Catherine Wood The way you make is quite traditional; carving wood into a human figure. But your work is very contemporary. Do you feel it is a natural progression or has it come through the conceptual training at Goldsmiths?

Tomoaki Suzuki When I started the course at Goldsmiths, I tried to be a Goldsmiths's student. I wanted to be very conceptual and I tried to avoid what I had studied in Japan, which was very traditional. That's why I came to London. But I couldn't do it and was really disappointed. However, one of the tutors, Paul Morrison, had a different idea. He said I shouldn't avoid what I was studying before. The experience had been important, and I should continue making figurative sculpture. Then I tried my idea, which was about fashion. Also, I decided to use wood. I was mainly modelling with clay in Japan, but I thought wood was better for my concept. Fashion is very short term, it changes very quickly, every year every season. Wood carving is a very traditional thing. I thought of combining the two, to create a crash of traditional and contemporary things.

Catherine Wood How do you make a wooden sculpture?

Tomoaki Suzuki I take 360 degree photographic images of the models, and digital video to see how the model actually moves. Normally they are my friends or friends of friends. I asked people on the street several times, but they just missed the appointments. So, I decided to only ask my friends.

Catherine Wood How important is the size of the figure?

Tomoaki Suzuki The size is really important. I wanted to be very objective. I wanted to create distance. Also, I put my figures on the ground, I tried to make a relation between the figure and the ground, which is very important, and quite existential. Then they are wearing contemporary clothes. I think it is one of the problems sculptors have, they try to be timeless. I feel that idea is a bit too romantic.

Catherine Wood Tell me your ideas about fashion.

Tomoaki Suzuki I found an interesting article about fashion in the newspaper, talking about David Beckham and Posh Spice. Their style and fashion are very popular in England, especially with the younger generation. British people are basically more individual or independent about fashion than Japanese people are, but, according to the article, the younger generations are now changing. They are easily accepting certain fashions. Japanese people tend to follow fashion but British people may become more like that in the future, by following the media.

Catherine Wood Tell me about the direction your work is taking?

Tomoaki Suzuki People say my ideas are about youth culture and fashion, but I want to expand my ideas to be more about race. I would like to study anthropology.

Catherine Wood Do you have a favourite type of music?

Tomoaki Suzuki When I make sculpture, I usually listen to Techno and Drum 'n' Bass because club culture is very important for contemporary fashion.

Interview 33 Hideyuki Tanaka

Nobuko Shimuta A lot of work goes into many of the images in your promotional videos, particularly "Denki Groove". Do you draw the storyboard first?

Hideyuki Tanaka Yes, I draw a detailed storyboard. It's difficult communicating with crew and cast on location, so I use the storyboard to do that. It's also easier to explain locations using a storyboard.

Nobuko Shimuta And you are also quite involved in art direction, aren't you?

Hideyuki Tanaka I do all the art direction myself. I also go and search for props with the Art Department. I regard filming in the same way as I do animation or computer graphics, because with animation, the artist creates the props and the background. Although, Electric Groove's "Volcanic Drum Beats", I created with Pierre Taki, one of the Electric Groove team members.

Nobuko Shimuta When you make a promotional video, do you have discussions with the artists? Or is your creative process based on your own image of the song or track?

Hideyuki Tanaka I don't have many discussions with the others. But I think it's really up to the artist whether we meet and discuss what they're doing. For example, I created the computer graphics animation, as well as the story line for Denki Groove's "Nothing Gonna Change". But because it's a promo, it's better if the other members become involved. In that sense, we came up with the ideas together.

Nobuko Shimuta On the whole, there seems to be an awareness of the Entertainment industry in much of Frame Graphics' work?

Hideyuki Tanaka We consider how design should be expressed within the context of Entertainment. And that's what we're influenced by. I think that in Entertainment, the form of expression itself (which includes design) is the service or the product. Whether a music video is considered as a promotion for a CD or an artist depends on the situation, but it's certainly a lot more fun to produce the video with the aim of entertaining.

Nobuko Shimuta What is the source of inspiration for your designs?

Hideyuki Tanaka The manga that I read as a child, TV programmes during the Showa period, 1980s culture and Techno music. I like games other than role playing games. As far as my own work is concerned, I've been involved in designing characters and in the art direction of the Play Station game "Bust a Groove".

Nobuko Shimuta What significance does Tokyo have for you, in your production work?

Hideyuki Tanaka I've travelled to other countries, but I've never lived overseas, and so working in Tokyo is just something that's happened naturally. I was raised in, and am now working in, a Japanese environment, so I think I've been influenced by everything here.

Nobuko Shimuta What are your thoughts on Tokyo's subculture?

Hideyuki Tanaka I'm not really sure when the "sub" starts. I've never thought deeply about it, but I don't think that sort of thing is restricted to Tokyo. The situation is far more complex. In my opinion, subculture is a word from the past, from a time when the situation was a lot simpler.

Nobuko Shimuta I get the feeling that the younger generation of creative people look on all media as having equal value. Do you agree?

Hideyuki Tanaka From TV to t-shirts, I don't feel there is any media difference. However, I do emphasize value differences in areas other than media.

Nobuko Shimuta "Characters" are central to your graphics. Why do you use characters?

Hideyuki Tanaka As a point of contact for the audience, and of course, because I like them. I think you have to like them to do the job. And I do believe that using characters as an interface has a strategic meaning, too. But it's a method that's been used for decades in the Entertainment world.

Nobuko Shimuta What's the story behind the VJ unit "Prince Tonga" that you've formed with Pierre Taki, a member of Denki Groove?

Hideyuki Tanaka When I was filming the Denki Groove footage, Pierre and I started discussing how we would like to do something different by sharing our ideas, and this led to the formation of the unit. We usually perform every three months in a club. We'd like to continue trying out various experimental ideas within this unit. We've recently been adding sound to the footage and improvising with the club DJ. Unlike normal editing, this creates a sense of live performance, and at times we come across new ideas purely by chance. That's where the real appeal lies.

Interview 34 Ichiro Tanida

Masa Sugatsuke How did you first start working in computer graphics?

Ichiro Tanida My first involvement with computers was in 1987, when I started using a Macintosh at the design studio I was working in. Initially I was only using

the Mac for graphic design, logos and layout, but I gradually began to create pictures.

Masa Sugatsuke What are you most conscious of when creating computer graphics?

Ichiro Tanida It's a pretty obvious thing, but the finish is important for me. Because, there are various shades that can be achieved, depending on the direction of the work, such as whether the computer graphic is to be the dominant image, or whether it's being used to highlight something else.

Masa Sugatsuke You also paint by hand; what is the main difference between using a computer and using paints and brushes?

Ichiro Tanida There are many differences in the actual creative process, but as far as expression goes, regardless of whether you use paints or a computer, the only difference is in the tools. There is no real difference.

Masa Sugatsuke Recently you have been involved in film-related work. Why did you move from graphics to movies?

Ichiro Tanida Probably because of my nature, by which I mean that I go with the flow (laughs). When you use 3-D software, you first start by modelling. And when the modelling is complete, you add some animation; then you become concerned with the acting, and so the natural progression is to direct. Eventually I wanted to start filming. When you leave your computer there are so many new discoveries, and your world expands. Naturally, the fact that the emergence of the personal computer enables anyone to edit film is also a major factor.

Masa Sugatsuke What words best describe your work, what do you call yourself?

Ichiro Tanida Director, because the work I'm mainly involved in at the moment is directing commercials. I'm told that I become involved in something and then suddenly change direction, but I disagree. Certainly, I'm not the type to continue using the same form of expression over a long period. I do loose interest in things quite quickly, and because of that the methodology that I apply changes constantly. At the moment, my aim is to create something that people can see and feel good about, even though it may be broader than what I normally do. And there are only really three or four areas I'm involved in - painting, design, computer graphics and film. And with computers, there's no need to have any technological skills.

Masa Sugatsuke Do you feel that your work reflects Tokyo, and what aspects in particular?

Ichiro Tanida Very much. Tokyo is the first place that various new cultures appear, and so I can see and listen to all the latest trends. And it's probably the result of all these influences coming together that makes Tokyo what it is. I believe humans are influenced by their environment. If I lived up a mountain, what I create would be quite different.

Masa Sugatsuke When you receive a brief from a client, what expectations do they have of you?

Ichiro Tanida Many of the briefs I receive are along the lines of, we want to do something out of the ordinary. When I first became involved in commercials I was told that I was on the edge, but now I'm told that I'm a mainstream director (laughs). It makes me happy when people say, use Tanida and your product will sell. As long as I'm involved in making commercials, I don't believe in making something that veers too far from the mainstream. Besides, there's probably something of value in the mainstream.

Masa Sugatsuke What are you most concerned with when making a film?

Ichiro Tanida Everything. It's only three years since I started working in film so everything concerns me. I want to be involved in everything - the direction, the technical side, creating something perfect and also making something that's less structured. I feel a bit like a student, as if I'd wanted to become involved in film-making, so I enrolled in a film school and I'm in my third year. I just enjoy everything that I do and I'm trying out all sorts of things. That's what it's like. But then I sound like an amateur, don't I? And I suppose this doesn't really answer your question.

Masa Sugatsuke What are the advantages and drawbacks of working creatively in Tokyo?

Ichiro Tanida The advantage is that you don't have to think of anything other than creating. You only have to think, I need such and such, and you can access it, whether it's a computer, paint or reference materials. It takes no time to go to a work meeting or to the editing studio. The drawback is that time goes so quickly here. And I don't mean in the sense that I could make something of quality if I had more time. It's that we are always in a fast time frame. And so I think, if that's the case, I may as well go out partying, but I'm basically a workaholic.

Masa Sugatsuke What aspects of London's culture have influenced you?

Ichiro Tanida I don't know if I can restrict it to London, but I like European art and design. In particular, I've been influenced by German artists. Of the artists in London, I'm interested in Marc Quinn. I also saw a book titled *Make My Night* by Paul Smith, which is a collage of photos that Smith took with a cheap camera, and it was fantastic. What I liked about it was the wonderfully hopeless quality of the work. Oh, and I love Gilbert and George!

Masa Sugatsuke What is the most enjoyable aspect of your creative process?

Ichiro Tanida It's hard for me to be specific about when that is; there's the moment that I get an idea, or the moment that I complete something; or during the filming or editing process. I don't know when I'll experience that enjoyment, and those moments are very short nowadays. That's why I immediately start creating my next work. I'm practically a drug addict.

Masa Sugatsuke Do you think there will be more people like yourself, working across media, emerging in the future?

Ichiro Tanida Yes, I do. With the emergence of the personal computer, we can take on all sorts of areas. And my role model is the Bauhaus. I'm aiming to be a one-man Bauhaus (laughs). Initially, I knew about the Bauhaus movement through the design aspect, but there were also all kinds of people working in photography, architecture, painting and film. I'd love to be able to work in all those areas. But these days, people might find it easier to understand if I described myself as a one-man Tomato. But if I did, I'd probably never master anything (laughs).

Interview 35 : Simon Thorogood

Jane Alison You've obviously got a broad range of interests, so what finally made you become a clothing designer?

Simon Thorogood It goes back to my Arts Foundation course and how I came to do fashion by mistake. We had to choose subjects. And sculpture or painting got filled up, so I had to do another one. Eventually I applied for a fashion degree because it was a medium in which I could express my interest in graphics and 3-D forms, on the body. I certainly had no desire to be a fashion designer when I was young and I still struggle with seeing myself as one now.

Jane Alison Now, that you are a clothing designer, what is it about the process of dressing people that you particularly enjoy?

Simon Thorogood Well, I think whatever you choose to do, there's a need to see people engaging with your work. It's great to see people wearing the clothes. But regards fashion, I'm excited by how broad the horizon currently is. Obviously people like Issey Miyake always had that exploratory attitude. Now doors have

h Thorogood really opened up and that has made fashion a very interesting medium. And a lot of discoveries that have been made in fine art or sound or whatever are now happening in clothing, certainly in terms of presentation.

Jane Alison Do you mean in terms of showing clothes as installation or performance?

Simon Thorogood Yes. I see myself as having grown from an high art school of thought where art could be whatever you wanted. And fashion, in its broadest definition, is about flux. So, in terms of movement or sculpture that can embrace all sorts of things, which I think is truly exciting.

Jane Alison You have maintained a very uncompromising stance in the fashion world, for instance, not participating in Fashion Week and not designing ready to wear clothes. Why did you choose that particular path? Was it because you were more interested in being an artist?

Simon Thorogood Possibly it has to do with that. When I started off I was very conscious that I had to make a series of decisions as to how I would play the game. I knew that if I wanted to be a regular dress designer, then I would have to follow a well-trodden path and it would mean a lot of sacrifices, because fashion is a commercial industry and I didn't want to involve myself in that. Possibly, it was a selfish thing in a sense that, rather than start off compromising, I decided I absolutely wanted to do it my way. My work is slightly interactive and about a shared framework. And, it's kind of an experiment and means that things can be tough but, on the other hand, I get to do lots of interesting projects. I think my attitude came from things I read, economic or cultural predictions. A book called *Global Paradox* highlighted how, in the future, businesses might be more tailored or commission-based because of a series of shifts in patterns of work: being global and local at the same time. These ideas engaged me, and I began to see how I could fit my patterns of work to these predictions.

Jane Alison Considering the global and the local, do you feel part of an international community of designers and how does that relate to your position in London?

Simon Thorogood I don't particularly feel that I'm part of the London scene. People tend to have a base, and I do. In fact, in an interview the Japanese composer Sakimoto said that he saw himself as an "outernational" – working outside the culture but still based in it, and I found that interesting.

Jane Alison You seem to work within quite a narrow range of abstract forms and the shifts are very subtle. I know that you are particularly interested in aeronautical engineering and your sources of inspiration are not specific to culture particularly. Can you say something about inspiration?

Simon Thorogood I tend to look to shapes and designs in different fields, whether it's engineering, aircraft design or music. I suppose it's a very boy thing, being drawn to mathematical systems, which I have a great empathy with. I am still fascinated by the Stealth aircraft because it turned over a new leaf in aviation by being a blend of different materials. So, visually, they were like fine examples of minimalist art. For me, it's about taking that aspect of something into the realm of clothing. And it's the same with music. I'm completely absorbed by systems in music, and people like John Cage, Brian Eno or Stockhausen who create very specific recipes to arrive at sounds or textures. I have been trying to build up a visual framework from those systems working with composers and musicians.

Jane Alison How do you translate that into making an item of clothing, and how does it effect your relationship with the wearer?

Simon Thorogood I design just what I want to. And it tends to be a culturally-aware person who wears my pieces, but that's certainly not what I'm aiming for. Perhaps there's a kind of empathy. I'm aware that all these interests are conveyed in the clothing because that's what I've chosen to do. And it's a fine line because you can establish a signature but that can also become a kind of conservatism, a form of sameness.

Jane Alison I wondered to what extent you are interested in boundaries between, being subversive and being traditional in the way you dress women?

Simon Thorogood Firstly, I'm not out to shock or provoke, and I don't try to do things that

are hype or modern or anything like that. I want to be contemporary but because my clothing has a kind of couture quality to it. I'm interested in traditional processes of making, for example, that piece made with duchess satin. I had to treat it and back it with various fusings and interlinings and treat the fabric to make it do what it wouldn't ordinarily do. So, there's something about the almost architectural process of making pieces that I enjoy.

Jane Alison Rei Kawakubo has been influential for you. Can you say something about the links between design in London and Tokyo?

Simon Thorogood I think that an interesting thing about people like Rei and Yohji Yamamoto is that they came at a very peculiar time culturally speaking. They were brought up in Japan when it still suffered from being in a cultural void, because it had been infiltrated by the USA. They started working from a very interesting point, where they could adopt very ancient things and, at the same time, very contemporary, forward-looking attitudes. It must have been a potent time. And those particular designers have always been instrumental in pushing boundaries for fashion in terms of fabrication, silhouette, function, concealment and colour. There is a lot of intellectual activity around their work because on the one hand, it can be worn as clothing but they often show their work in installations. For me as a designer brought up in a modern, pluralistic world, that's great.

Jane Alison We've decided to represent your work in this book with drawings. How important is drawing to you and what part does it play in your design process?

Simon Thorogood It is the fundamental, the starting point of everything with regard to what I'm looking at or feeling or thinking about. For example, a lot of the shapes in my works were line drawings, taken from the panelling not only of the Stealth but of various aircraft. So, those are the first things I do. Then they morph into colours, perhaps into 3-D forms, and into writing, and I enjoy putting together sketch books. Of course, I go and see painting and sculpture shows or installation and they stick in the back of the mind. Often a particular work has a resonance with me.

Jane Alison People who produce regular collections are able to change direction from one season to the next. You have a different way of working. How does change occur?

Simon Thorogood I'm catering to a niche market and it's one of those paradoxes that somebody's strength can also be their weakness. When you look at a designer's work, in a sense, you're dealing with their limitations. I certainly wouldn't attempt to try and achieve a feminine, floral look because I know I wouldn't be particularly good at that. I'm very aware that my limitations or my strengths are my signature. They can be my undoing because there's a danger of repetition.

Jane Alison Are developments in textile design significant to you?

Simon Thorogood The reason I felt drawn to that satin was because in a sense it is very ancient, a traditional couture fabric used for wedding gowns and that sort of things. Yet, it has a very modern feel to it, there's a paradox to it.

Jane Alison It looks like metal...

Simon Thorogood Yes. And you don't usually print on it, but the marks are almost invisible, blink and they disappear. On some pieces, I used very small facets of resin and perspex, and I've previously used fragments of wood. And often, these are just ideas from things that spill off the pages of a sketch book or the wall.

Interview 36 Kosuke Tsumura
Interview 36 Kosuke Tsumura
Interview 36 Kosuke Tsumura
Interview 36 Kosuke Tsumura
Interview 36 Kosuke Tsumura
Interview 36 Kosuke Tsumura
Interview 36 Kosuke Tsumura
Interview 36 Kosuke Tsumura
Interview 36 Kosuke Tsumura
Interview 36 Kosuke Tsumura
Interview 36 Kosuke Tsumura
Interview 36 Kosuke Tsumura

334
335

Suzannah Tartan The concept of FINAL HOME, which you presented in 1994, was "clothes for the urban dweller". It has been seven years since then, has anything changed?

Kosuke Tsumura The concept has not changed since the beginning. My creations are based on ideas of survival and protection. Protection is at the core of my idea of clothing, the concept that clothing is our ultimate home. At the time FINAL HOME was presented, I actually did come up against opposition that said, the homeless population must be reduced, the idea of clothes to aid such people is preposterous. But what I intended was not to demonstrate life on the streets as being a decline into poverty, or something miserable, but to show a shift in the concept of clothing. Fashion was originally haute couture for the upper classes, but it became something for ordinary people through the influences of hippie and street culture. I feel that since the first presentation of my clothes, the environment and circumstances into which they're received has changed.

Suzannah Tartan Do you feel that there has been an increase in people actively seeking a nomadic life, or that there are more dispossessed urban inhabitants?

Kosuke Tsumura My work is based on the idea that this would be the case, so in some aspects, yes, I think this is so. Although the state of society as a whole is not so different, it is true that one sees more and more abandoned buildings. All over the world more people are taking over and squatting such places.

Suzannah Tartan Simultaneously, these are clothes in which age and nationality are irrelevant, are they trans-gender as well?

Kosuke Tsumura People wear t-shirts and jeans regardless of age, right? It's the objective of FINAL HOME to become a new standard. It comes out of nowhere, like some new invention, and has no scent imprinted on it yet, so any scent can be added to it. The shopper buys something because of the scent. That is, they ascertain what category something belongs to by scent, and selects it according to that. Since it's advantageous for the consumer to buy what represents their status, they determine this by scent. New things are pure, and are not things with which the consumer can represent status, but I think this will change if the consumer learns to judge for his- or herself. I would be happy if more and more people come to buy my clothes with this understanding.

What is your image of survival in the city?

Kosuke Tsumura I like the image of cyberpunk ruins. I recognise a certain reality in the ruins that appear in "Bladerunner" and "AKIRA". It's an image of energetic ruins, of surviving in the urban jungle. There are spaces full of freedom to be found in ruins, and I find such spaces of freedom intriguing.

Suzannah Tartan Recycling and remaking seem to be on the increase in the urban setting. You have been collecting old and worn FINAL HOME items yourself, haven't you?

Kosuke Tsumura I've only been collecting FINAL HOME nylon coats. But currently, I've only been able to recover about five of them from users who have co-operated. Apart from that, I have gathered and stored items used in collections and for display, and sent them through an NGO. Although it is the volunteer organisations that are active in sending clothes to disaster-struck areas, I think participating in such schemes is a part of our service as a clothing manufacturer. Recycling is already advanced in the clothing industry, by way of a system called the "waste business" where floss is made from scraps or is re-spun to be made into mops or work gloves. The idea of recycling and remaking is indispensable to contemporary society. Everyone must do it.

Suzannah Tartan Paper clothing was presented as part of the 2001 Kosuke Tsumura collection. Isn't disposable clothing a very Japanese idea?

Kosuke Tsumura Do you think so? This time I used a non-woven fabric, which is OK to wash, up to three times. Paper is a convenient material both for travelling and for fashion purposes, and I feel that paper material will continue to be developed.

Suzannah Tartan Where do you see yourself in terms of the Japanese fashion scene and where is the main current in Japanese fashion?

The main current would probably be what Issey Miyake, Comme des Garçon, and Y's have accomplished. They are the Japanese main current. However, from the perspective of the West, this was a tributary, born as an antithesis to the main current in the West. It arose from indigenous religion and custom — like the kimono — and was a return to the foundation and essence of eastern clothing. And we are a further tributary to that tributary, and as a tributary, I think we intertwine with western clothing in a curious way. I think our place in the scene is one in which we produce information where there is no foothold.

Suzannah Tartan How do you view Japanese obsessions such as manga and technology?

Kosuke Tsumura The influence of manga is great. When the Japanese child thinks of form, they are influenced by a distorted perception, such as that of the robots in anime. I think that Japan is a country with a strong subculture.

Interview 37 Kyoichi Tsuzuki

Mami Kataoka If someone from England was visiting Tokyo, what places would you recommend if you were showing them around the city?

Kyoichi Tsuzuki I'd take that person to an ordinary sort of shopping area like Togoshi Ginza, then we'd go and have dinner in Kabuki-cho. After that we'd go late night shopping at Don Quixote. Visitors from overseas love this sort of thing. And if they had some time to spare at night, instead of going to an onsen (hot spring), I'd go to a place called Tokyo Kenko (Health) Land. Because in Europe, you can't go shopping at night nor can you really experience a city at night. To go shopping after dinner is a typically Asian experience. One reason why we can do this is because Tokyo is an extremely safe city. Soho in London is a huge conglomerate of shops, like Tokyo, but the shops don't stay open late, because it doesn't feel like a safe area. What most surprises overseas visitors is that large numbers of people, all sorts of people, walk into Kenko Land and they all change into matching muu muus, with both men and women in the same place.

Mami Kataoka It's like being in a living room with a group of strangers, isn't it?

Kyoichi Tsuzuki That's right. And the safety aspect and the cleanliness are two things that you can't even buy in the USA or Europe. And it's these things that are inaccessible in Europe, that visitors to Tokyo really love.

Mami Kataoka There are all night markets in Asia, aren't there?

Kyoichi Tsuzuki The area around Kabuki-cho is really similar to the markets in Asia. The large izakaya pubs in Kabukicho are full at 7am. That's where the people working all night in bars go for a drink after work. There's a sort of Asian energy in these places, and it's made possible because there are no religious restrictions preventing people from working at night or on Sundays. In comparison, England is quite the opposite and extremely restricted. The shopping, the food and the architecture are all pre-determined. There's a huge difference in the two societies, with the message of one society being along the lines of, we are a society created by adults, while the other is more, we might not have much style, but we're going to do as we please. So it's really interesting to visit both cultures.

Mami Kataoka Do you enjoy London?

Kyoichi Tsuzuki When a Japanese tourist goes to London and sees the streets filled with Edwardian buildings, they are impressed by their beauty, but these buildings

do nothing for the people living in London. And even if the English wanted to build something unusual, it wouldn't be allowed. Architects and intellectuals tend to like the London way, but I actually don't think it matters, both are fine. One is no better than the other. It all comes down to each person's taste. The ideal would be to have the sensibility to be able to enjoy both. But, I think Tokyo and London are really similar, and people are constantly coming and going and there's always been a compatibility between the two. I think young people in Japan feel a real sense of familiarity towards London.

Mami Kataoka You've spent many years observing lifestyles, as in your work *Tokyo Style*. Have you noticed any major changes compared to a decade ago?

Kyoichi Tsuzuki Computers. The small houses that I'm photographing at the moment are really cramped but there is a computer. It's like people say, 'I don't have any money, but at least I have an iMac. When I was photographing *Tokyo Style* ten years ago, only a very small number of households had a computer, whereas now quite a few homes are without a TV; they only have a computer and a mobile phone but no telephone.

Mami Kataoka The congested appearance of the rooms hasn't changed over the years?

Kyoichi Tsuzuki There is an oversupply of apartments, so it's become much easier to move if you want to. In the past, even with rented apartments, people who wanted to decorate their interior space would install shelves and things like that to make it as homely as possible, but nowadays, less and less young people who do that sort of thing. Now, they simply attach flyers and posters to the walls, and that's their interior decoration. Which means that when they move, all they have to do is to remove the posters from the walls. So if anything, the apartment has become a fairly insignificant box. Rather than creating a home, it's more like changing your clothes. The old attitude or style was, I'm renting, but I want to make it like my own home. But now people think, I'm renting and I'm going to end up moving so I may as well keep things simple. The interior design industry is growing, but sales are really booming in lightweight, easily transportable items.

Mami Kataoka So the increase in the number of variety stores is because people are putting things together in their own way?

Kyoichi Tsuzuki That's what you see in Harajuku and in the fashion worn by young people. Rather than spending a lot of money on one major item, they're wearing and combining lots of smaller and less expensive things. This applies to both interiors and clothing. Except for young people who are really obsessed by clothes, most kids wear a t-shirt and jeans, and they might pick up something at a flea market that could be added, or later subtracted, from their outfit. I think there's less and less desire to own things, and I think this trend will continue, because these kids were born middle class. And I think that the desire to work hard and earn a lot of money in order to be able to own lots of things is actually quite uncool amongst these people.

Mami Kataoka When you look at the cycle of new magazines appearing and then disappearing, one after the other, I would have thought that Tokyo was a city of desire, where there's a constant attempt to absorb whatever is new.

Kyoichi Tsuzuki That's only what people are made to think. In the past, a magazine would be published with expectations that it would remain in the market for at least a year, but magazines simply can't withstand the market for that long any more, and so if it doesn't sell after three months, then it folds. Despite this, the number of fashion, music and computer magazines continues to grow, and, whether it's a good thing or not, there are certainly increasing opportunities for individuals to come across a magazine that makes that person feel that it is their very own magazine.

Mami Kataoka Finally, could you tell us one more place you recommend in Tokyo?

Kyoichi Tsuzuki You can't pass up Nakano Broadway, where you find printing shops, the famous manga shop Mandarake, shops selling materials for drawing manga, haberdashery and second-hand clothing. It's a world in itself, and there's nothing like it anywhere else. From the young person's point of view, Nakano Broadway must be like their own special universe. And it's the sort of place that wouldn't work if it was consciously created by big business; it had to evolve naturally.

Mami Kataoka Do you often go to the Nakano and Shinjuku areas?

Kyoichi Tsuzuki I go there a lot. Places like Koenji. Also, around the Chuo line late at night. The atmosphere of the area from Nakano to Koenji is similar to Notting Hill in London. There is a mix of young and middle-aged people, and people who have lived there for decades, and the feeling you get is that they tolerate each other, coexisting with little effort. There aren't that many places where you can see an old man and a punk sitting next to each other at a counter, eating revolving sushi.

Interview 38 Naohiro Ukawa

Interview 38 Naohiro Ukawa
Interview 38 Naohiro Ukawa
Interview 38 Naohiro Ukawa
Interview 38 Naohiro Ukawa
Interview 38 Naohiro Ukawa
Interview 38 Naohiro Ukawa
Interview 38 Naohiro Ukawa
Interview 38 Naohiro Ukawa
Interview 38 Naohiro Ukawa
Interview 38 Naohiro Ukawa

Toru Hachiga Who is Naohiro Ukawa? Is he a graphic designer, writer, filmmaker, VJ or an artist? You mentioned in one magazine interview that you don't give yourself a title, and that you ended up doing all these things as part of a natural progression. Is this how you feel?

Naohiro Ukawa I don't think I'm so special that people would want to know who I really am. Of the approximately 200 million sperm in a single ejaculation, only two or three dozen sperm actually reach the egg. And, those that end up gathering around the egg are waiting for a chance to inseminate it, and in the end, only a single sperm miraculously fuses with the egg! So, I guess I'm nothing more than a product of chance – and an extremely abnormal one at that.

Toru Hachiga There seems to be almost a sense of greed in your constant pursuit of expression, while your work displays a strong sense of energy. In that case, could you explain what it is that lies at the root of your creativity?

Naohiro Ukawa I wonder myself. Perhaps I've got thick blood, or a lot of red blood cells. Within the context of graphic design, because graphic design has always been a form of expression that has demanded anonymity, I feel that the very act of exposing one's ego contradicts that role. Because, after all, I'm not working within the context of art where the artist plays a central role, and so it would be truly horrible if the bloated ego lurking beneath my creativity was to be exposed! And having to even discuss, in this day and age, the difference between design and art is something I find totally irrelevant, but whatever the case may be, I am not an artist. If I had to describe myself, I'd say I'm everything other than an artist. And so within this context, perhaps my energy is derived from the desire I have to try and communicate, in an even more positive way, with other people.

Toru Hachiga And what is most important to you about your designs and films? In what way would you like people to be effected by your work?

Naohiro Ukawa Graphic design is the visualised wound that results from the process of trial and error that takes place during the bargaining and manoeuvring between the wishes of the client and my ego. That's why graphic design is more than simply based on some trend. Graphic design expresses thought, philosophy, humanity, even sexual trauma and the mechanics of getting on in the world. And if we were to really examine what design is, then you'd see that even a single straight line reveals some kind of thought process. That's why I've always tried to be aware of keeping my brain in tune in order to maintain a balance so that I'm not an idiot nor too much of an intellectual, and to always maintain a sense of innocence.

Toru Hachiga You seem to be interested in a lot of different things. What interests you most at the moment?

Naohiro Ukawa "ECDT = Ishidate Tetsuo"! The satellite cable channel, Channel NECO, has recently been running endless repeats of programmes featuring Ishidate Tetsuo.

In this new century, I wasn't sure that his trademark statements like "Go ahead and do it!", "Whaaat?" and "Cheeboo" still work, and that the quip "I love wakame (seaweed), simply love that wak'ame", is relevant today. And yet I find myself deeply immersed in the world of Ishidate despite these doubts. I recently had the opportunity to take part in a panel discussion at Sony University, and it was during this discussion that I realised that "ECDT = Ishidate Tetsuo" was still relevant! When I mentioned, as a joke, that someone should manufacture an electronic ECDT pet, there was a very positive response that I simply hadn't expected! Yes, ECDT is a key individual in eliminating the generation gap! However, having said this, I don't think people in London will understand.

Toru Hachiga There must be something unique to Tokyo that influences you creatively, what do you think that is?

Naohiro Ukawa As a designer, the amount of information in this city and the speed that trends are consumed gives me a thrill, a real sense of pleasure that I can become totally absorbed in. I visualise a client's wishes and then send it out into the world. The function demanded of graphic design is that it acts as a filter or an effects pedal. For example, we designers would never be Jimi Hendrix. If anything, we are more like the "wow wow" effect pedal used by Jimi. Although we aren't able to create the sound ourselves, if we are pressed, we can add clarity to the sound that's already been created and send that sound out into the world. The fate of such an effect pedal can also be seen as something masochistic, in that it continues to be used within the context of the wishes of the client. And, therefore designers are always vulnerable because there is always the question, is this filter still valid? If we're lucky, the filter might be revived as a result of some trite interpretation of the times and then it enjoys a period of prosperity again. And our fate is to continue floundering within our corrupt system of consumption. However, because there's a bit of the masochist in me, I do recognise that there's no other pleasure quite so convenient to my needs. It's because we are so absorbed by the thrill of living in Tokyo that we are able to ridicule trends.

Toru Hachiga You often use the word "yabai" when you speak but the Japanese word yabai is probably very difficult to express in English.

Naohiro Ukawa Well, I would have preferred it if the word yabai had been written in katakana (laughs). And I'm sure that if 10,000 exclamation marks were added to yabai and this was then amplified, then the nuance of the word would eventually be understood. I suppose you'd express yabai in English as strange or weird. I personally use the word as the ultimate praise for something. And I express the level of my feelings at the time through the number of exclamation marks that follow the word. Equally, I also try to produce quality work so that whoever sees it unconsciously shouts, Yaabaaaaaaaiiiiii!!

Toru Hachiga And what sort of creative work is Naohiro Ukawa planning for the future?

Naohiro Ukawa I've recently been spreading the lie that I organised an Ishidate media performance at the National Athletic Stadium entitled "A Projection for ECDT". This imaginary performance goes like this. 26 ECDT balloons, each twenty meters in diameter and printed with a silk-screened image of Ishidate Tetsuo's face, are filled with helium. When pressure is applied to the balloons, the balloons bump into each other and start moving. The afro hair of Ishidate Tetsuo's silk-screened image has been printed using pigment that contains Worcester sauce! As the ECDT balloons are lighter than air, when they are lined up above the smoke-filled stage, the audience can see a row of Ishidate's afros floating in the mist. Then, 16 hungry crows that were captured in Nishi-Shinjuku are released, and these crows react to the smell of the sauce and start pecking at the afros! And it appears as though Ishidate himself is being attacked and at the same time, the crows also appear to be feeding their babies! For sound effects we use a series of Ishidate expressions that are sampled from TV and looped, and played at top volume! The show is designed in such a way that the sensors only react when the crows actually approach the ECDT balloon, and the Ishidate expression, go ahead and do it! is output with a heavy delay applied to the sample. So we end up with an extremely obsessive performance, and the audience are totally perplexed!

Interview 39 UNDER COVER
Interview 39 UNDER COVER
Interview 39 UNDER COVER
Interview 39 UNDER COVER
Interview 39 UNDER COVER
Interview 39 UNDER COVER
Interview 39 UNDER COVER
Interview 39 UNDER COVER

Nobuko Shimuta When UNDER COVER first appeared on the scene, it was often introduced as the vanguard of street fashion. What is your take on street fashion?

Jun Takahashi For me, it is connected to music: Punk, Hip-Hop, Trance. In terms of the spirit, I would say that it is something "anti". All music contains an element of the anti. The street links to this. I find that there are lots of interesting people in and around Harajuku, and the street, I think, is the attitude that orients itself toward originality.

Nobuko Shimuta What is this anti-attitude against?

Jun Takahashi Society, the establishment, the decorative... and also oneself. In the way one destroys what one creates in order to move on to the next thing. I'm also anti the epithet of "street". I think I've learned to think of my creations in a pure manner.

Nobuko Shimuta Recently, much of your mode of expression seems to be about reduction.

Jun Takahashi I was working on eliminating the non-essential, but now I've eliminated too much, and so I am currently in the process of rethinking. In the past, the anti element had been reflected strongly in the form, but more recently it has stopped showing up outwardly, so the element of anti is not apparent on the outside, but rather, I remain anti until I am completely satisfied within myself.

Nobuko Shimuta Are there any designers that you were influenced by when you started out making clothes?

Jun Takahashi When I was a student, I was very much struck by Vivienne Westwood's Seditionaries and Sex collections. That Punk attitude was extremely exciting. There was a sense of having my eyes opened when I saw Vivenne's clothes; the unity and elegance of them despite embracing taboos as their theme. Perceptions of failure that I was taught in school were completely subverted. I think it influenced my ensuing direction of breaking taboos.

Nobuko Shimuta How do you select the themes of your collections?

Jun Takahashi The themes tend to be concrete ones. In Relief, I consciously attempted to create a worn look from the beginning, mixing together extreme elements, contrasting them and neutralising different patterns.

Nobuko Shimuta Is there anything that you are concerned about in particular?

Jun Takahashi My aim is to create a maximum effect with minimum ideas. I want to make one plus one equal about fifty-thousand, perhaps somewhat like a chemical reaction.

Nobuko Shimuta What sort of position do you take toward the Japanese subcultures of manga and technology?

Jun Takahashi Technology, I feel now, is a hindrance. I got rid of my cell phone. It's not as special a thing within Japan as it may appear from the outside. I think that technology is something you need a minimum of. But the technology today, whether it's cell phones or otherwise, there's an incredible glut of it and it's useless. Manga I read quite a lot. What do I like? Hmmm, I like the violent ones. Right now I'm into this one called *Koroshiya 1*. Movies too, I like Japanese ones best. I like the pathos they have.

Nobuko Shimuta What about violence and action in Hollywood movies?

Jun Takahashi I don't watch them very much, because the thing is, they aren't very realistic. They're game-like, and clean. It's the same with Japanese manga, but the way

n Takahashi in which they kill in Japanese movies is much more realistic, it's quite scary.

Nobuko Shimuta It's true that there's a certain kind of reality in the violence. Is that reality an important element in your work?

Jun Takahashi I judge everything by whether something is real or not real; although it's somewhat difficult to define exactly what is real. When I can immediately understand the way of thinking behind it from the way it's made just by looking at it, then something is real. It's honest, it isn't effected and it does exactly as one wants.

Nobuko Shimuta What sort of place is Tokyo for you?

Jun Takahashi A place that I've lived for a long time, a chaotic place, with lots of things to inspire me as well; mode, street, subculture all mixed together. In the aspects of culture and street fashion, I think it's a place where things and information from other countries are jumbled up and disordered, a mess of mismatches. Tokyo is a place where lots of disorganised things come together and combine. It is an attractive place, but I also feel a sense of blockage. But it is this jumbled-up Tokyo that I want to continue to create.

Interview 40 World Design Laboratory
Interview 40 World Design Laboratory
Interview 40 World Design Laboratory
Interview 40 World Design Laboratory
Interview 40 World Design Laboratory
Interview 40 World Design Laboratory
Interview 40 World Design Laboratory
Interview 40 World Design Laboratory
Interview 40 World Design Laboratory
Interview 40 World Design Laboratory
Interview 40 World Design Laboratory

Noriko Saito How did you meet and why did you decide to work together?

Tomoyuki Usuta We met in London through a friend. Yuichi makes clothes and I am keen on spatial and graphic design, so we thought it was a good idea to start a shop together.

Noriko Saito Why did you come to London, and how does living in London influence your work?

Tomoyuki Usuta When I worked as an art director at an advertisement company in Japan I had to represent my ideas within a very narrow frame under tight control. In London I thought I could expand my creativity, be more free, and it actually happened.

Yuichi Takenoshita I chose London because I liked the Beatles! But, now I think every aspect of London, including the food, scenery and lifestyle has influenced my creativity. If I was working in Tokyo my design would be something different. Working in London is very important to me.

Noriko Saito Is there any other important element such as music or manga that influences your creativity?

Yuichi Takenoshita In my childhood, I watched manga on TV a lot. I think that kind of environment has influenced my identity and creativity.

Tomoyuki Usuta Yes, the influence of Japanese culture is hidden within me and comes out when I create something. It's always in our work in some way.

Noriko Saito Tell me what you think of fashion and creativity in Tokyo?

Yuichi Takenoshita In terms of the level of perfection, I think Japanese art, fashion and design are excellent. And Japanese people are very good at wearing dresses well. But, to me they tend to adopt only the surface, and don't see the philosophy lying beneath the trend.

Noriko Saito Some of your works look like medieval dress but at the same time very sci-fi. What is the philosophy behind your work?

Yuichi Takenoshita I am interested in combining historical and futuristic imagery, expressing sci-fi and hard-edge images with natural material such as hemp. Also, I adopt elements from crustaceans.

Tomoyuki Usuta This time we actually set a concept – entomology – based on our imagination of the world from an insect's point of view. From the insect's eye, things must look very different. We always see from the human's point of view, which creates limitations, but to deeply feel and understand something, it is important to imagine a different viewpoint.

Noriko Saito Your shop has an amazing interior. Why did you design like that?

Tomoyuki Usuta We wanted to entertain our customers and create a completely different space from the outside world, so as to draw you into our own world.

Noriko Saito What new direction are you planning for your work?

Tomoyuki Usuta I think there is a turning point in fashion right now. A major change is happening, for example with the standard shape of a suit. With changes in lifestyle, the role of clothing in society will also change. So, we always try to see things differently.

Interview 41 Masayuki Yoshinaga

Mami Kataoka When did you start taking photographs?

Masayuki Yoshinaga I first thought about taking up photography 11 years ago. Because of my troubled past, I had never even contemplated taking up photography, but when I was 23, I went to Europe to see an English friend I had met in Japan. I also visited some other countries and I took photos of my travels using a camera that an aunt gave me. A Japanese fashion designer who I met while travelling saw and liked my photographs, and continued to be extremely supportive of my work, and that's when I began doing something serious with photography. I was 25 and enrolled in a photography school.

Mami Kataoka When did you start photographing "bosozoku" (biker gangs)?

Masayuki Yoshinaga I moved to Tokyo and became an assistant to the advertising photographer, Yoshimura Norito, studying under him and I began photographing models. But the photographs that I was taking unintentionally, the ones I happened to take, were documentary-style photographs. In fact, it was the photographs that I took of underground construction work in the Hankyu Sanbangai in Umeda that enabled me to graduate from photography school. While I was working, only the glamorous aspect of photography was visible and I gradually began to question why I was drawn towards photography. So, I went back to Osaka and started taking photographs of my old friends, and it was these photographs that developed into my bosozoku series. My first work was a photograph of people living in a town called Juso. At that point, I decided to record my own experiences, and I wanted to photograph the various experiences that I've had in my life. The collection of photographs of Asians living in Japan titled *Nippon Takaine* (Japan very expensive) is also based on the experiences I had during my travels through Asia. I believe that Asians accept the Japanese, in a real sense, much more than Americans and Europeans. This is another reason why I wanted a real record of Asians, not the negative image of Asians created by the mass media. I wanted to show them as they really are, opening their hearts to their neighbours and looking out for us. However, this is only an off-shoot of my activities, and not the core. My core feelings about this issue are expressed by the book *Moushiwake-gozaimasen* (I'm sorry).

Mami Kataoka Do you continue to photograph bosozoku because you want to express the negative emotions that lie within each member of the bosozoku?

Masayuki Yoshinaga As far as the bosozoku are concerned, what I want is for people to acknowledge who they really are, rather than any desire on my part to express what they are feeling. For me, even their motorbikes are an art form. Bosozoku must be the youngest age group to create something for the express purpose of it being seen by someone else. A 14- or 15-year-old's creative work is usually something like a drawing that you do only because the teacher tells you to. But the bosozoku are concerned with their work being seen by members of their own gang, the rival gangs and the girls that they're interested in, in that order, and are also unconsciously aware of the general public. I think it would be great if people could see what they are actually trying to express. Through this process, I myself, Japan as a whole and also the bosozoku themselves can feel liberated. But, despite the fact that we all have potential, the situation as it stands is that when the bosozoku go out into society, society treats them as second-class citizens. The majority of bosozoku are in their teens, with little life experience. I wonder how much longer the Japanese government and police will continue to avoid greater issues by treating them as scapegoats. As far as I am concerned, photography is a mission. I feel as though something is actually drawing me to photography.

Mami Kataoka How does the fact that you live in a big city influence your work?

Masayuki Yoshinaga Well, in the sense that I go to Saitama or Kanagawa to photograph bosozoku, Tokyo is simply geographically close to these towns. As far as other influences go, so many photographers are emerging and I find myself effected by and conscious of so many different elements. In one sense, this makes me tougher, so that I don't get swept away by the forces around me. There are lots of things that I want to do and want to photograph. I want to go out to the regional areas of Japan because I want to record something that is in danger of being forgotten by modern Japan. For example, there are lots of place names that contain the word "kami" (god). I'd like to visit these places, photograph the landscape there and talk to the residents, so that I can leave behind, for the generations to follow, a record of these god-places. I'd like to photograph the people that live in these places, against the background of Japanese farmhouses and terraced fields, as created by their ancestors, while being aware of the dignity of the people who coexist with nature.

Mami Kataoka So what you are saying is that you happen to live in Tokyo at the moment because of your work, but that the environment of Tokyo is not essential to your personal expression?

Masayuki Yoshinaga I'm based in Tokyo so that I can earn the money to enable me to take the photographs that I want to leave behind for future generations, and also because information is so accessible here; it's the centre for so many things. There is no particular need for me to live in Tokyo. But because it happens to be the geographical centre from where I go out to the suburbs, Tokyo is also a convenient location. The reason I want to photograph rural areas is because I was born and brought up in Osaka and I have a special "akogare" (longing) for the countryside. I'd find it difficult to live in a pastoral sort of place, and that's why I enjoy the moment through the medium of photography.

JAM: Tokyo-London Directory
JAM: Tokyo-London Directory
JAM: Tokyo-London Directory
JAM: Tokyo-London Directory
JAM: Tokyo-London Directory
JAM: Tokyo-London Directory
JAM: Tokyo-London Directory
JAM: Tokyo-London Directory
JAM: Tokyo-London Directory
JAM: Tokyo-London Directory
JAM: Tokyo-London Directory
JAM: Tokyo-London Directory

Aa
Aa
Aa
Aa
Aa

Airside
24 Cross Street
London N1 2BG
UK
Tel: +44 (0)20 7354 9912
Fax: +44 (0)20 7354 5529
E-mail: info@airside.co.uk
www.airside.co.uk

Azumi, Shin and Tomoko
E-mail: azumi@uk2.so-net.com
www.azumi.co.uk

Bb
Bb
Bb
Bb
Bb

Bump
Unit D, Flat Iron Yard
Ayres Street
London SE1 1ES
UK
Tel: +44 (0)20 7407 7482
Fax: +44 (0)20 7378 6537
E-mail: bump@btconnect.com
www.bumptown.co.uk

Cc
Cc
Cc
Cc
Cc

Chalayan, Hussein
Ex-directory

Constantine, Elaine
c/o Marco Santucci
85 Essex Road
London N1 2SF
UK
Tel: +44 (0)20 7226 7705
Fax: +44 (0)20 7226 9563
E-mail: sharon@marcosantucci.com
www.marcosantucci.com

Cornelius
3-D Corporation Limited
Alfaspin Building, 3-16-8
Aobadai
Meguro-ku
Tokyo 153-0042
Japan
Tel: +81 (0)3 3496 2590
Fax: +81 (0)3 3496 2591

Dd
Dd
Dd
Dd
Dd

Davis, Paul
c/o MAP
1st Floor
59-61 Tabernacle Street
London EC2A 4AA
UK
Tel: +44 (0)20 7490 2829
E-mail: juliesims@mapltd.com
www.mapltd.com

Deluxe (Klein Dytham architecture)
1-3-3 Azabu Juban
Minato-ku
Tokyo 106-0045
Japan
Fax: +81 (0)3 3505 5347
E-mail: kda@klein-dytham.com
www.klein-dytham.com

Deluxe (Tokyo Brewing Company)
1-3-3 Azabu Juban
Minato-ku
Tokyo 106-0045
Japan
Tel: +81 (0)3 3560 3559
Fax: +81 (0)3 3560 3559
www.tokyo-ale.com

Deluxe (Namaiki)
1-3-3 Azabu Juban
Minato-ku
Tokyo 106-0045
Japan
Tel: +81 (0)3 5575 2456
Fax: +81 (0)3 5575 2457
E-mail: abe@namaiki.com
www.namaiki.com
www.namaikicycles.com

Deluxe (Nakameguro Yakkyoku)
1-3-3 Azabu Juban
Minato-ku
Tokyo 106-0045
Japan
E-mail: dj@nakameguro.com

Ee
Ee
Ee
Ee
Ee

Elliott, David
Assistant Director (Arts)
The British Council
1-2 Kagurazaka
Shinjuku-ku
Tokyo 162-0825
Japan
Tel: +81 (0)3 3235 8031
Fax: +81 (0)3 3235 8040
E-mail: david.elliott@britishcouncil.or.jp
www.britishcouncil.org
www.britishcouncil.or.jp
www.uknow.or.jp

Enlightenment
2-1105 Kaminoge Haim
3-16 Kaminoge

Setagaya-ku
Tokyo 158-0093
Japan
Tel: +81 (0)3 3705 5470
Fax: +81 (0)3 3705 5471
E-mail: elm@kt.rim.or.jp

Eshun, Ekow
E-mail: ekow.eshun@mailbox.co.uk

Ff
 Ff
Ff
 Ff
Ff

Farrelly, Liz
E-mail: efarrelly@hotmail.com
E-mail: liz@farrelly.demon.co.uk

Fox, Shelley
c/o Abnormal
The Electricians Workshop
2 Michael Road
London SW6 2AD
UK
Tel: +44 (0)20 7736 1143
Fax: +44 (0)20 7736 1156
E-mail: info@abnormalpr.co.uk

Friendchip
E-mail: data@friendchip.com
www.friendchip.com

Gg
 Gg
 Gg
 Gg
Gg

Gontarski, Steven
c/o White Cube
31-37 Hoxton Street
London N1 6NL
UK
Tel: +44 (0)20 7930 5373
Fax: +44 (0)20 7749 7470
E-mail: info@whitecube.com
www.whitecube.com

Gorgerous
c/o Mizuma Art Gallery
Twin S Building
5-46-13 Jingumae
Shibuya-ku
Tokyo 150-0001
Japan
Tel: +81 (0)3 3499 0226
Fax: +81 (0)3 3498 6704
E-mail: y-umem@mizuma-art.co.jp
www.mizuma-art.co.jp

Groovisions
GRV Company Limited
1-11-10 Nakamachi
Meguro-ku
Tokyo 153-0065
Japan
Tel: +81 (0)3 5723 6558

Fax: +81 (0)3 5723 6356
E-mail: grv@groovisions.com
www.groovisions.com

Hh
 Hh
 Hh
 Hh
Hh

Hachiga, Toru
+81
7-4-12 Akasaka
Minato-ku
Tokyo
Japan
Tel: +81 (0)3 3587 9374
Fax: +81 (0)3 3587 9375
E-mail: hachiga@dd-wave.co.jp

Hachiya, Kazuhiko (PetWORKs)
E-mail: hachiya@petworks.co.jp
www.petworks.co.jp/~hachiya

Hiropon Factory
493 Marunuma Art Residence
Kamiutimagi Asaka-shi
Saitama 351-0001
Japan
Tel: +81 (0)48 456 2548
Fax: +81 (0)48 456 2535
E-mail: ky2t-mrkm@asahi-net.or.jp
www.hiropon-factory.com

Homma, Takashi
5A Soen Building, 2-9-8
Ebisu Minami
Shibuya-ku
Tokyo 150-0022
Japan
Tel: +81 (0)3 3714 8395
Fax: +81 (0)3 3714 2665

Hoogland-Ivanow, Martina
c/o Z Photographic
10 Adela Street
London W10 5BA
UK
Tel: +44 (0)20 8968 7700
Fax: +44 (0)20 8968 7722
E-mail: olivia@zphotographic.com

Ii
 Ii
 Ii
 Ii
Ii
 Jj
 Jj
 Jj
 Jj
Jj

Jarvis, James
E-mail: mail@worldofpain.com
www.jamesjarvis.co.uk
www.worldofpain.com

Jarvis, James

c/o Silas
2-8 Scrutton Street
London EC2A 4RJ
UK
Tel: +44 (0)20 7375 1900
E-mail: info@silasandmaria.com

Judd, Ben
c/o Vilma Gold
66 Rivington Street
London EC2A 3AY
UK
Tel: +44 (0)20 7613 1609
E-mail: mail@vilmagold.com
E-mail: benjudd16@yahoo.co.uk
www.vilmagold.com

 Kk
 Kk
 Kk
 Kk
Kk

Kataoka, Mami
Tokyo Opera City Art Gallery
3-20-2 Nishishinjuku
Shinjuku-ku
Tokyo 163-1403
Japan
Tel: +81 (0)3 5353 0756
Fax: +81 (0)3 5353 0776

Kyupi, Kyupi
www3.osk.3web.ne.jp/~kyupi2/

 Ll
 Ll
 Ll
 Ll
Ll
 Mm
 Mm
 Mm
 Mm
Mm

Made Thought
Studio 7 Victoria Mills
9 Boyd Street
Whitechapel
London E1 1NH
UK
Tel: +44 (0)20 7488 4005
Fax: +44 (0)20 7488 2991
E-mail: info@madethought.com
www.madethought.com

Morris, Chris
Ex-directory

Multiplex
E-mail: studio@multiplex-tv.com
www.multiplex-tv.com

 Nn
 Nn
 Nn
 Nn
Nn

Nagashima, Yurie
Matrix Inc
#203 2-28-9 Jingumae
Shibuya-ku
Tokyo 150-0001
Japan
Tel: +81 (0)3 3821 1144
Fax: +81 (0)3 3821 3553

NAKA
Ex-directory

Nakajima, Hideki
Nakajima Design
4F Kaiho Building, 4-11
Uguisudani-cho
Shibuya-ku
Tokyo 150-0032
Japan
Tel: +81 (0)3 5489 1758
Fax: +81 (0)3 5489 1758
E-mail: nkjm-d@kd5.so-net.ne.jp

Nara, Yoshitomo
Stephen Friedman Gallery
25-28 Old Burlington Street
London W1S 3AN
UK
Tel: +44 (0)20 7494 1434
Fax: +44 (0)20 7494 1431
E-mail: info@stephenfriedman.com

Nara, Yoshitomo
Tomio Koyama Gallery
Saga 1-8-13-2F
Koto-ku
Tokyo 135
Japan
Tel: +81 (0)3 3630 2205
Fax: +81 (0)3 3630 2205
E-mail: tkoyama@tke.att.ne.jp

NIGO/A BATHING APE
Ex-directory

 Oo
 Oo
 Oo
 Oo
Oo

Ogden, Jessica
c/o Abnormal
The Electricians Workshop
2 Michael Road
London SW6 2AD
UK
Tel: +44 (0)20 7736 1143
Fax: +44 (0)20 7736 1156
E-mail: info@abnormalpr.co.uk

 Pp
 Pp
 Pp
 Pp
Pp
 Qq
 Qq
 Qq

Qq
Qq

 Rr
 Rr
 Rr
 Rr
Rr

Rounthwaite, Graham
Art Department
Unit 131, Canalot Production Studios
222 Kensal Road
London W10 5BN
UK
Tel: +44 (0)20 8968 8881
Fax: +44 (0)20 8968 8801
E-mail: graham5@btinternet.com
www.art-dept.com

 Ss
 Ss
 Ss
 Ss
Ss

Sanai, Masafumi
#402 Dai-ni GS Manshon
1-9-6 Hatagaya
Shibuya-ku
Tokyo
Japan
Tel: +81 (0)3 3373 2847
Fax: +81 (0)3 3373 2847

Sawa, Fumiya
E-mail: fumiya238@hotmail.com
www.code-re.com

Schoerner, Norbert
c/o CLM
19 All Saints Road
London W11 1HE
UK
Tel: +44 (0)20 7750 2999
Fax: +44 (0)20 7792 8507
E-mail: camilla@clmuk.com
E-mail: nick@clm.com
www.clmuk.com

Six Eight Seven Six
244 Kilburn Lane
London W10 4BA
UK
Tel: +44 (0)20 8968 6876
Fax: +44 (0)20 8969 7121
E-mail: info@68-76.com
www.68-76.com

Shimuta, Nobuko
Nippon Design Center
1-13-13 Ginza
Chuo-ku
Tokyo 104-0061
Japan
Tel: +81 (0)3 3567 3527
Fax: +81 (0)3 3564 9445
E-mail: shimuta@ndc.co.jp
E-mail: shim@ea.mbn.or.jp

Shoreditch Twat
c/o Neil Boorman
333 Old Street
London EC1V 9LE
UK
Email: neil@333oldstreet.freeserve.co.uk

Spencer, Ewen
c/o PYMCA
Unit C, Zetland House
5-25 Scrutton Street
London EC2A 4HJ
UK
Tel: +44 (0)20 7613 3725
Fax: +44 (0)20 7613 3437
E-mail: pymca1@netcomuk.co.uk
www.pymca.net

Sugatsuke, Masa
Composite
Hougado Corporation
Daini-Okazaki Bldg
4F 3-3 Sakuragaoka
Shibuya-ku
Tokyo 150-0031
Japan
Tel: +81 (0)3 3496 8501
Fax: +81 (0)3 3496 8505
E-mail: hougado@netjoy.ne.jp
www.compositemag.com

Suzuki, Tomoaki
Galerie Michael Janssen
Norbertstrasse 14-16
D-50670 Cologne
Germany
Tel: +49 (221) 130 0830
Mobile: +49 172 655 3444
Fax: +49 (221) 130 0831
E-mail: jans@khm.de

Swift, Lucy
Design Promotion Project Manager
The British Council
11 Portland Place
London W1B 1EJ
UK
Tel: +44 (0)20 7389 3157
Fax: +44 (0)20 7389 3164
E-mail: lucy.swift@britishcouncil.org
www.britishcouncil.org/arts/design

 Tt
 Tt
 Tt
 Tt
Tt

Tanaka, Hideyuki
E-mail: tanaka@framegraphics.co.jp

Tanida, Ichiro
John and Jane Doe Inc
#101 Likura Comfy Homes
3-4-4 Azabudai
Minato-ku
Tokyo 106-0041
Japan
Tel: +81 (0)3 3586 2537

Fax: +81 (0)3 5573 4292
E-mail: jjd@ta2.so-net.ne.jp

Tartan, Suzannah
Casa della Luna #501
3-9-14 Honcho
Nakano-ku
Tokyo 164-0012
Japan
Tel: +81 (0)3 3374 4512
Fax: +81 (0)3 3374 4512
E-mail: suzana@gol.com

Thorogood, Simon
E-mail: simon_thorogood@hotmail.com

Thorogood, Simon
c/o Spore
E-mail: ben@spore.co.uk
E-mail: suzanne@spore.co.uk

Tomlinson, Marcus
c/o Streeters
5th Floor
113-117 Farringdon Road
London EC1R 3BX
UK
Tel: +44 (0)20 7278 7588
Fax: +44 (0)20 7278 7567
E-mail: rachel@streetersuk.co.uk

Tsumura, Kosuke
A-net Inc
1-1-11, Shin-Ohashi
Koto-ku
Tokyo 135-8332
Japan
Tel: +81 (0)3 5624 4854
Fax: +81 (0)3 5624 4856

Tsuzuki, Kyoichi
E-mail: infotsuzuki@nifty.com

Uu
Uu
Uu
Uu

Ukawa, Naohiro
#101/102 Habitation Sogawa
2-6-21, Shinmachi
Nishi Tokyo-shi
Tokyo 202-0023
Japan
Tel: +81 0422 51 3797
Fax: +81 0422 51 3797
E-mail: momndad@fra.allnet.ne.jp

UNDER COVER
Collezione 2F
6-1-3 Minami Aoyama
Minato-ku 107-0062
Japan
Tel: +81 (0)3 3407 1232
Fax: +81 (0)3 3407 1232

Uu
Uu

Uu
Uu
Uu

Ww
Ww
Ww
Ww
Ww

World Design Laboratory
9 Dray Walk
The Truman Brewery
91 Brick Lane
London E1 6QL
UK
Tel: +44 (0)20 7854 0063
Mobile: +44 (0)789 009 3416
E-mail: world-design@talk21.com
www.w-d-l.com

Xx
Xx
Xx
Xx
Xx
Yy
Yy
Yy
Yy
Yy

Yoshimoto, Banana
Yoshimoto Banana Office
4-48-49, Sendagi
Bunkyo-ku
Tokyo 113-0022
Japan
Tel: +81 (0)3 5685 4995
Fax: +81 (0)3 5685 4996

Yoshinaga, Masayuki
#102 Adachi-so
1-9-6 Yutenji
Meguro-ku
Tokyo 153-0052
Japan
Tel: +81 (0)3 5722 3379
Fax: +81 (0)3 5722 3379

Zz
Zz
Zz
Zz
Zz

Acknowledgements
Acknowledgements
Acknowledgements
Acknowledgements
Acknowledgements
Acknowledgements
Acknowledgements
Acknowledgements
Acknowledgements
Acknowledgements
Acknowledgements

Aldis Animation
Mat Bickley
Irene Bradbury, White Cube
Alice Cicolini, The British Council
DJ Chari Chari
Judith Clark
Rachel Clark, Streeters
The Designers Republic
Kirsty Dias
Michael Donlevy
Emma and Greg Eden, Warp Records
Kodwo Eshun
Fontaine Limited
Fuji Xerox Company Limited
Alison Gibb
Haruna Ito
Michael Janssen
MAP
Annika McVeigh
Dan Melunsky
Metro Imaging
Tim Milne
Iain Morris, Channel Four
Jonathan Morris-Ebbs
Chris Noriaka, One in the Other Gallery
Emma Reeves, Dazed and Confused
Takeshi Sakurai
Mark Sanders
Peter Snadden
Keiji Terai
Bridget Virden
Georgina Warrington, Talkback Productions
Yuko Yabiko, Pineal Eye
Kaori Yamada
Tomoko Yoneda
Kaori Yoshida